SEVENTEENTH AND EIGHTEENTH-CENTURY
FASHION IN DETAIL

AVRIL HART AND SUSAN NORTH

PHOTOGRAPHS BY RICHARD DAVIS
DRAWINGS BY LEONIE DAVIS

V&A PUBLISHING

First published by V&A Publications, 1998, as *Historical Fashion in Detail from the 17th and 18th Centuries*

First Published in North America by Rizzoli International Publications Inc., 1998, as *Fashion in Detail from the 17th and 18th Centuries*

This edition published 2009

V&A Publishing
Victoria and Albert Museum
South Kensington
London SW7 2RL

Distributed in North America by Harry N. Abrams, Inc., New York

ISBN 978 1 85177 567 5
Library of Congress Control Number 2008937855

10 9 8 7 6 5 4
2013 2012 2011

New cover design: Lizzie B Design
Designer: Area
Photographs: Richard Davis, V&A Photographic Studio
Drawings: Leonie Davis

Front cover illustration: Mantua and petticoat of cream silk, embroidered with silver-gilt and silk thread, English, 1740s. T.179&A–1959 (see p.64).

Back cover illustration, left: Man's Court coat of embroidered and appliquéd striped silk, lined with ivory silk twill, French, 1790s. 106–1891 (see p.118); **right:** Polonaise gown of striped lustred silk, English, c.1775. T.96–1972 (see p.68).

Inside cover illustration: Woman's gown of cotton tamboured with coloured silks, English, c.1780. T.391–1970 (see p.162).

Frontispiece: Polonaise gown of Chinese painted silk, English or French, late 1770s. T.30–1910 (see p.66).

Acknowledgements, facing page: Gauntlet of a leather glove, English, 1600–1625. T.42–1954 (see p.210).

Printed in Singapore by C.S. Graphics

V&A Publishing
Victoria and Albert Museum
South Kensington
London SW7 2RL
www.vandabooks.com

Contents

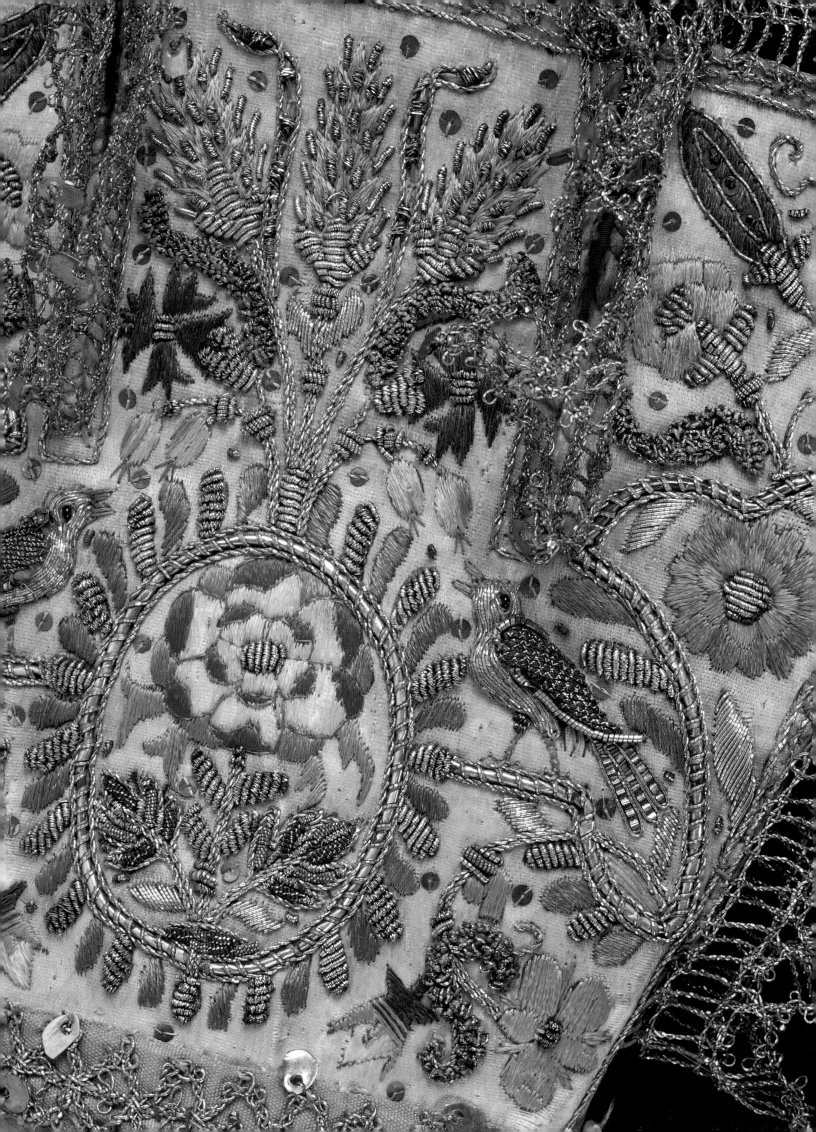

Acknowledgements

We have received considerable help and advice whilst writing this book and would like to thank the following for their time and patience: Joanna Marschner of the State Appartments and Royal Ceremonial Dress Collection at Kensington Palace; Lynn Szygenda of the Embroiderers' Guild; and colleagues at the V&A including Valerie Mendes, Chief Curator of the Textiles and Dress Department; Linda Parry, Linda Woolley, Clare Browne, Lucy Pratt and Debbie Sinfield, also of Textiles and Dress; Anthony North of the Metalwork Department; Hilary Young of the Ceramics Department; and Lynda Hillyer and Marion Kite of Textiles Conservation; and textiles consultant Santina Levey.

The superb photographs were taken by Richard Davis and the excellent drawings are by Leonie Davis. We would also like to thank the team at V&A Publications: Mary Butler, Miranda Harrison, Rosemary Amos, Geoff Barlow and Clare Davis.

Introduction

These remarkable photographs of the V&A's collection of historical dress capture the essence of each stylish garment, opening up new perspectives on high fashion between 1600 and 1800. Offering a lively survey of fashionable patterns, fabrics and colours, the images depict a wide variety of styles and effects, from the minimalism of mid-18th-century whitework to the flamboyant excesses of high Baroque flowered silks. The close-ups reveal an impressive fusion of diverse skills and creative thought, which culminated in sumptuous - often blatantly extravagant - attire for men and women belonging to a wealthy élite. Accurately capturing each fragile work in time, this volume provides an invaluable photographic archive of the collection's glories. There is no better way in which these garments can be viewed and understood in such detail.

The authors, like forensic scientists, unravel layers of meaning, analysing each detail and bringing the clothes back to life by placing them in context. Focussing on the complexities of lost techniques as well as the intricacies of elaborate fabrics and trimmings, they emphasise both the abundance of skills and the frequent use of expensive, hand-made materials. It was these materials which fed the art and craft of fashion, before the invention of the sewing-machine and the dominance of ready-to-wear clothing. Laborious and time-consuming processes - from the making of a tiny bespangled

button to the construction of yards of delicate fly fringe - were fundamental to the creation of these lavish styles. Most of the featured works were made for important, formal occasions, such as Court appearances and weddings. High-cost adornments, including gold and silver thread, give important clues to the characters, tastes and habits of their owners. As demonstrated by the magnificent mid-18th-century mantua on pages 60-61, it was not just construction and adornment which required immense skill: the pinning, folding and draping of such garments upon the wearer was an art in itself.

Elegant and precise line drawings illustrate the clothes in their entirety, providing an invaluable guide to understanding the garments. By arranging the book in themes a clear narrative of the history of dress emerges, including references to significant design sources, contemporary writings and portraiture. The authors succinctly describe cut, construction and fastening methods, then delve beneath to expose and explain the form-making - and often uncomfortable - ingenuities of padding, stiffening and boning.

The investigation demonstrates the extreme vulnerability of historical dress. Subject as it was to wear and tear, it was often altered to suit new fashions. In addition, there is considerable evidence of recycling, as garments or parts of garments reappear as fancy dress, theatrical costume, ecclesiastical vestments and even furnishings. Some suffered frequent plunderings, such as the splendid early 17th-century pinked gown shown on pages 174-5, which had its entire left side, most of its back, and its costly silver trimming cut away for reuse. Attention is also drawn in the text to careful repairs on favourite garments and, most poignantly, to irreversible decay. This is seen, for example, on a number of 17th-century women's jackets whose wonderfully intricate embroidery is fast disintegrating, due to the use of a black silk embroidery thread which is self-destructing as a result of the original dyeing process.

It is a truism that the past informs the present, and the V&A's collection has inspired and enthralled many leading fashion designers including Vivienne Westwood, Christian Lacroix, Karl Lagerfeld and John Galliano. Such innovators have an innate understanding of historical dress, and details - such as the linear dynamics of a corset or the decorative appeal of slashed satin - can excite their inventive talents. Through their vision the past is reborn. These inspirational possibilities, together with the need to share the endangered glories of certain garments that are just too fragile to exhibit, motivate this splendid visual feast.

Valerie D. Mendes
Chief Curator, Department of Textiles and Dress

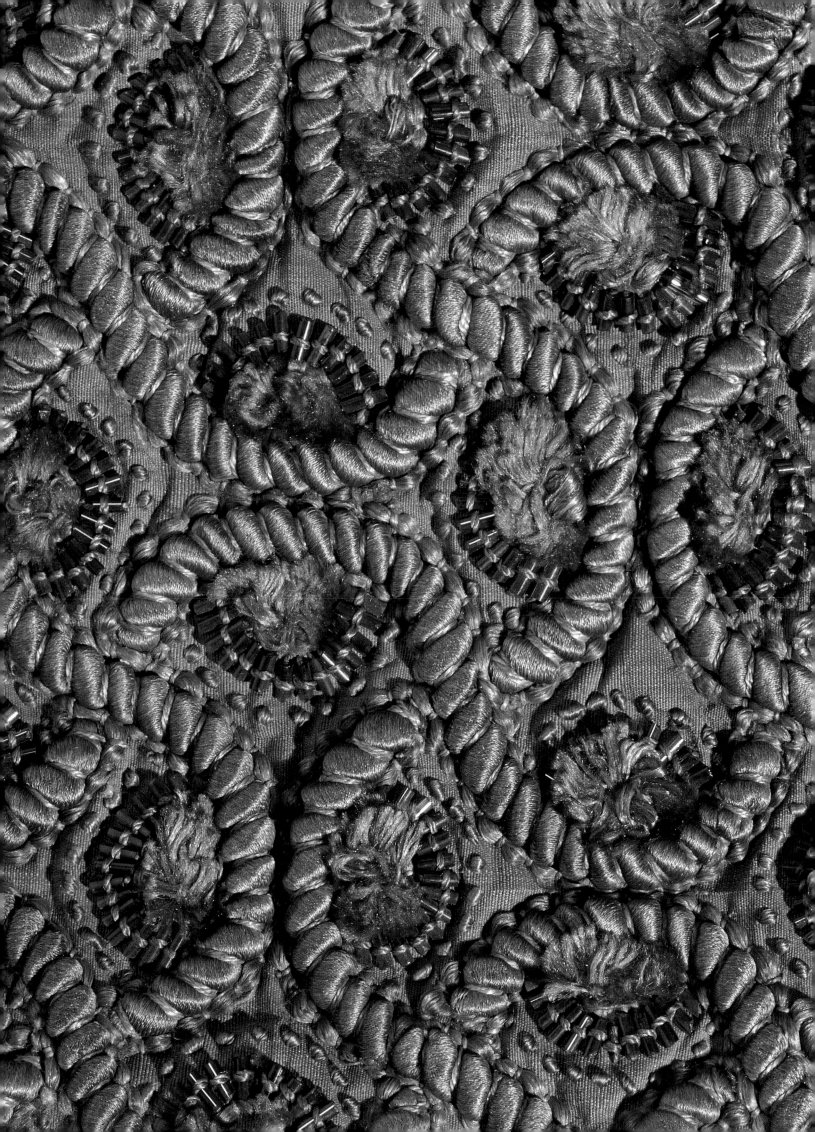

Stitching, Seams, Quilting & Cording

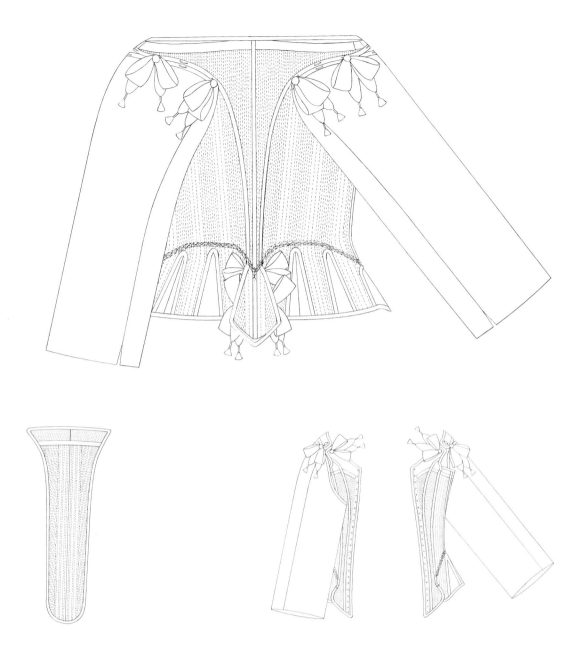

THIS PAIR OF sleeved stays are handstitched throughout in pink silk thread, and all the edges are bound with corded silk ribbon. The boning is extremely fine and arranged to achieve and accentuate the fashionable attenuated figure of the 1660s to 1670s. The stays are constructed in ten sections; the main seams of each section are covered in ribbon which can be seen clearly in the drawings. The boning extends below the waistline. The detail shows the centre back with the shaped central tab or tail of the stays and silk ribbons which are decorative rather than functional. The sleeves are elbow length, and cut straight without any shaping. They are attached at the armholes by pink silk taffeta ribbons matching those on the tail of the stays. The sleeves are optional and could be removed if desired. The busk was placed at the centre front and held in position by lacing, allowing for an adjustment in fit as well as

protecting the wearer from the discomfort of the lacing. These stays were made for a very small person.

The 1660s and 1670s were transitional decades for women's fashions. Hitherto fashionable women's dress consisted of a two- or three-piece ensemble of a richly decorated bodice worn with an equally rich petticoat and overskirt. It was during this time that the bodice changed its function from an outer garment to become an undergarment – the stays – worn under an outer layer, such as the mantua. The function of the stays was to be a support or stay for the mantua which was a loose unstructured robe without any boning. Such robes were open at the front and met at the centre front waist, leaving a triangular portion of the front of the stays visible which was covered by a stomacher.

For more details about these stays, see p.138.

A sleeved pair of stays and busk of pink watered
silk trimmed with pink silk taffeta ribbons.
English, 1660-1670
Given by Miss C.E. Gallini
T.14&A-1951

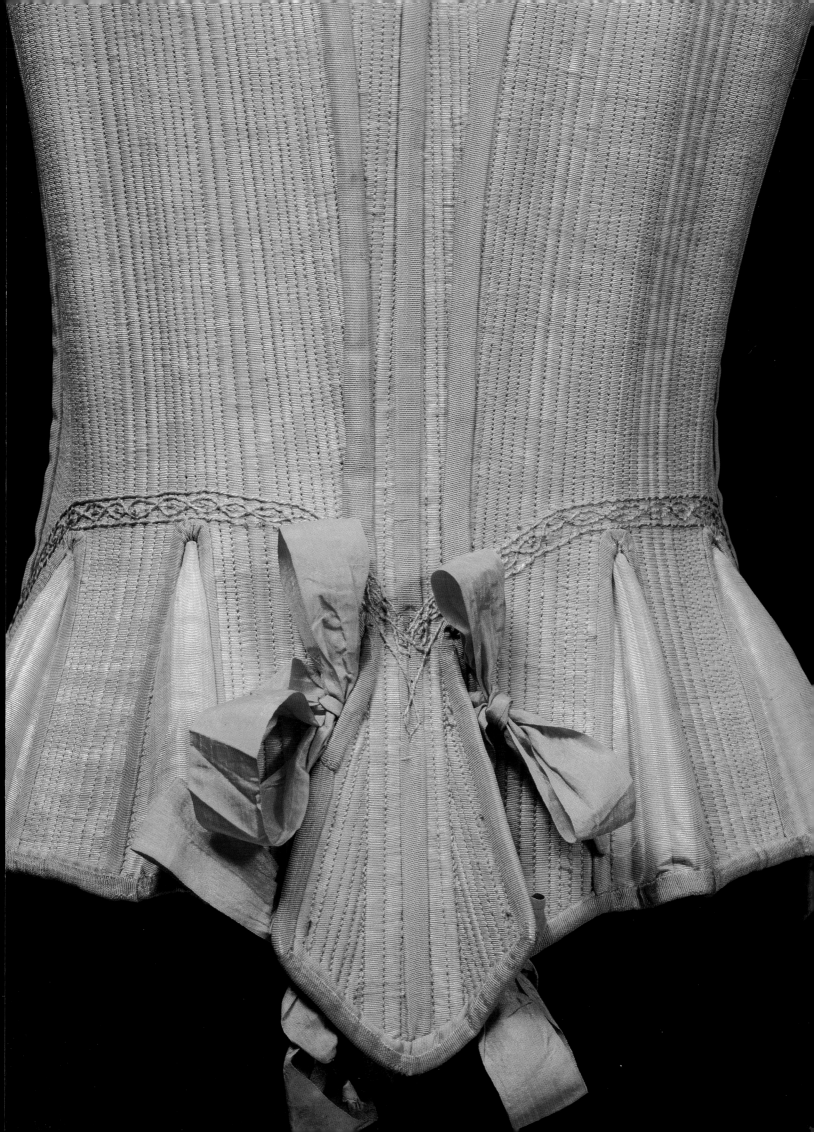

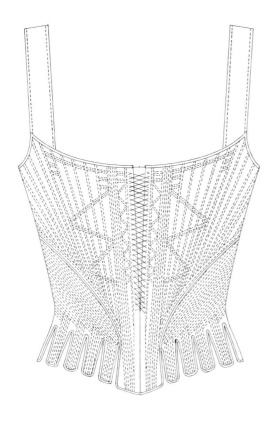
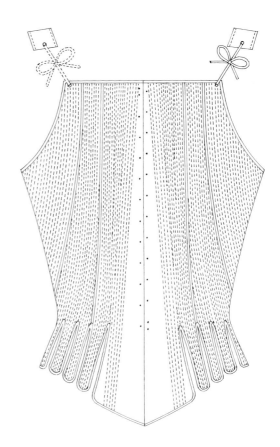

WHITE STITCHING AND silk ribbon against red wool give a decorative contrast and emphasise the main seam lines of these boned stays of the 1780s which are made of wool and linen and stiffened with whalebone.

The extremely fine and regular stitching of these stays is a crucial part of their composition, as well as their visual appeal. While stays were a practical garment and not meant to be seen, their construction and finishing demonstrate fine craftsmanship and an eye for decorative detail.

The narrow rows of even handstitching form the compartments into which the thin strips of whalebone (baleen) were inserted to give the stays their rigid shape. The stitching and whalebone follow the piercing and diagonal shaping of the stays at the side – essential to form the curvilinear torso so desirable in the 1780s. An additional heavier curved strip of whalebone is fitted around the top front of the stays to emphasise the fashionable curve of the bust. These stays are composed of three layers of fabric, the outer one of red wool, an inner layer of linen or canvas (forming the other side of the whalebone compartments) and finally a linen lining. When worn, the shaped and boned tabs at the lower edge splayed over the hips and gave added fullness to the petticoat tied at the waist over the stays.

A pair of stays of red wool.
English, 1780-1790
Given by the family of the late Mrs Jane Robinson
T.192-1929

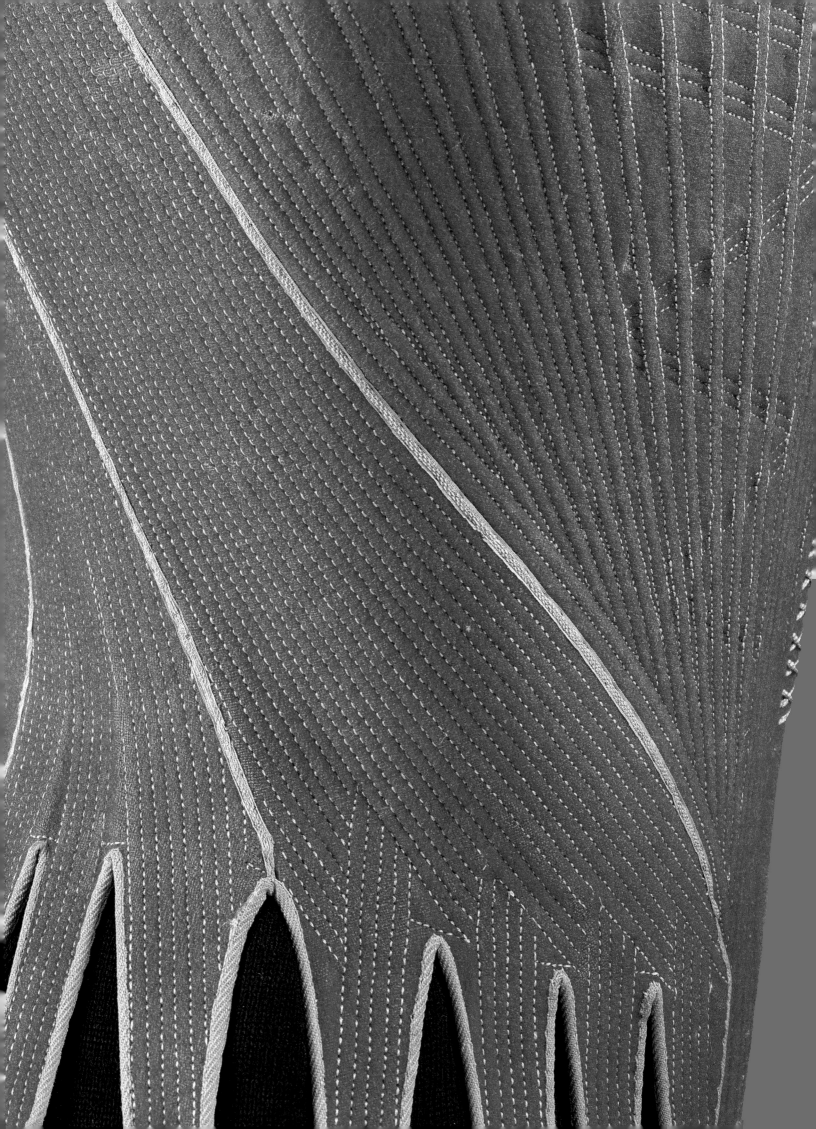

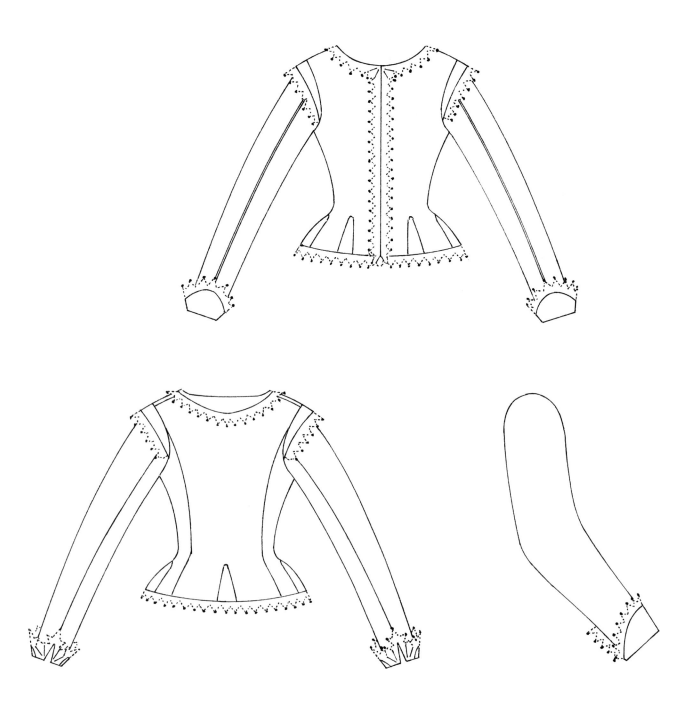

THE EMBELLISHMENT OF the seams of this exquisitely embroidered jacket emphasises its method of construction; at the same time, it introduces straight lines into the curvilinear pattern of the embroidery. Silver-gilt thread in plaited braid stitch outlines each of the five gores set into the lower edge.

The jacket has a high round neck and is constructed of two front sections extending slightly round to the back and joining a wide, shaped back panel. The close-fitting, curved sleeves are cut in two pieces. Like the gore seams, both the side back seams and the front sleeve seams are outlined in silver-gilt plaited braid stitch.

Originally, pink silk ties were used as fastenings, remnants of which can still be seen on the inside front edges. In the 1620s a trimming of silver and silver-gilt bobbin lace decorated with spangles was added to all edges of the jacket. Hooks and eyes would have replaced the silk bows in order to fasten the garment without interfering with the new lace trim.

Such richly embroidered and lavishly trimmed jackets were typical of formal day wear for Englishwomen. In the portrait of Margaret Laton which shows her wearing this jacket, she completes her ensemble with a deep Italian needlelace collar and cuffs, a black velvet gown, a red silk petticoat and a whitework apron.

For more details about this jacket, see pp.74 and 148.

A woman's jacket of linen embroidered with silk and
silver-gilt thread, trimmed with silver and silver-gilt bobbin lace.
English, 1610-1620
T.228-1994

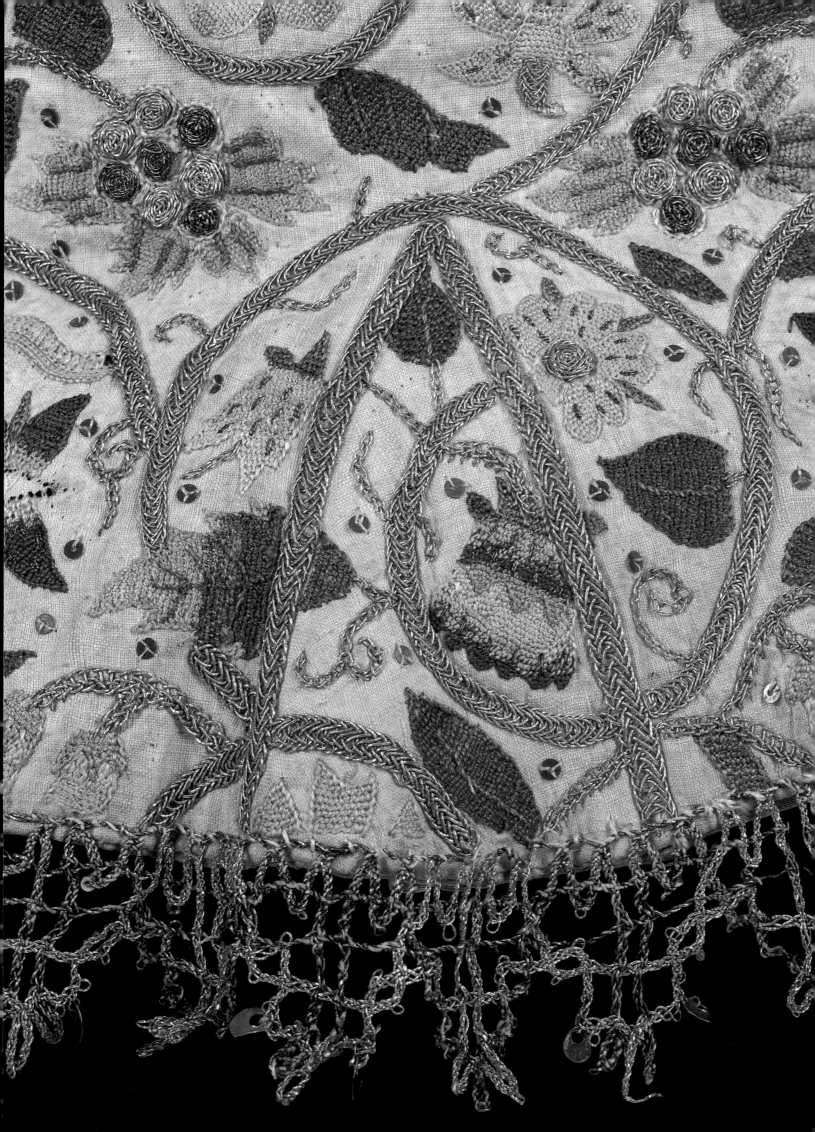

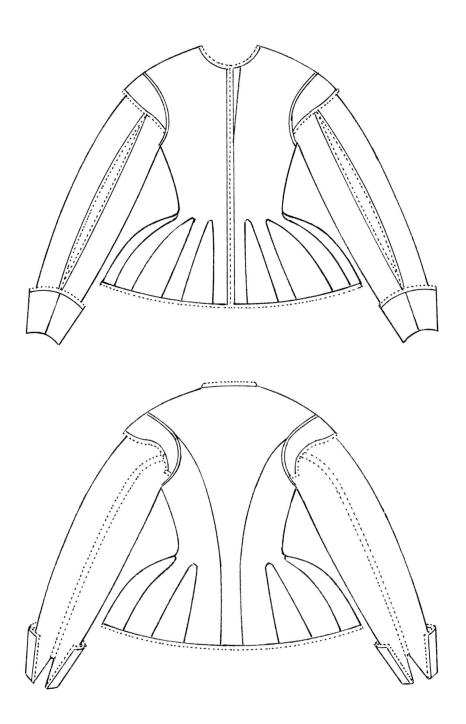

Narrow bobbin lace in black and white linen, inserted between the edges of the back sleeve seams, echoes the colour scheme of this blackwork jacket dating from the 1620s. The undyed linen is embroidered in black silk in a pattern typical of the early 17th century: scrolling stems bearing a variety of flowers, insects and birds, worked in a range of decorative stitches.

The high waist and fairly narrow sleeves indicate the transition period between the long-waisted, tight-sleeved style of the late 16th and early 17th century, and the short-waisted, full-sleeved jacket which became popular for women during the reign of Charles I. This example has a round neck opening down the front, shoulder wings and square, turned-back cuffs. The jacket front extends round to the side back where it joins to a narrow centre back panel. Four gores in each of the front sections allow the jacket to extend over the fullness of the hips. The curving sleeves are cut in two pieces, with the front seam left unstitched from shoulder wing to cuff, allowing the smock sleeves to show through. All the jacket's edges, including the slit sleeves are trimmed in black and white bobbin lace with an indented border.

For more details about this jacket, please see p.150.

A woman's jacket of linen embroidered in
silk thread and trimmed with bobbin lace.
English, 1620s
T.4-1935

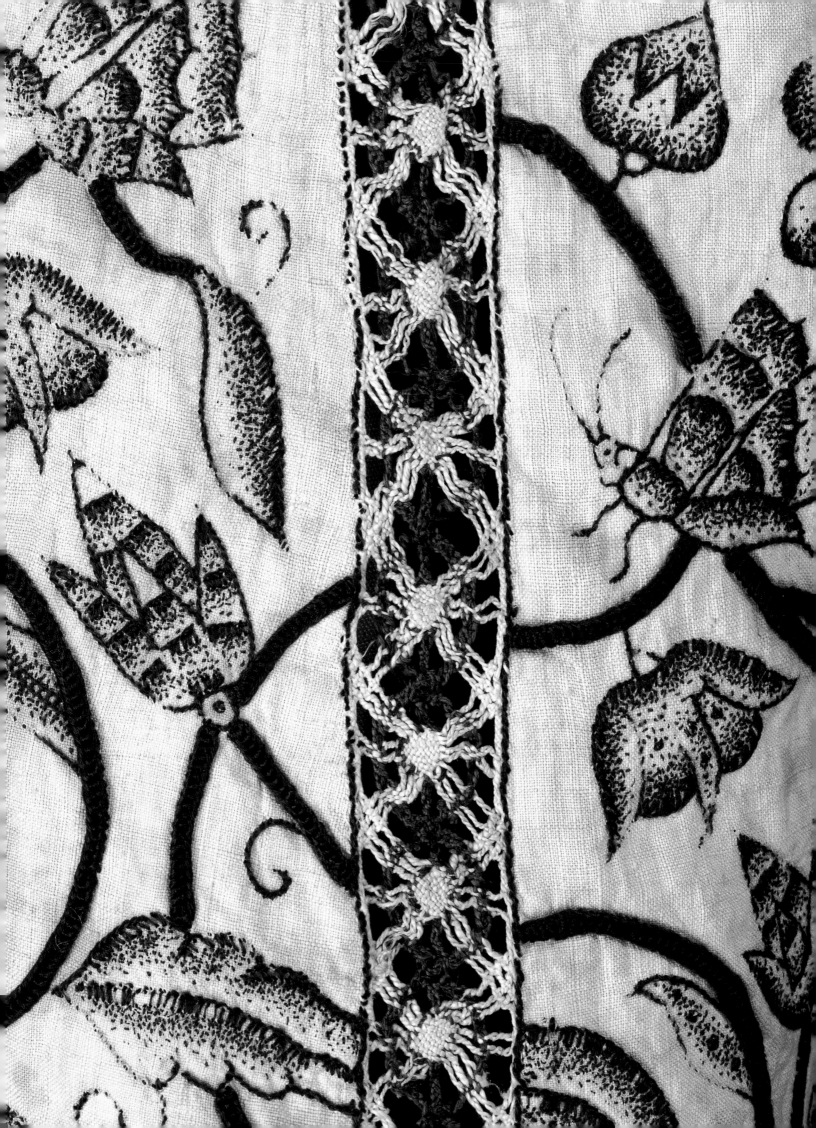

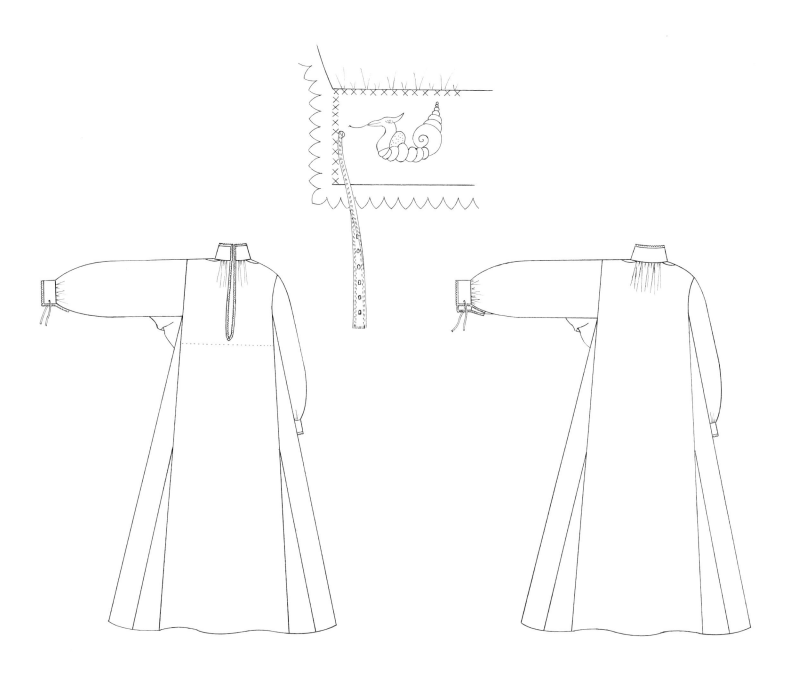

A SIMPLE CROSS stitch embellishes and reinforces the seams of this early 17th-century smock, shown where the shoulder, sleeve, gusset and side seams meet. Made of fine linen, the smock is constructed in the traditional method, using rectangular lengths for the front and back, full-length sleeves, collar and cuffs. Three triangular gores inserted at each side seam add width. A square gusset folded diagonally gives ease under the arm, while small triangular gussets reinforce the neck at the shoulder seams.

The sleeves, collar, cuffs and body of the smock, to the waist, are embroidered in a once vivid, but now faded, pink silk. A repeating pattern of twenty-four motifs includes stylised roses, acorns, peapods and carnations alternating with cats, snails, grasshoppers, a variety of birds and various hybrid creatures (see drawing detail above), all outlined in stem stitch. Four of these figures can be traced to a known design source, Richard Schorleyker's *A schole-house for the needle*, first published in 1624.

The smock was an article of women's underwear, worn under the bodice or jacket, petticoat and gown. The collar and shoulders would have been visible above the neckline of the jacket or gown, and through slashed or open-seamed oversleeves would flash glimpses of these delightful flowers and extraordinary creatures.

A woman's smock of linen
embroidered in silk thread.
English, *c*.1630
T.2-1956

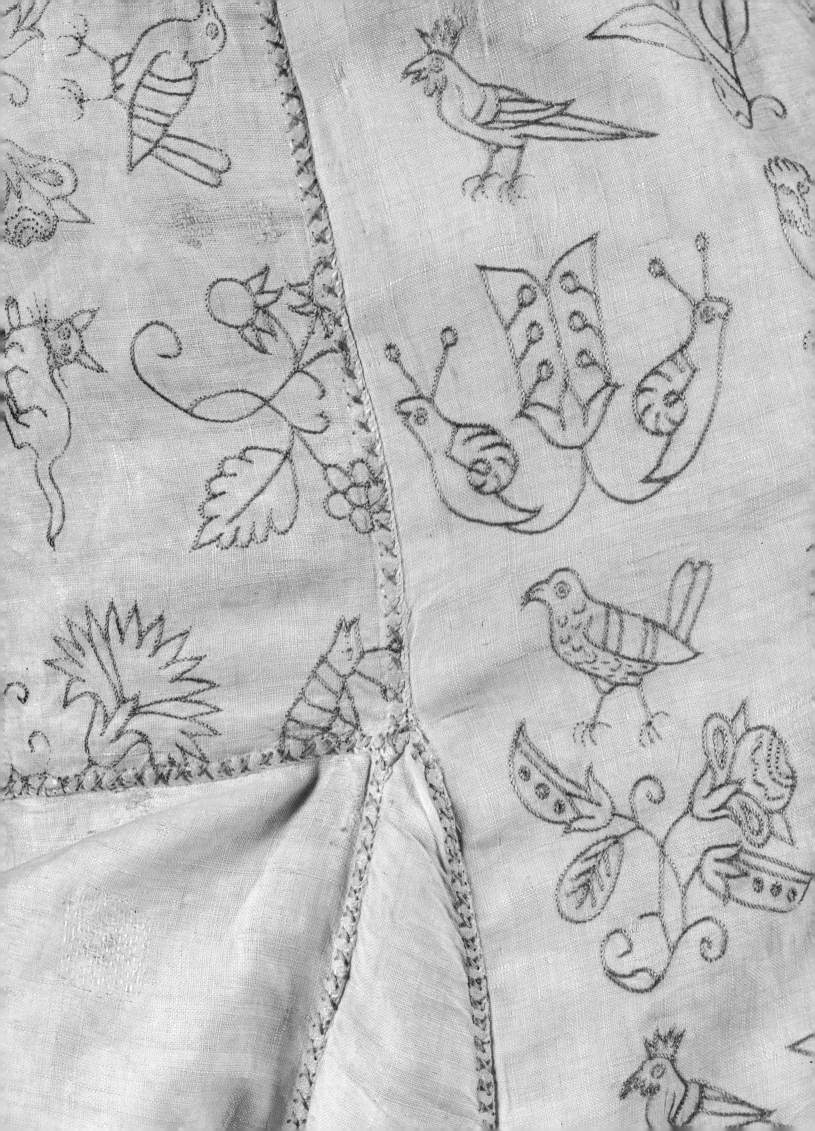

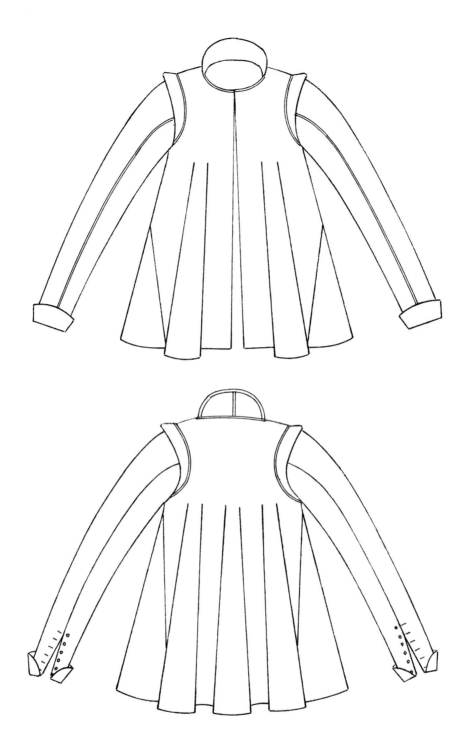

FINELY PIPED SEAMS add detail and visual interest to this uncharacteristically simple jacket of the first quarter of the 17th century. It is made of a linen ground with additional pattern wefts of ivory silk and silver, and lined with fustian. The jacket fronts are pieced at the sides; side gores give the garment a wide flared shape. The narrow, two-piece sleeves have a padded shoulder wing at the top and a curved, turned-back cuff which closes with six buttons.

A curved collar stands up at the back; the front neck is bound with a bias strip. Two eyelets pierce the collar at the centre back, performing the same function as a supportasse, that is, holding in place the starched lace or plain linen ruff that would have been worn with the jacket. The narrow piping extends along the seams in front of the sleeves, along the shoulder wings and at the back of the collar. Its bias cut intersects the horizontal stripes, breaking up the linear effect.

Like the next jacket discussed, this loose-fitting garment was part of informal dress, not worn in public or depicted in portraiture. Its unconstructed shape would have made it particularly comfortable and could have easily accommodated a pregnancy.

For further details about this jacket, see p.112.

For further details about this jacket, see p.112.

A woman's jacket of ivory silk
and linen with a silver stripe.
English, 1600-1620
188-1900

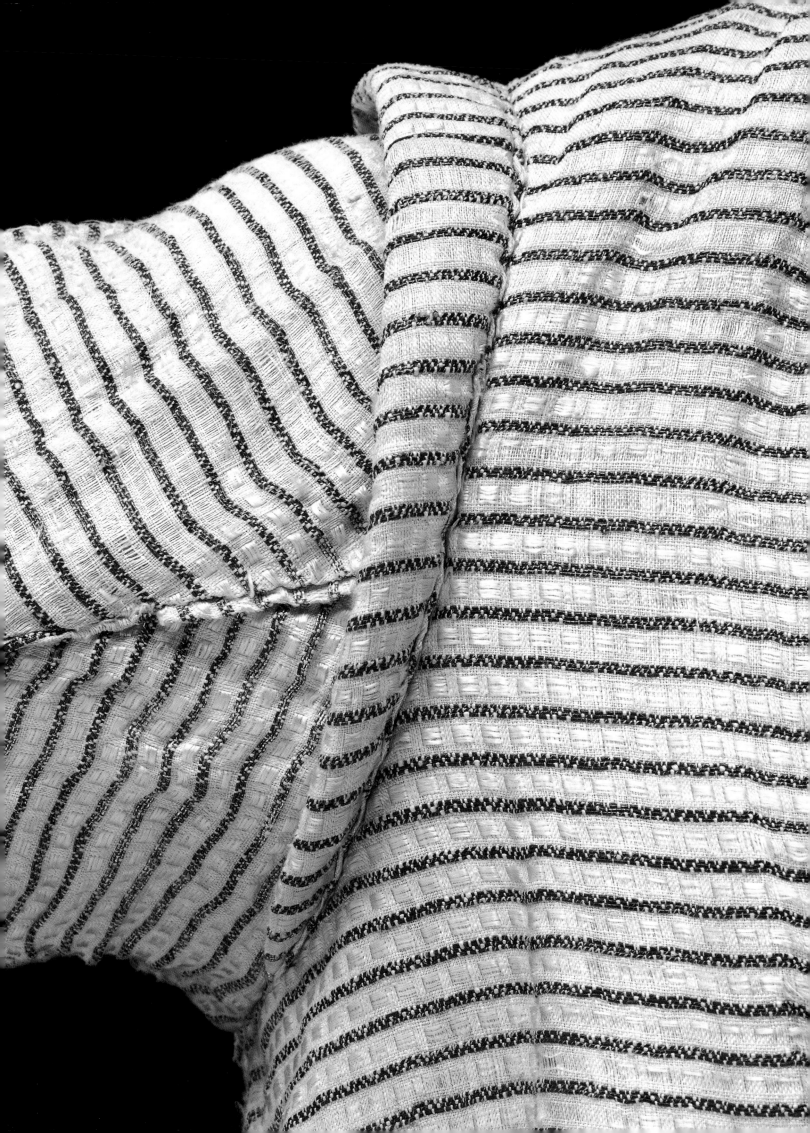

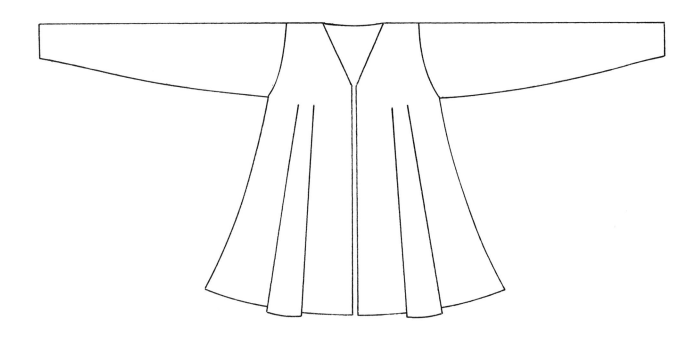

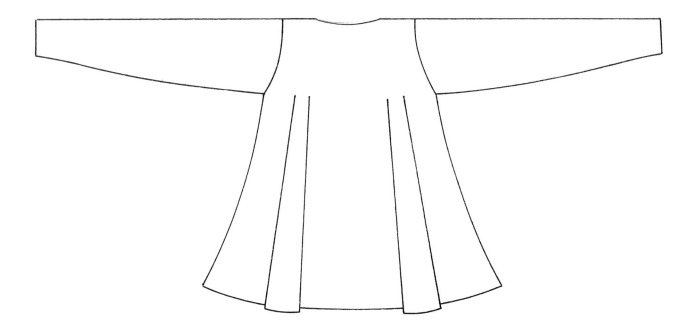

A LACED INSERTION stitch in two shades of green joins the sleeve seams as well as the side seams of this deceptively simple woman's jacket, dating from the first quarter of the 17th century. Similar in shape to the previous jacket, this V-necked example in plain linen has its three main pieces cut with flared sides to give a loose fit. The one-piece sleeves have slight fullness at the top, eased into the shoulder and narrowing at the wrist.

Over this basic unlined shape springs a lively pattern of coiling stems which sprout a wealth of flowers and fruits: roses, honeysuckle, pansies, cornflowers, strawberries, currants, peapods and acorns, all worked in chain, stem, satin, trellis, darning, plaited braid stitches and couching, with coloured silks, silver and silver-gilt thread. The edges of the garment are embroidered in crossed buttonhole stitch.

To the left of the seam can be seen traces of the original design left unworked. The fine yet solid line indicates that the pattern was drawn in ink on the linen with a fine-nibbed pen.

A woman's jacket of linen embroidered
in silk, silver and silver-gilt thread.
English, 1600-1625
Given by A. Solomon
919-1873

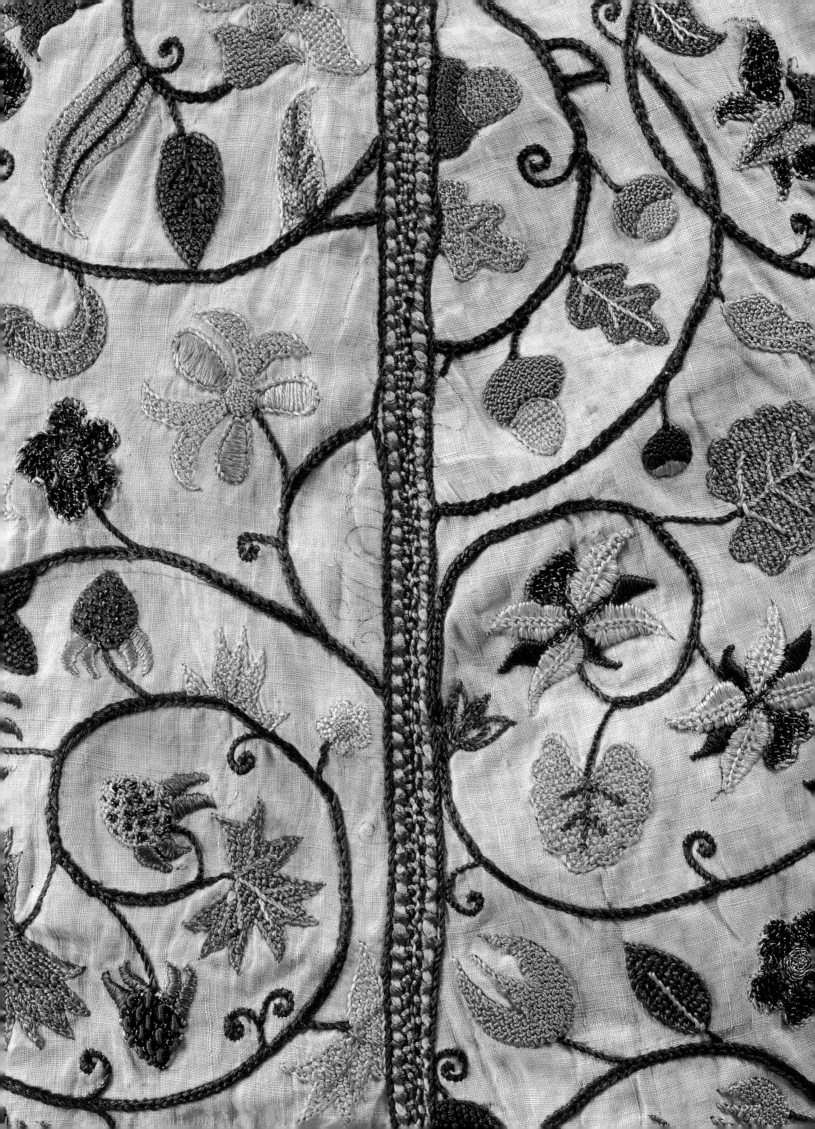

A PATTERN OF stylised leaves and flowers against diaper and shell grounds fills the back of this oyster-coloured satin doublet of 1635-40. It has a stand-up collar and fastens down the front with satin-covered buttons. From the pointed waist hang two large tabs in front, one at each side and two at the back. The long curved sleeves have narrow shoulder wings and close at the wrist with eight buttons. Lines of knotted and tufted floss silk follow the seams and hems of the doublet. The waist is highlighted by twelve large bows of figured silk ribbon.

The quilting pattern of the back carries over to the waist tabs, collar and under sleeves, while a simple chevron decorates the doublet front. A pair of breeches completes the ensemble, with decorative quilting at the front and the chevron design at the back.

Running stitch in silk thread creates the quilting pattern. The seams within the quilting and the varying directions of the quilt design on the doublet suggest that this outfit was made from an earlier bed cover. Great care was taken to incorporate the original composition into the doublet and breeches in a symmetrical way, and to ensure the successful reincarnation of this splendid needlework.

For further details about this doublet, see pp.112 and 138.

A man's doublet of quilted
satin lined with silk and linen.
English, 1635-1640
347-1905

A RICH BUTTERCUP-YELLOW silk, quilted in a simple pattern, makes up this beautiful pair of mid-18th-century pockets. They are wedge shape in form, with backs of undecorated yellow silk. A diaper pattern fills the centre, with a scrolling wave design around the border. The edges of the pockets and pocket openings are finished with matching yellow silk grosgrain ribbon. Both pockets are attached to a single yellow linen tape.

Eighteenth-century women's gowns did not include pockets; they were separate items worn under the hoop, singly or in a pair, suspended from a tape around the waist. Access to the pockets and their contents was gained through openings in the side seams of the petticoat and its overlying gown. This practice explains the meaning of the nursery rhyme:

'Lucy Locket lost her pocket
Kitty Fisher found it
Not a penny was there in it
Only a ribbon round it'

Pair of pockets, quilted silk with linen tape.
English, 1740s
T.87:A-1978

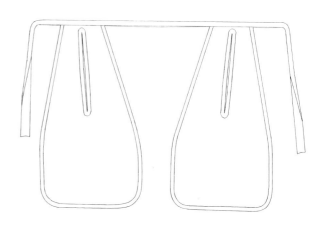

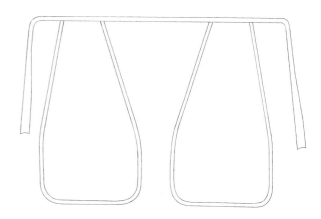

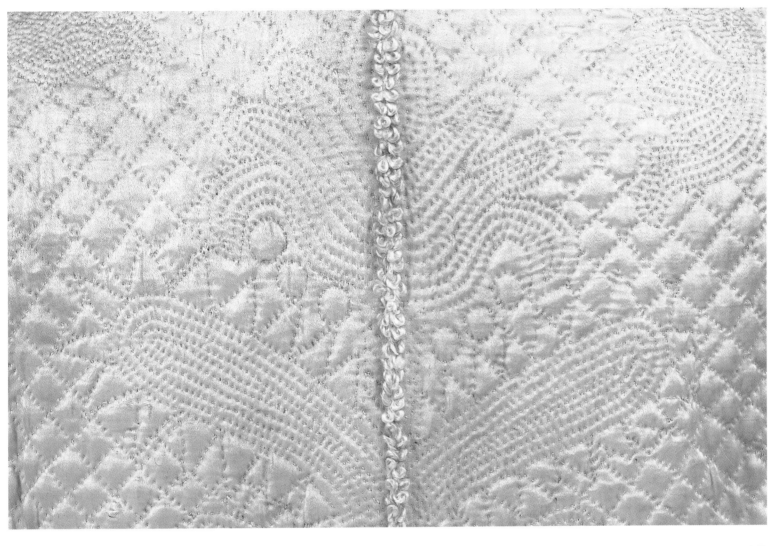

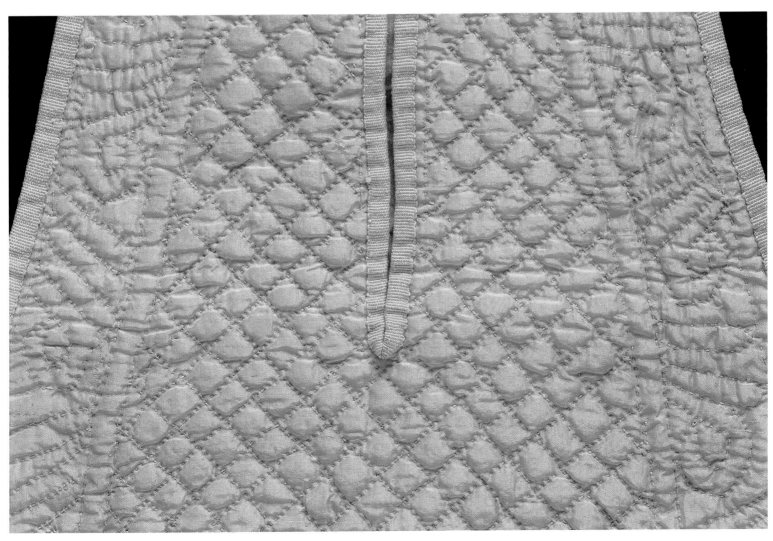

AT FIRST GLANCE, this strikingly textured sleeve appears to be corded. In fact, the fabric has not been worked in the traditional cording method. S-shaped lengths of cotton cord, covered in green satin, have been couched down on a matching emerald ribbed silk, creating a grid of intersecting waves. The couching stitches fall into the twists of cord, accentuating its spiral nature. A line of green floss silk is couched on either side of the cord; a tuft of the same type of thread springs from the concavity of each corded curve. Tubular green glass beads, arranged in a sunburst, surround the tufts, and are outlined with a spray of seed stitches in the floss silk. These beads were

most likely produced in the Murano glassworks outside Venice.

This pair of curved, fitted, two-piece sleeves is all that remains of an early 17th-century man's or woman's doublet. Wardrobe accounts of Elizabeth I list several items made of fabrics tufted with silk and others worked with 'bugles', as these beads were called in the 16th century.[1]

1. '61 Item one Mantle of white Sipers (Cypress – a silk-linen blend fabric) tufted with heare (hare) coloured silke with a small passamaine (braid) lace of like colour silk and venice silver.... 31 Item one foreparte of white Satten embrodered allover with bugles made like flowers upon stalkes within knotts.' Janet Arnold, *Queen Elizabeth's Wardrobe Unlock'd* (Maney & Son 1988), pp.259 and 290.

A pair of sleeves of silk embroidered
and with applied cording and glass beads.
English?, 1600-1625
225-1893

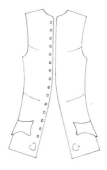

HEART-SHAPED INSERTIONS, in the lower corner of each front, worked in Hollie point, bear the initials PB and AB with the date 1744, suggesting that this intricately worked waistcoat may have been made for, and worn at, a wedding. The waistcoat is corded and embroidered around the front edges and on the pocket flaps, in a pattern of stylised flowers and leaves. A variety of stitches are used: stem, satin, running stitch and French knots with drawn thread work and honeycomb filling. This style of whitework garment was very popular in the 1740s, and worn particularly in summer as such waistcoats were light, cool and easily washed.

The fronts are shaped with one dart at the armhole and a long, curving dart at the waistline. These and other alterations seem to have been made later to accommodate raising hemlines and changes in waistcoat styles, as well as to allow an expanding figure to continue to wear what must have been a treasured garment.

A man's waistcoat of cotton whitework.
English, 1744
Given by Mr E. Wallace Young
T.207-1957

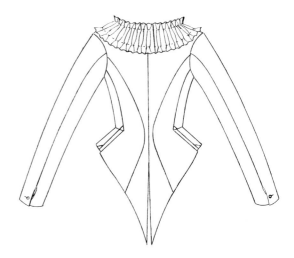

THE PURPOSE OF the quilting on this garment is to give the elegant but thin, printed cotton the added firmness and crispness of line required by its stylish shape. A running stitch of linen thread delineates the plain diaper pattern, but it cleverly follows the print's spacing so that each tiny sprig of flowers, fruits or berries falls in the centre of the quilted lozenge.

This shapely little jacket is the epitome of 1780s fashion. The narrow, natural-length waistline is accentuated by small tabs. For a precise fit, the back is cut in four pieces, and a long diamond-shape tail is placed at the centre. The fitted sleeves reflect the new longer style reaching to the wrist. Circling the neck is a wide pleated ruffle extending around the deep décolletage, which would have been filled in with a kerchief.

A woman's jacket of quilted printed cotton.
English, 1780s
T.219-1966

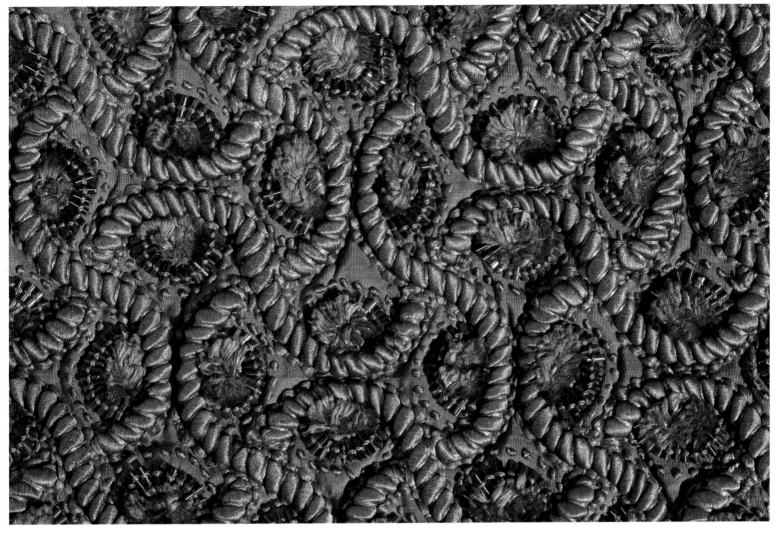

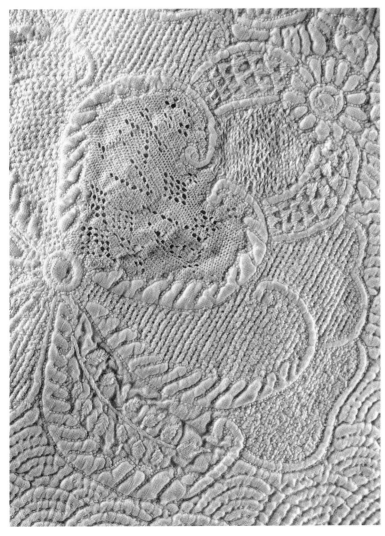

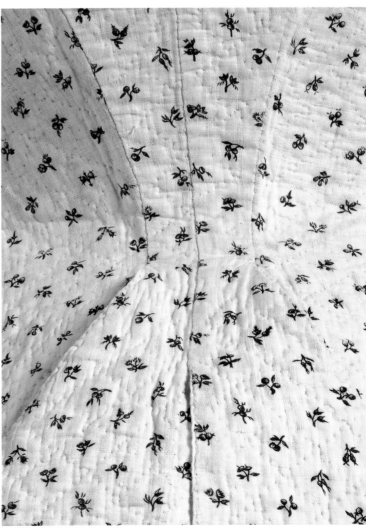

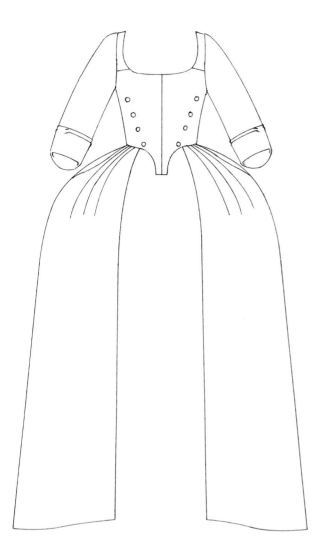
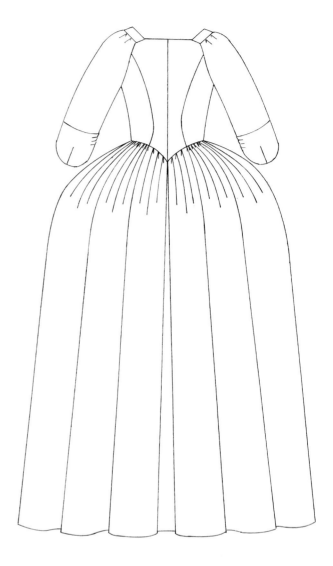

ANOTHER EXAMPLE OF a beautiful bed covering being given a second life can be seen in this exquisitely corded linen gown of the late 1770s. It has been made over from a bed cover dating from the mid-18th century. One edge has been transformed into the border of the skirt with a densely corded spiral ground, over which curl stylised fruits and flowers worked in diaper quilting. Above the border's shaped gable edge float more corded floral and fruit motifs. A fine running stitch in linen outlines the compartments through which the cotton cord was drawn.

The skirt of the gown is a continuous length of wide linen which has been box pleated to the fitted jacket. The short, straight sleeves end in a narrow cuff, shaped over the elbow. Four linen-covered buttons decorate the front which closes down the centre.

The petticoat accompanying the gown is also made from a bed cover, but one of a different pattern, in a finer linen, but inferior quality of cording. When worn together, however, these discrepancies would not have been evident and the two garments made a cool, practical and elegant summer ensemble.

A woman's gown of corded linen.
English, 1775-1780
759-1907

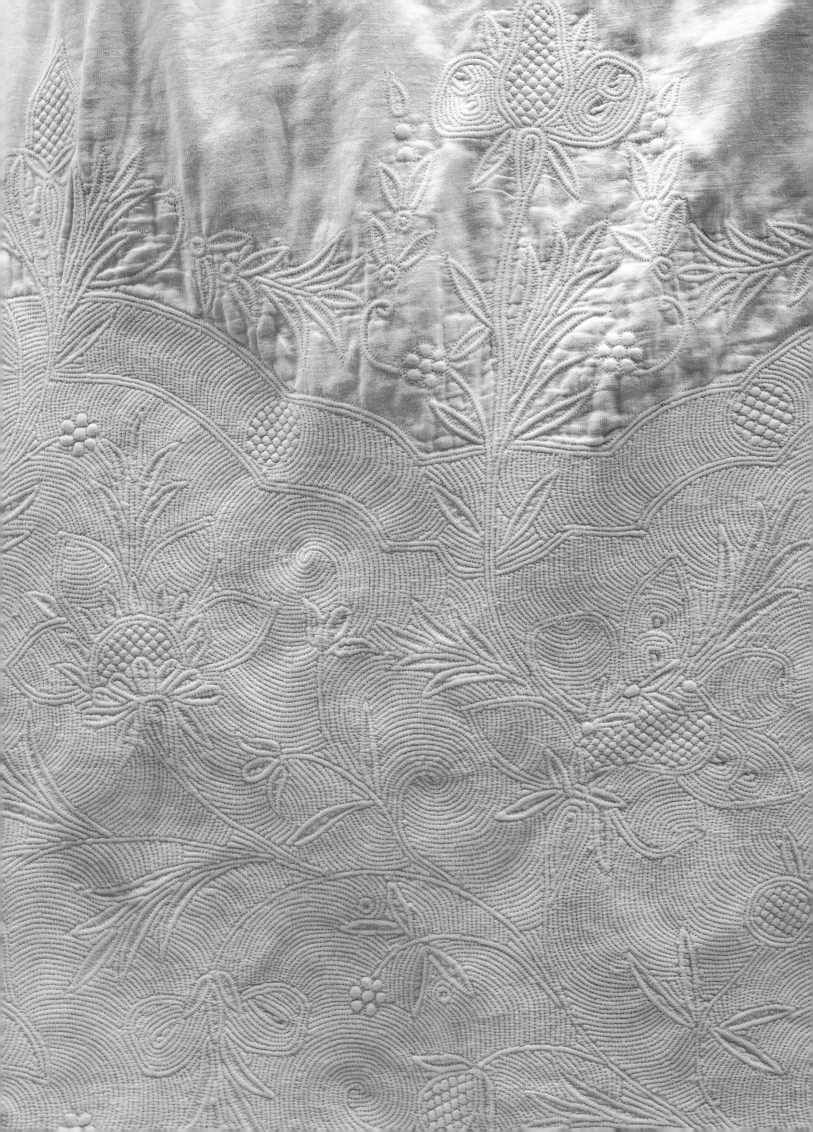

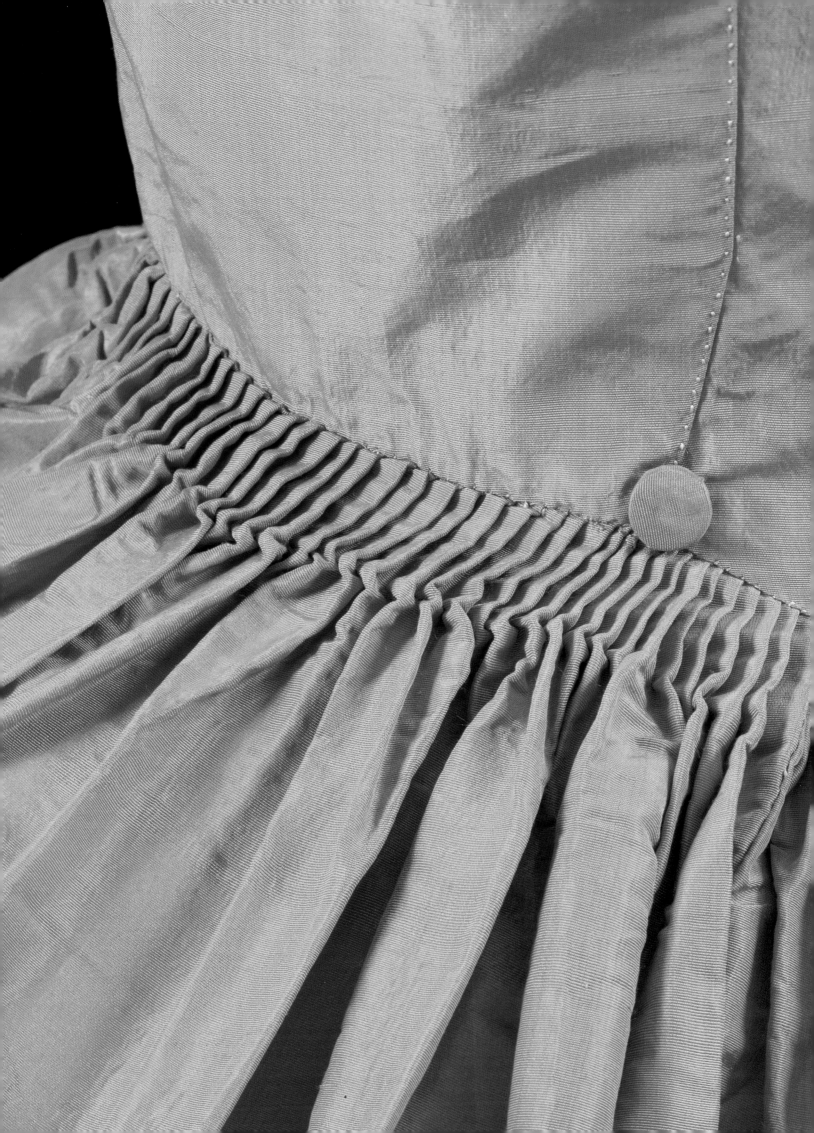

Gathers, Pleats & Looped Drapery

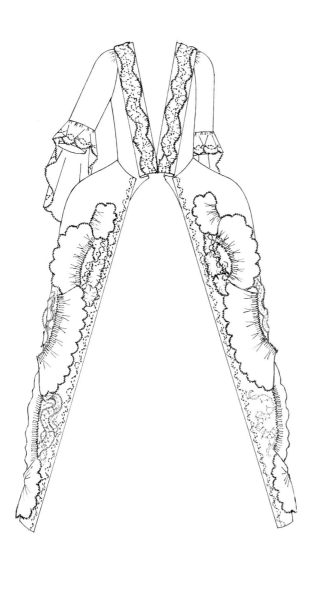

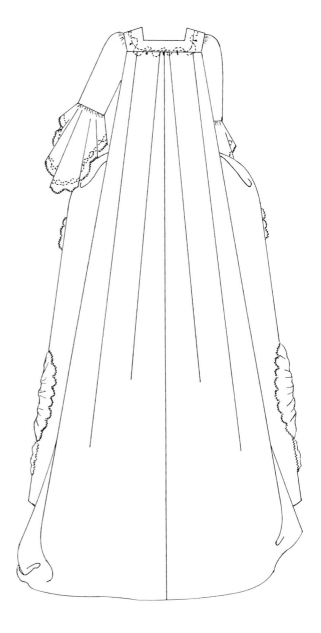

GATHERED TRIMMINGS ON the front facing of a sack-back gown of 1760-65 are repeated on the matching petticoat. The detail illustrates part of a long strip of silk about four inches wide which has been tightly gathered along one edge and pinked and scalloped along the other – both edges are left raw. The gathered band has been arranged in a serpentine scroll by twisting the band backwards and forwards down each front. Additional trimming in the form of fly fringe and narrower bands of silk further enrich the decorative effect. These elaborate features are typical of the second half of the 18th century. The lack of brocading and of costly metal threads in this silk means that it was moderately priced making it a suitable choice for a fashionable day or afternoon dress.

The flowing style of the sack-back was flattering to most women making it a popular garment throughout the 18th century. This ensemble would have been worn with a hooped petticoat, a foundation garment worn under the silk outer petticoat acting as an essential support to both the petticoat and the robe. The term 'sack-back' describes the distinctive double box pleats originating from the back of the neck line which were allowed to flow out behind the wearer, creating an elegant trained silhouette as well as displaying the silk to great advantage.

Dress of this period rarely survives totally intact, as owners made alterations to accommodate changes in fashion, to make fancy dress, or to re-use expensive decorative trimmings. This particular gown has been slightly altered and is missing at least two sleeve ruffles and some sleeve trimmings. The gathered trimming on the gown has been re-arranged.

For more details about this gown, see p.50.

A woman's sack-back gown
of yellow and white woven silk.
English, 1760-65
T.426-1990

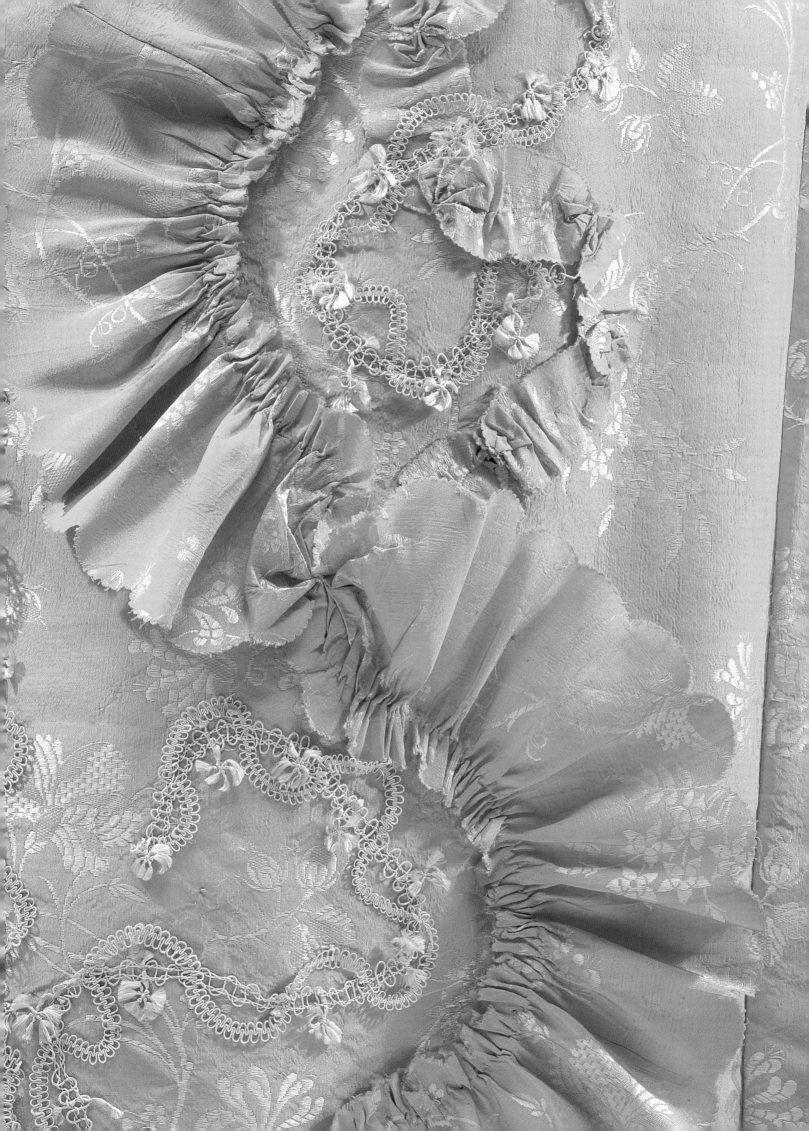

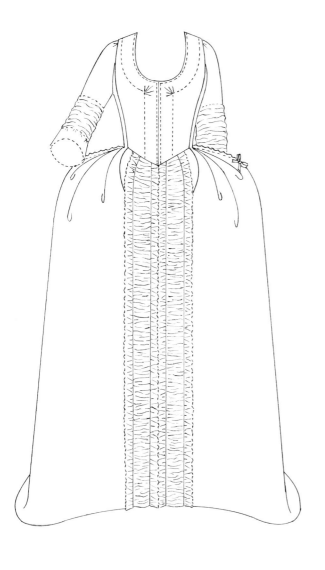
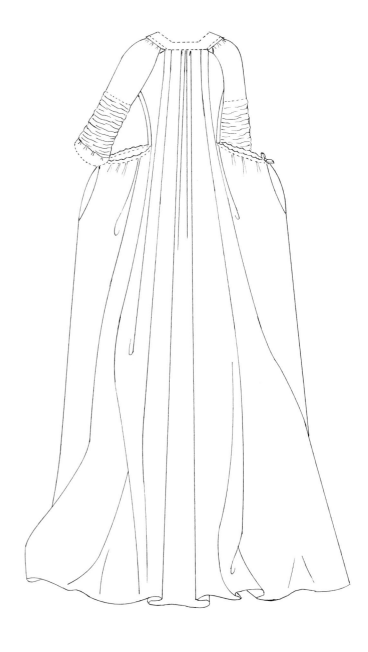

THE TRIMMING OF the broad bands of ruched, bobbin-made net in coarse linen thread, decorates the front edges of the skirt and sleeves of this elegant and stylish, summer day-wear, French sack-back gown of 1775 to 1780.

The gown of vertically striped white muslin is lined throughout in pink silk. The stripes alternate with floral sprays of whitework tamboured embroidery and the lining shows through the delicate and fine white muslin giving the garment a pale pink colour. The gown has edge-to-edge front openings and was originally worn over a petticoat (possibly in plain silk) and a small hooped petticoat. The gown's skirt was adjusted to fit comfortably over the hooped petticoat by pink silk drawstrings over the hips. The pocket-holes are set in the seam below each of the drawstrings.

A woman's gown of embroidered, striped
white muslin, lined with pink silk and trimmed
with bobbin-made net of linen thread.
French, 1775-1780
T.332-1985

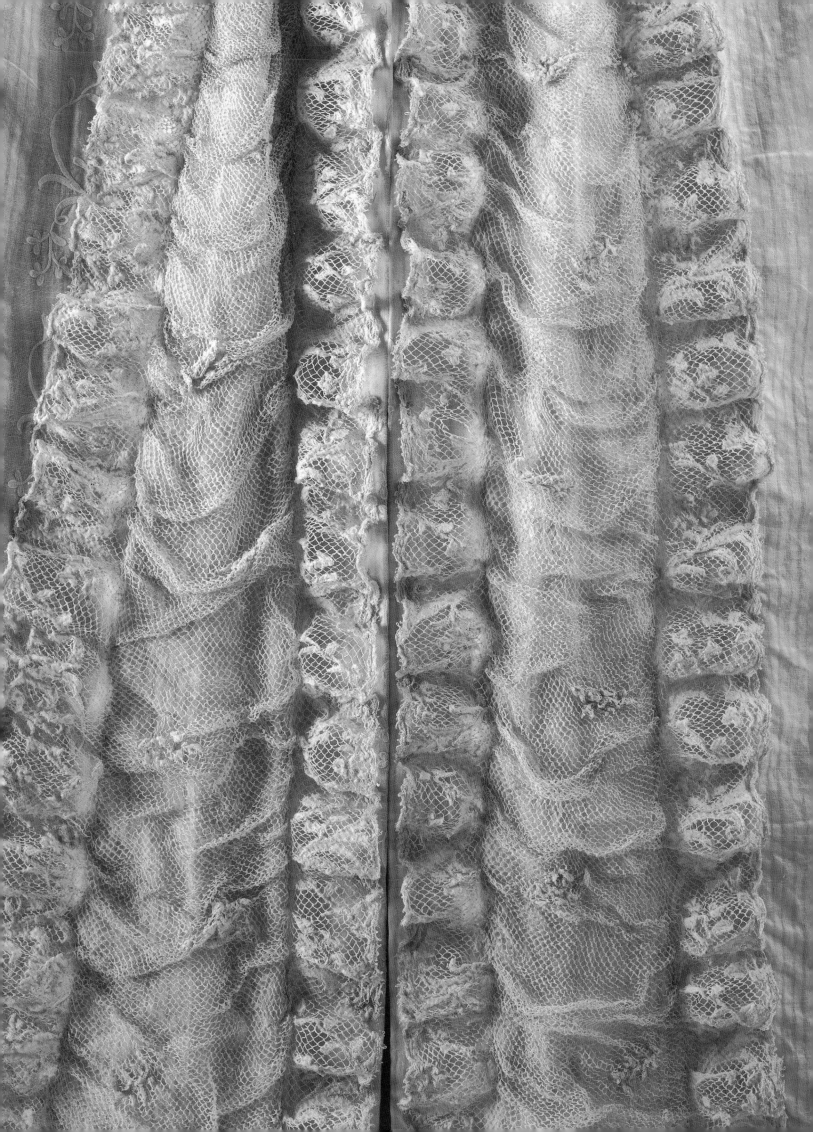

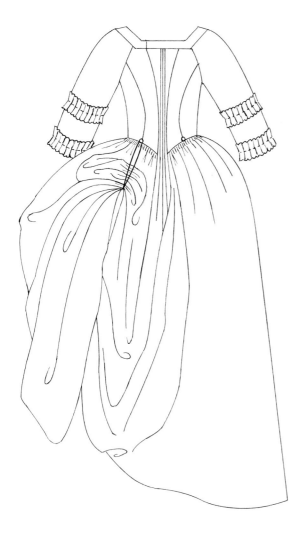 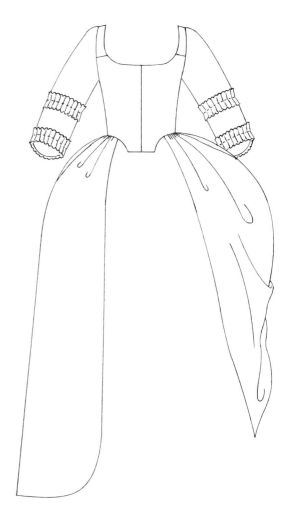

SUPERB DRESSMAKING SKILLS are illustrated in the pleated and gathered waist of this taffeta day-wear open gown of about 1774.

It is plain but stylish with a tightly fitted torso and low décolletage and a finely pleated or 'English' back to the bodice. The sleeves are elbow length with ruched frills of matching silk. This gown could be worn as a polonaise by raising and draping the skirts on the hips, an effect achieved by means of a pair of looped silk cords which fasten onto a pair of buttons. The buttons are stitched to the back waistline and each cord is attached to the back of the button within the garment. When not in use the cords hang loose under the skirts. The drawings show the alternative style of leaving the skirt down.

This gown would probably have been worn with a matching silk petticoat (now missing) over a hooped petticoat. In exceptionally good condition and immaculately made, the gown has only minor alterations to the trimmings on the cuffs.

A woman's polonaise gown of taffeta.
English, c.1774
Given by Miss A. Maishman
T.104-1972

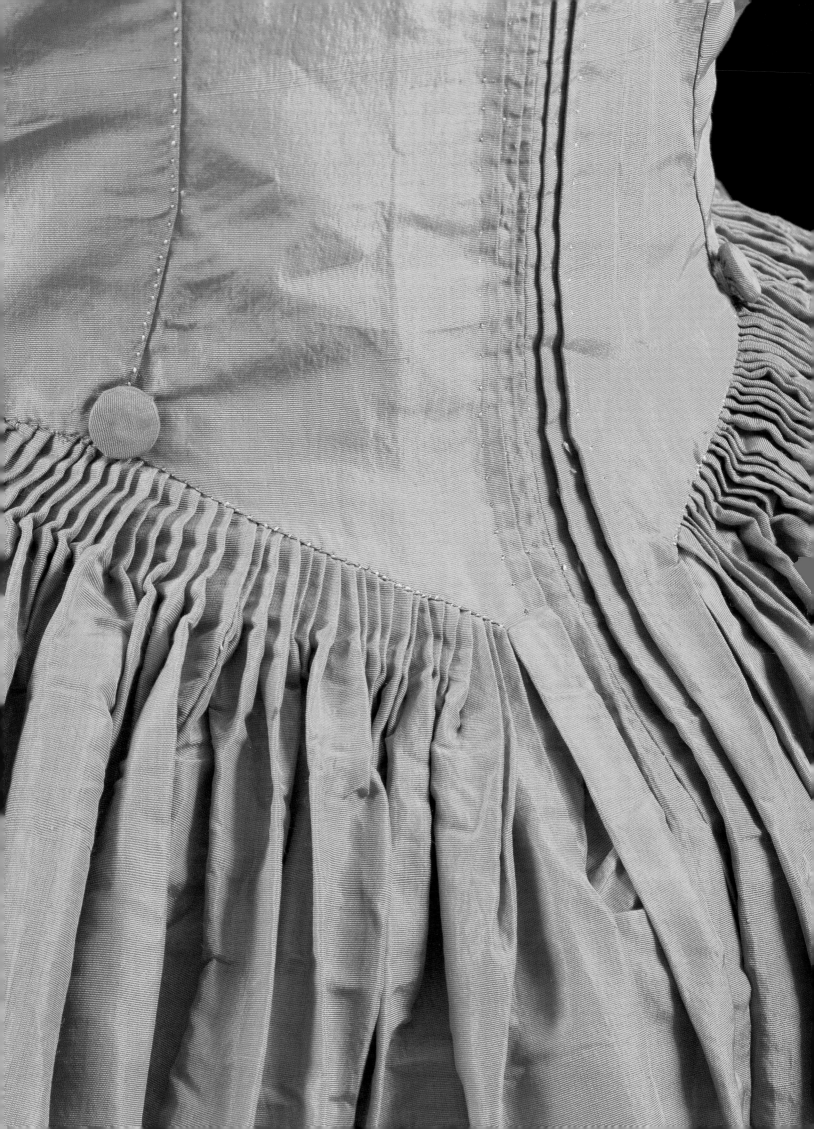

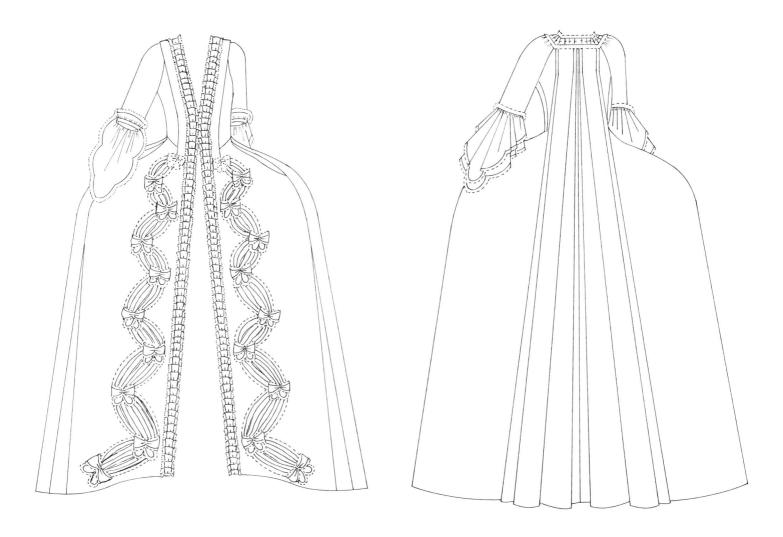

ELABORATE PADDED TRIMMING, edged with blonde lace, is applied in zig-zag formation along the centre front edges of the skirt panels of a 1770s sack-back gown.

This formal, open-fronted gown has a matching petticoat, made of ivory woven silk. The silk has a figured design of vertical leafy stripes which glistens in the light and acts as a rich counterfoil to the pronounced three-dimensional padded trimming. An ensemble like this would have been worn on grand occasions. The padded decoration has an angular quality which is in keeping with the linear designs of the 1770s.

A woman's sack-back of ivory figured silk.
French, 1770s
Given by Mr Eric Bullivant
T.163-1964

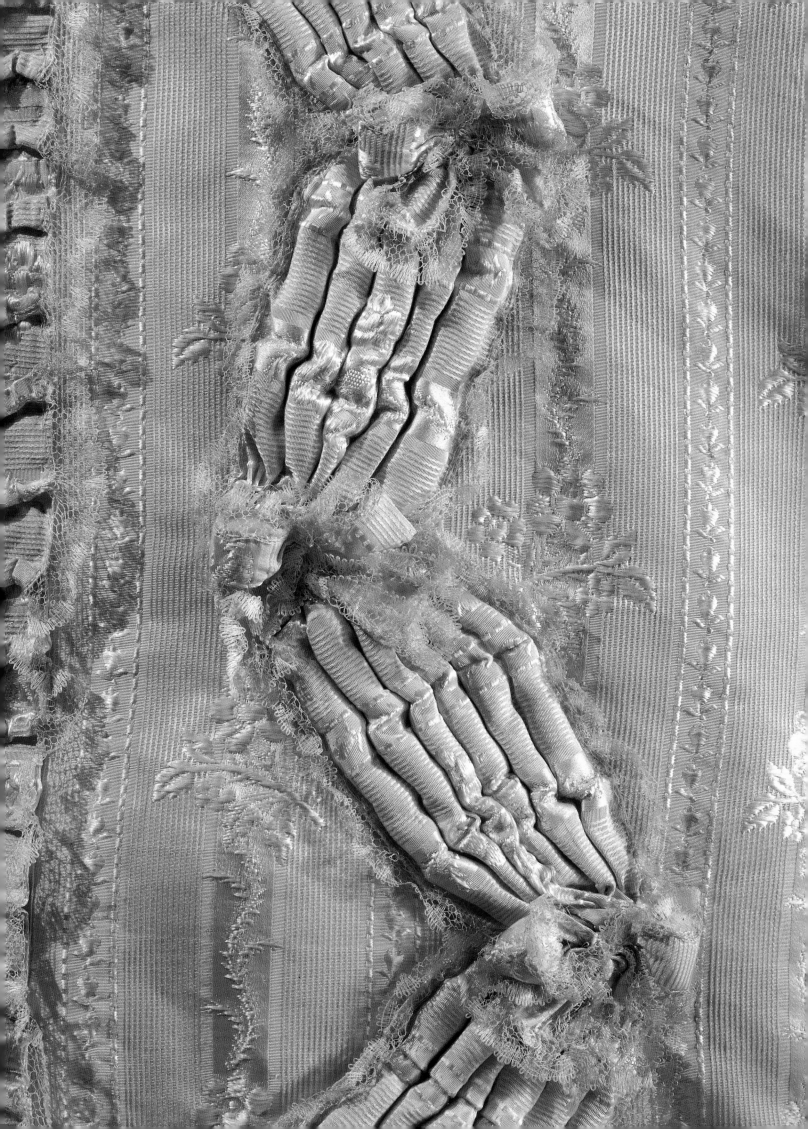

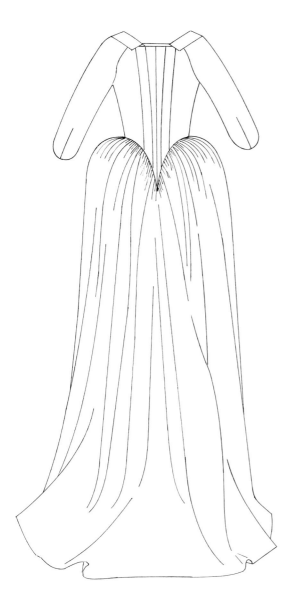
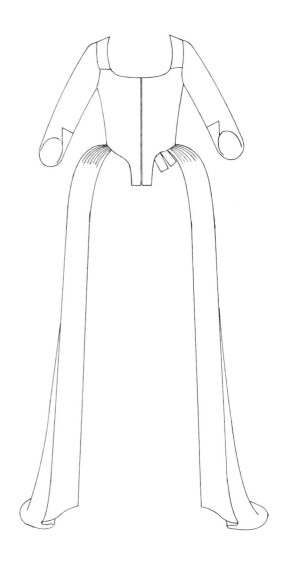

THE FULLNESS OF the skirt is contained by the tightest possible gathers around the waistline of this 1780s open gown of printed cotton.

The printed design is enhanced by a polka-dot overprint in gold. A fashionable gown for day wear it has a tightly fitted bodice with low décolletage and elbow-length sleeves. The open-fronted skirt would have revealed a petticoat of either a light-weight silk or matching printed cotton. The characteristic cut and style of the 1780s can be seen in the back of the bodice with its deeply pointed centre reaching well below the waistline. There are two narrow pieces of supple whalebone inserted either side of the centre back seam which create and maintain this fashionable shape. The tight, slim bodice appears even narrower set against padded hips and a 'bumroll' at the back. In the late 18th century a pad or bustle tied behind at the centre back was an essential undergarment made to accentuate the tight bodice and small waist and provide an elegant profile to the figure. The pad often seems to have been made of cork. It was worn throughout the 1780s and 1790s, when it became smaller and rose higher, preventing dresses from falling into the small of the back.

A woman's gown of printed cotton
with gold polka-dot overprinting.
Dutch, 1780s
T.217-1992

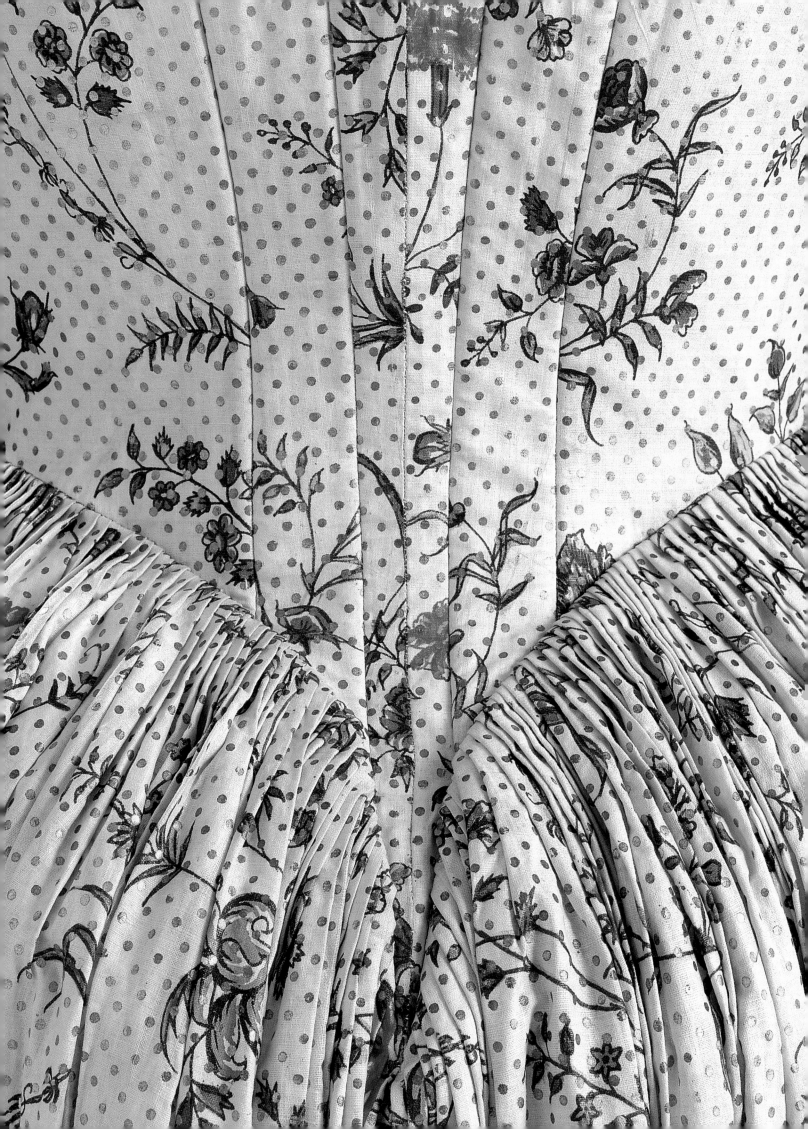

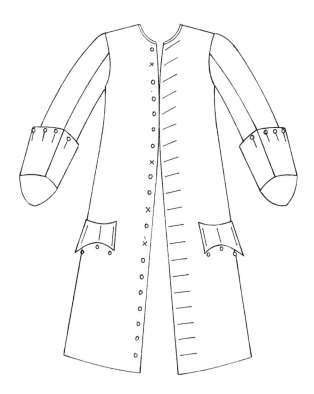
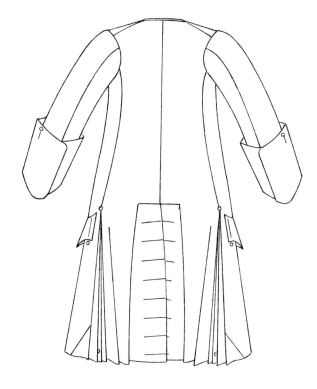

THESE FASHIONABLE PLEATED skirts to a man's silk dress coat of the 1740s are stiffened with an interlining of woven horsehair and buckram and lined with a further layer of unspun wool. This gives a dramatic flare to the skirts causing them to stand out independently.

The outfit consists of a matching dress coat and breeches in beige figured silk and is probably French. Men's fashions of this period had tightly fitted bodies which were accentuated by full, pleated skirts to the coats. To balance these full skirts the sleeve cuffs are wide and deep reaching to the elbow.

The full skirts have open side seams which are kept in place by stays of chain-stitched thread and several buttons which hold the open seams together, and serve a decorative as well as a practical purpose. When open, the side seams and centre back vent, which had their origins in riding dress, allowed the coat to drape comfortably when seated on a horse.

For more details about this coat, see p.116.

For more details about this coat, see p.116.

A man's dress coat of figured silk.
French, 1740s
T.614:1-1996

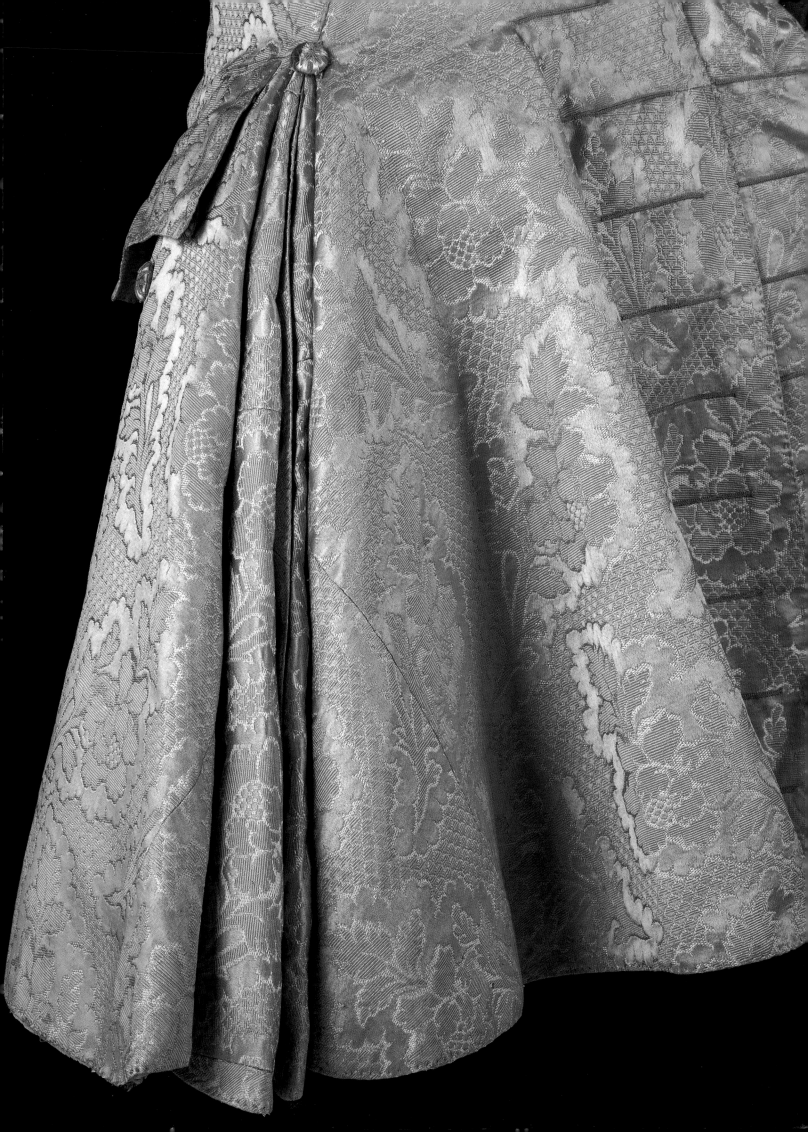

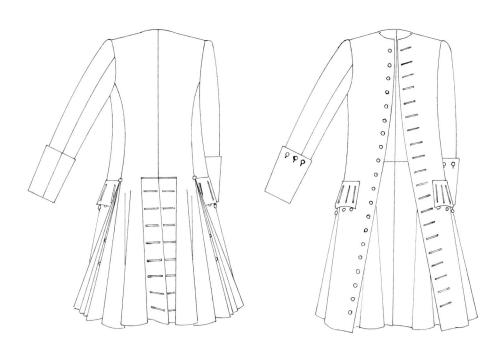

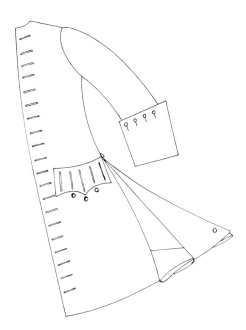

SOFTLY ROUNDED SIDE pleats on the skirts of this superb cloth coat of the 1750s to 1760s are quite full and have been interlined so that they hang in heavy folds. The detail shows the left-hand side pleats. This is a formal day coat which forms part of a three-piece suit with matching waistcoat and breeches made of superfine wool with a felted finish. It is complete with original silver-gilt buttons.

The fashion of the 1740s for extravagant full-skirted coats made with stiff interlinings, which can be seen in the previous example, had declined by the 1750s and 1760s. The pleats of this coat flank the open seams which extend from hip to hem on each side of the coat, and are partially closed by a pair of button stays. The origin of the open seams in men's coats has

already been mentioned, but they also served another purpose relating to the fact that in the 18th century all gentlemen were entitled to carry a sword. The side vents allowed the sword to pass through the coat without damaging the garment. Stays prevented the sword from swinging about and also controlled the movement of the skirts.

The suit is good-quality formal day wear. An elegant, understated ensemble, the only decorative highlights are the gleaming buttons. This was typical dress for an English gentleman of the period and epitomises the English taste for quality without ostentation.

For more details about this coat, see p.84.

A man's formal day coat of
felted wool with silver-gilt buttons.
English, 1750s-1760s
T.329-1985

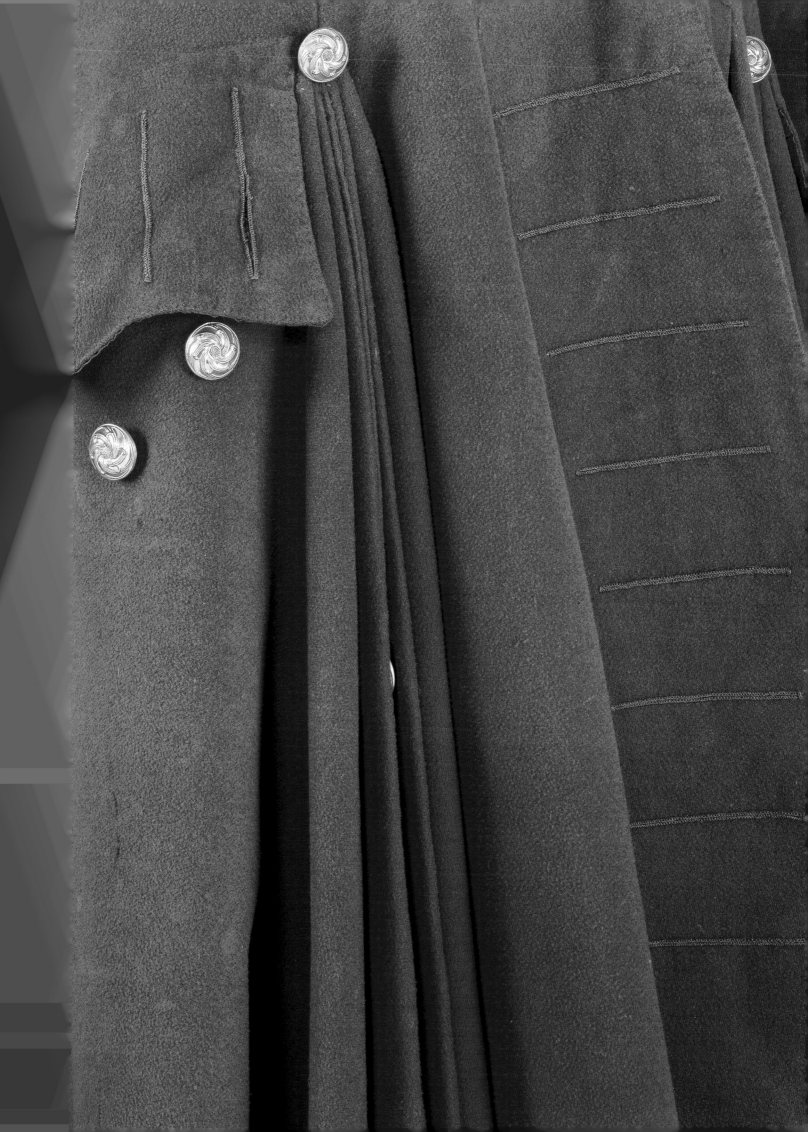

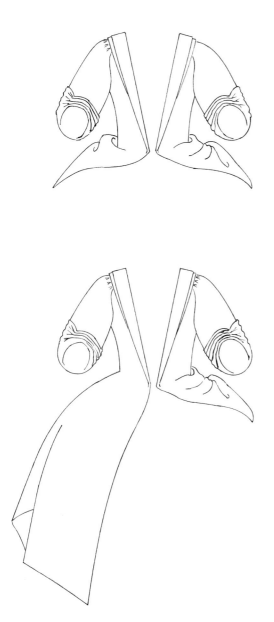

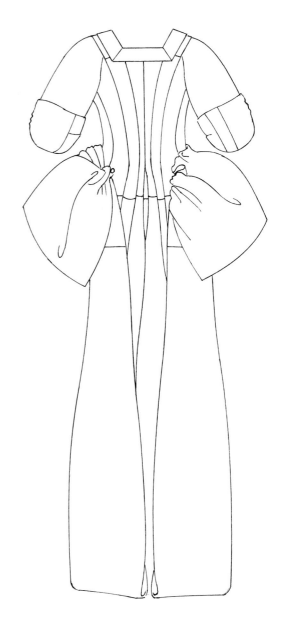

THE PLEATED BACK of this mantua of about 1732 is a fine example of skilful dressmaking. The pattern of the silk has been carefully matched either side of the centre back seam so that the design is balanced.

The mantua comprises a trained open robe and matching petticoat of brocaded silk with chenille. Mantuas were originally worn as fashionable everyday garments in the late 17th century, but by the 1730s were confined to formal-dress occasions and became the required style of Court dress.

A mantua is defined as a trained open gown, draped at the hips, with the train pinned up behind. The gown is always worn with a matching petticoat over a hooped petticoat. A stomacher would have been worn to cover the bosom, and stays at the V-shaped opening formed at the front. The entire ensemble would be finished at the neck and sleeve cuffs with lace trimmings and ruffles; these were stitched to the neck and cuffs of the chemise.

A trained mantua of brocaded silk with chenille.
English, late 1730s
The silk French or English, *c.*1732
T.9-1971

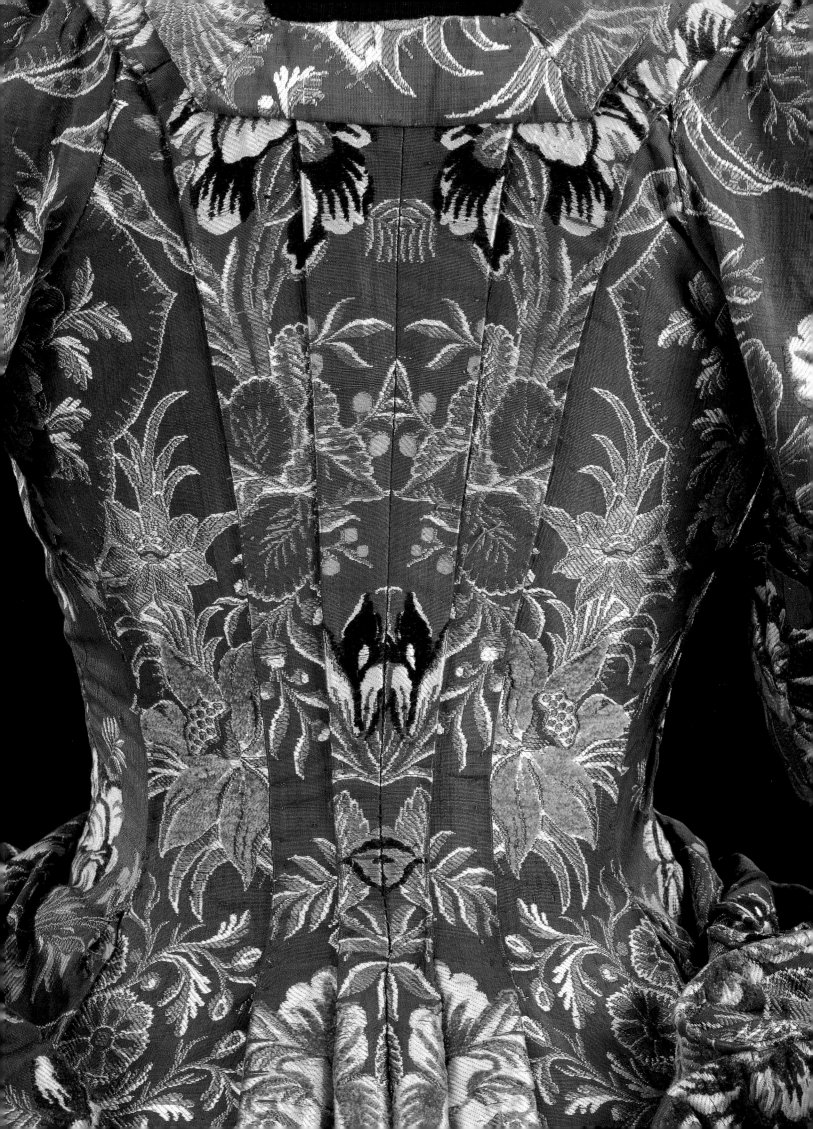

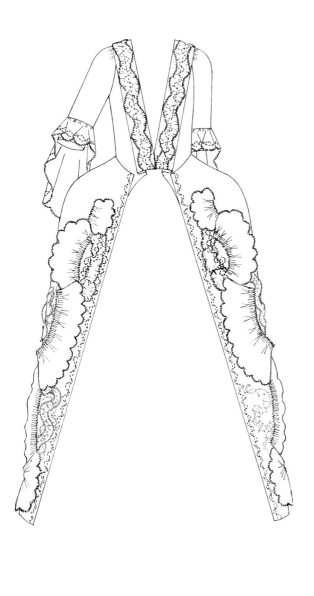

THE DOUBLE BOX arrangement of the pleats at the back of this 1760s sack-back gown is typical of the construction of such garments in the mid-18th century. Almost all gowns of this style were made of four widths of silk at the back and two at the front. The lengths of silk were cut to accommodate the height of the wearer. By adjusting the depth and placement of the pleats at the waist and shoulder, the gown would be made to conform to the shape and exact measurements of the woman for whom it was made. Examination of many of these sack-backs reveals that this was the case, as each is slightly different in the width and arrangement of the back pleats. The fact that the back of the gown was meant to fall loose and unstructured from the pleats also made fitting a standard circumference of fabric to an individual much easier.

Typical of 1760s style are the single ruffles on the sleeves and the waist seam at the front of the gown. The rococo influence is evident in the curvilinear arrangements of the wide and narrow ruffles on the skirt, intertwined with white silk fly fringe. The narrowness of the front panels (less than one width of silk) and the slight awkwardness of their join with the bodice may indicate that the seamstress was inexperienced in accommodating recent alterations in the style of the sack-back: adapting to a narrower hoop and the newly introduced waist seam.

The brilliant yellow and white silk, made at Spitalfields between 1755 and 1760, is woven in a pattern of flowers and leaves.

For more details about this gown, see p.34.

A woman's sack-back gown
of yellow and white woven silk.
English, 1760-1765
T.426-1990

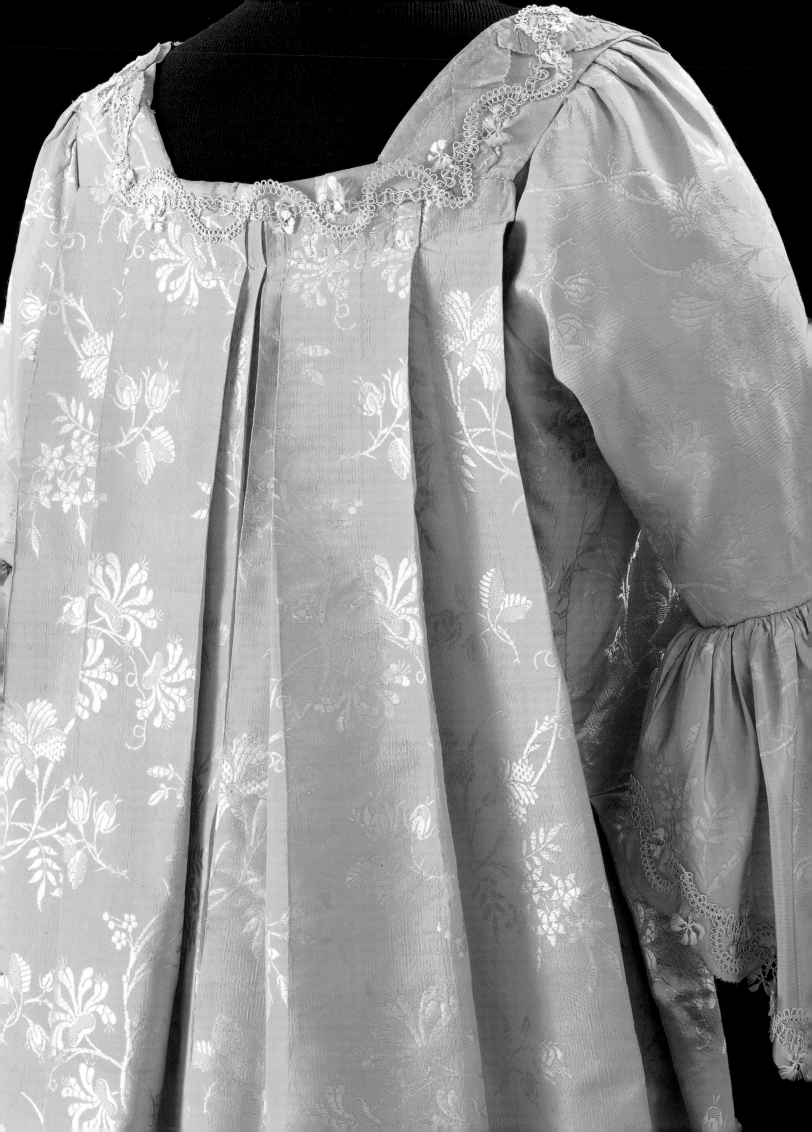

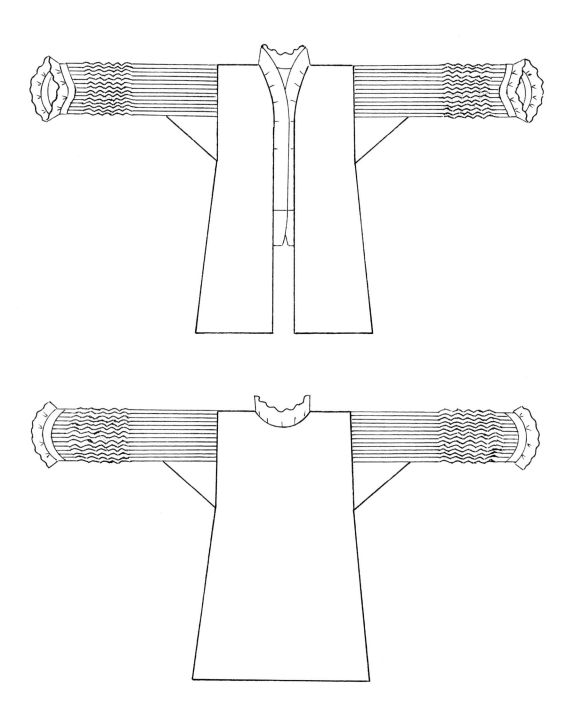

THIS FINELY PLEATED linen sleeve belongs to a dressing jacket of the 1760s to 1770s. The jacket reaches to the hips and the sleeves are three-quarter length. The neck and cuffs are trimmed with delicate cambric frills. The detail illustrates the lower part of one sleeve which has been pleated into tight concertina-like folds – the pleats are thought to be original 18th-century laundering. Such fine pleating would have been carried out under tension which pulled the stitched pleats into line making it possible to carry out the ironing, which would have taken hours to complete. Different-sized irons were used, some so small they would be mistaken for toys today.

Ladies wore such dressing jackets as protective garments when attending to their toilette, and especially when their hair was being dressed, as this could involve hair powder falling on their clothes.

This particular garment has a chemise to match with exactly the same type of sleeves. The fine pleating meant they were more comfortable and practicable to wear under the tightly fitted sleeves of robes and gowns. Men's shirts of the late 18th century also had pleated sleeves which could slip easily into coat sleeves which had become increasingly tighter in fit.

A woman's dressing jacket
of linen with pleated sleeves.
English, 1760s-1770s
T.28-1969

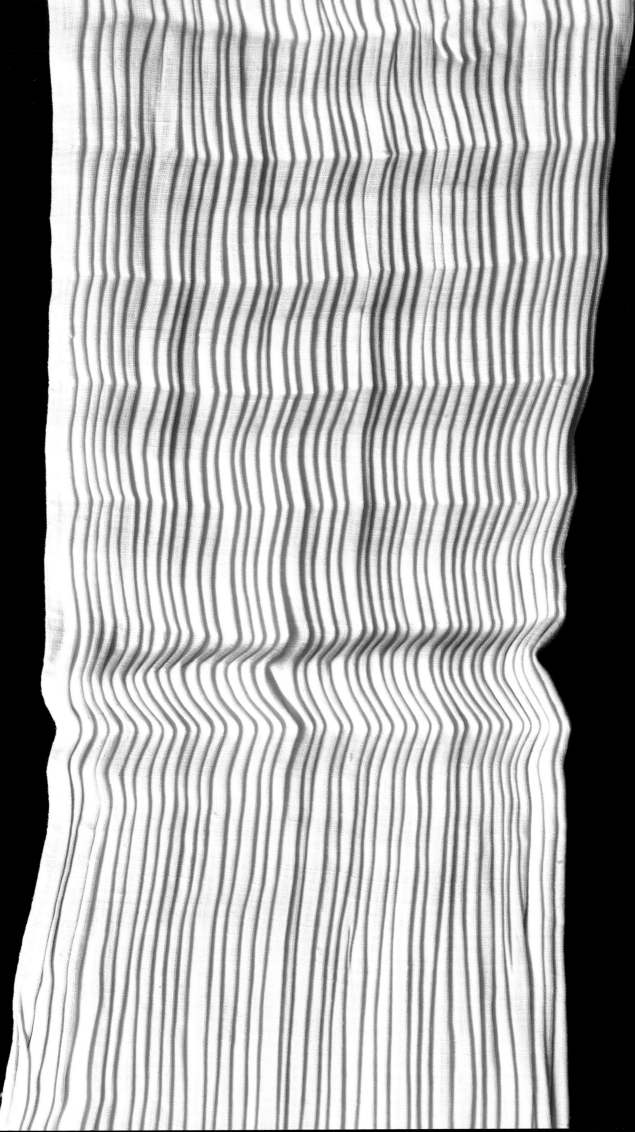

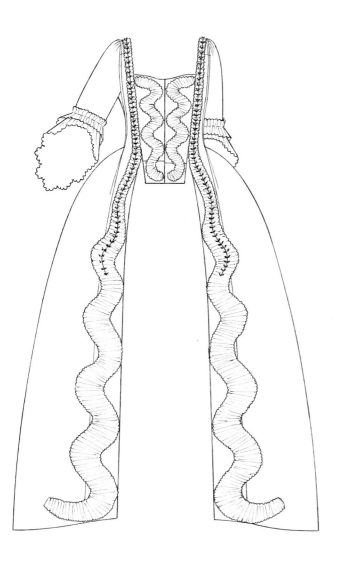

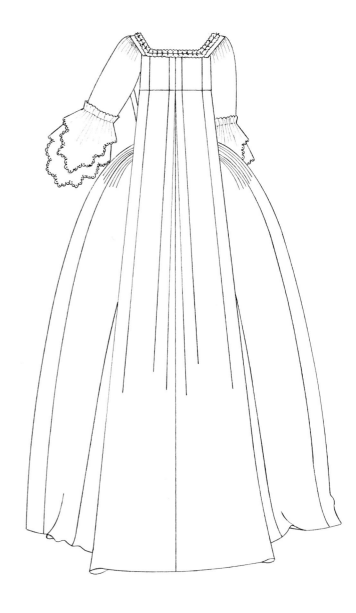

THE SPECTACULAR WATERCOLOUR effect of a chiné silk is enhanced by the wide pleating and unstructured back waist of the sack-back gown. A large pattern of red flowers and green foliage lies against a ground design of meandering maroon, pink and yellow lines. To achieve the lightly smudged outlines of the chiné pattern, the warp threads were first wound on a frame and printed with a design. They were then transferred to the loom and the weft threads woven in, resulting in a blurring of the warp pattern. Most chiné silks were French and could only be imported to England in restricted lengths. Such a shortage may have necessitated the uncharacteristic horizontal seam seen at the back here and on the front of the gown. Nevertheless the pattern has been very carefully

matched. According to an 18th-century author on dressmaking, aligning floral patterns or stripes as economically as possible was 'a matter of genius and talent'.[1]

Gathered frills of silk trim the front of the gown, with a smooth transition from the narrow straight robings on the bodice to the deep curvilinear arrangement on the skirt. The double sleeve ruffle and unseamed front waist are typical of a 1750s gown.

1. 'Que la plus grande difficulté qui se rencontre, quand on a des étoffes à fleurs ou à compartiments, est de les bien appareiller et assortir réglièrement, en ménageant sur l'étoffe le plus qu'il est possible; c'est une affaire de génie et de talent.' François Alexandre de Garsault, *Art de Tailleur* (1769), p.51.

A woman's sack-back gown of green,
red, maroon, pink and yellow chiné silk.
English or French silk, 1750s
T.16-1961

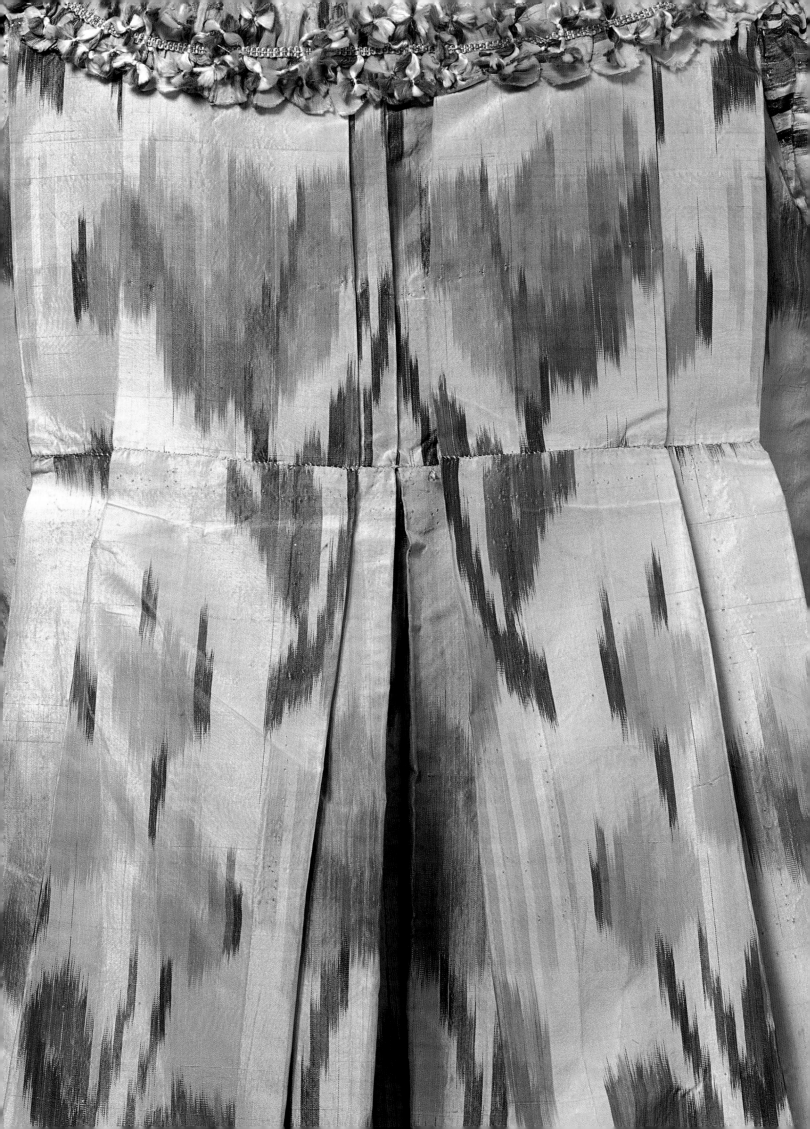

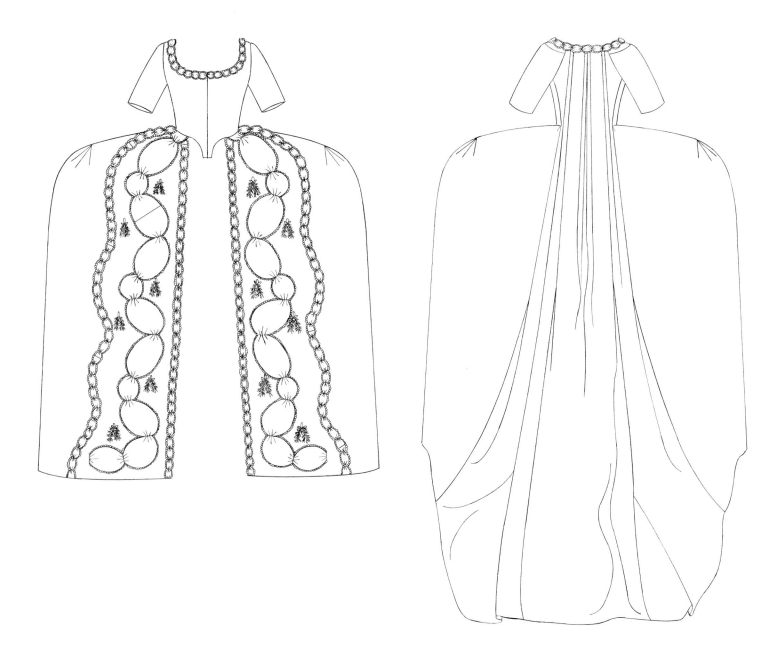

An ARC OF precise, wedge-shaped pleats illustrates how this sack-back gown fitted over a wide side hoop. By the 1770s, the contour of the petticoat had evolved into a bell shape for all but the most formal wear. A large hoop was still required for Court and evening wear, and the construction of a gown had to be adjusted to accommodate the extra width. Seven lengths of white satin were used for this example; one additional piece at the back allows the extension at each side. The

high, almost square shape of the hoop that would have been worn under the gown is typically English.

The formality of the style and its unvarying colour indicate that this may have been worn for a wedding or betrothal. The closed-front bodice, waist seam and short, plain sleeves date the gown to the late 1770s.

For more details about this gown, see p.124.

A woman's sack-back gown of white satin.
English, 1775-1780
T.2-1947

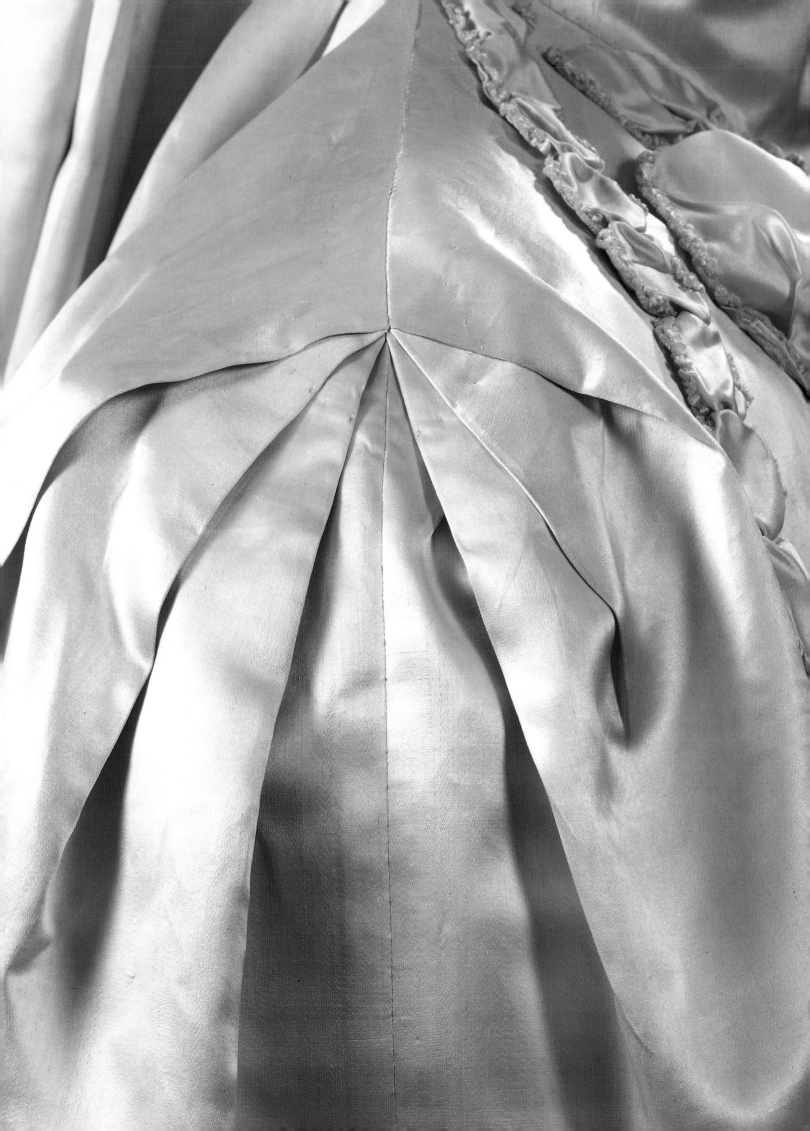

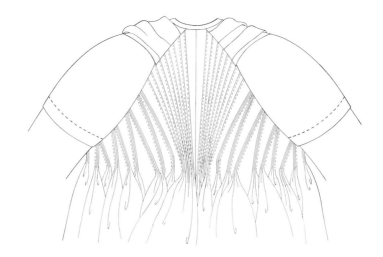

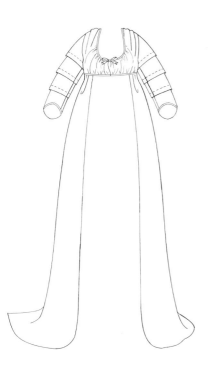

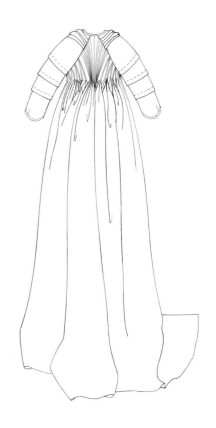

DESPITE THE RADICAL change in the style of women's dresses under the influence of neo-classicism, back pleating remained a convenient method of fitting a gown to an individual while providing fullness to the back. This gown demonstrates how the traditional construction techniques of 18th-century dress-making adapted to the high-waisted styles that became popular in the 1790s.

Here the silk is arranged in a series of narrow pleats on either side of the centre back. Because the dress uses three lengths of silk at the back, the centre back is not a full seam, but a small tuck to accommodate two pieces of whalebone. There are nine narrowly radiating pleats on either side, then a pattern of double groups of three pleats fanning out from the raglan shoulder seam. This produced the desired neo-classical style: a closely fitting upper bodice with a full, slightly trained skirt at the back.

In keeping with the tradition of the 18th-century sack-back, the gown is open at the front, to be worn over a petticoat. Nevertheless, the cut of the bodice conforms to the new high-waisted style, gathered at the shoulder seam and waist seam, with a drawstring neck (the original silk ribbon survives). A lining in the form of an inner linen bodice is another legacy of unchanged construction methods.

The silk of this gown reflects the changing fashions in textile design. The beige satin ground woven in a pattern of tiny yellow leaves and white sprigs is lightly figured with pink and red flowers, the pale colouring and small abstract motifs exemplifying neo-classical taste.

A woman's gown of beige figured satin.
English, *c.*1795
Given by Miss Hermoine Field
T.116-1938

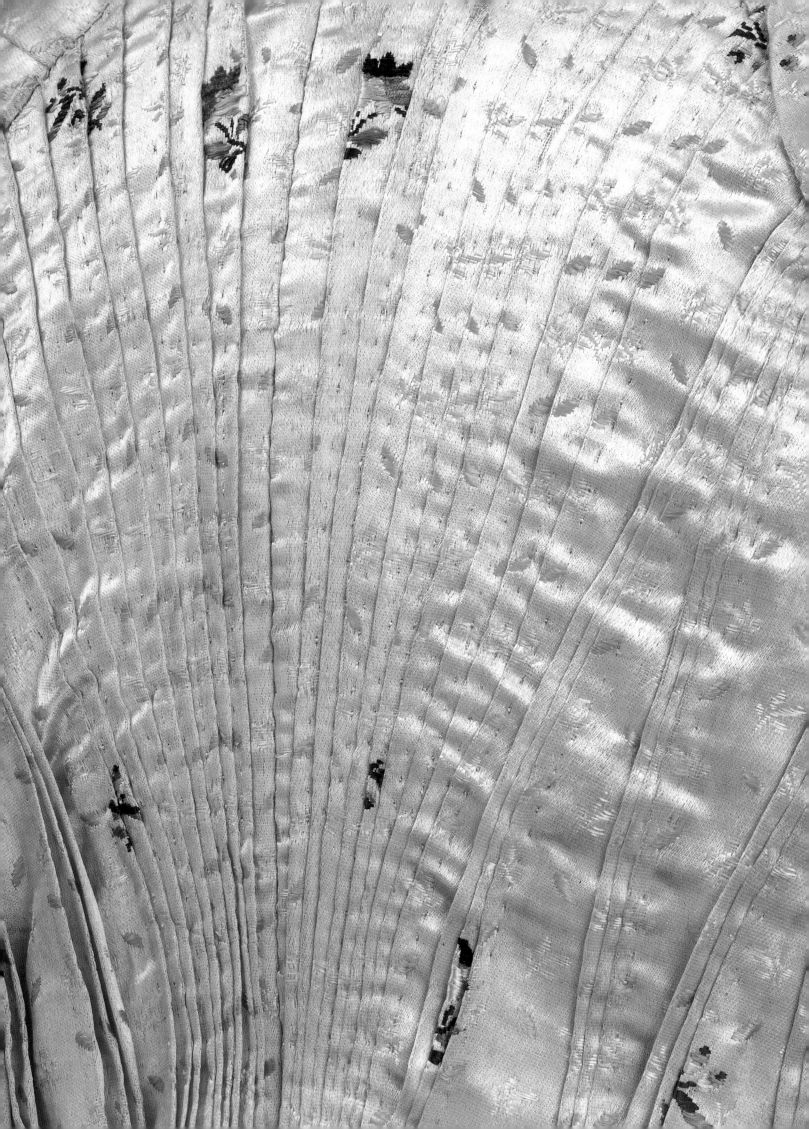

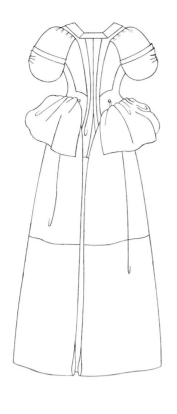

KEY
The capital letters on the right hand side correspond to the lower case letters on the left hand side.

▨ = wrong side of fabric

☐ = right side of fabric

ABCD = side pieces opened out showing construction

abcd = side pieces draped and folded
A = drapes over looped cord H to button at G on each hip
E = the train
F = back of bodice
G&G = buttons at each hip
H&H = looped cords attached *behind* each button

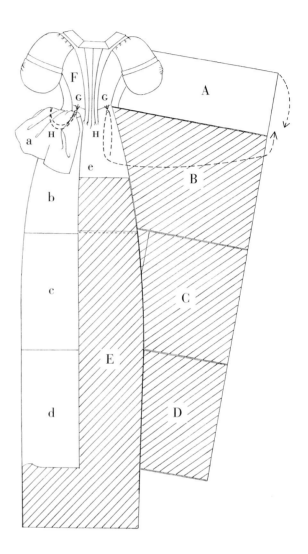

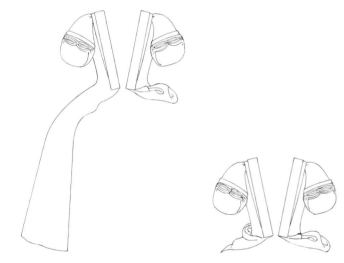

The DRAPED SKIRTS of this magnificent 1730s mantua cleverly conceal the complex construction of a trained mantua gown. The detail illustrates the left waist, seen from the back.

The ensemble comprises a trained open gown and matching petticoat. In the early 18th century mantuas were considered to be the correct dress for formal occasions and were obligatory for Court dress.

The diagram shows the back view of the mantua with one side draped and the other opened out flat to show the complicated construction of the train, and the method of using both the right and the wrong side of the silk, so that when draped and pinned in place, only the right side is seen. The right-hand side of the train **Ee** fully opened out shows the additional side pieces **abcd** caught back, and by a looped cord and a button **GH** at the hip the lower side pieces are folded across the train.

Pinning up and draping a train or 'tail' successfully was an art, and a source of pride to the wearer when she achieved a perfect effect. In 1734 the Duchess of Queensbury wrote of her own mantua: 'I can assure you my tail makes a notable appearance'. [1]

1. *Letters of Henrietta Countess of Suffolk 1712-1767* (London 1824), 2 Vols, Vol. 1, p.68.

A trained mantua of brocaded silk.
English, 1733/34
Given by Gladys Windsor Fry
T.324-1985

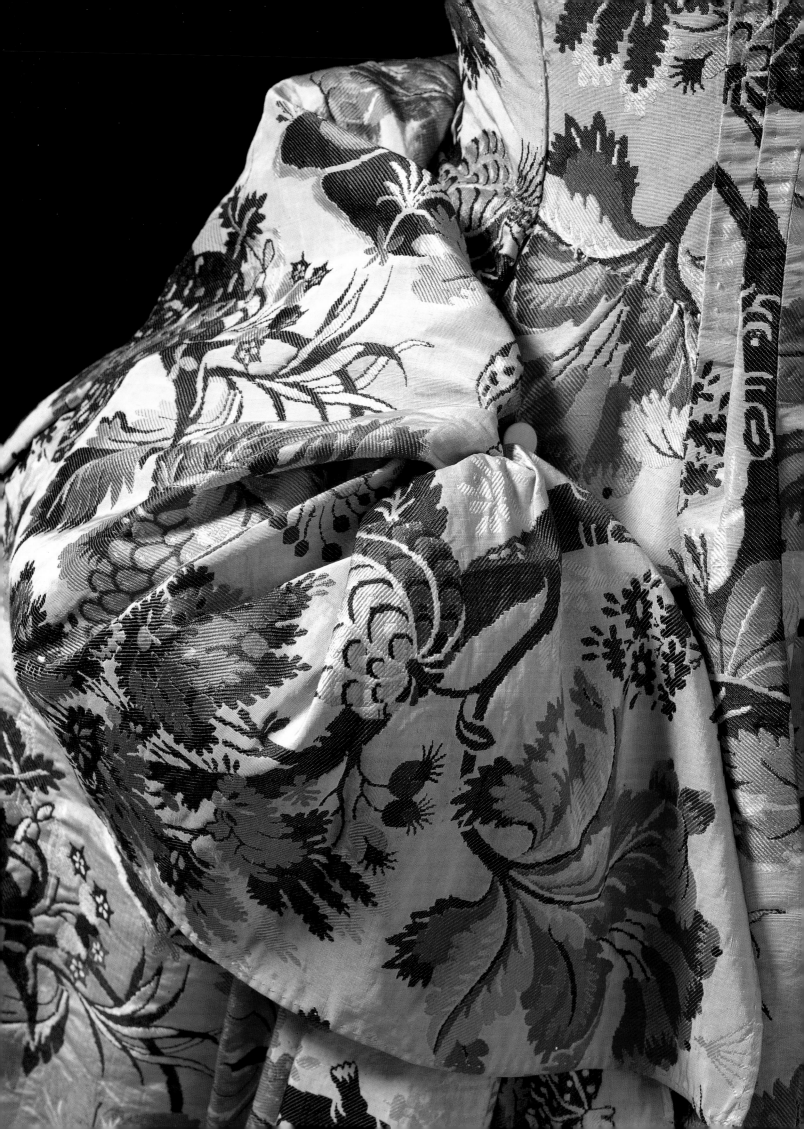

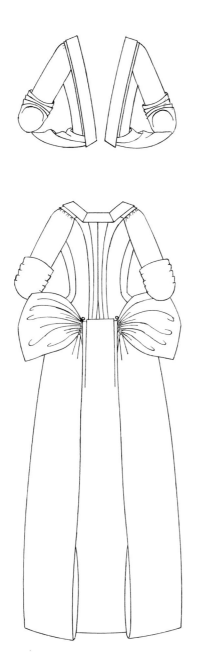

THE MOST MAGNIFICENT of Court dresses, this red silk mantua exemplifies the height of formal fashion, and the zenith of the professional embroideress's skill. The style of the mantua was perfectly suited for maximum display of wealth and art, the wide hoop petticoat a metaphorical canvas for the needle, the fitted, trained mantua offering ample potential for elegant drapery.

Silver filé thread, frisé, strip, purl, and spangles, couched and embroidered in satin stitch, are used in this luxurious Tree of Life design. The pattern is densest at the hem of the petticoat, an almost solid ground of swags and trellis filling, over which grow the 'trees' bearing flowers and twisting leaves, and continue above the border. Some of the metal

thread pierces the red ribbed silk, in certain areas of satin stitch, but in general, the silver lies on the surface, couched down with the linen thread. Needlelace in silver thread and strip, with silver thread and spangle tassels, decorates the stomacher. In all, some ten pounds of silver was used to adorn this mantua.

As remarkable as the design and execution of the garment, is the fact that the train is signed: 'Rec'd of Mdme Leconte by me Magd. Giles.' Mdme Leconte has been identified as a Huguenot embroideress working in London between 1710 and 1746. This continental connection may explain the heavy ornate nature of the embroidery design which shows the influence of French rococo style.

Mantua and petticoat of
red silk embroidered with silver thread.
English, 1740-1745
Given by Lord and Lady Cowdray
T.227&A-1970

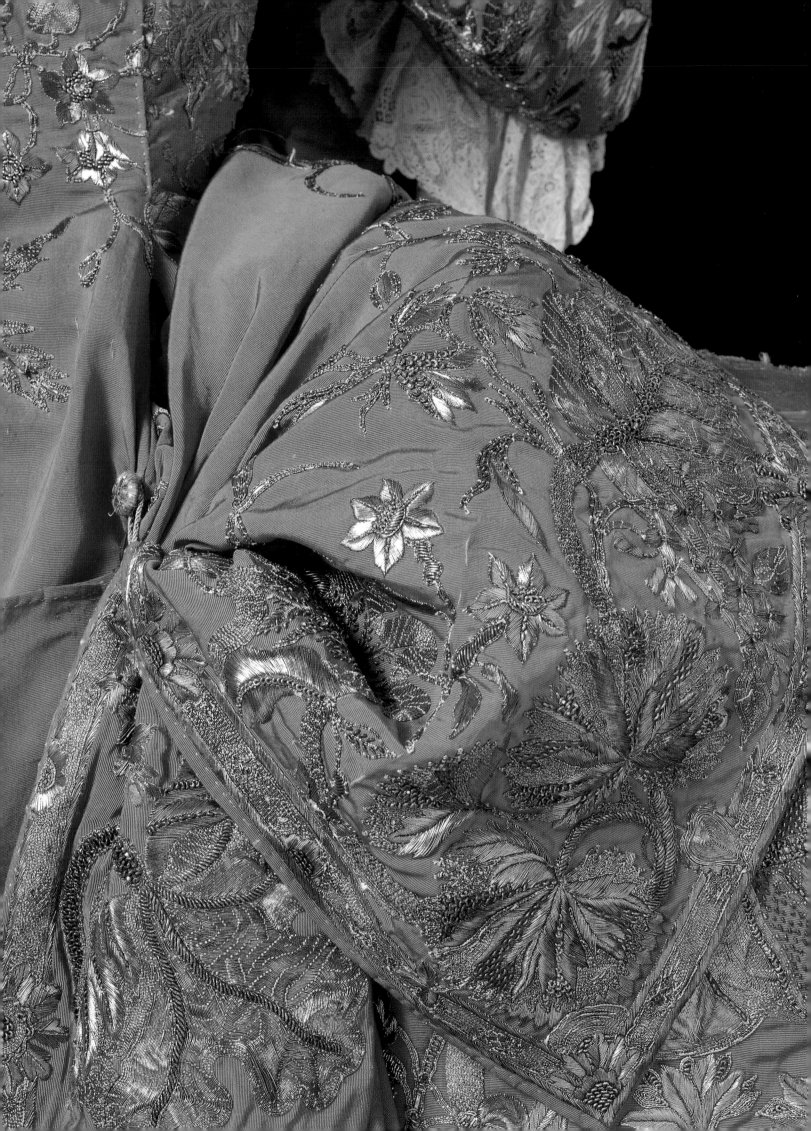

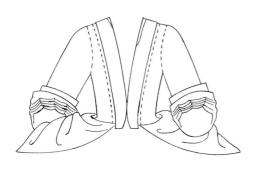

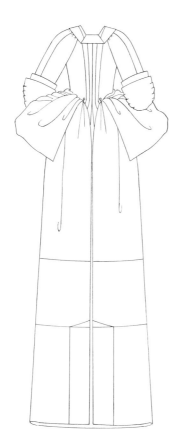

WHILE THE PATTERN of a woven silk mantua could be matched to the shape of the gown only to a limited degree, those embroidered were carefully designed to fit its particular cut. In this example, the configuration of the needlework follows the corner and edges of the draped train. Where the arcaded trellis borders meet stands an urn from which grow serpentine stems bearing large naturalistic flowers and leaves. The side panels below the front corners of the mantua are reversed, so that the right side of the embroidery shows when the train is properly draped.

The cream-coloured ribbed silk is embroidered and couched with silver-gilt thread and purl, while the floral elements are worked in coloured silks. Both the sleeve cuff and front robings are embroidered in the same pattern as the mantua and petticoat, but it has been scaled down to fit their narrow dimensions. In comparison to the embroidery style of the previous mantua, the palette is lighter, the flowers more naturalistic, and the overall design more delicate, characteristic of the English rococo style. Patterns such are this were following similar stylistic developments in woven silk design.

Extensive alterations were made in the 19th century to adapt this mantua for fancy dress, some of which have been reversed to regain its original form.

A mantua and petticoat of cream silk
embroidered with silver-gilt and silk thread.
English, 1740s
Given by Miss Katharine Boyle
T.179&A-1959

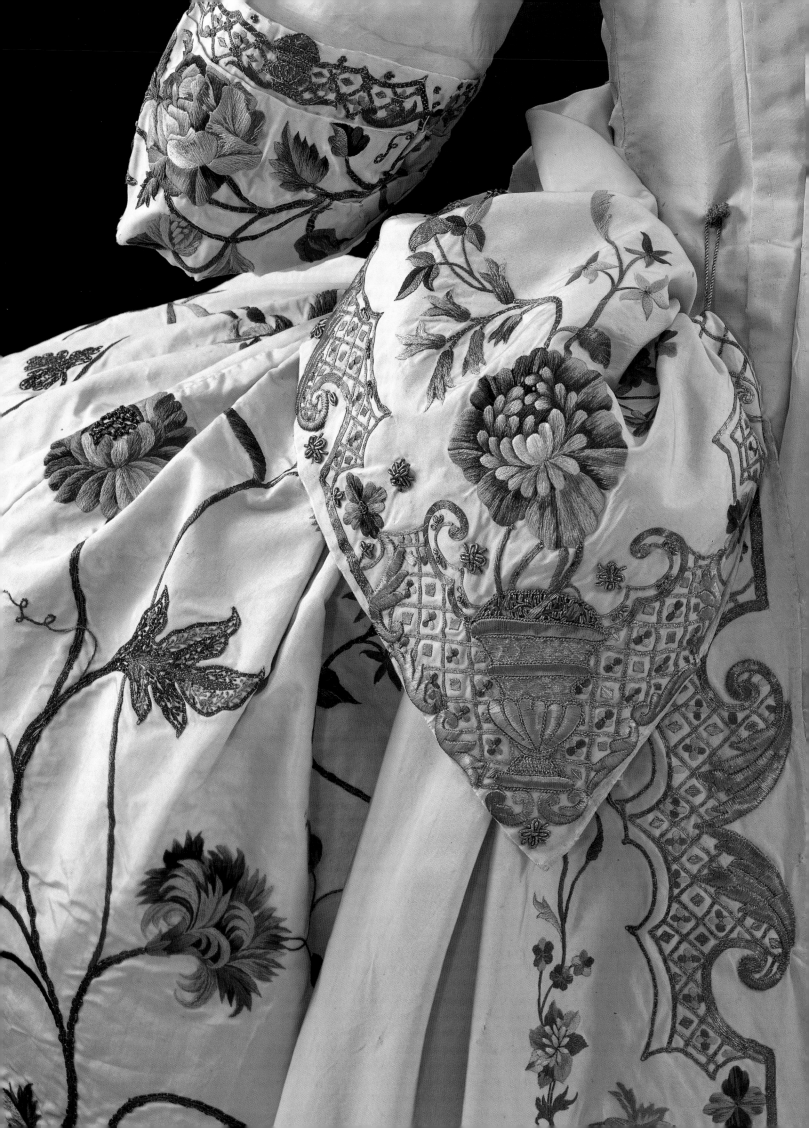

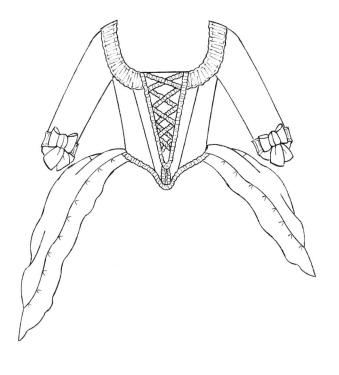

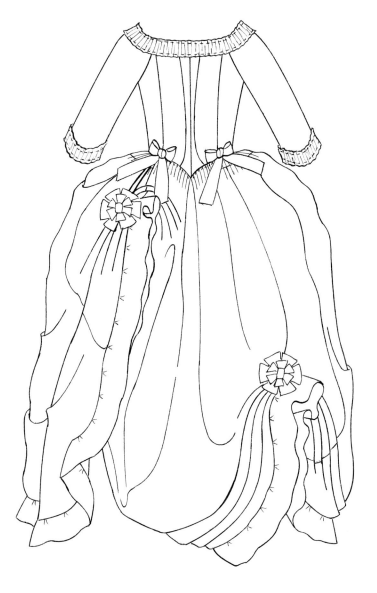

SKILFUL AND STYLISH draping characterises the polonaise style of the 1770s, and is illustrated in this detail showing a gown of Chinese painted silk.

Of all the 18th-century styles it is the polonaise that has caught the popular imagination as the embodiment of 18th-century female dress. The style originated in France and was fashionable between 1776 and 1780.

This gown is trimmed with ruffles of plain green silk at the neck, cuffs and around the skirt. The draperies of the skirt which create the polonaise style are stitched into attractively pre-arranged folds; the stitching is concealed with a green silk rosette. The drapery is looped up at the back by means of braided silk cords. The loops originate from inside the bodice emerging under the two silk bows at the back waist and looping over the rosettes. The drawing shows the polonaise correctly draped on one side and undraped on the other to illustrate the arrangement of the pre-arranged folds.

A polonaise gown of Chinese painted silk.
English or French, late 1770s
Given by Mrs George Shaw
T.30-1910

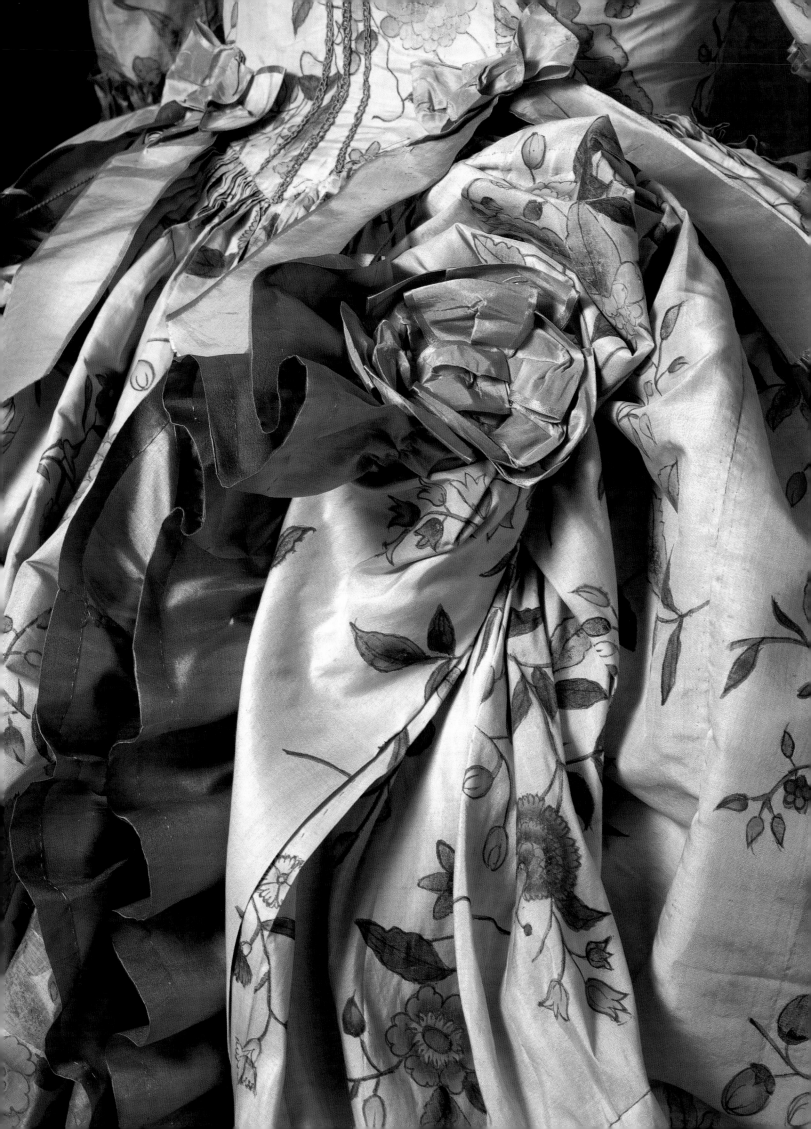

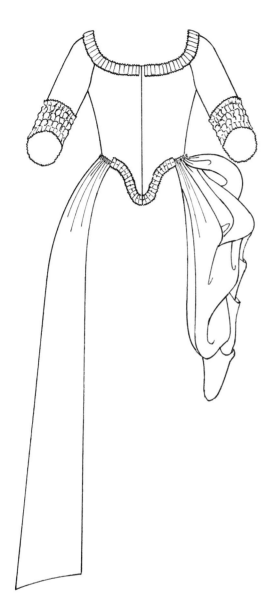
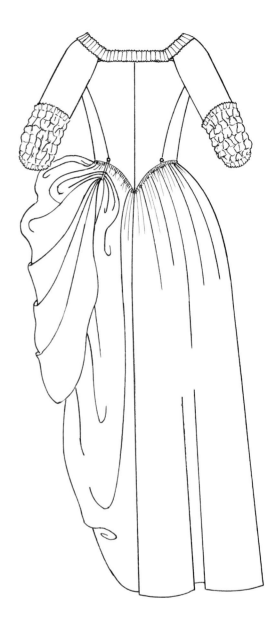

THE CRISP, FAN-LIKE drapery of this attractive polonaise gown of about 1775 is further enhanced by the subtle gleam of the lustred surface of the silk.

There are two loops for the polonaise drapery; these are stitched inside the bodice behind the buttons which are stitched to the outside of the back waist. When creating the drapery for the polonaise, the skirt is caught up and held by the loops, the ends of which are fastened over the buttons on the waistline. Another and unusual decorative effect has been created at the waist by the skirt, which has been concertina-pleated and stitched to the outside of the bodice, creating a narrow tightly frilled ridge.

Draping the skirt was not only a fashionable option, it also served as a practical method of raising the skirt above the ground from the dirt and dust.

A polonaise gown of striped lustred silk.
English, c.1775
Given by Miss A. Maishman
T.96-1972

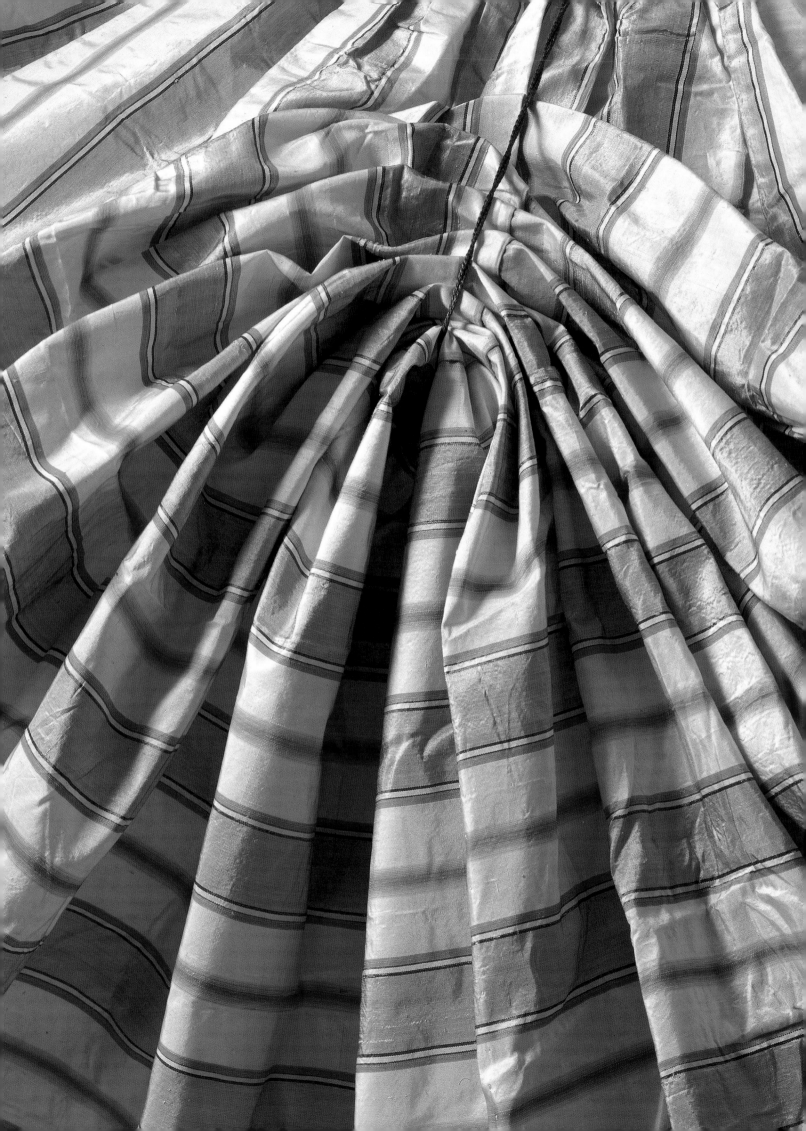

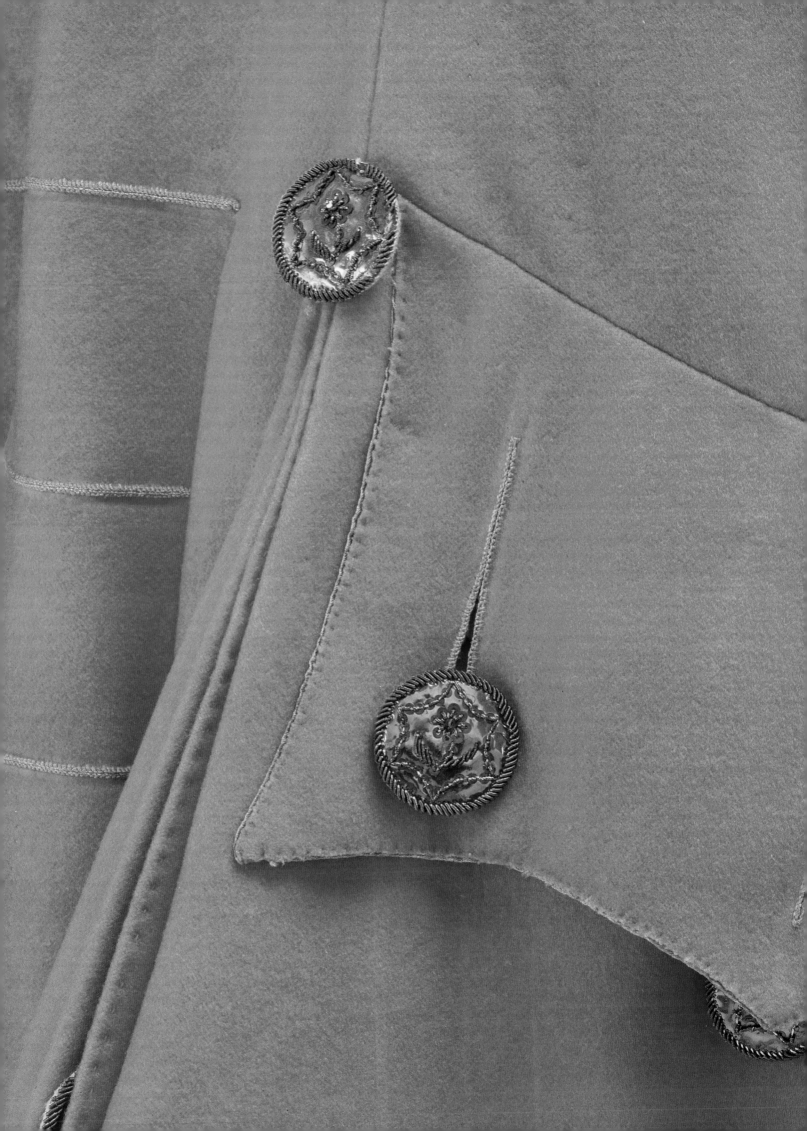

Collars, Cuffs
& Pockets

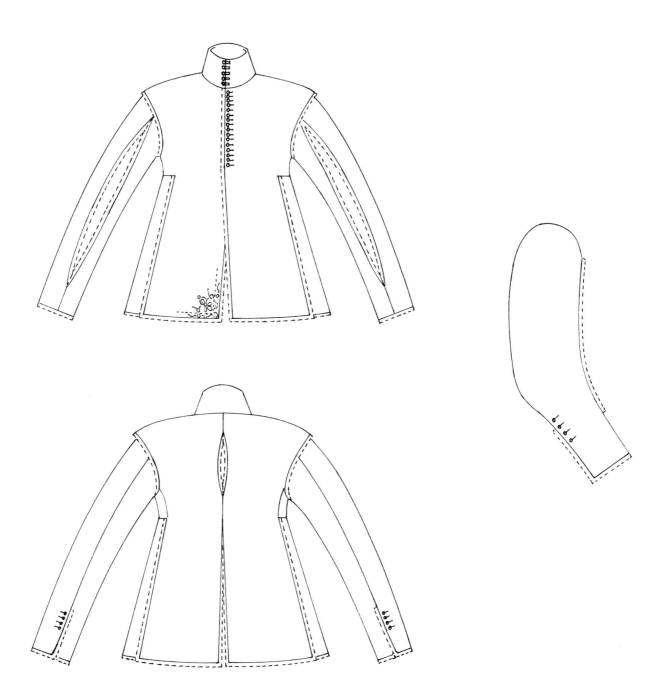

AN UPRIGHT STIFFENED collar of glazed, bleached linen offers a superb polished surface for the embroidered decoration on this doublet of 1635 to 1640. All the embroidery is carried out in linen thread demonstrating a sophisticated use of white-on-white decoration. An elegant design of inverted heart-shaped scrolls is worked in back stitch on the collar. The rest of the doublet is embroidered in back stitch, French knots and couching.

The collar is fastened with five buttons and corded loops. It is stiffened with pad-stitched layers of buckram. Doublets of the 16th and 17th centuries were furnished with collars of this type until the 1660s to 1670s when they went out of fashion.

Doublet collars were designed to reach the jaw line and provided a firm support either for the supportasse which in turn held up the ruff, or for the elegant, lace-trimmed falling bands which were such an important feature of this period. The height of the doublet collar ensured that the white linen falling band draped over in a becoming manner.

This elaborately decorated doublet would have graced grand occasions. It is made in a fashionable style with an open centre back seam and open seams to the front of the sleeves which were intended to allow the shirt to be seen. These features are shown in the drawings.

For more details about this doublet, see p.114.

For more details about this doublet, see p.114.

A man's doublet of glazed bleached
linen embroidered in linen thread.
English, 1635-1640
177-1900

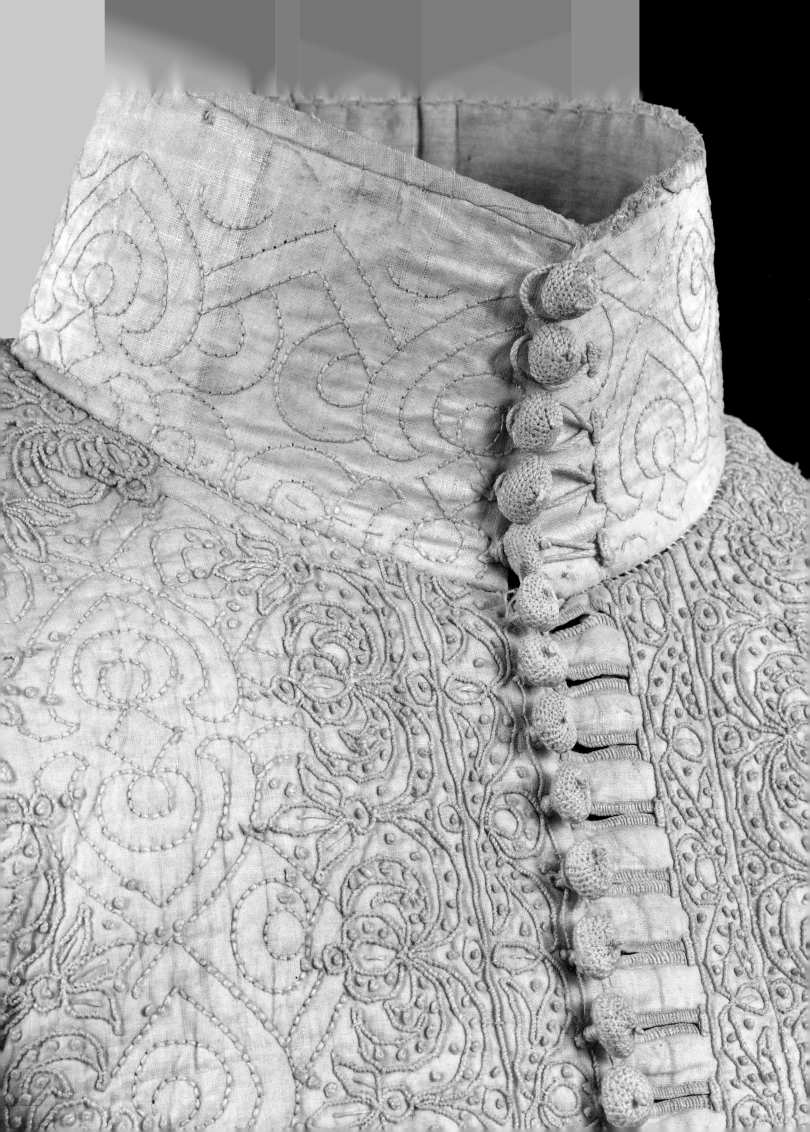

This DELICATE TURNED-DOWN collar of an embroidered linen jacket of 1610 to 1620 is lined with apricot-pink silk taffeta and trimmed with silver and silver-gilt bobbin lace. Gleaming lace is enhanced by silver spangles on the lace which create a twinkling effect when the garment is moved. In order to give maximum decorative impact such costly garments were frequently enlivened by trembling spangles and prettily coloured linings. It should be remembered that at night clothes were worn in the glimmering light of candles when the reflective metal threads and spangles were really seen to advantage.

This jacket was worn by Margaret Laton (d.1641), daughter of Sir Hugh Browne, a merchant of the City of London; she married Francis Laton (1577-1661), one of the Yeoman of the Jewel House. Please see pp.16 and 148 for further details of this jacket.

A woman's jacket of linen embroidered
in coloured silks and silver-gilt thread, and trimmed
with silver and silver-gilt bobbin lace.
English, 1610-1620
T.228-1994

A KALEIDOSCOPE OF colours are used for this superb embroidered Court dress coat and waistcoat of the 1780s to 1790s. The coat is of uncut purple-brown velvet and the waistcoat is of white ribbed silk. Both garments have been embroidered around the collars, fronts and pockets and the back pleats of the coat in richly coloured silks, with a matching design of trailing leaves and flowers carried out in satin stitch.

The style of men's dress by the end of the 18th century was slim and fitted the figure; full side skirts with stiffening and padding had completely disappeared from coats to be replaced with curved or cut-away fronts, flat pleats and longer skirts which formed tails at the back. Sleeves were longer and tighter and cuffs smaller. Waistcoats lost their skirts and were cut straight across at the waist. Short stand collars appeared on coats in the 1760s and became fashionable in the 1770s when they also appeared on men's waistcoats. As coat collars rose in height over the next two decades, waistcoat collars almost matched them in size. The detail shows the collars of both coat and waistcoat, illustrating the cut-away stepped arrangement of the coat collar at the front which allows the waistcoat to be visible.

This suit is reputed to have been worn by Sir William Hamilton (1730-1803) when envoy to the Court of Naples 1764-1800.

A man's embroidered Court dress coat
and waistcoat of embroidered velvet and silk.
French, 1780s-1790s
Bequeathed by C. A. Beavan
T.231&A-1917

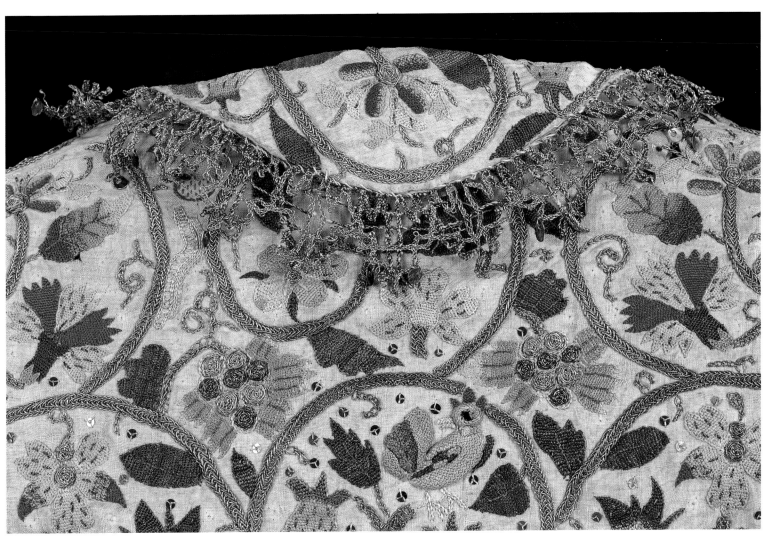
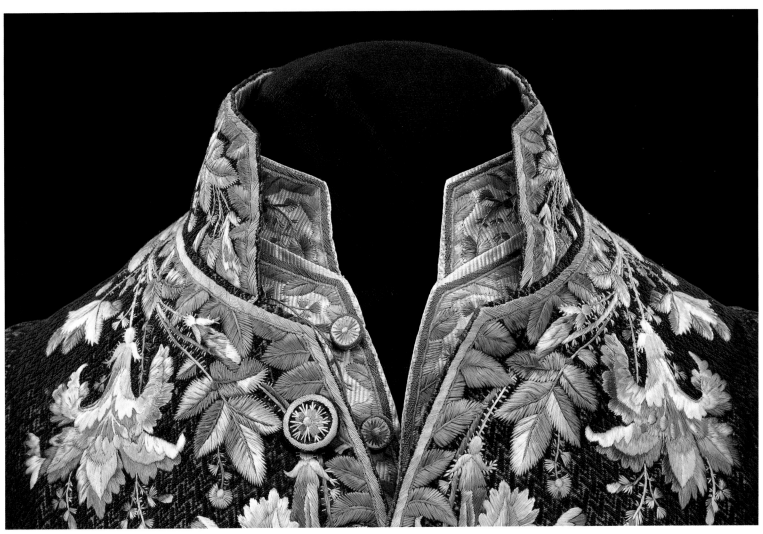

THE POINT IN the centre back of the collar on this salmon-pink ribbed silk coat is a feature of men's dress in the late 1770s and early 1780s. Other aspects of the cut confirm this date: the narrow side pleats, the long tight sleeves with simple round cuffs and the coat's curving front edges. The pale colour and very simple decoration indicate a move away from the richer palette and more ornate embroidery seen earlier in the century.

The braid trim consists of an ivory and yellow striped gros-grain ribbon with additional threads of silver strip and thread. Silver spangles and purl embellish the fourteen buttons of woven silk and silver strip.

Men's coats were collarless in the late 17th and early 18th centuries. In the 1730s, the collar reappears on the informal English frock coat. It continued to increase in depth and by the late 1770s appeared on formal wear as well.

For more details about this coat, see p.118.

A man's coat of salmon-pink silk
with silk and silver ribbon trim.
English, 1775-1780
Given by Mrs Phoebe Timpson
T.363-1995

AN ECCENTRICALLY COLOURED faux 'leopard spot' is the strongest feature of this otherwise unadorned man's coat. The imitation markings, made with black and white silk, are woven as part of the pile of a turquoise velvet. Such whimsical patterns were a feature of men's fashions in the late 1770s and early 1780s; a portrait of John Campbell, Baron of Cawdor, painted by Sir Joshua Reynolds in 1778 shows a similar 'leopard-spot' velvet waistcoat in a more natural colouring. The same effect could also be achieved with a chiné silk; such a fabric appears in one of Marie Antoinette's dress books dated 1782.[1]

This coat exemplifies the elongated style of fashionable men's coats in the 1780s. The fronts curve back sharply, the side seams have moved closer to the centre back and the pleats are narrow. In addition to the deep, pointed collar, there are small revers at the front – a new development in cut that dominated men's coats for several decades. The long narrow sleeves with round cuffs accentuate the slender line.

1. Aileen Ribeiro, *Fashion in the French Revolution* (Batsford 1988), p.30.

A man's coat of turquoise, black and
white 'leopard-spot' silk velvet.
French, 1785-1790
T.17-1950

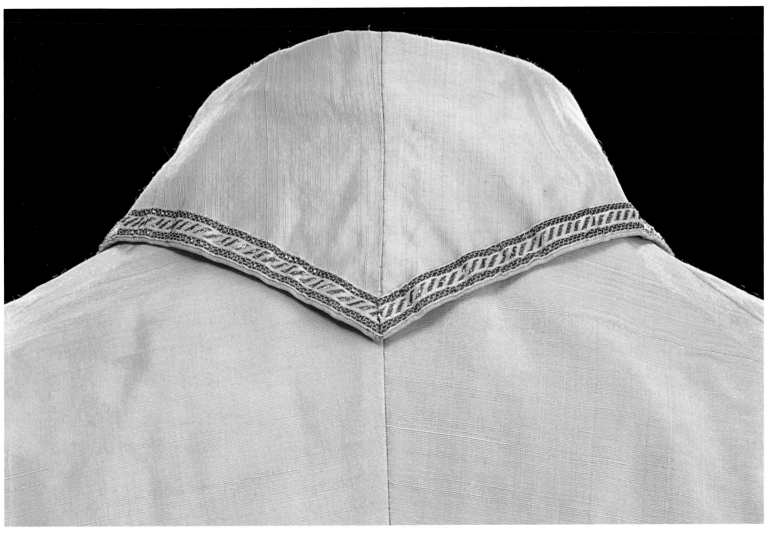

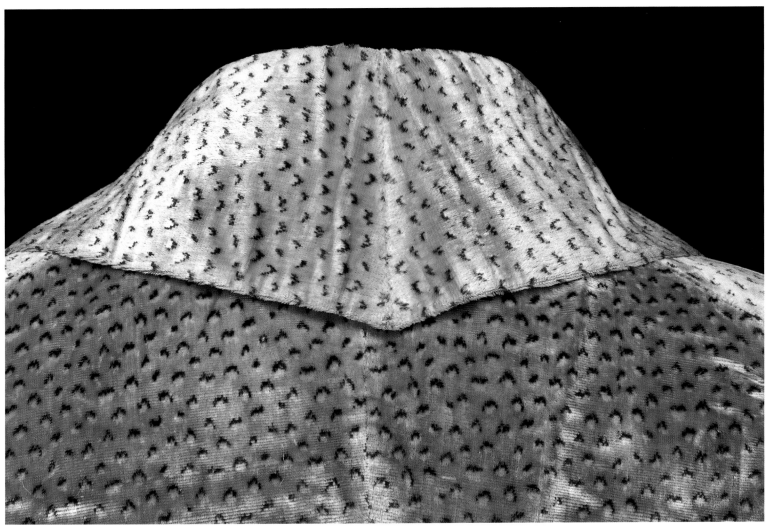

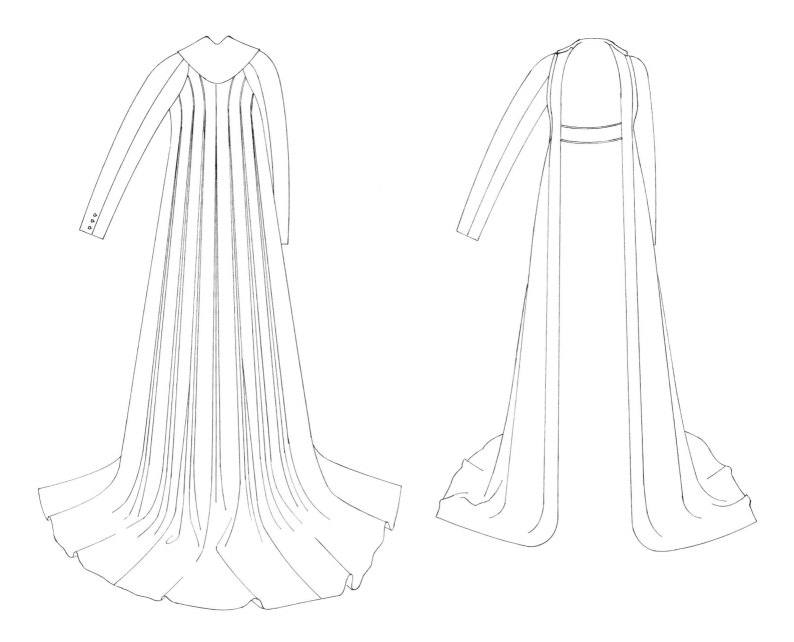

A DEEP, ROUNDED collar finishes the neckline of this stylish open gown in painted Indian cotton. Its high-waisted bodice is shaped front and back with box pleats arranged in groups of three and falling loose at the back into a train. The variations in depth of the pleats indicate that they were the principal method of fitting the gown to its wearer. The long, curved, two-piece sleeves fasten at the wrists with three Dorset thread buttons. The gown is open at the front, with only a narrow belt to close it, and was meant to be worn with a petticoat. The bodice is lined with linen and has two overlapping lining fronts. A scattering of pin holes along their centre edges reveals how they were fastened. Above the belt, a large kerchief would have been worn.

The slight irregularities between the repeats of this pattern show that it has been painted, rather than printed. The actual process involved applying each colour by brush or resist dyeing in stages. India was the primary source for painted cottons throughout the 18th century. By the 1790s, Indian designers and painters had long been using European pattern books and swatches of European fabrics as templates for design, thus the Indian painted cottons of this date reveal the same configurations of serpentine stems bearing flowers and leaves that are found in English woven silks of the 1750s and printed cottons of the 1780s.

A woman's gown of Indian painted cotton.
English, 1795-1800
Given by Margaret Simeon
T.121-1992

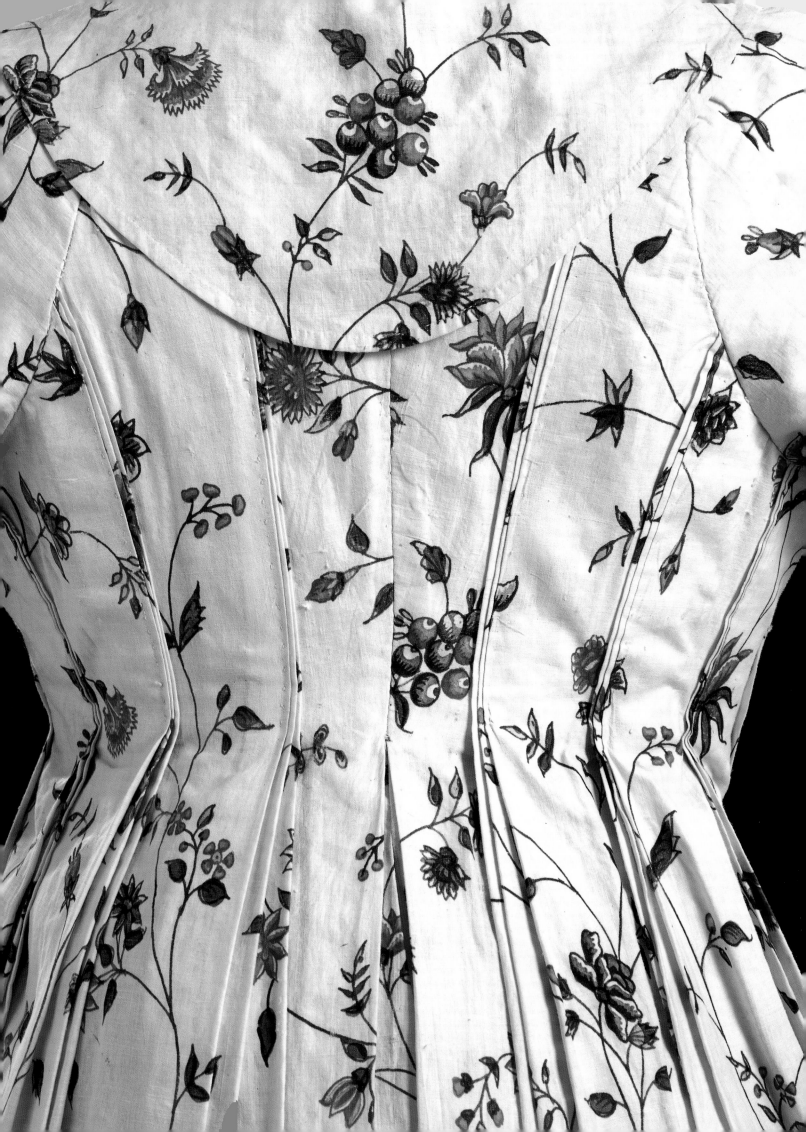

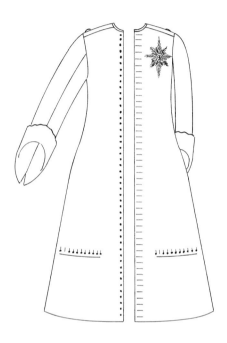

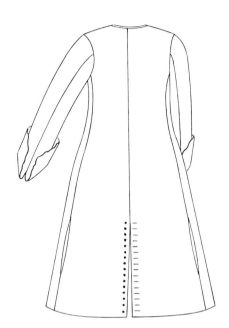

FLOPPY 'HOUNDS-EAR' CUFFS finish the tightly fitted sleeves of this coat of fine wool, richly embroidered in silver and silver-gilt threads, of 1673. The floral and foliate pattern has couched outlines enclosing padded and raised central elements achieved by wrapping silver thread around parchment strips.

This coat forms part of a suit which includes a matching pair of breeches, worn by James, Duke of York, for his wedding to Mary of Modena in 1673. It is a transitional style which evolved in the 1670s when men left off the doublet and petticoat breeches in favour of the new and more comfortable three-piece ensemble of coat, waistcoat and knee breeches.

The sleeves are three-quarter length with narrow turned-back open cuffs; these were nicknamed 'hounds-ear' after the floppy-shaped ears of hunting dogs. The detail shows the inside of the cuff from the back revealing embroidered decoration which continues from the sleeve. The cuffs are faced with a fiery reddish-orange ribbed silk, enriched with silver bobbin lace and embroidered silver-gilt coils. As was customary this silk facing matches the lining of the coat.

Though the waistcoat no longer exists, it may well have been of a rich silk (possibly red) figured in silver to echo the coat's decorative mood and colour. Waistcoats at this time had long fitted sleeves buttoned at the wrists and with cuffs which extended beyond the coat which was worn open to reveal the waistcoat.

The emphasis on a fine waistcoat led to an interesting development in the design of early 18th-century coat cuffs when it became fashionable for the cuffs of a dress coat to match the waistcoat. Avoiding the need, as well as the considerable expense, to buy a coat to match each waistcoat, a gentleman could have detachable cuffs made of waistcoat material. These cuffs were then simply attached to a dress coat by hooks and eyes.

For more details about this coat, see p.96.

A man's wool coat embroidered in
silver and silver-gilt thread,
worn by James, Duke of York, at his wedding in 1673.
English, 1673
T.711.1-1995

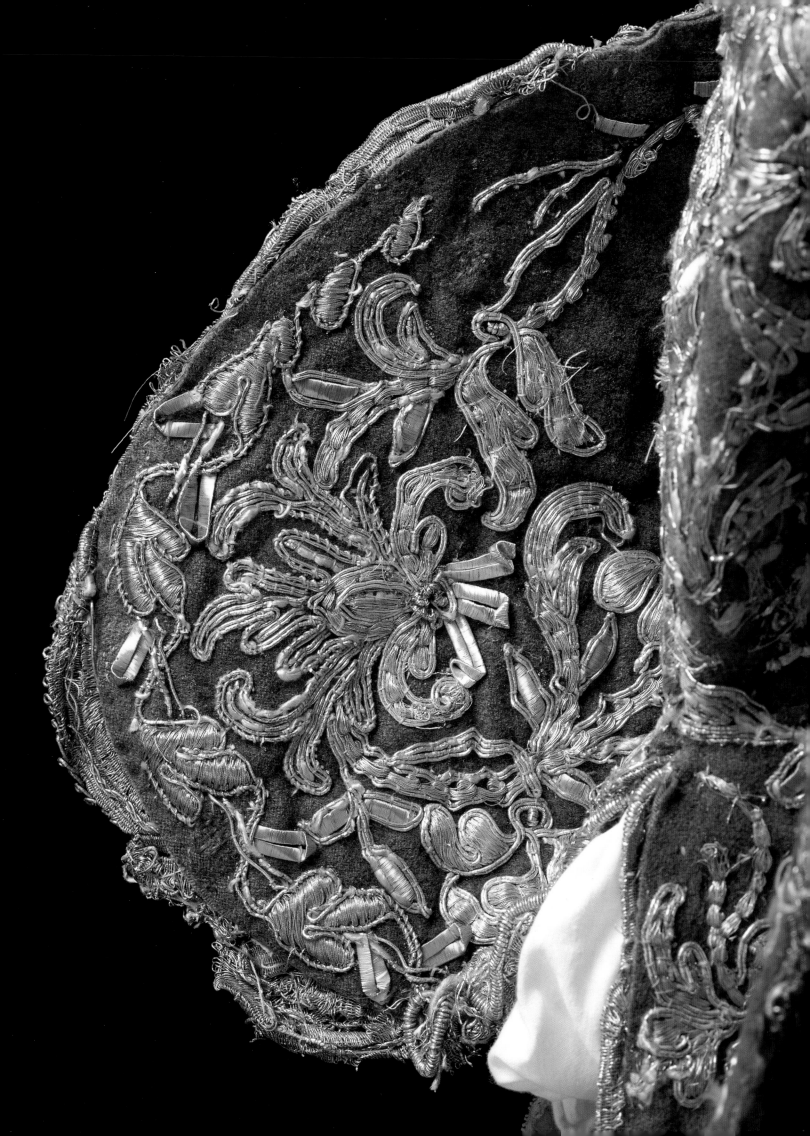

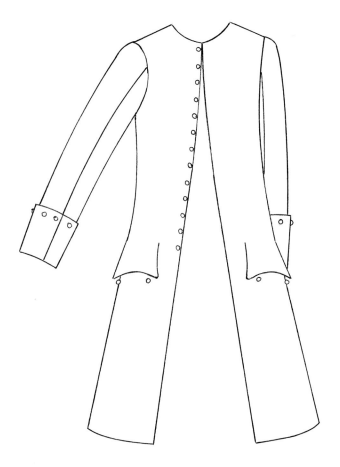

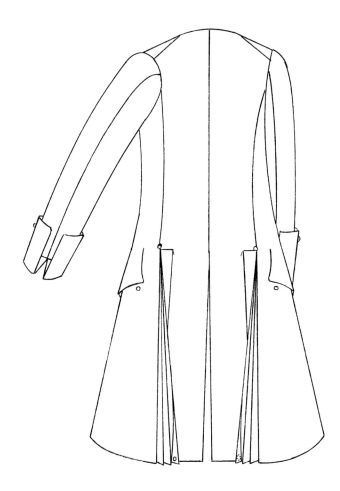

This DRESS COAT is extravagantly embroidered in silver-gilt thread, purl and sequins. It forms part of a suit with matching waistcoat and is probably French, made for an Italian customer, about 1760s. The embroidery extends down each front and around the pockets and the open cuffs.

The detail shows the cuff from the back revealing a richly embroidered white satin lining.

This suit would have been worn at Court and for other grand occasions. It originally formed part of a private Italian collection. For more details about this coat see p.100.

A man's dress coat of sprigged
silk velvet embroidered in silver-gilt thread.
Probably French /Italian, 1760s
Given by Mr W. R. Crawshay
T.28-1952

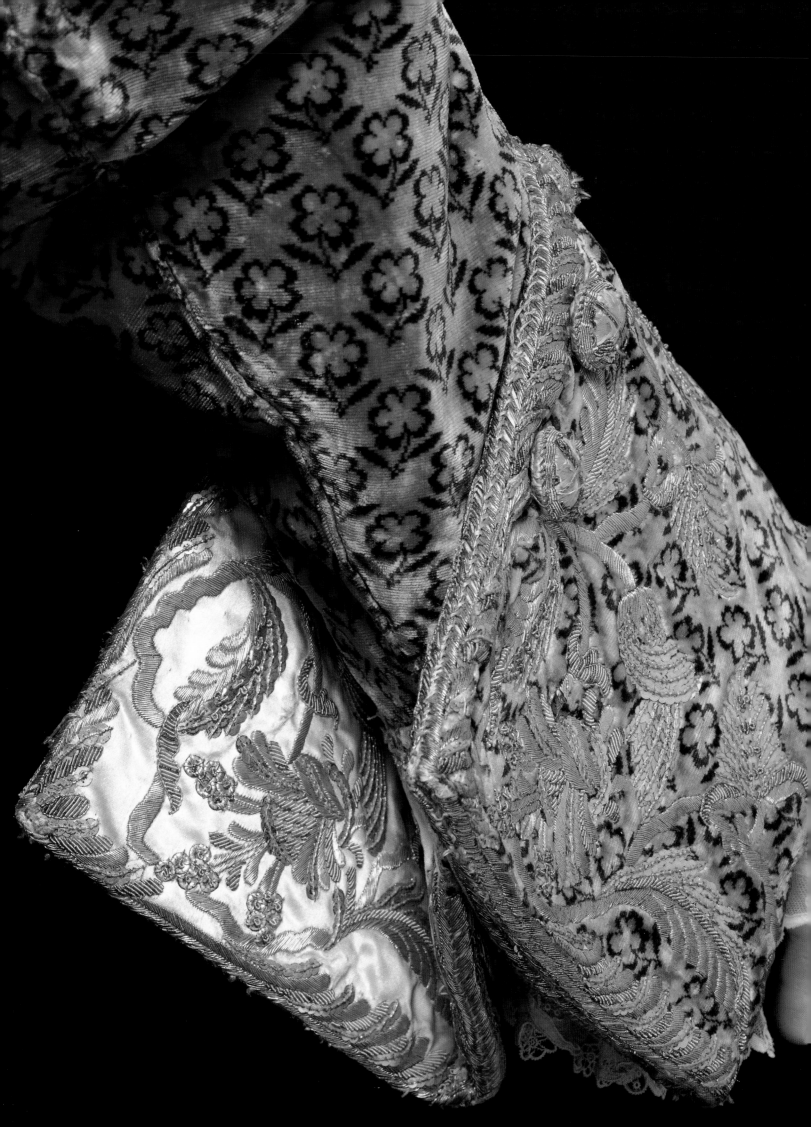

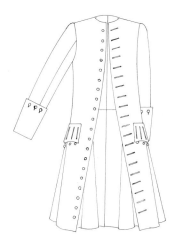
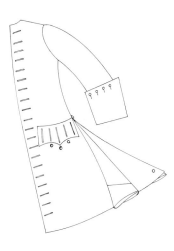

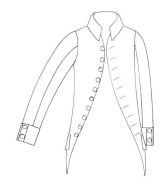

LARGE CUFFS DECORATED with silver-gilt buttons complete the sleeves of this dress coat. It forms part of a three-piece suit of the 1750s to 1760s with matching waistcoat and breeches made of superfine wool with a felted finish.

The detail shows part of the cuff and its complement of buttons. The drawing opposite illustrates the cuff showing its slightly angular shape. In the first half of the 18th century coat cuffs were quite large extending to the elbow. The buttons and buttonholes were purely decorative. Cuffs were prevented from flopping out of shape by being stitched to the sleeve.

For more details about this coat, see p.46.

A man's dress coat of felted wool with silver-gilt buttons.
English, 1750-1760s
T.329-1985

IRIDESCENT COLOURS OF blue and green shot ribbed silk give a sense of luxury to this otherwise plain frock coat of the late 1780s, cut in the style of a riding coat with curved open fronts. The tightly fitting sleeves have a false slit with two button cuffs, shown in the detail. This cuff has a slit with an attached flap, lined with a twilled green silk, but the buttons have been stitched through to the sleeve and there are no buttonholes. Slit cuffs are not functional by this date, deriving from an earlier style of a close-fitting coat sleeve made without cuffs known as the Mariner's cuff. For further information, see p.88. In the late 18th century stylised versions of this cuff appeared on men's fashionable coats. The slit cuff with buttons has been retained on men's lounge jackets to this day, but most of these are decorative; sometimes the cuff has buttons and a slit, but no button holes. Only bespoke tailors provide functional buttons and buttonholes.

English, late 1780s
Given by Mrs N.J. Batten
Circ. 455-1962

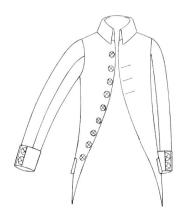

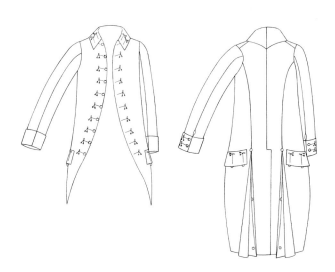

A STRIKING COMBINATION OF colours for this striped frock coat of the late 1780s enlivens its essentially plain style. Similar in cut to a riding coat, with curved fronts and tightly fitted sleeves, it has a slit with two button cuffs similar to the one decribed above. The detail shows a round cuff with a two-button flap with button holes, which although functional are not likely to be used as the buttons are large and fragile. This type of cuff is a stylised version of the earlier Mariner's cuff, popular in men's fashionable dress at the end of the 18th century. The buttons are worked in matching silks to the coat, probably over a wooden core. The design is quartered; each quartering is created by a form of needle-weaving where silk threads are laid side by side, and passed over and under each other.

A man's frock coat of striped silk.
English, late 1780s
Given by Mrs N. J. Batten
T.92-1962

A SMART RED wool frock coat of the 1780s is embroidered with tassels in silver-gilt thread on the points of the collar and cuffs down each front. It is cut in the style of a riding coat with curved fronts and full back pleats and a back-vent overlap. The sleeves are tightly fitted with open cuffs and two functional buttons and buttonholes.

The buttons are worked in silver-gilt thread over a wooden core.

A man's frock coat of wool embroidered in silver-gilt thread.
English, 1780s
Given by Lt Col. H. D. Hunter
T.74-1962

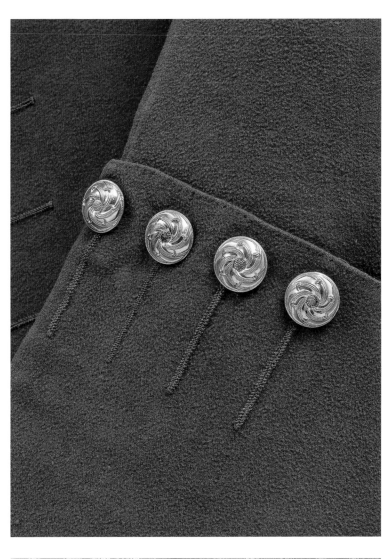
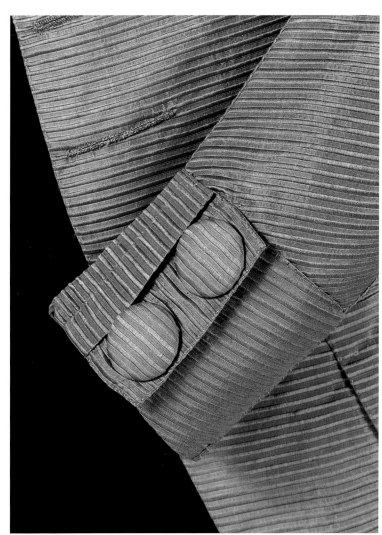
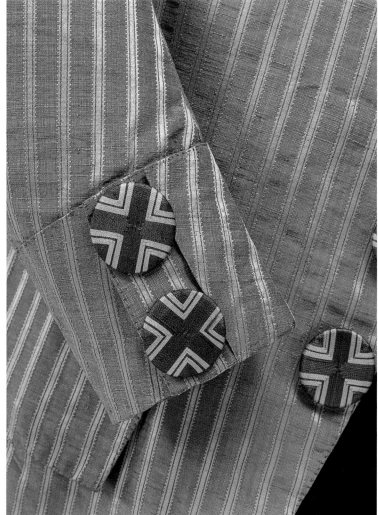
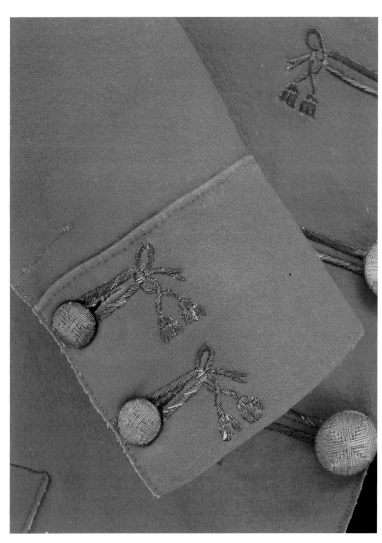

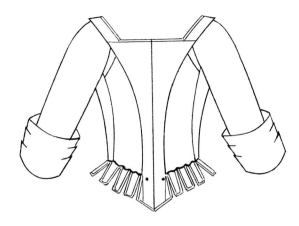

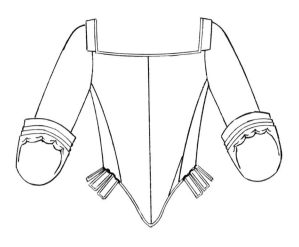

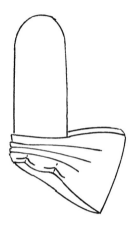

A GLISTENING YELLOW silk taffeta enhances this undecorated bodice of the 1740s. It is constructed from eight panels of silk with a boned centre back opening with a fly which conceals the lacing. The waistline is tabbed and has a decorative cord stitched along the line of the tabs, which can be seen in the drawing. The sleeves are elbow length with winged cuffs which have been pleated and stitched at the front to keep their shape. Winged cuffs were fashionable in the 1740s and were sometimes stiffened with card or paste board, though these cuffs are not stiffened. This type of bodice was worn as informal dress and was also habitual dress for children and young girls.

A woman's bodice of silk taffeta.
English, 1740s
Given by The Reverend R. Brooke
870-1864

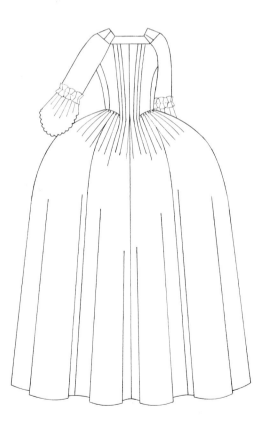

AN ATTRACTIVE COMBINATION of colours, a rose-red ground with trails of white flowers woven in *gros de tours* with flush effect, decorates this good-quality silk of the 1740s. A garment made of a luxury silk could survive remodelling through several generations of fashionable changes. This particular gown,

with a pleated English back, was last altered in the 1760s. The detail shows a single ruffle on the elbow-length sleeve which has a scalloped edge and is headed by a pleated and pinked frill. On occasions unfashionable dresses were passed to poorer relatives, friends or servants. Churches also benefited, and many altar frontals and ecclesiastical vestments survive today which were once grand 18th-century dresses.

Recording life at Court in England in the 1780s and 1790s, when in her twenties with a young family but in attendance at Court, Mrs Papendiek notes she was constantly altering one particular puce gown between 1784 and 1791, by which time it was 'at its last gasp'. She defends the practice of re-using one dress over and over again: 'a silk gown would go on for years, a little furbished up with new trimmings – and a young woman was rather complimented than otherwise'.[1] Silks were expensive, although some woollen fabrics were even more costly. Ladies were economical and careful with their dress materials and clothes. In the 1740s *gros de tours* was a luxury silk, and was frequently ordered by the Master of the Robes at a cost of twelve and seventeen shillings a yard. A cheaper silk was half the price at five or six shillings a yard. [2]

1. *Court and Private Life in the Time of Queen Charlotte: Being the Journals of Mrs Papendiek, Assistant Keeper of the Wardrobe and Reader to Her Majesty*, Mrs Vernon D. Broughton, ed.(London 1887), Vols 1 & 2.

2. The Master of the Robes was responsible for the maintenance and supply of luxury fabrics and furs for robes required on ceremonial occasions.

A woman's gown of woven silk.
English, 1760s
Given by Mrs H.H. Fraser
T.433-1967

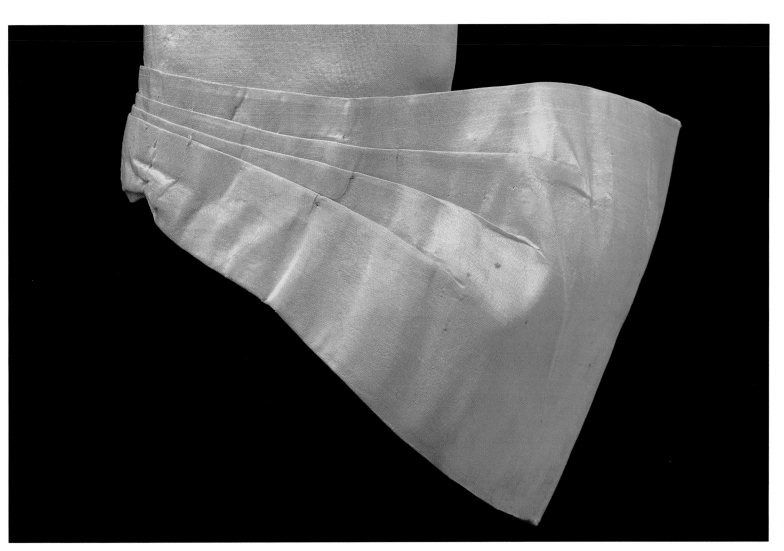

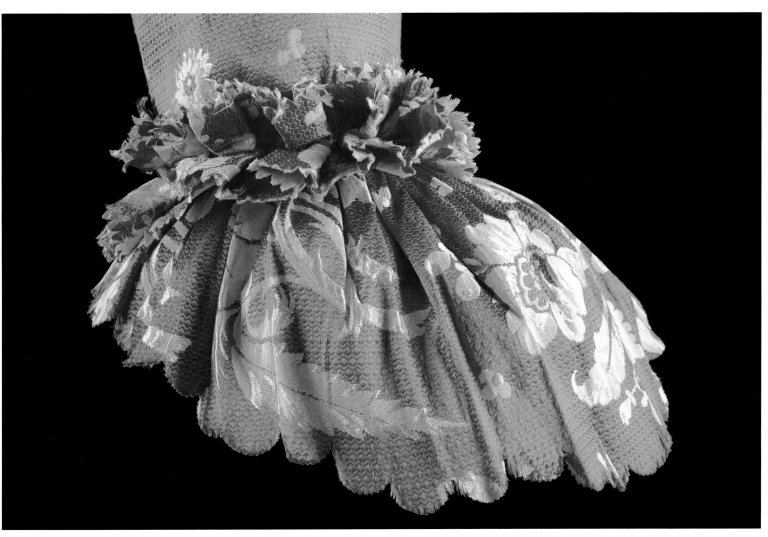

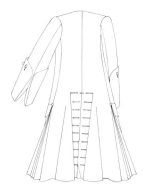
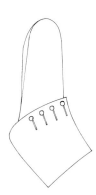

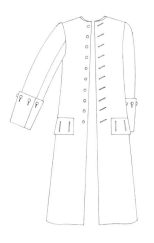
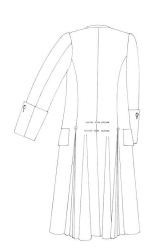

A DEEP, GENTLY rounded cuff is the stylistic focus of this unadorned silk coat of the 1730s. Measuring 9¾ inches (24.7cm) on the inside curve and 12⅜ inches (31.5cm) on the outside curve, this open cuff, or open sleeve, as it was called, would have extended well past the elbow. The coat is to the knee, with buttons and buttonholes running from neck to hem and full, heavy pleats at each side. All of these features are characteristic of men's coats of the 1730s. Many were made of richly coloured velvets and wools, and lavishly decorated with lace. This example in fawn-coloured ribbed silk demonstrates a popular alternative with little or no ornament, in soft shades of mauve, beige and grey. In the early 18th century, these subtle hues were described by such expressive terms as 'snuff', 'tobacco' and 'mouse'.

A man's coat of fawn ribbed silk, lined with matching silk.
English, 1730s
658-1898

SILK TISSUE IN a vibrant pattern of blue and yellow flowers with meandering white bands over a red ground is left to speak for itself in this mid-18th-century coat. The flamboyant open sleeve of the 1730s has retreated to a simple round cuff, and the buttons and buttonholes extend only from neck to waist level. Shallower, flatter side pleats signal a narrowing of the silhouette. The merest suggestion of a collar, barely more than a binding, surrounds the neck, indicating the influence that the informal frock coat was beginning to exert on formal dress.

A man's coat of silk tissue with blue and yellow flowers over red and white ground, lined with silk and fustian.
English or French silk, 1760s
T.114-1953

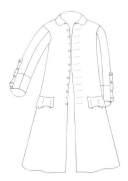
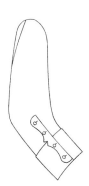

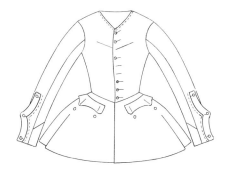

THE THICK WOOL fabric lends a sculptural quality to the Mariner's cuff on this strictly utilitarian garment. A vertical opening with a scalloped flap runs parallel to the length of the sleeve, intersecting the cuff. Such a cut of sleeve became popular for men's coats in the 1750s, a style first seen on those worn a decade earlier by military and naval officers (although naval and army uniforms were not made official until 1748 and 1751, respectively). The lack of any decoration but for a brown velvet collar reinforces the coat's informality. Its dark, grey-brown shade suggests that it may be the fabric known in the 18th century as 'drab'. A label sewn to the inside collar indicates that this coat once belonged to the 19th-century theatrical costumiers, L.& H.Nathan, where it would have experienced a second, and no doubt more arduous, life.

A man's coat of drab wool with a velvet collar.
English, 1750s
467-1907

MEN IN CIVILIAN life were not alone in their fondness for the stylish Mariner's cuff. It captivated 18th-century women, who borrowed its shape for their riding habits. The most practical garment in a woman's wardrobe, the riding habit was worn for riding, walking, travelling and any other outdoor activities requiring warm, hard-wearing clothing. A skirt and coat in matching wool fabric, sometimes with a corresponding or contrasting waistcoat, constituted the riding habit, which drew inspiration from menswear for its styling. Collars, cuffs, pocket-flaps and side pleats were all part of a woman's riding coat, although the cut of the garment inevitably made a number of concessions to the female figure.

A woman's riding coat of brown worsted, lined with yellow silk.
English, 1740-1760
T.197-1984

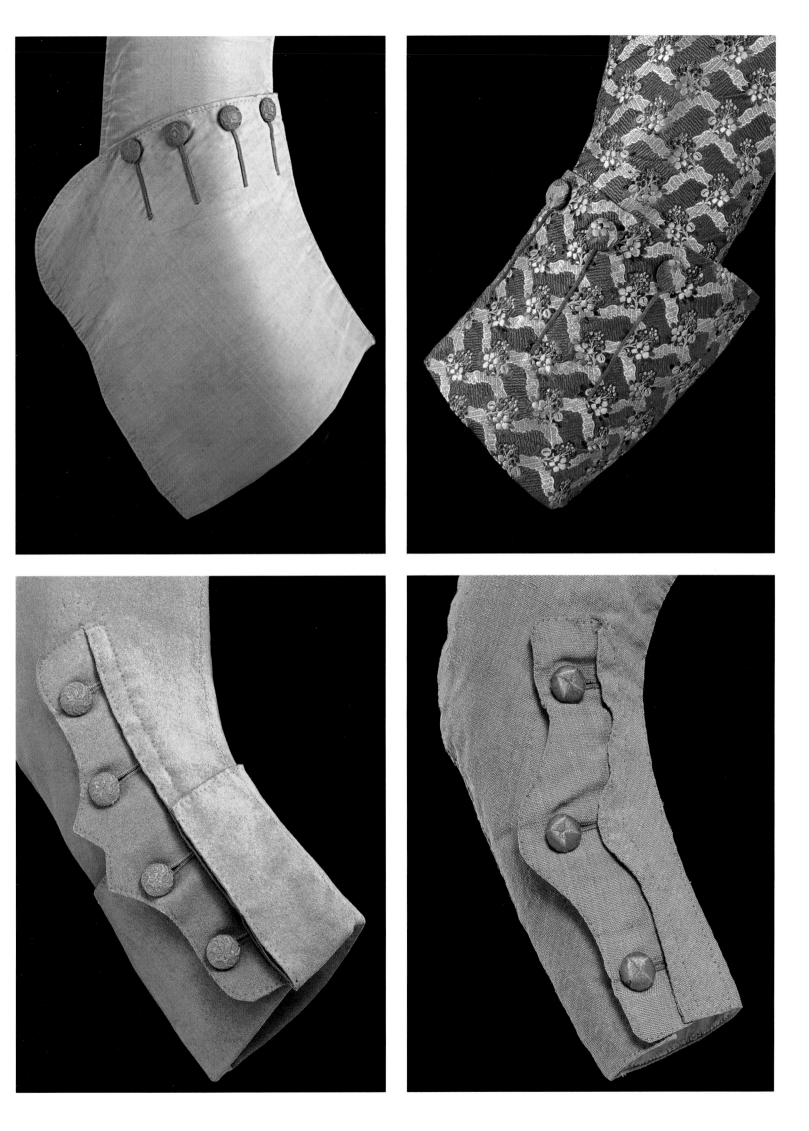

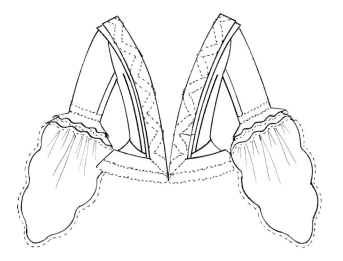

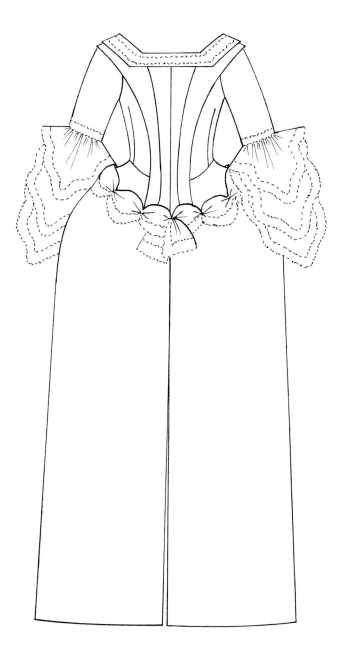

THE CLASSIC ROCOCO triple-sleeve ruffle is found on this mantua from the 1750s. Not only was it the height of fashion in informal attire by this time, but had also been introduced into Court dress. The mantua is made of a Spitalfields brocaded silk lustring of 1745 to 1746, and trimmed with coloured silk bobbin lace. Once a fresh green, warm salmon-pink and ivory, the lace has faded somewhat from exposure to light.

Ten years later, the style of the mantua had changed from its 1740s form. In this example the train is no longer tucked up at the back. The side panels still fold around to the back and they remain reversed so that the right side of the fabric shows, but they are now stitched to the waist, rather than folded over a looped cord. Replacing the elegant drapery on the hip is a gathered band of robing, continuing from the front of the bodice around across the back at the waist. The front darts are 19th-century modifications for fancy dress.

The matching petticoat is made from eight panels of silk and shaped to fit the French style of hoop with a sloping, rather than square profile. Its extreme width was another requirement of Court dress.

A mantua of brocaded silk lustring.
English, 1750s
T.44-1910

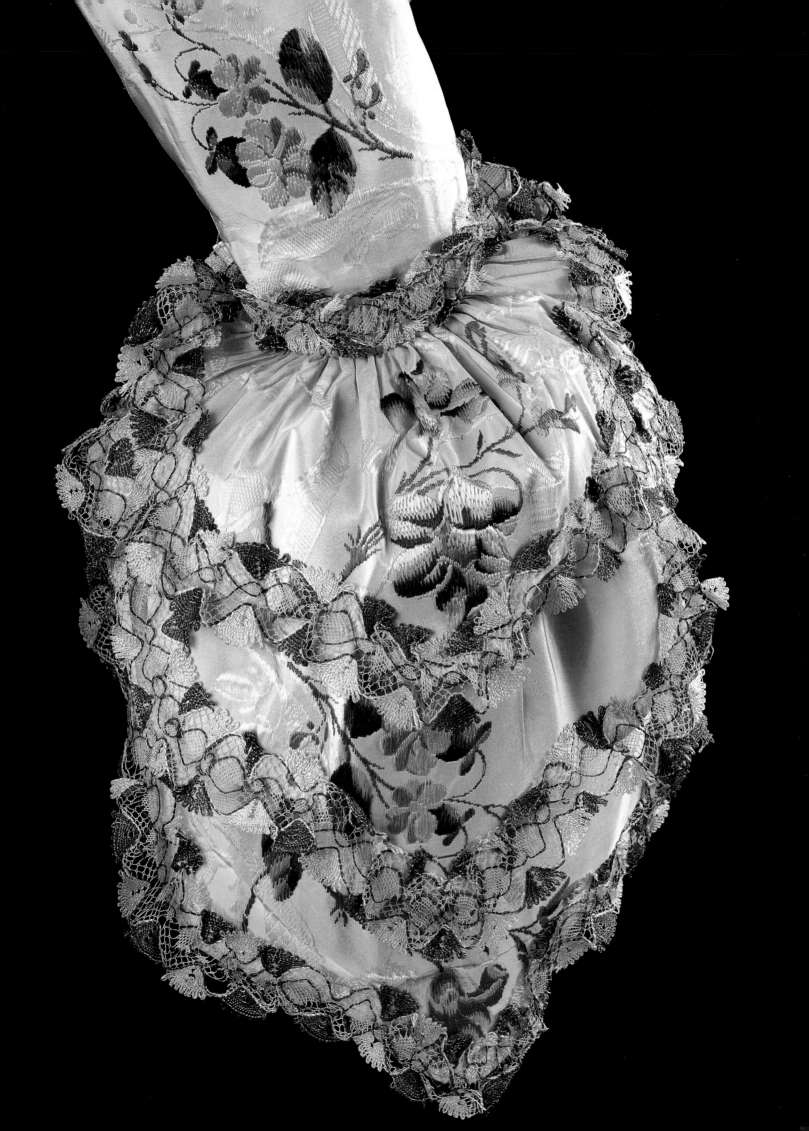

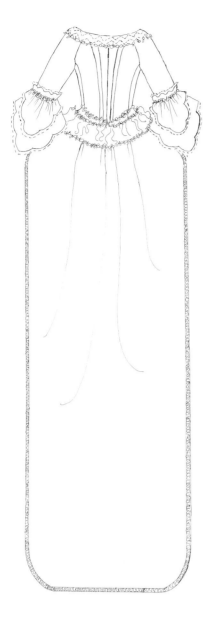

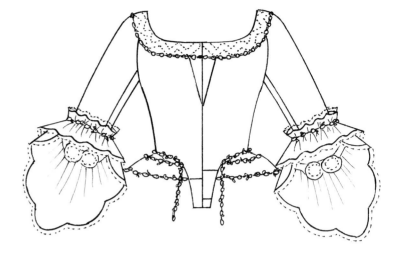

A TANGLED GARDEN of chenille embroidery and braid flourishes on the white satin ground of this late 18th-century mantua. Coloured silk twist and chenille thread, tamboured in a meandering pattern of flowers and leaves decorate the fabric, while a wired braid of chenille threads, wound into the shape of more flowers and leaves, trims the edges of the sleeve ruffles, neck and sides of the mantua train. A blonde and chenille bobbin lace edges the braid and outlines the neck.

This mantua demonstrates formal style about two decades later than the previous example. It has the characteristic wide band of fabric, trimmed and gathered across the back waist. The side panels have disappeared; the long train is an exten-

sion of the two panels of silk used for the bodice back. By the 1780s, the wide hoop had been modified to a round shape of more modest dimensions, similar to those worn with informal dress. Sleeve ruffles remain, but are reduced from three tiers to two.

The quality of the embroidery suggests that it is French. Its style mimics the woven silk patterns of the 1750s, designs which remained fashionable in needlework until the 1790s. The mantua was probably made in the late 1770s and then modified slightly in the bodice in the 1780s. Its petticoat of matching fabric suffered extensive alterations in the late 19th century for fancy dress.

A mantua of white satin embroidered
and trimmed with chenille.
English, of French embroidered silk, 1775-1785
Given by Major W.S. Gosling
T.13-1952

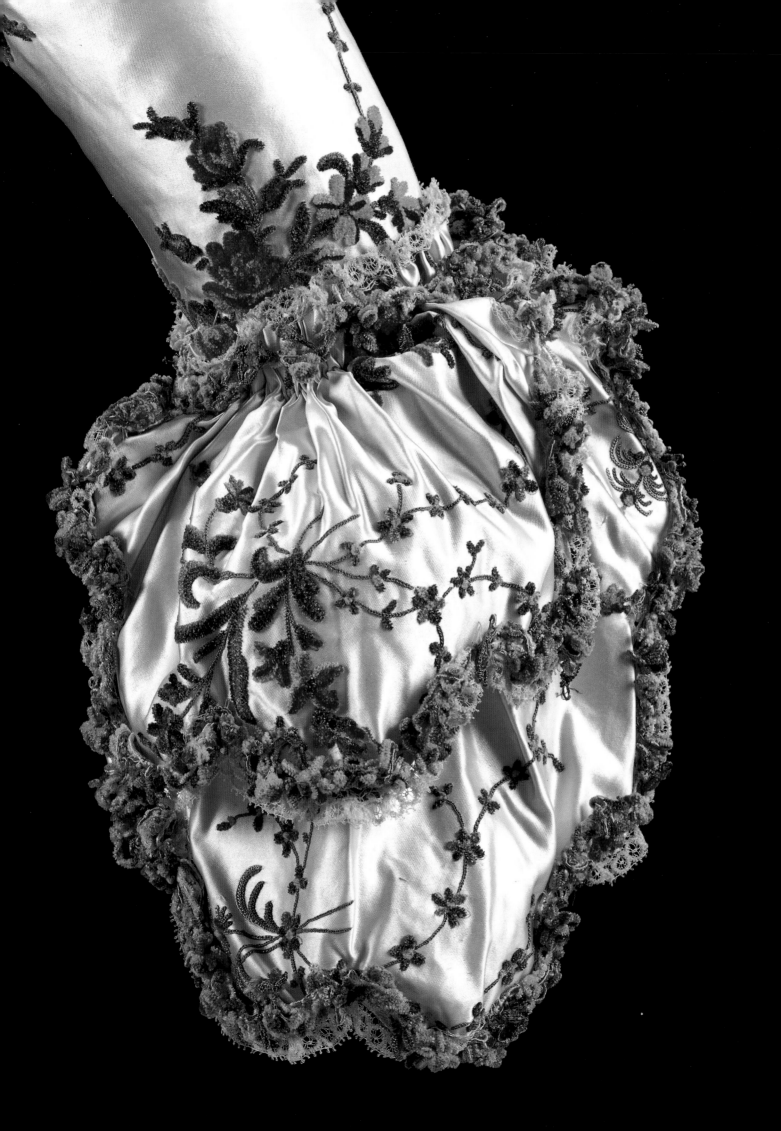

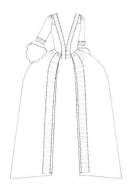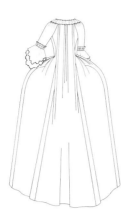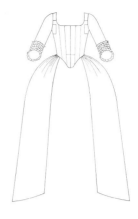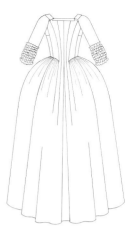

A BEAUTIFUL BLUE silk damask constitutes this modest sack-back of the 1760s. The fabric, with an allover pattern of large flowers and leaves, dates from about 1742 and is probably English. Silks pre-dating the construction of the dress are quite common. Once woven, bolts of silk might be available for sale for many years, and it was not unusual to store lengths of silk before making them up or giving them away as a gift. The high cost of woven silks meant that their value did not diminish even as fashions changed. Characteristic of the 1760s are the double sleeve ruffles and the arrangement of the pleated ruffle in a straight line down the opening of the gown's skirt, both indicating a waning of the rococo influence.

A sack-back gown of blue silk damask.
English, 1760s
Given by the Surrey County Federation
of Women's Institutes
T.122-1957

By THE 1770s, the sleeve ruffle had disappeared from informal gowns, replaced by a plain round, pleated, or shirred cuff, like the one shown here. This gown is made of lustring in a woven stripe that was popular during the decade. The distortion of the stripes in the gathering for the cuff creates an interesting visual effect. Informal gowns such as this have a fitted back shaped by several seams. The front of the gown meets in the centre, doing away with the need for a stomacher.

A close analysis reveals that this gown and its matching petticoat have been remade from another garment. All the seams of the original were unpicked and a new version in the latest fashion carefully pieced together using every scrap of fabric.

A polonaise gown of striped lustring.
English, 1770-1775
Given by Miss Maishman
T.92-1972

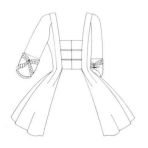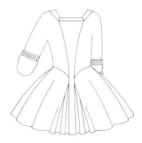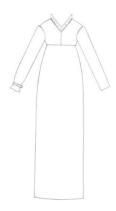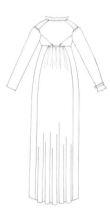

A PLAIN, ROUND cuff is embellished with a pleated trim, and gently shaped over the elbow by virtue of a loop and button, which gather it up on the inner side of the sleeve. Made of Indian painted cotton, this simple little jacket, or caraco, as it was called in the 18th century, belies the complexity of its construction. It looks at first like a short version of a sack-back gown, but there are a number of unusual aspects to its cut. A T-shaped piece has been cut from one piece of cotton, constituting the back and whole of the sleeves; these fold over the arm forming a raglan seam in front. At the back, shaping is achieved by tucks rather than the traditional pleats or seams.

A petticoat, in matching painted cotton, completes the ensemble.

A caraco of Indian painted cotton.
English, 1770s
Given by the family of the late Sir Luke Fildes, KC
T.229-1927

LONG SLEEVES IN women's dress became fashionable in the 1780s, and with them, new ways of fastening and decoration at the wrist. In this very simple cotton gown from the late 1790s, the sleeve is closed with a narrow band of fabric, edged with piping, which fastens with hook and eye.

While the pattern of the fabric is similar to that of the jacket on the left, the crispness and precision of the English printed cotton seen here contrasts with the loose, flowing execution of the Indian painted fabric. Block-printing on cotton began in England in the 1750s, imitating the designs of imported Indian fabrics. The pattern of floral trails seen here exhibits a blend of influences from Indian-painted and printed textiles, and rococo woven silks, a style which remained popular until the end of the century.

A woman's gown of printed cotton.
English, 1795-1799
T.355-1980

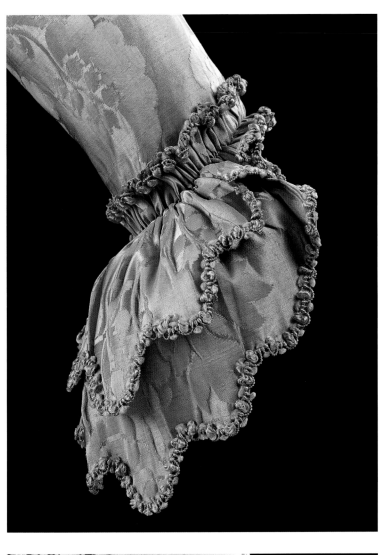
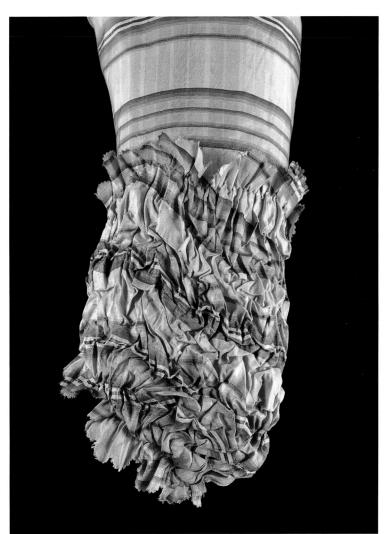
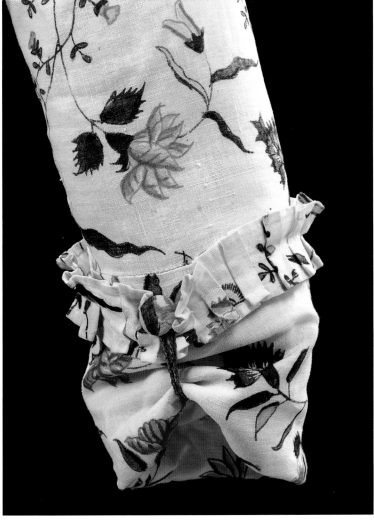
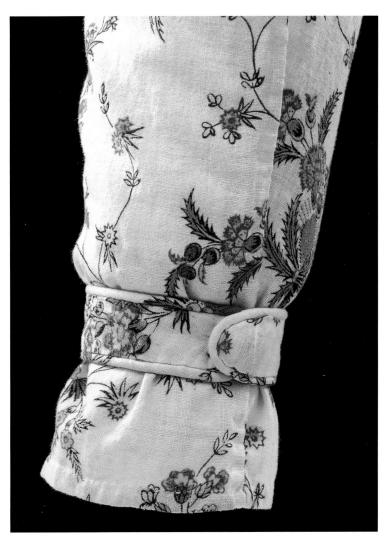

TEN SMALL ROUNDED buttons, worked in silver-gilt thread, ornament each of the pockets of this white silk coat brocaded with silver-gilt thread.

The detail illustrates the pocket on the right front. Pockets such as these were intended to remain open, and were therefore furnished with purely decorative buttonholes and buttons. Other styles had functional button fastenings to prevent the pockets from gaping open. The shape and position of pockets were experimented with in the late 17th century as tailors continued to develop the new fashion of a closely fitted knee-length coat and waistcoat. There were two styles of pocket, a vertical one with an open slit, placed either singly or in pairs on each skirt front just below the waistline, or horizontal ones, which sometimes had narrow flaps and were placed just above the hem. Vertical pockets were eventually superseded by the horizontal style: 'Yet he would have it in the ancient mode, with little buttons, round cuffs, narrow skirts, and pockets within two inches of the bottom.'[1]

The pockets on this coat have narrow flaps which are held down at each end by a button; all the buttons are worked in silver-gilt thread over a wooden core.

The coat forms part of the wedding suit of Sir Thomas Isham (1657-1681). He died aged twenty-four from small-pox, the day before his wedding, and the suit was never worn. It suffered some alterations for fancy dress before a later member of the family thought all the Isham family's historical clothes should be preserved for posterity.

1. Ned Ward, *The London Spy* (1689).

A man's coat of white ribbed silk with a
brocaded pattern of leaves and sprigs in silver-gilt thread.
English, 1680
175-1900

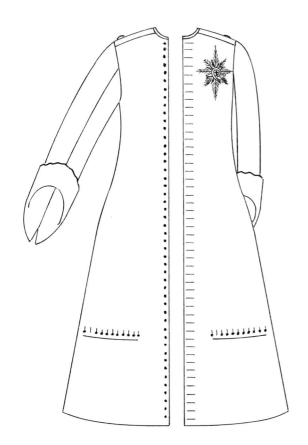

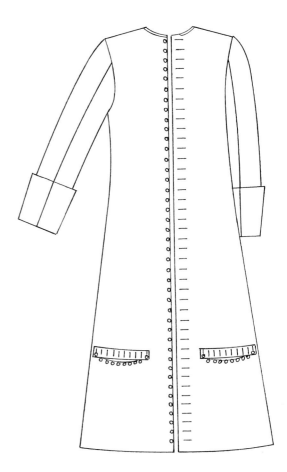

ELABORATE LITTLE BUTTONS worked in silver and silver-gilt thread peep through the buttonholes of this richly embroidered coat. The coat forms part of a suit worn by James, Duke of York, on the occasion of his wedding to Mary of Modena in 1673. The cut of the coat was straightforward consisting of two front panels and two back panels and constructed with a centre back seam and two side seams. The seams are open from the hem at the centre back and sides to allow ease of movement, and follow the practical tradition of riding dress, which requires the coat skirts to fall over the thighs when riding and offer some protection from the weather. The coat fits the body and flares out slightly over the hips and reaches the knee. The coat has buttons and buttonholes from neck to hem, none of which were ever used. It was the fashion for the coat to remain open to reveal a superb waistcoat.

The detail shows a pocket which has a narrow flap with functional buttons and buttonholes. The buttons are worked in silver-gilt thread over a wooden core. They do not show any signs of wear for the buttonholes are small and fit tightly around each button making them difficult to fasten. The inside of the flap is faced with a fiery reddish orange silk matching the lining of the coat. When he became James II, his wardrobe accounts revealed that all his suits required 19 dozen buttons (228) for a coat, waistcoat and breeches. For further details about this coat, see p.80.

A man's wool coat embroidered
in silver and silver-gilt thread.
English, 1673
T.711.1-1995

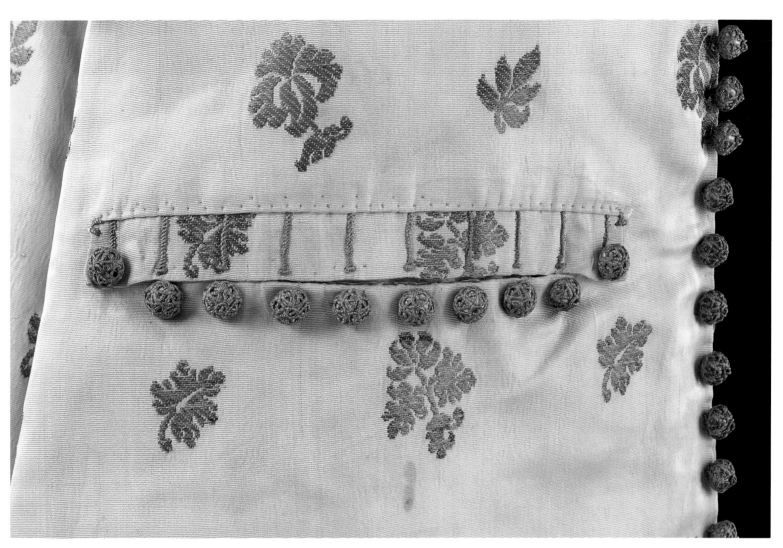

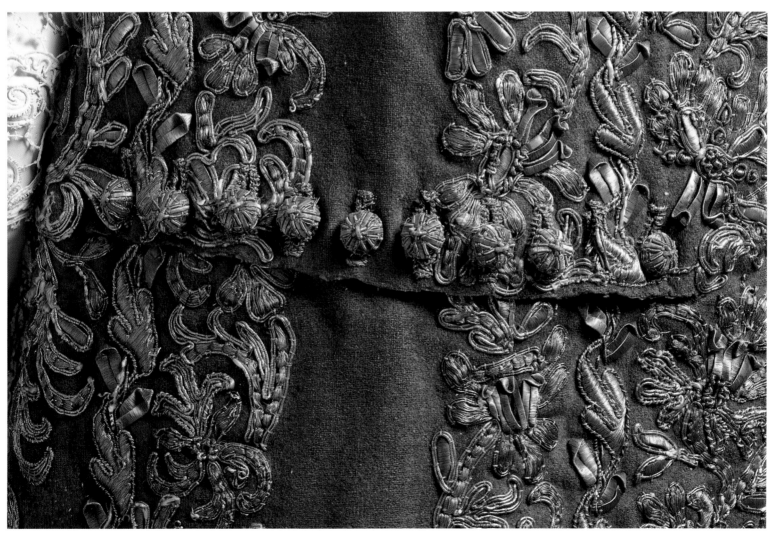

THE ELEGANTLY SHAPED pocket flaps of this coat are emphasised by a thin line of blue silk taffeta around the edges. Made of superfine red wool, this coat of 1760 to 1770 is part of a suit which includes a matching waistcoat. Like all 18th-century coats it is constructed from two front and two back panels and has full back pleats to the coat skirts. The sleeves are wrist-length finished with round cuffs.

The pocket illustrated in the detail has a deep three-pointed flap with two functioning buttons, and one purely decorative – the middle button and buttonhole. These eye-catching buttons are covered in red foil and embroidered with silver spangles and silver thread. The coat and pocket flaps are lined with light blue silk taffeta which has been eased around the edge of the coat front and pocket flap to appear like a fine line of piping.

Pockets with vestigial flaps first appear in the late 17th century (for further information, see p.96). By 1700 coat pockets were placed horizontally at or near waist-level and provided with triple-pointed flaps.

They were almost always furnished with buttons and buttonholes, some of which were simply applied as decoration. In addition, trimmings such as woven metal braids were often applied to emphasise the shape of the flap and the buttonholes.

A man's superfine wool coat with a blue silk taffeta lining.
Dutch, 1760-1770s
T.214:1-1992

GLISTENING SILVER-THREAD embroidery combined with silver foil and spangles decorate the pocket flap of this superb silk waistcoat of the 1740s. The embroidered decoration is applied down the front edges and all around the pockets and pocket flaps. The flared skirts of the waistcoat are stiffened with buckram or horsehair to retain their shape. The buttons down the front extend from neck to hem though the corresponding buttonholes only extend to the waist.

The detail shows a pocket flap which has a button stitched on each corner and four stitched below the flap; all of them are decorative, there are no buttonholes.

This waistcoat could have been part of a wedding outfit. The choice of silver and blue or white were popular colour combinations for wedding ensembles in the 18th century. Samuel Richardson, in his novel *Pamela*, describes the wedding clothes of Mr B.: 'And my dear Sir in a fine laced silk waistcoat of blue Paduasoy....'[1]

1. *Pamela* by Samuel Richardson, (1762; 8th edition), Vol.2, pp.374-5.

A man's waistcoat of blue ribbed silk
embroidered in silver thread, foil and spangles.
English, 1730s-1740s
Given by Mrs C.C. Stisted
T.29-1950

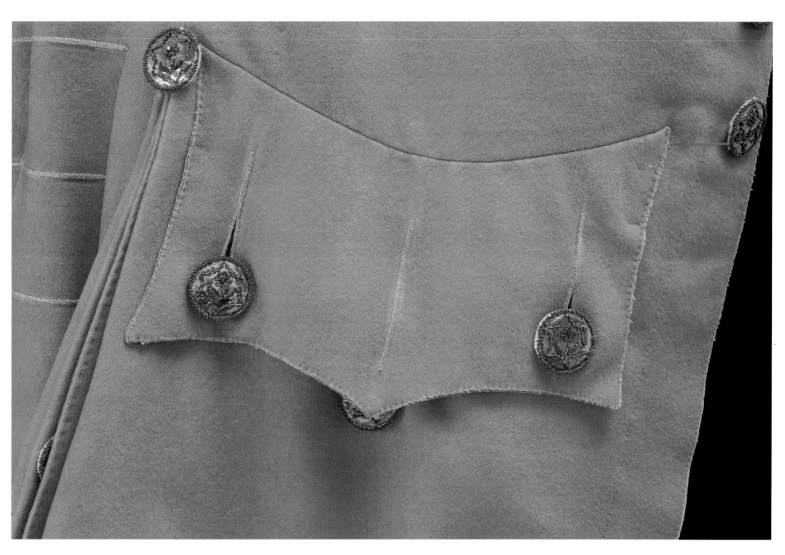
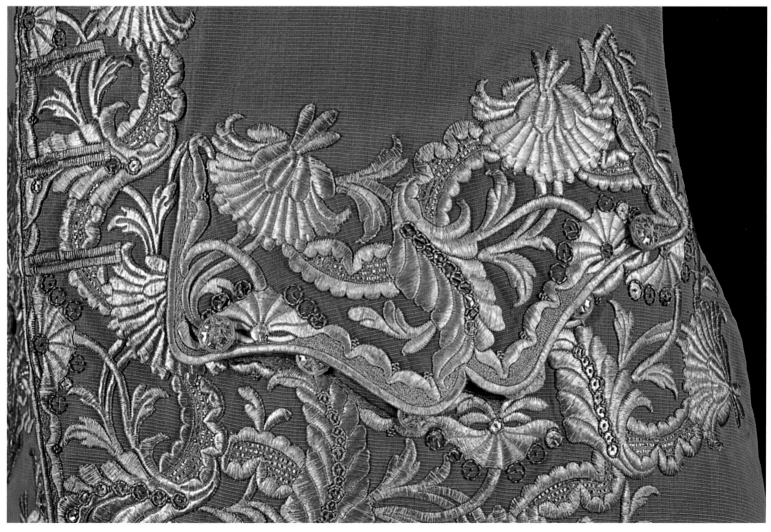

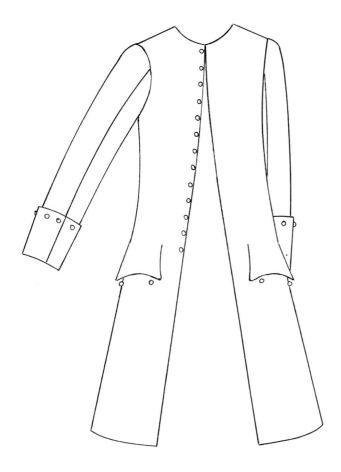
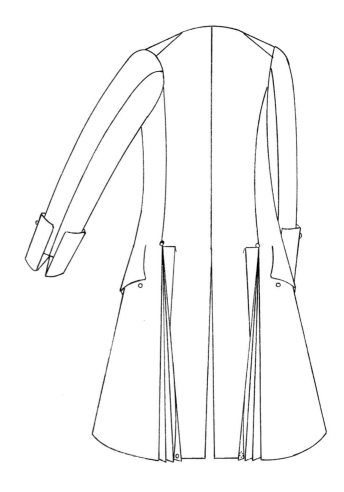

EMBROIDERY IN SILVER-GILT thread, purl and spangles completely covers this pocket flap. It flows over the seam to blend with the rich silver-gilt embroidery that encrusts this sprigged velvet dress coat of the 1760s. The effect of this totally embroidered surface is illustrated in the detail. The flap has three points which are complemented by a button stitched below each point on the coat skirt.

The shape of pocket flaps remained fairly constant throughout the 18th century. They were usually three-pointed on coats and waistcoats but the variations on this design were considerable. A coat flap might have buttonholes which were purely decorative, functional or none at all (both types are illustrated on p.98); the buttons could be placed below each point on the coat front or stitched under the flap and buttoned to the flap or placed on the flap itself. The points could be single or divided, as shown on p.98.

In the late eighteenth century, as men's styles became increasingly close-fitting, a pocket plus its contents ruined the line of a garment. Therefore pockets were frequently dispensed with in coats and for some waistcoats, but were still indicated by means of pocket flaps.

For further information about this coat, see p.82.

A man's coat of sprigged silk velvet, richly
embroidered in silver-gilt thread, purl and spangles.
French/Italian, 1760s
Given by Mr W.R. Crawshay
T.28-1952

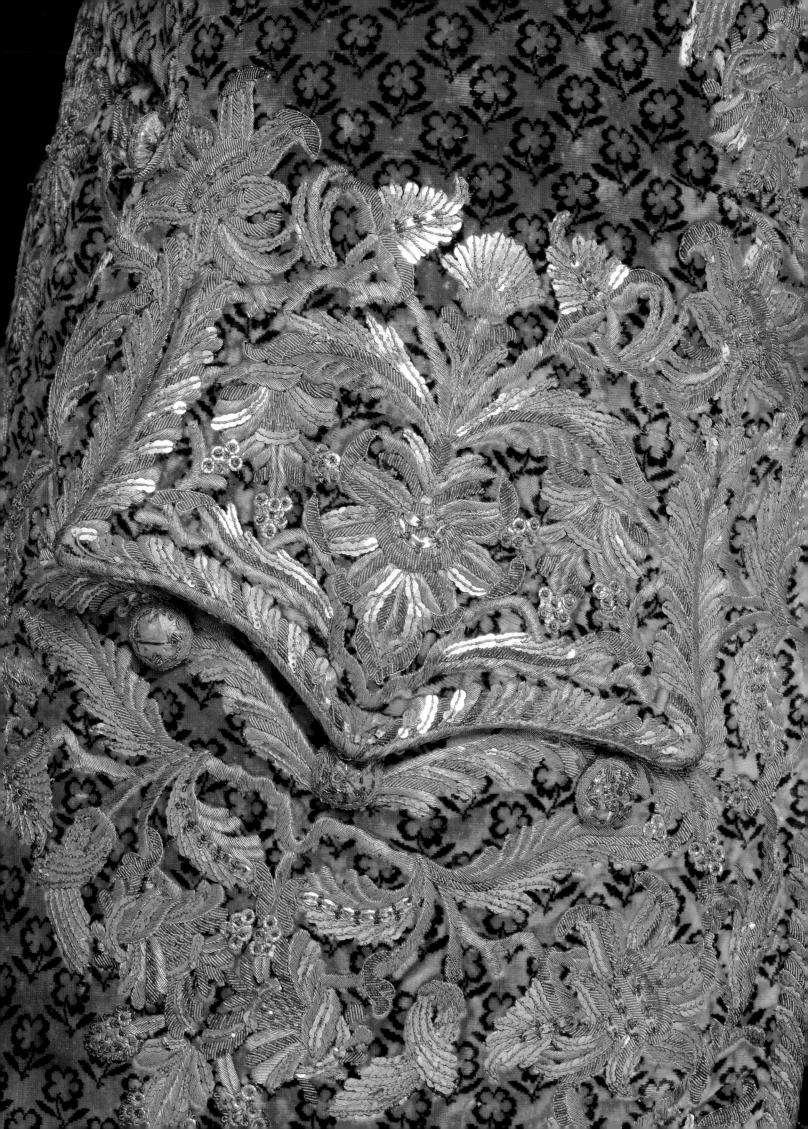

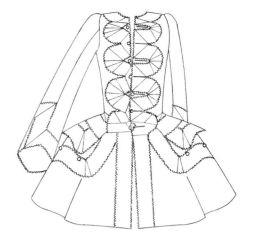

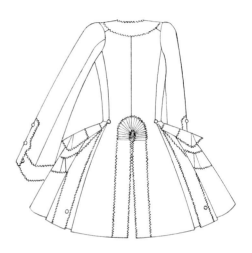

THE EXPERT HANDLING of wide, heavy silver braid transforms this woman's riding jacket of the mid-18th century. The sparkling trim has been adroitly manipulated to edge the pockets, pocket flaps and cuffs, and angled into wide scallops around the buttons and buttonholes down the front. Manoeuvring it around sharp corners has been accomplished by mitring, while the painstaking gathering of the braid's inner edge has eased it into the curve of the back neck and over the top of the back vent. The trim consists of three parts, a 1⅞ inch (4.8cm)-wide ribbon of silver thread woven in a geometrical pattern. Stitched on either side is a narrow (⅓ inch; 8mm) braid of silver gimp.

The narrow, pointed waist and flared coat skirts which accommodate a wide hoop help date the jacket to the 1750s, as do the rococo curves of the braid arrangement. The side-pleats, cuff and shaped pocket flaps are details borrowed from men's fashions and commonly found in the riding habit. Imitating the splendour of military braid while accentuating a woman's figure, this dashing garment on an 18th-century 'amazon' must have turned many heads.

For more details about this jacket, see p.116.

A woman's riding jacket of brown camlet
with silver braid, lined with brown silk.
English, 1750s
T.554-1993

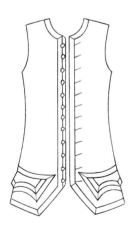

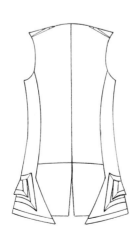

A MUCH MORE modest braid of silk, silver thread and silver-gilt strip, woven in a simple geometric pattern, adorns this waistcoat of plain blue satin. Again mitring and gathered edges enable the ¾ inch (2cm)-wide braid to be fitted around the corners on the inside and outside of the shaped pocket flap. Like many metal braids of this period, the silver has tarnished and only a faint glimmer of the gilt remains. The waistcoat is lined with fustian and blue ribbed silk, with a back made of glazed blue wool.

A man's waistcoat of blue satin
edged with silver and silver-gilt braid.
English, 1770s
Given by Messrs Harrods
T.1053-1913

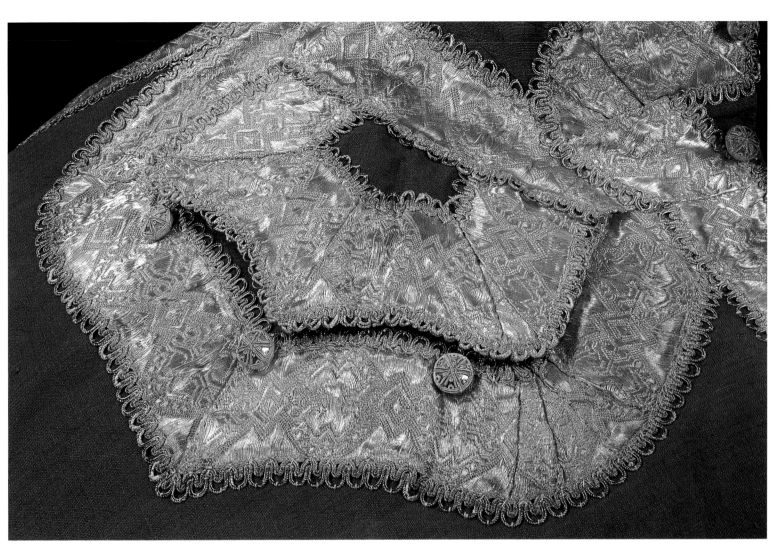

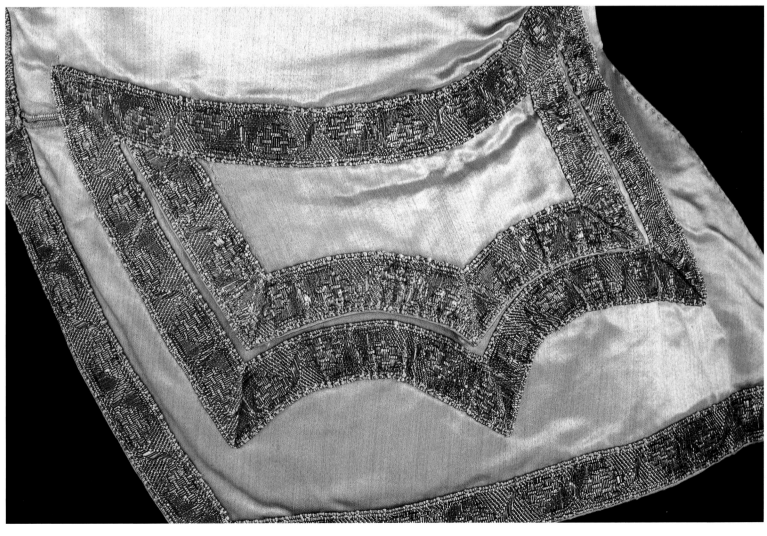

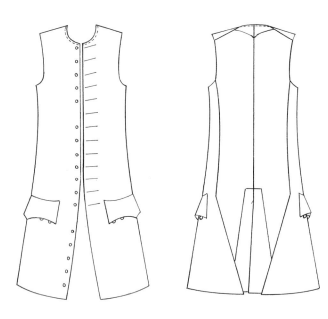

THE DESIGN FOR the velvet of this pocket flap was woven specifically to fit its exact configuration. By the 1730s, French silk manufacturers had begun to weave their velvets to fit the shape of the panels making up the waistcoat, accommodating the curving centre front edge, and working the pattern into its corner with the lower hem and the corner at the side, as well as weaving pocket flap shapes as part of the length of fabric. The technique was called '*à disposition*' or 'woven-to-shape'. In this snuff-coloured velvet of the 1750s, the pattern is made of cut, uncut and voided velvet in a characteristically rococo design of flowers, a meander imitating the texture of rope and lambrequined scrolls.

There is no definition of the neckline, side seam or armhole in the woven pattern, allowing these to be cut where necessary to fit the wearer. The centre front and lower hem were cut close to the pattern edge leaving a narrow seam allowance, turned under and stitched to the lining. The separate pocket flaps were cut out, lined and sewn to the waistcoat fronts above the pocket openings.

What makes this waistcoat particularly exceptional is that the back is made of a rare piece of cotton velvet. In this early and infrequently found example of 18th-century corduroy, the wales of light brown cotton have been woven in an unusual decorative pattern.

A man's waistcoat of
snuff-coloured cut, uncut and voided velvet.
English or French velvet, 1750s
T.197-1975

AN UNUSUAL BRAID of Indian painted and tamboured cotton in two widths has provided the inspiration for the embroidery of this 1770s waistcoat. The wider braid ($^3/_4$ inch; 2cm), used on the pocket flaps and along the front and lower edge, has a pattern of wavy lines bearing floral sprigs against a ground of dots. The lines and flower motifs have been outlined in tamboured silver thread. Around the pockets, a narrower braid ($^5/_8$ inch; 1.6cm) is used, with the floral sprigs and dotted background, similarly enhanced.

The double meanders on the braid have been copied in the decoration of the waistcoat front, tamboured in silver thread and salmon-pink silk. An attempt to duplicate the floral motifs has been made, not by painting, but by filling in with tambouring in coloured silks. The differences in technique and colours indicate that more than one hand was involved in the creation of this waistcoat, although overall the effect is one of harmony and homogeneity.

The pocket flaps on this waistcoat are much shallower than the woven one above, and the waistcoat skirts have shortened from mid-thigh to hip level. By comparing the two garments on this page, the progression of men's fashion over two decades can be clearly seen.

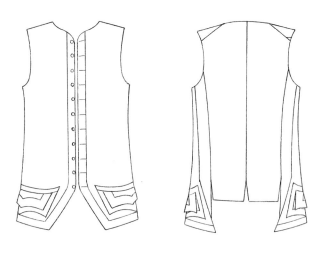

A man's waistcoat of cotton tamboured
with silk and silver thread, edged with braid.
English, with Indian braid, 1770s
Given by Miss Bury
467-1880

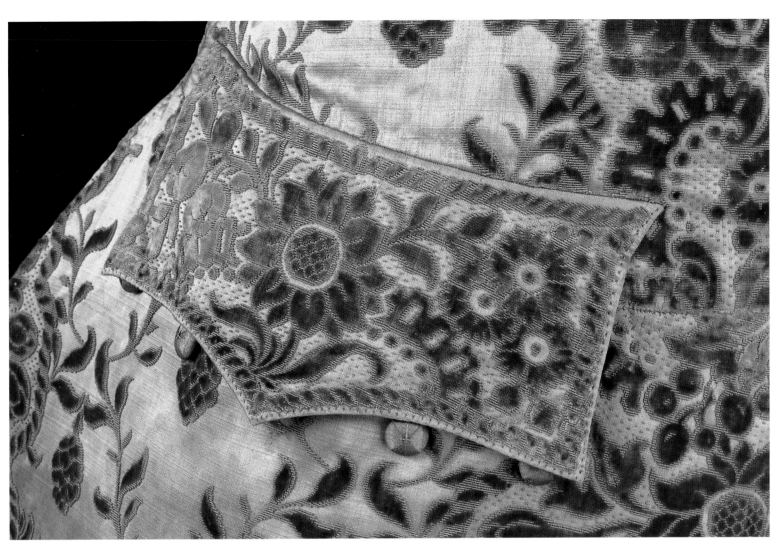
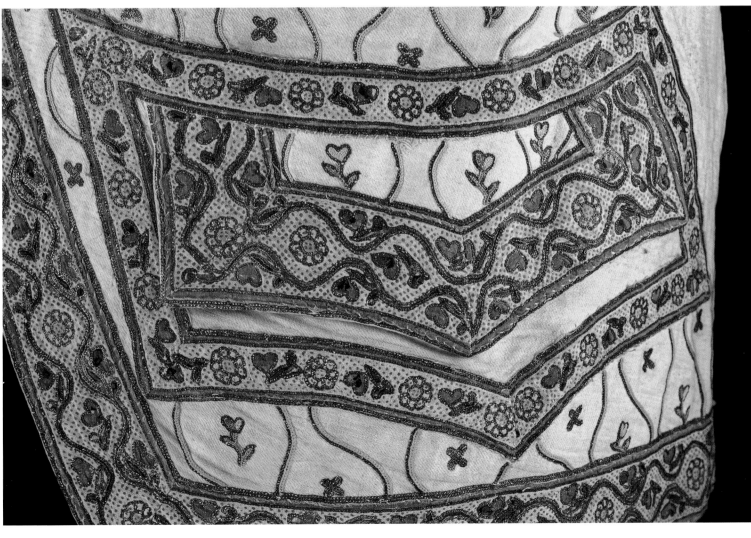

THIS EXTRAORDINARY LENGTH of embroidered silk documents three important aspects of 18th-century dress: the high calibre of French tambour work, the method of embroidering and constructing a waistcoat, and the efforts to which the English went to acquire desirable French fashions. Two lengths of ivory ribbed silk have been tamboured in a pattern of roses, exactly to the shape of the four embroidered pieces comprising a waistcoat. The work is remarkably fine and even; the use of shaded threads gives it a depth and almost photographic clarity.

What makes this waistcoat shape truly exceptional is the stamp seen on the inside of the lower right edge. It reads 'Custom House / SEIZED DOVER / GR II'. In other words, this is contraband, a French waistcoat apprehended during an attempt to smuggle it into England during the reign of George II (1727-1760). For most of the 18th century, heavy duties were imposed on the import of French silks and laces in order to protect British textile industries. Smuggling of these and other taxable goods was endemic throughout all levels of English society. In 1766, the Reverend William Cole wrote to his friend, Horace Walpole, about the attempts of the authorities to thwart this illegal practice: 'At Dover they are very strict at the custom-house in searching for laced clothes, and rummage the boxes quite to the bottom....'[1] Such scrutiny obviously proved fruitful. Articles seized in this manner were usually burnt, so the survival of this beautiful, forbidden object is indeed remarkable.

1. W.S. Lewis, ed., *Horace Walpole's Correspondence* (Oxford University Press 1937), Vol. 1, p.101.

Waistcoat shape, tamboured in ivory ribbed silk.
French, 1750s
T.12-1981

THE THREE-POINTED pocket flap of this embroidered waistcoat has been shaped to fit the shallow cut-away skirt front. The flap conceals a real if rather small pocket. The embroidery stitches are stem and satin stitch, French knots and couched chenille thread.

The cut of the waistcoat is typical for a dress waistcoat of this date. The fashionable high waistline of the late 18th century greatly reduced the length of waistcoats and consequently waistcoat skirts. Pockets were often indicated by a pocket flap which in the case of dress waistcoats had three points whether there was a pocket or not. Sporting and day waistcoats of the 1780s and 1790s had square cut fronts which were more comfortable for riding but at the same time conformed to the higher waistline. Pockets were open with straight tops and without flaps.

This waistcoat has a claim to fame as it is illustrated in *The Tailor of Gloucester* by Beatrix Potter. It appears several times in the book but is particularly well known in the illustration with the note 'No more twist'. Beatrix Potter visited the V&A when preparing her book and arranged to have a selection of 18th-century men's outfits put out for her to draw. These drawings were so accurate that they are an invaluable guide when identifying the items she selected.

A man's formal dress waistcoat of satin embroidered in coloured silks and chenille.
English, 1780s
652:A-1898

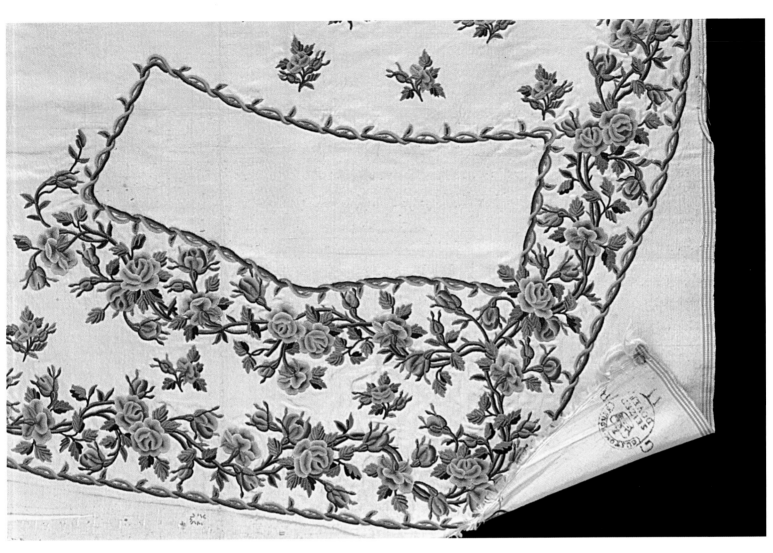
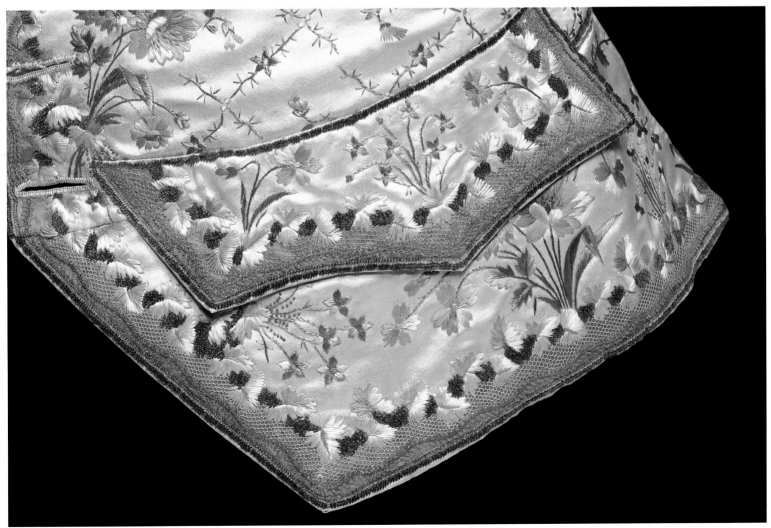

Two PLAYFUL MONKEYS gather fruit from a palm tree beneath the pocket of this 1780s waistcoat. They are embroidered in coloured silks on an ivory ribbed silk. The design for this image can be found in a patternbook for embroidered waistcoats in the Musée Historique des Tissus in Lyon, executed in watercolours on a reddish-brown background.[1] There are no instructions for the embroidery of the waistcoat front edge or space above the pockets; the embroiderer has invented a pattern based on that below the pocket, using palm fronds, sprays of grass and floral sprigs. On the linen back, the name 'Kaspar von Metternich' has been monogrammed with the date of 1780.

As well as floral patterns, figurative and pictorial designs proved popular for waistcoat decoration in the 1780s. Tigers, dogs and scenes from the opera appear on other embroidered waistcoats of this period in the V&A collection. The Lyon patternbooks contain lions, air balloons, architectural ruins and pastoral scenes among their wealth of embroidery designs.

1. 'Les Macaques', Vol. A, 334, no.35.

A man's waistcoat of embroidered ribbed silk.
French, 1780s
T.49-1948

BOTH THE GARMENTS on this page illustrate the developments in waistcoat styles in the late 18th century. Gone are the skirts and pocket flaps, the latter reduced to a placket, while the waistcoat ends in a straight line at the hips. A stand-up collar and revers are new features, with embroidery on the inside that will show when the garment is worn.

The paler colour palettes and restrained style of decoration of these two waistcoats are typical of the neo-classical design principles dominating art and dress. In comparison with the vibrant hue of the 1750s waistcoat shape on p.106, the pink of this 1790s satin example is much more subdued. The rhythmic rococo meanders and sprays of naturalistic flowers have become straighter, more stylised and geometric, as well as smaller in scale. A zig-zag of tambouring within two straight lines adds a little movement in this example, while a gentle twist of almost abstract flowers and leaves, in silk and chenille thread, edges the front and lower hem.

A man's waistcoat of tamboured pink satin.
English, 1790s
Given by the family of Dr and Mrs Hildred Carlill
T.355-1985

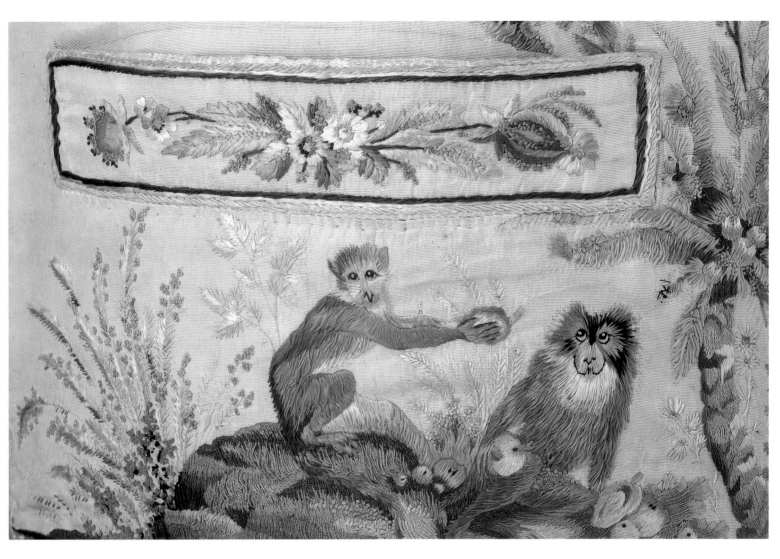

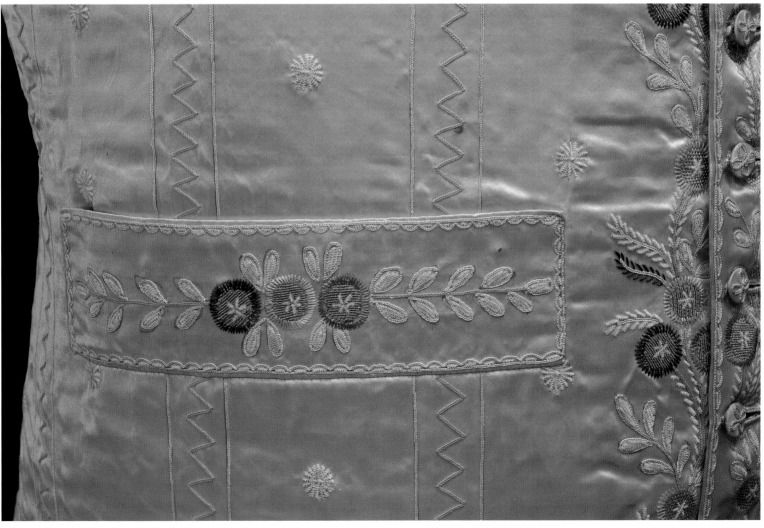

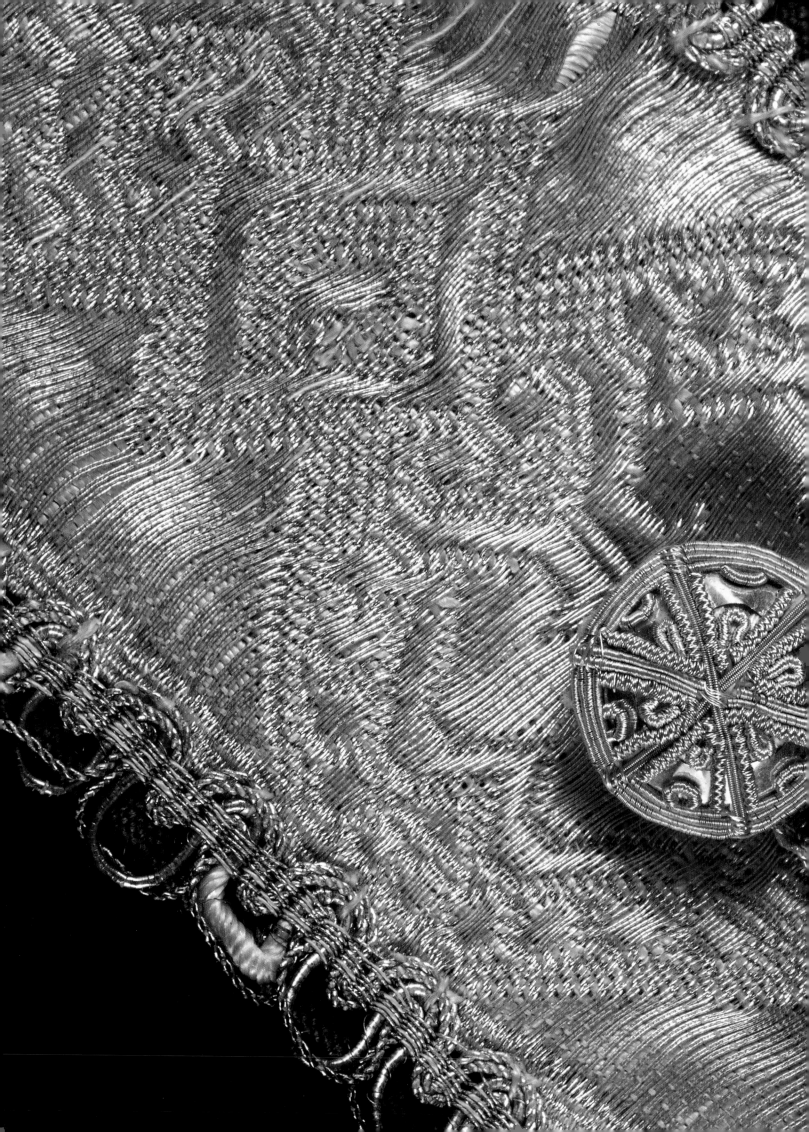

Buttons

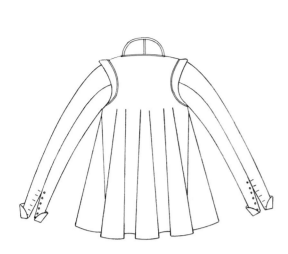

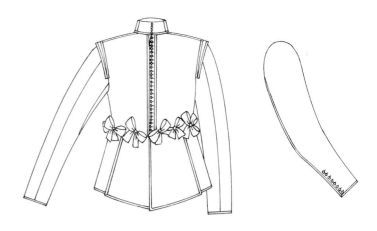

TINY ROUND WOODEN buttons are decorated with silver thread which has been plaited by hand using a passementerie technique. There are six buttons, shown in the detail, which occur on the sleeves of a woman's loosely cut, hip-length jacket of woven silk and linen, with a silver stripe, of *c.*1600 to 1620. Each sleeve has a semi-circular turned-back cuff, as seen on several other jackets (see pp.148 and 150). For further details about this jacket, see p.22.

A woman's jacket of woven linen
and silk with stripes in silver thread.
English, 1600-1620
188-1900

RIDGED, CONICAL-SHAPED buttons of carved wood are decorated with white silk thread in a passementerie technique done by hand. The detail shows the sleeve cuffs of a man's doublet which forms part of a quilted white satin suit of about 1635 to 1640. The sleeves taper towards the wrist and are fastened by eight buttons along the seam. The change in fashions in the 1630s brought in a more natural shape to the figure, producing a style which is cut more like a jacket, having just eight deep tabs at the waistline decorated with lacing ribbons or 'points'; these have become purely decorative instead of functional. The breeches by this date are supported by large metal hooks on the breeches waistband. For further details about this doublet, see pp 26 and 138.

A man's doublet of quilted white satin.
English, 1635-1640
347-1905

BUNCHES OF VARIEGATED mini-tassels and woven braids surround the ornamental buttons on the sleeves of this woven silk doublet of 1625 to 1630. It is cut in the high-waisted style of the 1620s with paned sleeves and panes across the chest and back.

The sleeves are full and paned above the elbow, but fit tightly from the elbow to the wrist, and each would have been fastened at the wrist by eight buttons on the back seam of the sleeve. The forearms are richly decorated originally with ten bars of satin strips overlaid with narrow braids, the ends finished with bunches of mini-tassels and a button placed in the centre of each bar, purely as decoration. The same decoration is repeated at the centre back.

The braids, buttons and tassels are all worked in a passementerie technique. The buttons are of silk, matching the doublet, and are worked by hand over a wooden core.

This doublet would have been the height of fashion and suitable to be worn at Court or for any other grand occasion.

A man's paned doublet of woven silk
with a floral pattern of about 1625 to 1630.
French, 1625-1630
170-1869

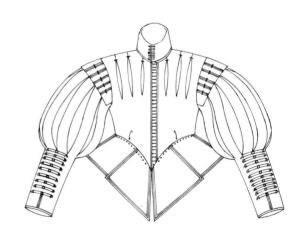

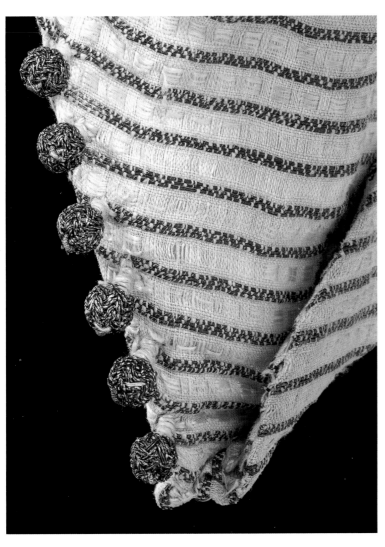

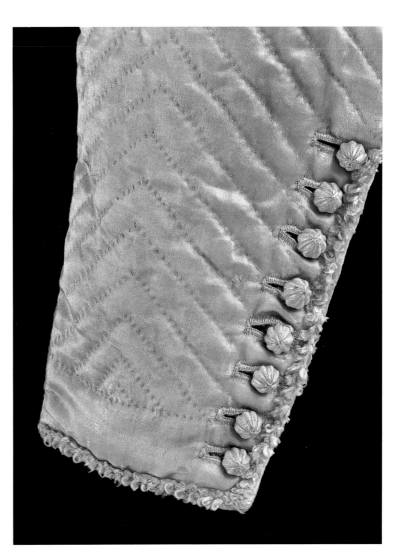

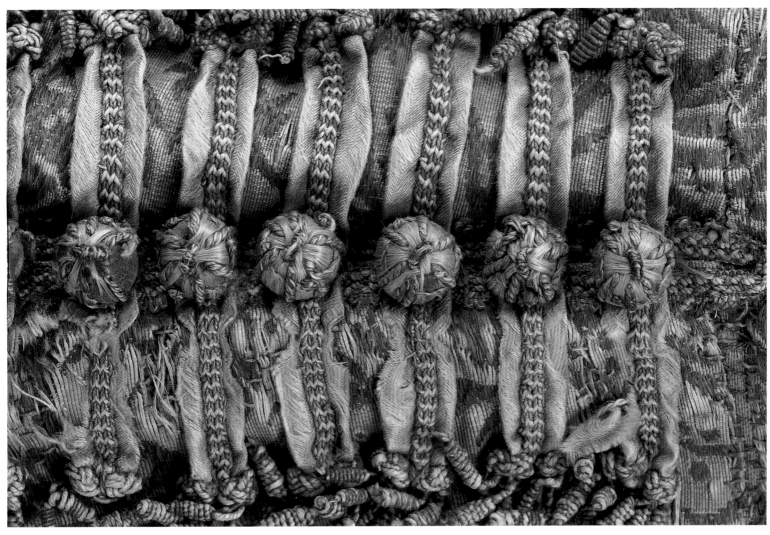

THESE DELIGHTFUL PASSEMENTERIE buttons are worked in linen over a rounded wooden core like a bead, and have meticulously worked buttonholes. Their shape and design is typical of buttons of the 16th and 17th century on both men's and women's doublets. This is a man's doublet of about 1635 to 1640. Passementerie techniques were varied creating many different patterns. The work was done by hand using plaiting and a needle. This set of buttons are quite conservative compared to those made of metal threads, and the very elaborate buttons which appear on 18th-century men's dress. In keeping with the rising waistline of the late 1630s, this doublet only fastens from the neck to the fashionable waist, with just sixteen buttons. For more details about this doublet, see p.72.

THE PASSEMENTERIE BUTTONS on this pinked and stamped ivory satin doublet of the 1630s are typical of the 17th century in their simplicity. Twenty-nine of them in a tightly packed row once fastened the front; two are now missing. They are comprised of a circular wooden base with a hollow over which double strands of linen thread have been interlaced. Two thick twists of linen cross at the top of each button forming a finial.

On the sleeves, a slightly different button has been used. Here, a more elongated spherical wooden form is covered with single linen threads in a herringbone pattern.

For more details about this doublet, see p.178.

A man's doublet of calendered
linen embroidered in linen thread.
English, 1635-1640
177-1900

A man's doublet of pinked and
stamped ivory satin, lined with ivory silk.
English, 1630s
348-1905

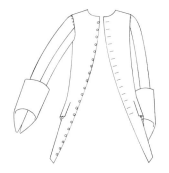

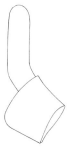

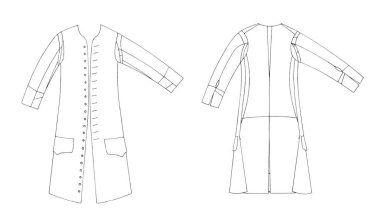

BY THE 18TH century, passementerie buttons boasted much richer materials and more complicated designs. On this satin waistcoat, the wooden button mould has five indentations in the top, into which silver foil has been pressed. Around this cruciform shape is worked silver filé and frisé threads and purl. Such elaborate fastenings complement the dense embroidery, composed of coloured silks and a variety of silver threads worked in a late baroque pattern of large flowers and leaves. The richness of this sleeved waistcoat is appropriate for the special event for which it was made: the marriage of William Morshead of Carthuther in Cornwall to Olympia Treise, on 23 April 1745. The coat that would have matched this garment no longer survives, but its cuffs were removed and added to the sleeves of the waistcoat some time later.

SILVER FOIL, FILÉ and purl cover the wooden core of the thirty-one buttons which adorn this sleeved waistcoat of the late 1730s, where they vie for attention with the opulence of the woven fabric. A brown ribbed silk is richly brocaded with coloured silks, chenille, silver filé and frisé in a pattern of large flowers. Such an expensive material has been reserved for only the parts that will show under a coat: the waistcoat fronts, the back skirts, and a wide band at each wrist.

A man's sleeved waistcoat of
ivory satin embroidered with silk and silver threads,
lined with ivory ribbed silk and fustian.
English, 1745
T.94-1931

A man's sleeved waistcoat of
brown ribbed silk brocaded with silk, chenille and
silver threads, lined with ivory ribbed silk.
English, 1735-1740
T.72-1951

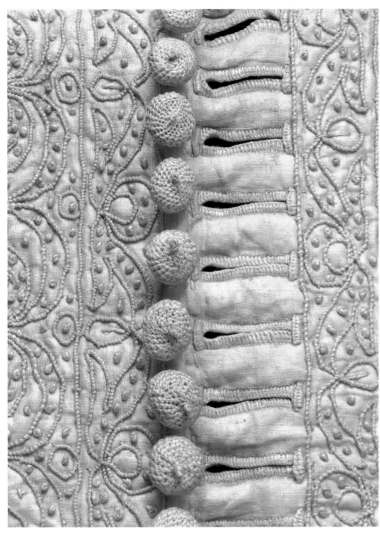
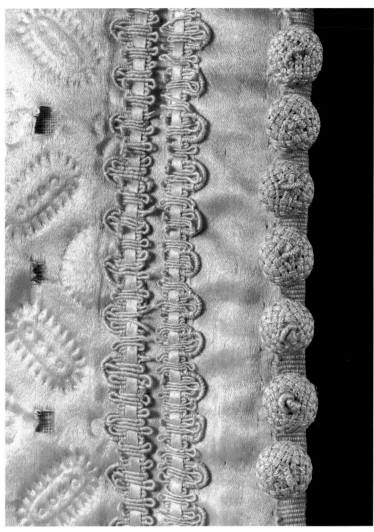
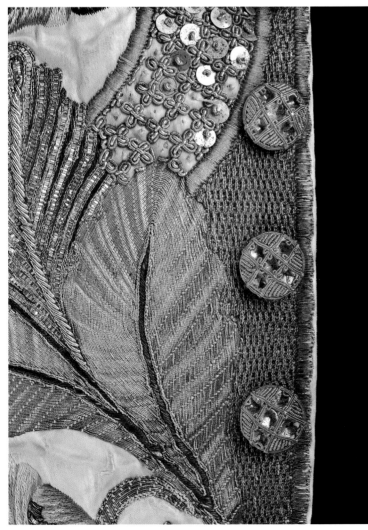
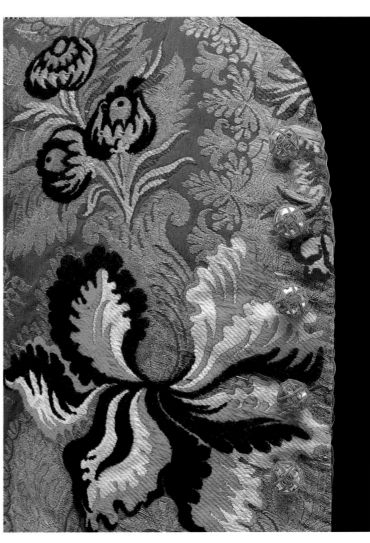

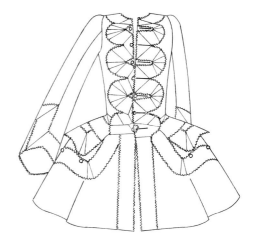

A RADIATING DESIGN of silver filé and frisé over foil decorates the buttons on this mid-18th-century woman's riding jacket. Only one of the three adorning the cuff is a working button; its loop of twisted silver filé can just be seen on the lower right. Seven identical buttons are used to fasten the front of the jacket and one reinforces the top of each side pleat.

For more details about this jacket, see p.102.

A woman's riding jacket of brown
camlet with silver braid, lined with brown silk.
English, 1750s
T.554-1993

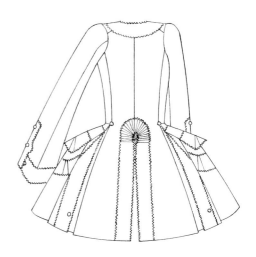

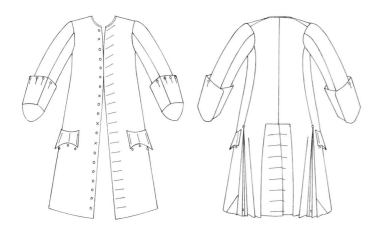

GLOSSY BEIGE SILK threads have been wound repeatedly over a domed wooden core to form the ground colour of the mid-18th-century passementerie coat button illustrated in the detail. It has been finished with a cruciform pattern of tightly coiled silk cords. The gleam of the threads complement the glistening surface of the beige and white figured silk coat. Passementerie buttons in silk were always made to match the colours of a garment.

For more details about this coat, see p.44.

A man's coat of beige silk.
French, 1740s
T. 614:1-1996

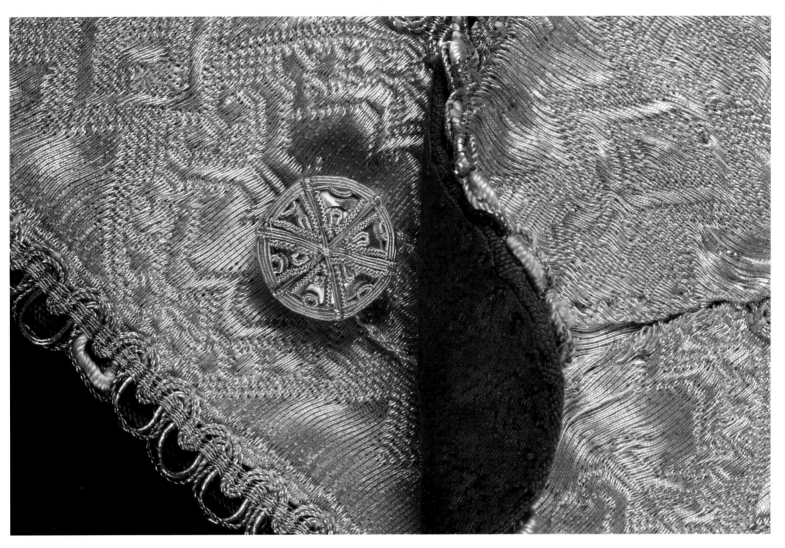

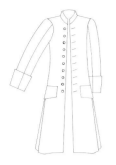
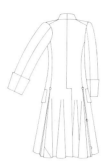
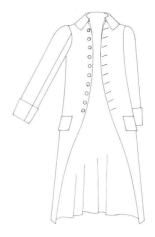
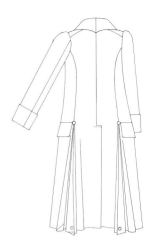

PLAIN PEWTER BUTTONS with a simple, machine-engraved design finish off this modest fustian coat of the mid-18th century. The button-engraving process was known as engine turning; the motif was incised by means of a pattern disc, called a rosette, attached to a lathe. Here, repeating the engraving in concentric circles has given depth and texture to the trefoil motif. Engine turning was used for ivory and box-wood in the 17th century, and by the 18th century it had become a popular method of decoration for metals, including buttons and silver boxes.

Like the coat on p.114, this is also reputed to have been made for a wedding, but its simplicity contrasts with the embroidered example. It is clear from the condition of the coat that it was much worn and, as such, exemplifies the restrained tastes and economical habits of the 18th-century English middle class.

A man's coat of fustian lined with linen.
English, 1750s
Given by James Potter, Esq., Master-Tailor of Derby
T.962-1919

TWELVE GILT-BRASS buttons embellish this man's coat of the 1780s in a subtle grey/brown wool flecked with blue and red. Metal buttons were either cut from a sheet or cast in a mould. Their decoration was made by a variety of methods: hammering, chasing, engraving, stamping or moulding. The effective pattern of a central rosette with radiating lines and concentric circles on these buttons was created during the casting process.

The fabric of the coat features a woven stripe; the dots or specks of colour are made by extra warp threads in red and blue. The deep turned-down collar with a point at the centre back, the long skirts and simple cuffs, all date the coat to the 1780s.

A man's coat of wool, lined with silk.
English, 1780s
T.358-1980

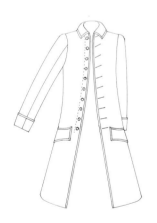
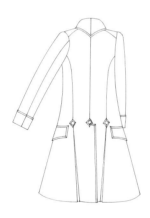
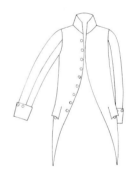
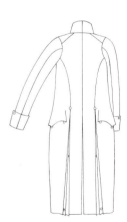

ELABORATELY EMBROIDERED BUTTONS and a simple silk and metal thread braid are the only adornment on this salmon-pink silk coat of the late 1770s. Interwoven pink silk, silver-gilt filé and silver strip form the base of the button, onto which are sewn silver spangles threaded on silver-gilt filé. The button shown here occurs at the top of the back pleat. The narrow braid edges the pleat, and it has been cleverly mitred to serve a double purpose: to reinforce the top of the pleat and also to form a decorative ground for the button. For more details about this coat, see p.76.

A man's coat of salmon-pink silk
with silk and silver ribbon trim.
English, 1775-1780
Given by Mrs Phoebe Timpson
T.363-1995

BUTTONS EMBROIDERED WITH floss silk, pastes and silver spangles form an integral part of the fine needlework on this 1790s man's formal coat. Each has a 'wheel' of satin stitch enclosing a central paste encircled by spangles; they act as 'punctuation points' echoing the elements of the main embroidered decoration. The striped brown silk of the coat has been appliquéd with wavy bands of pink silk overlaid with an early machine net (that is, a net made on a warp frame). Over this ground spreads a pattern of leafy sprays also worked in silk, pastes and spangles. Embroidery samples at the Musée Historique des Tissus in Lyon show several remarkably similar patterns, all using a net ground, with pastes and spangles worked in comparable styles, on dark, striped silks.

A man's Court coat of embroidered and
appliquéd striped silk, lined with ivory silk twill.
French, 1790s
106-1891

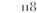

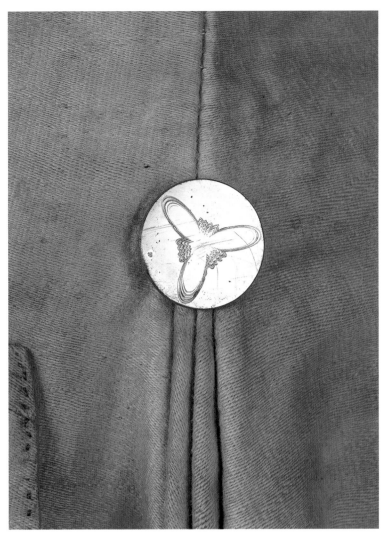
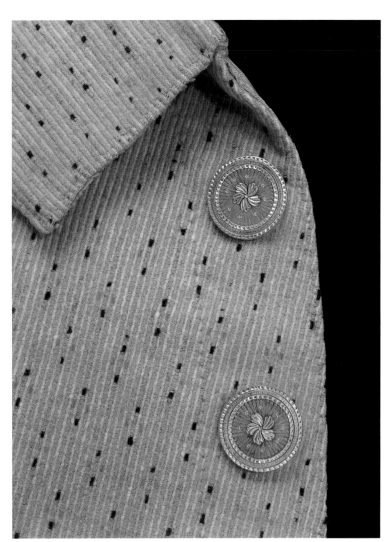
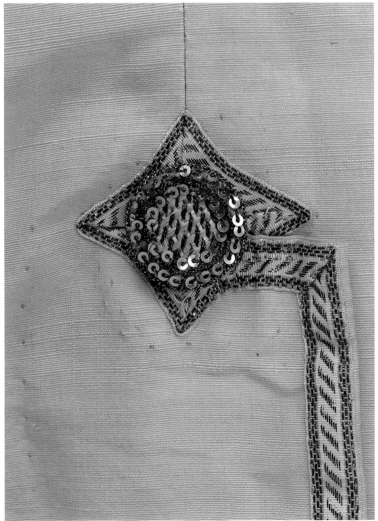
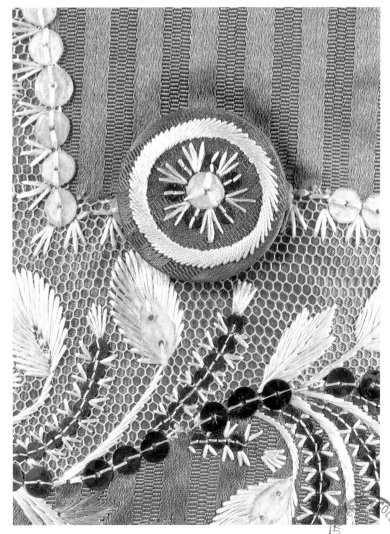

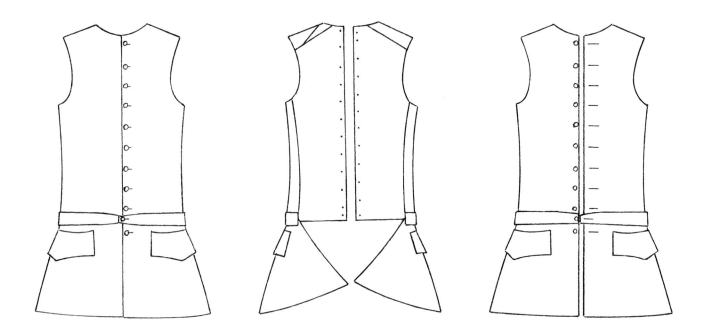

Dainty silver-gilt passementerie buttons fasten a 1760s woman's riding waistcoat in eye-catching bright pink silk. Each button has a wooden core, similar in shape to a custard squash. The knobbed edges form useful notches to secure strips of foil and threads which are wound over the silver-gilt foil ground.

The upper part of women's 18th-century riding attire consisted of a masculine-style coat and waistcoat. Here the influence of men's dress ended, and, mounted side-saddle, 18th-century equestriennes had to cope with the encumbrances of petticoats and riding hoops.

A woman's waistcoat of pink silk embroidered
with silver-gilt thread and sequins.
English, 1760s
Given by T. J. Edward
T.155-1979

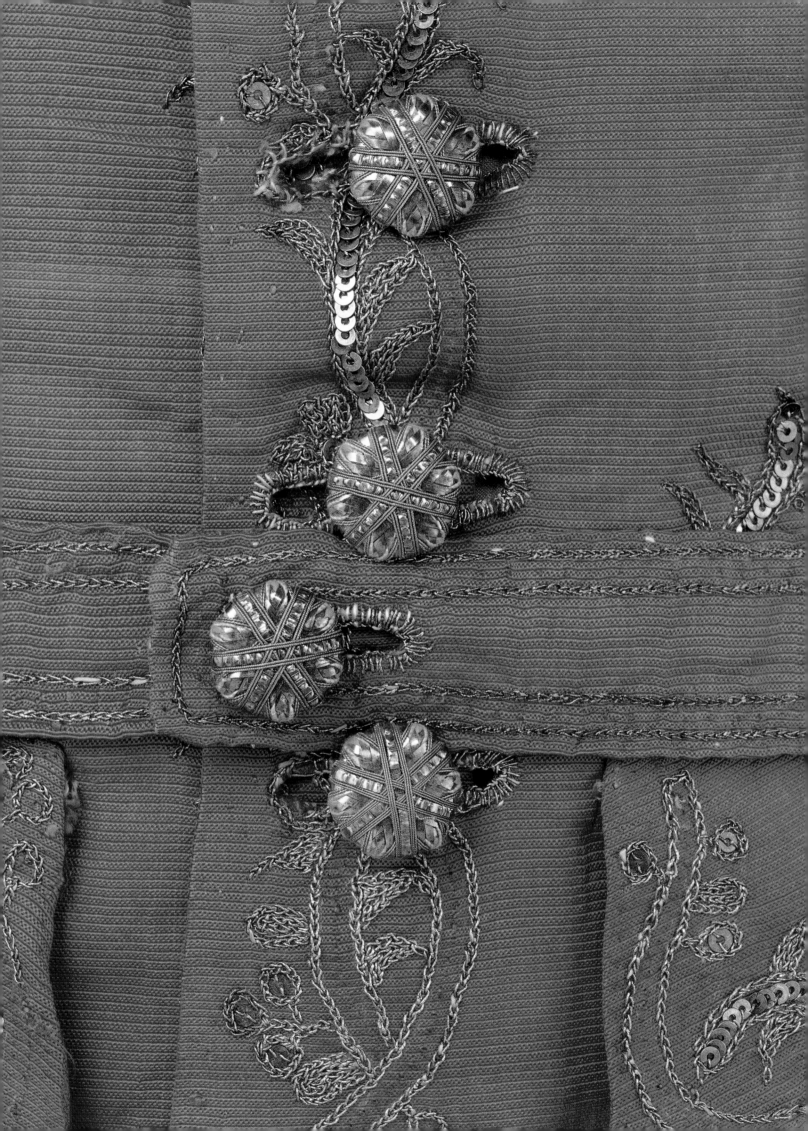

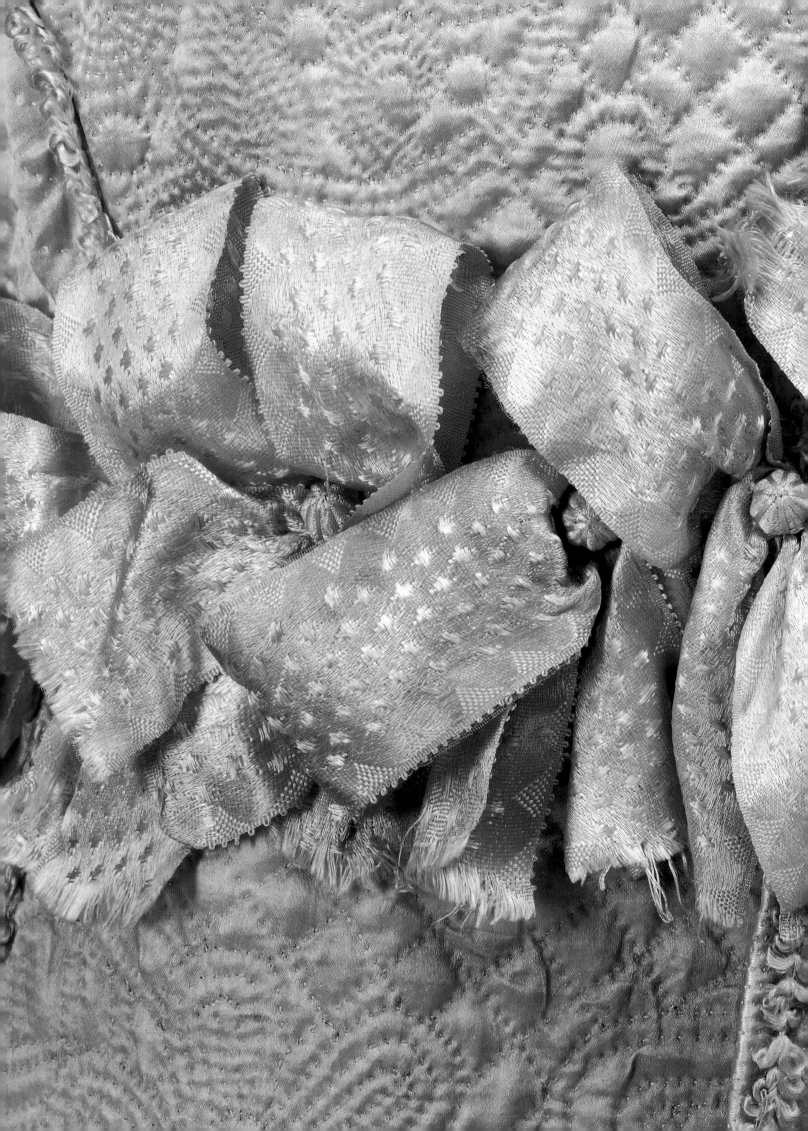

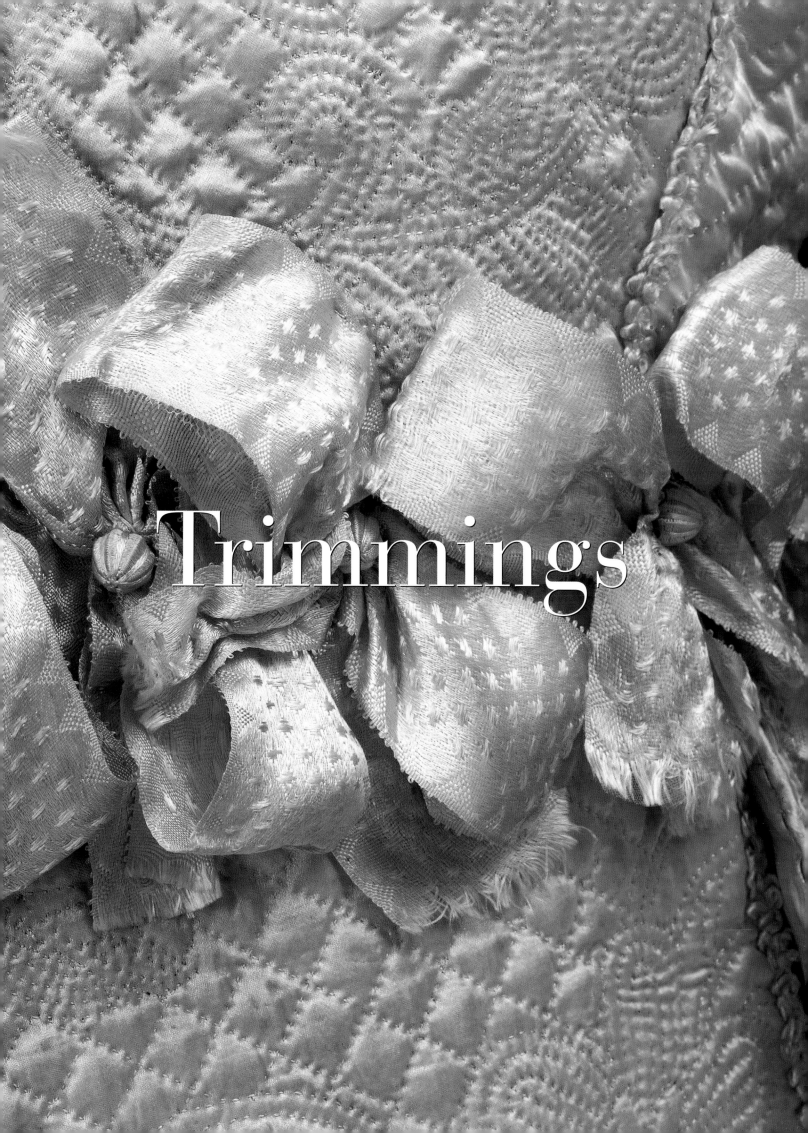

Trimmings

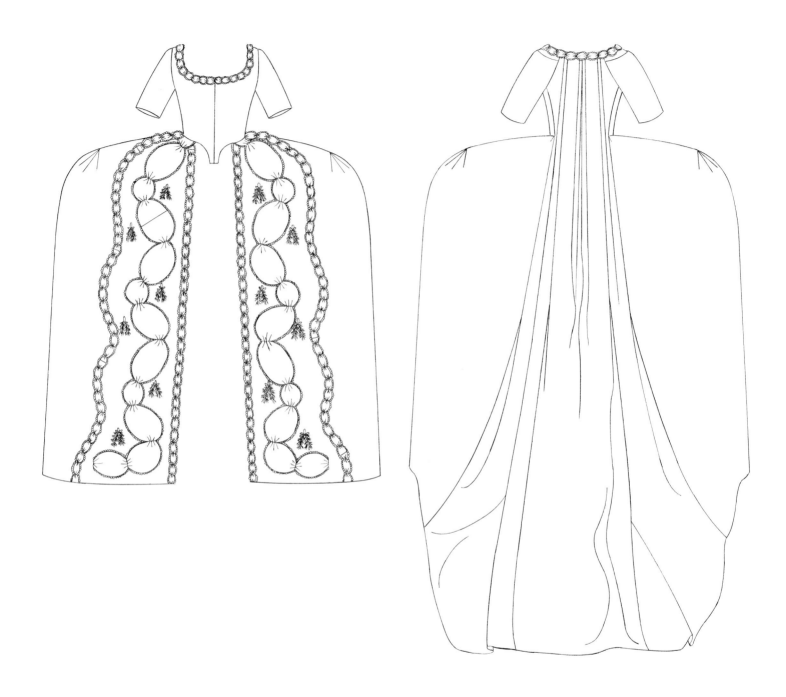

A DOZEN DELICATE tassels decorate the front skirt panels of a trained 18th-century sack-back gown. The sack-back forms part of a white satin gown and matching petticoat of the late 1770s.

The tassels are made of fly braids and silk chenille sus-pended from tiny metal rings decorated with silk knots. Their fluffy texture, shimmer and delicate form is set against gleaming satin and the lines of prettily puffed satin trim.

For more details of this gown, see p.56.

A woman's sack-back gown of white satin
English, 1775-1780
T.2-1947

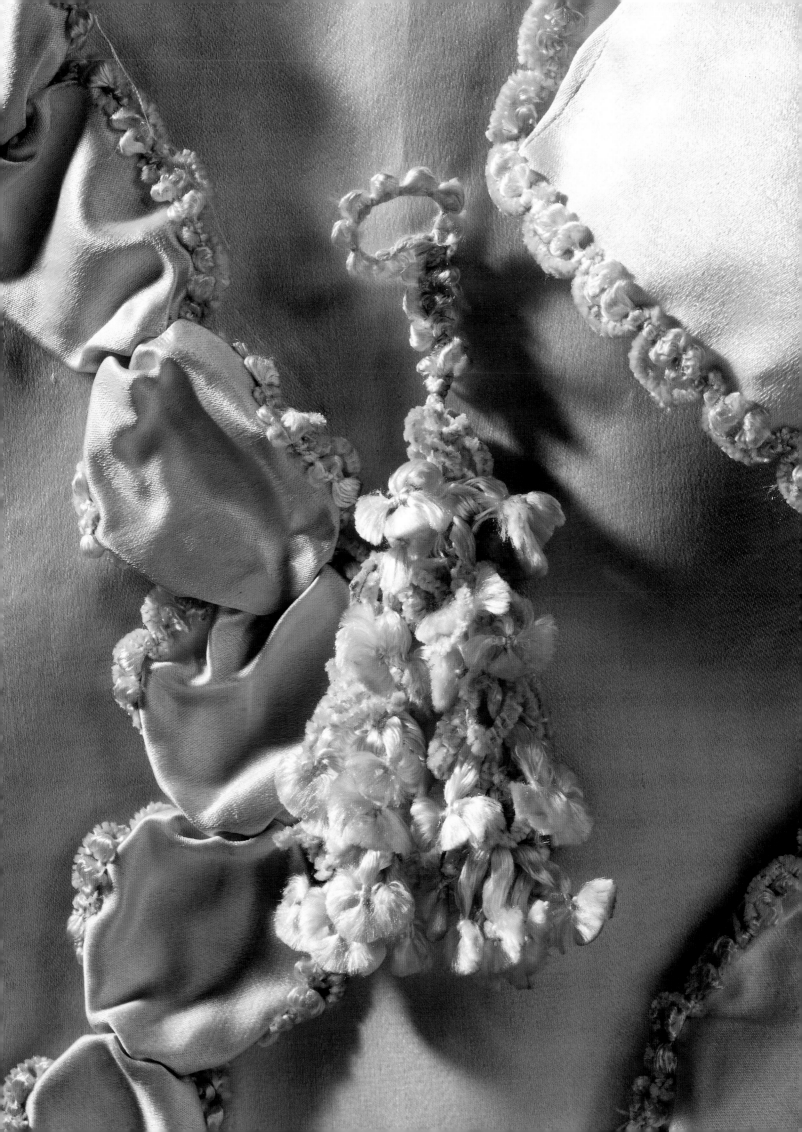

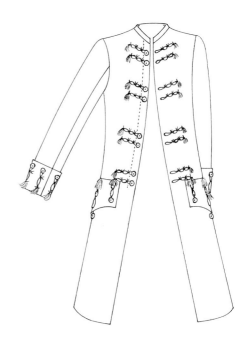

EMBROIDERY IN SILVER-GILT thread and silver-gilt spangles sparkles against the cream wool of a dress coat of the 1770s.

The professionally worked design consists of finely drawn garlands and festoons entwined together and worked over narrow ribbons of plain ivory silk. At intervals the garlands are caught up by tasselled cords. This pattern is restricted to the fronts, pockets, cuffs and back pleats. Tasselled decoration worked in silver and silver-gilt purl is shown on the cuff in the detail. A sliver of colour is just visible along the bottom of these tassels; this is a line of raised satin stitch embroidered in red silk. The fine buttons on the cuff are purely decorative, of silver and silver-gilt foil wrapped over a wooden core, embroidered with spangles, silver, and silver-gilt thread. This embroidered decoration is typical of the late 18th century as it enters the neo-classical period which favoured austere yet elegant motifs. Tassels in various forms were a particularly popular element of design at this time.

A man's coat of wool with embroidered decoration
of tassels in silver and silver-gilt thread and spangles.
English, 1770s
656-1898

THIS MAN'S LILAC wool dress coat of the 1770s is lavishly decorated with mother-of-pearl buttons and tasselled frogging of silver thread and silver spangles. The 2-inch long (5cm) tassels hang free from the frogging down the fronts, along the pocket flaps and around the cuffs. They would have swayed in the most beguiling manner when the wearer moved. The frogging is of silver spangles stitched to strips of parchment arranged in simple open twists with the tassels attached at one end. These are constructed from a circlet of spangles from which hang two strands of silver spangles laid on silver strip and about a dozen silver threads worked in chain stitch. The combination of silver threads and spangles provides a shimmering effect, and would have been especially effective in candle light. The mother-of-pearl buttons which are highlighted with tiny coloured pastes around the rims give added lustre.

A man's coat of wool trimmed with tasselled
frogging in silver thread and silver spangles.
English, 1770s
Given by Mrs Phoebe Timpson
T.365:1.-1995

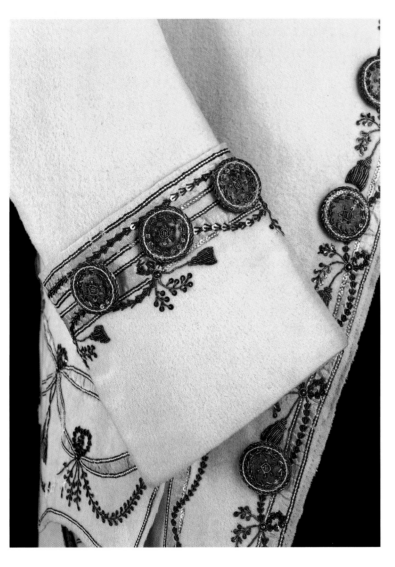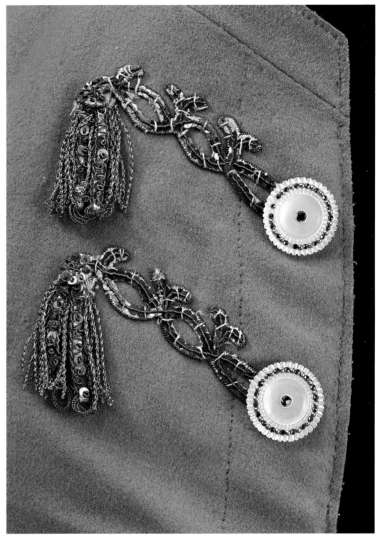

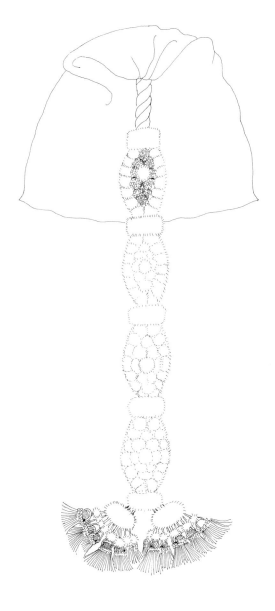

THIS 18TH-CENTURY knitted silk cap is dominated by a superb 16 inch (40.5cm)-long silk tassel, which matches the cap. The tassel is made up from over 100 silk threads, divided into two skeins and twisted into a rope which measures 1½ inches (3.8cm) from the crown to the first of four flattened lozenge shapes which can be seen in the drawing. The fluffy appearance of the tassel is created by the ingenious use of tufted silk rings which have been threaded onto the skeins of silk. They have been tightly bunched together so that the tufted ends merge creating a soft silky pile.

The cap has an attractive all-over design of chevrons and lozenges. Tasselled caps like this were worn by both men and women, probably on gala occasions or festivals, and formed a distinctive part of Spanish traditional dress.

A cap of knitted silk.
Spanish, late 18th century
Given by Mrs Pamela Sanguinetti
T.176-1958

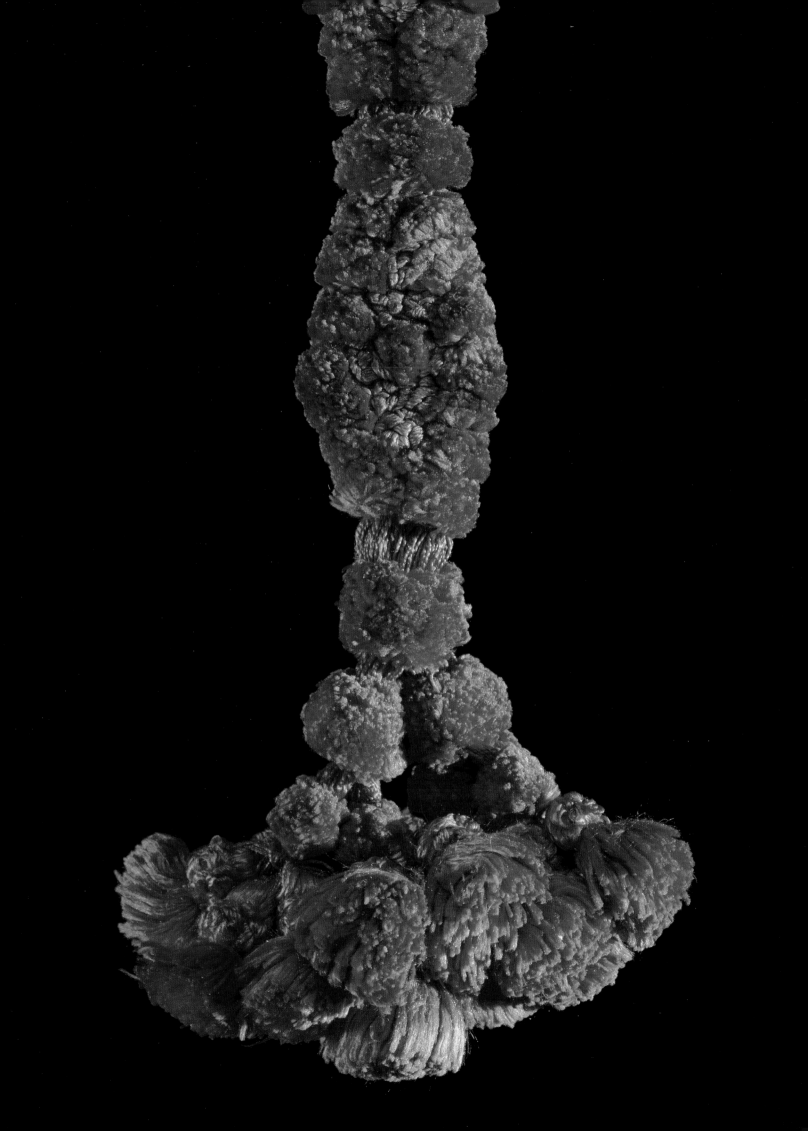

An INDIAN CASHMERE shawl was ingeniously re-styled to make a man's square cut waistcoat of the 1780s. A most attractive feature are the fringed ends of the shawl which have been incorporated as the trimming on the edges of the lapels. Lapels were introduced as a regular part of men's coats and waistcoats in the 1780s and 1790s. One of the innovations of this new fashion was to wear the waistcoat lapel over the coat lapel as an eye-catching feature. This fashion was eventually assimilated into men's evening dress as the silk lapels which appear on all full-dress tail coats and dinner-dress jackets.

A man's waistcoat of cashmere.
English, 1780s
Given by J. Gordon Macintyre
T.440-1966

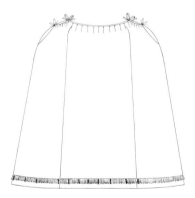

A PETTICOAT OF a trained wedding gown of 1782 is made of white Spitalfields silk woven with silver strip in a design of small silver leaves and trimmed with a silver fringe. This elegant gown has a closed bodice and an open-fronted skirt revealing the matching petticoat. The detail reveals the attractive trimming on the petticoat. It consists of a fringe of silver strands headed with a row of silver spangles and interspersed with tassels also decorated with silver spangles. The white with silver combination conveys bridal purity and the silver elements were introduced to glint in the light as the bride moved about. This wedding ensemble is said to have been made for a Miss Sara Bodicott who married her cousin, Samuel, of Yarborough Hall, Norfolk, in 1782. Sadly she died, just eight years later, on 2 July 1790.

A petticoat of white silk woven with silver strip.
English, 1782
Given by Mrs R. Stock
T.80A:-1948

THIS WHITE SATIN waistcoat is extravagantly trimmed with dyed rabbit fur. Occasionally used as a decorative trimming on men's and women's dress in the 18th century, here, it is in strips to imitate fringing. This is one of the most outrageous and daring uses of fur, especially as it is dyed a virulent green. However the colour may have undergone a chemical change after two-hundred years. There are several charming features to this waistcoat: it has black velvet ribbon embroidered with spangles, foils and pastes, embroidered floral buttonholes and an embroidered carnation on the lapel. The introduction of lapels on waistcoats seems to have inspired this delightful idea, as it appears on other waistcoats of the period. Similar waistcoats were made in France for the Spanish market.

A man's waistcoat of white satin with fur trimming.
French/Spanish, 1780s-1790s
Given by Miss Theophania Fairfax
T.858-1919

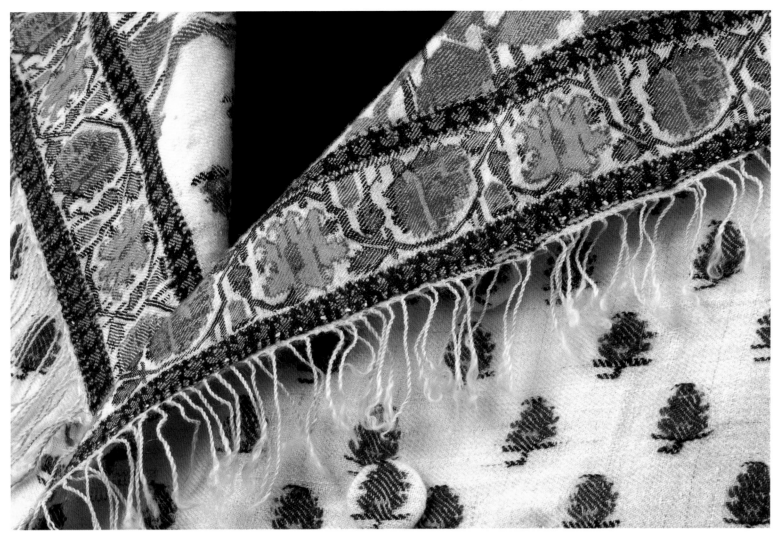

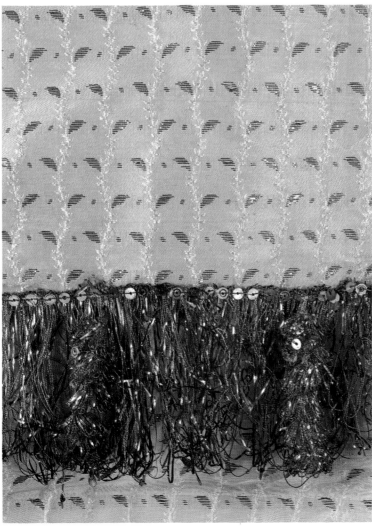

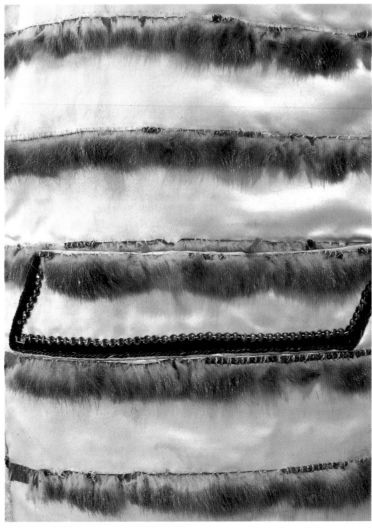

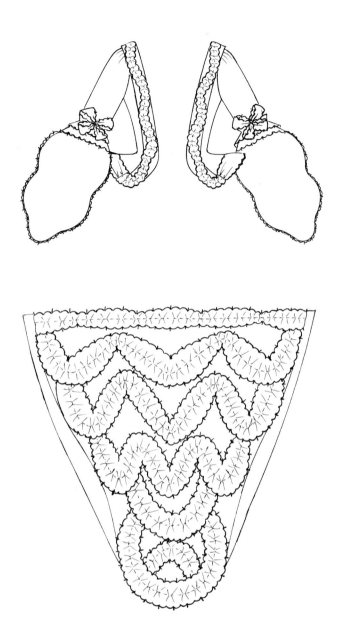

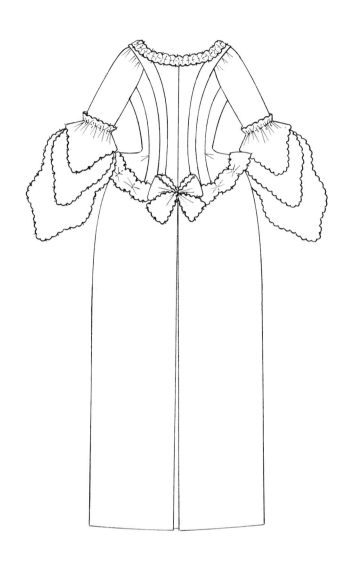

YARDS OF MULTI-COLOURED, intricately woven braid trim every edge of this 1760s mantua, stomacher and petticoat. It consists of red silk woven with loops of white cord, and loops and tufts of yellow, red and white floss silk. Some of the tufts are knotted at the ends to hold their shape, while others are knotted at the base to allow them to fray. The gathered ruffles of the stomacher have been edged with braid and then arranged in deep curves. The mantua is made of Spitalfields silk with a woven design of shaded red, pink, orange and yellow floral sprays against an ivory ground patterned with cannelé stripes and feathers. The random combinations of the patterns of textile and braid, as well as the surface broken by applied gathers and fringing, create a shimmering, fractured texture so characteristic of rococo decoration.

Fly fringe is a particular type of trimming found on women's clothing in the third quarter of the 18th century. It was a form of braid using cord and floss silk usually woven, but also knotted and tufted. Fly fringe was produced by the passementerie trade (known in Britain as parchmentry) and sold by the haberdasher. Barbara Johnson bought '2 dozen and a half of fringe... at eight shillings a dozen' to match a garnet-coloured paduasoy in 1762, and included swatches of both in her album.[1] While twenty-four yards of fringe may seem excessive, the dense coverage of the surfaces in the mantua shown here indicates how easily such a length of braid could be used.

1. Rothstein, Natalie, ed., *Barbara Johnson's Album of Fashions and Fabrics* (Thames and Hudson 1987), plate 9.

A mantua and stomacher of
ivory silk trimmed with fly fringe.
English, 1760s
Given by Mrs P. Lloyd
T.120&B-1961

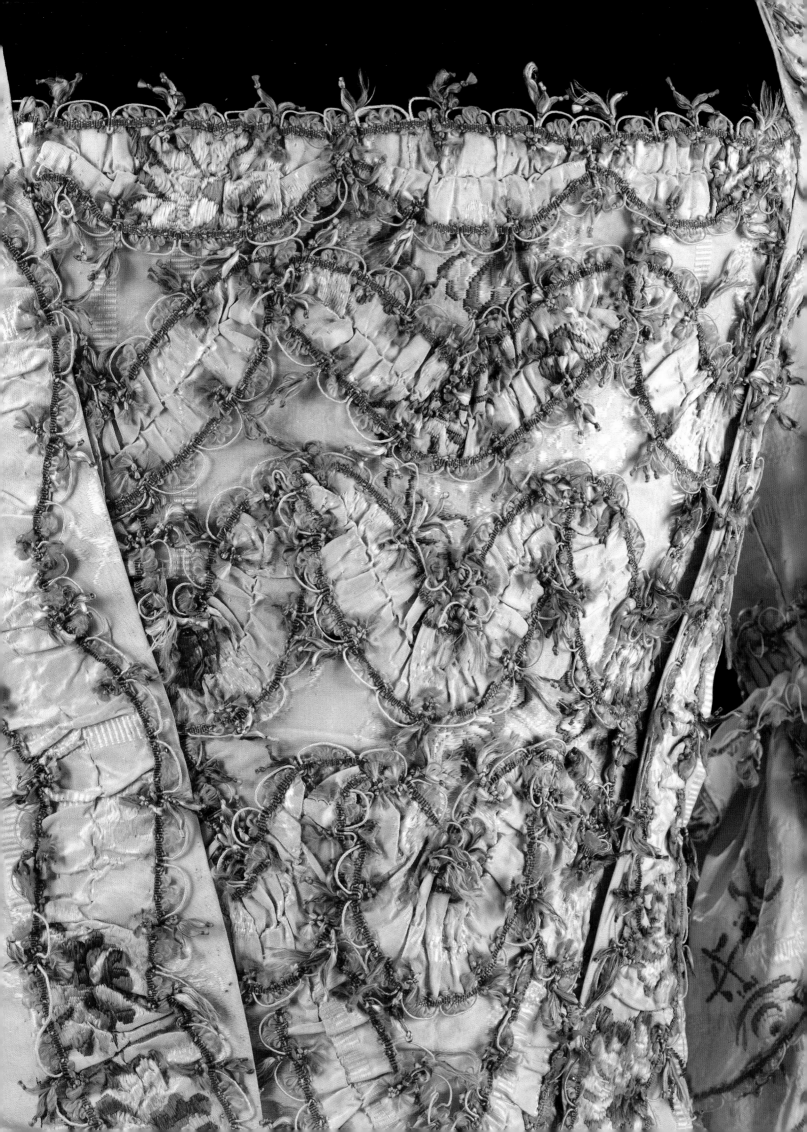

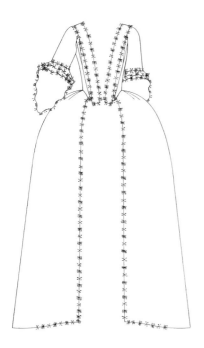

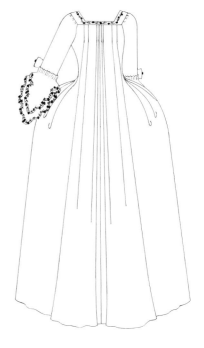

Tiny rosettes made of parchment strips, covered with silk and twisted into the configuration of petals, form the decorative focus of the fly fringe on this 1760s sack-back gown. Their shape and method of manufacture resembles similar rosettes used in the embroidery of James II's wedding coat almost a hundred years earlier (see p.80).

In this 18th-century example, a plain beige silk has been embroidered only on the robings, sleeve ruffles and front edges of the gown. Coloured silks in satin stitch and couched silver-gilt strip and filé thread have been worked in a pattern of large flowers and leaves. In addition to the rosettes in various colours, this distinctive braid incorporates loops of silver-filé thread, with tufts of coloured floss silk.

A sack-back gown of silk embroidered with coloured silk
and metal threads, trimmed with parchment fly fringe.
English, 1760s
700-1864

The rosettes in the fly fringe of this sack-back gown have been made with concentric circles of tiny loops of floss silk in contrasting or graduated colours of white, pink and maroon. Some are wired in pairs to the main braid, allowing them to stand upright from the silk. The fringe itself is made of a core thread of linen wrapped in dark-green floss silk with short tufts of white and green silk. The overall effect, like most fly fringes, was of a twisting vine sprouting tiny leaves and flowers.

The green and white satin has additional shaded stripes of darker green and brown. Individual sprays of pansies, morning glories, auriculas, carnations, bluebells and roses have been embroidered in chenille thread on the white stripes, accentuating the floral theme of the braid.

A sack-back gown of striped satin embroidered
with chenille thread, trimmed with fly fringe.
English, c.1770
Given by the late Miss E.M. Cooke
T.471-1980

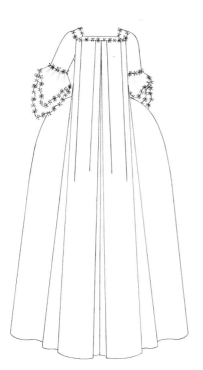

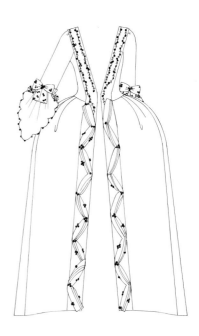

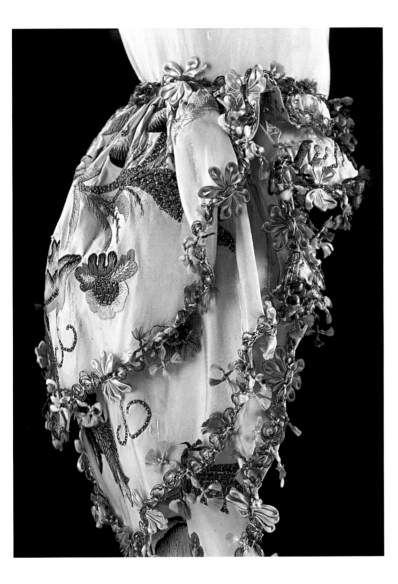
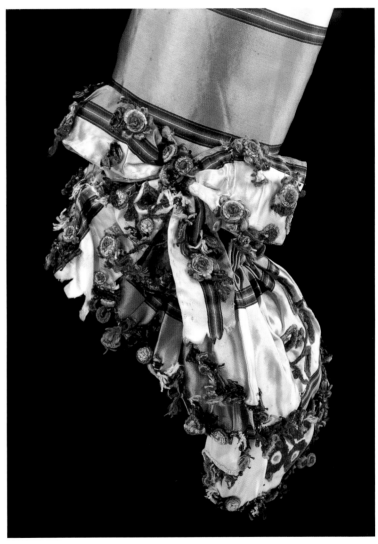

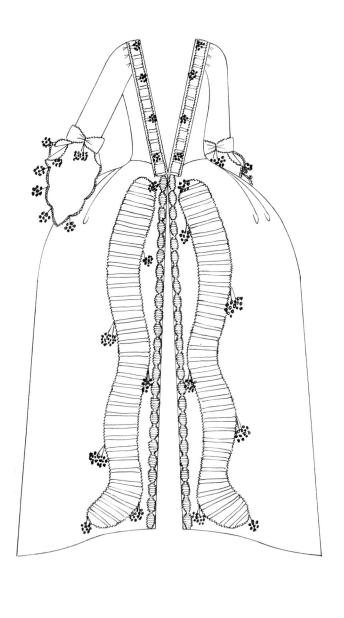
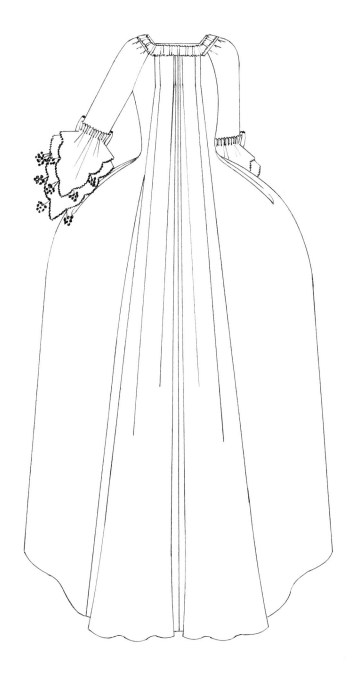

Two TYPES OF fly fringe have been used on this sack-back of 1770, one as a trim and one as type of tassel. White floss silk woven with a twisted silk cord, with tufts of green and pink silk comprises the braid edging the engageants, front and robing ruffles. These have been further embellished with tassels made of a fringe of twisted and knotted white and green floss silk, with tufts of yellow and green. Added to these are circles of blue and graduated shades of pink silk which give the effect of small posies. Down the front of the gown these measure about 3⅛ inches (8cm). Shorter lengths of the same fringe have been attached to the corded braid on the sleeve ruffles.

The gown is made of ivory silk patterned with stripes and floral sprigs, and brocaded with floral sprays in yellow, blue, green and shades of pink. The degree to which the braids match the colouring of the dress fabric suggests that they may have been made to complement each other. In Barbara Johnson's album, the shades in the fly fringe correspond perfectly with those in the silks which they accompanied. In these cases, the braid maker may have created a fringe to match a silk pattern supplied by the weaver, and the two would have been supplied by the silk mercer.

A sack-back gown of figured ivory
silk trimmed with fly fringe.
English, c.1770
Given by Miss Galfin
T.12-1940

136

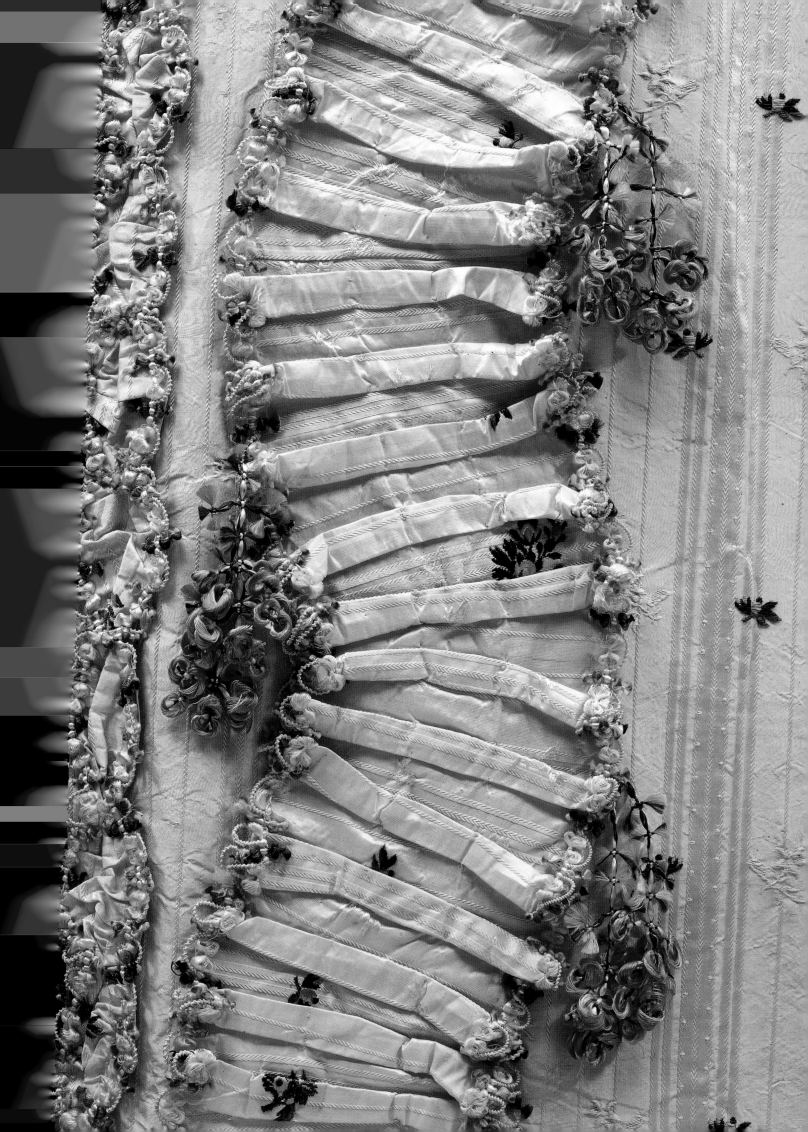

THE PINK SILK taffeta ribbons on these 17th-century stays perform a practical, as well as decorative role. They attach the sleeves to the body of the stays through threaded loops, allowing them to be worn or left off according to the discretion of the wearer; they also fasten the shoulder strap to the stay front. What is especially unique about this ribbon is that it retains the aiguillettes, a thin strip of tinned iron, crimped around the end of each ribbon, so that it can be threaded through the loops easily and without fraying. A pink grosgrain ribbon binds all the edges of the busk and stays and covers the latter's seams.

This side view illustrates the typically late 17th-century profile of the stays. The whaleboned back reaches as high as the shoulders and covers the very top of the arm, dipping in front to show some décolletage. Both the front and back are flattened, creating the long, tubular torso fashionable for women in the 1660s.

For more details about these stays, see p.12.

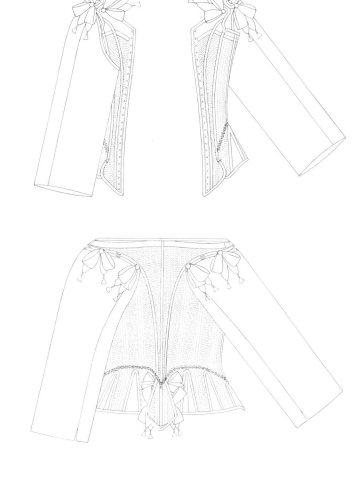

A pair of sleeved stays and busk of pink watered
silk trimmed with pink silk taffeta ribbons.
English, 1660-1670
Given by Miss C.E. Gallini
T.14-1951

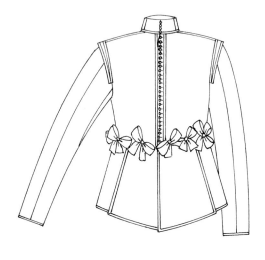

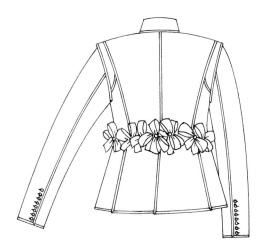

EIGHTEEN DEEP BOWS of ivory silk ribbon adorn the waist of this 17th-century quilted doublet. Originally, ribbon points were used to attach the doublet to the breeches, but with the growth in size of the waist tabs or doublet skirts, the ribbons became decorative in order to remain visible. Large metal hooks on the inside of the breeches fasten them to the doublet. The 4cm-wide ribbon is woven in a small figured pattern of diamond shapes. A decorative picot is formed by extending the weft threads beyond the selvedges. Each bow has a thread-covered, shaped conical button stitched to its centre.

Vast amounts of ribbon were used to decorate fashionable dress in the 17th century, both English-made and imported from France and Venice. Shoe roses and garters sported enormous bows of ribbons; they were also threaded with jewels and worn as necklaces. Along with jewels, strings of pearls and veils, ribbons were incorporated into women's hairstyles.

Due to their fragile nature and exposure to wear, the survival of ribbons from this period is very rare. The crispness and volume of these bows are particularly remarkable.

For more details about this doublet, see pp.26 and 112.

A man's doublet of quilted satin lined with silk and linen.
English, 1635-1640
347-1905

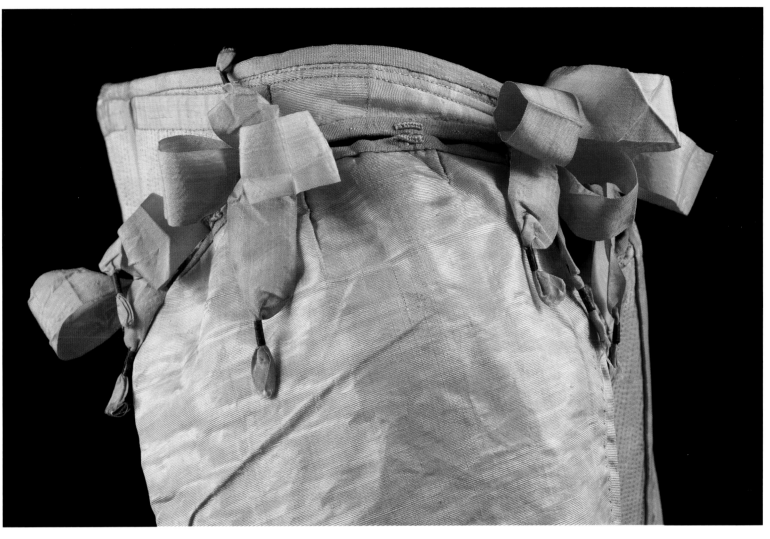

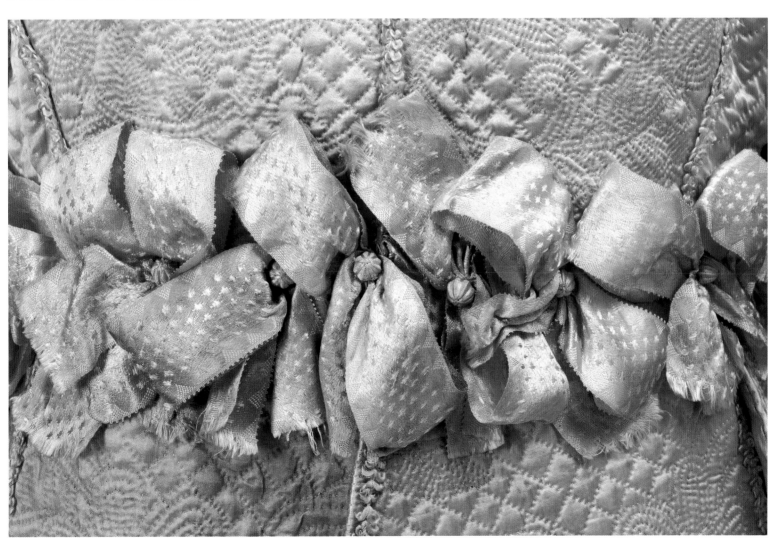

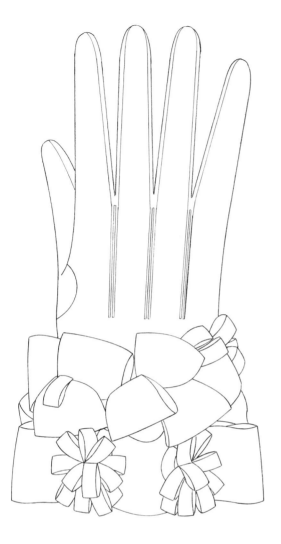
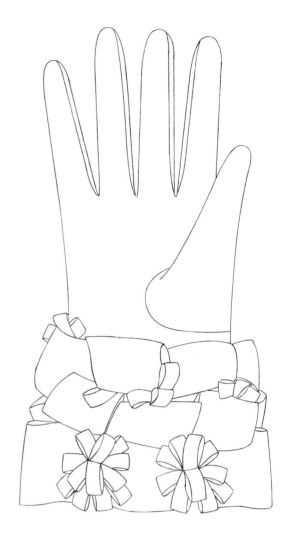

Two TYPES OF subtly coloured and intricately woven ribbons cover the gauntlet of this mid-17th-century suede glove. The widest one (1 inch; 2.5cm) incorporates two stripes of silver thread and strip in a rarely found gauze weave, flanked with stripes of tabby woven beige silk and silver-gilt strip. The weft thread is silver, which forms a picot on either side of the ribbon. Ivory and salmon-pink silk with silver strip form the narrower (⅜ inch; 1cm) ribbon; an identical version in maroon and yellow is also used. Unfinished selvedges create a decorative frayed edge. The gauze ribbon has been arranged in deep loops and interspersed with clusters of loops of the narrower trim.

Ribbons were an important adornment for gloves and this taste for a looped or ruched treatment exemplifies the style of the 1660s and 1670s. This glove is otherwise unadorned. A faint line of beige along the seams indicates that it was dyed after it was sewn together, with a pad soaked in dye, rather than being dipped.

All types of trim – tassels, ribbons, fringes, galloons, tapes and metal braids – were known as 'narrow' wares, as they were originally woven on narrow hand-looms, mainly by women in the 14th and 15th centuries. Only one lace or ribbon could be worked at a time. The Dutch engine loom was invented about 1604 and by the middle of the century it was capable of weaving up to twenty-four ribbons at a time, while requiring only one worker to operate it. This sudden increase in the output of narrow wares may well have contributed to their extravagant use in 17th-century dress.

A glove of dyed suede trimmed with
metal thread gauze ribbon and silk ribbon.
French, 1660-1680
T.229-1994

Applied
Decoration

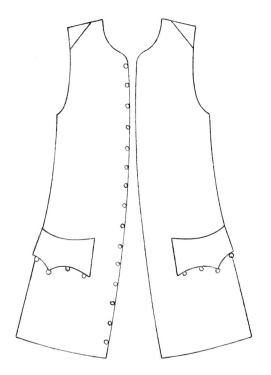

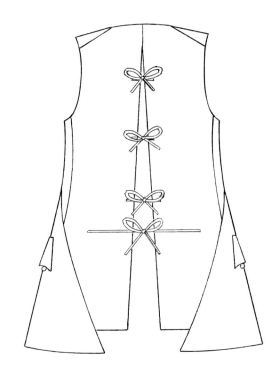

Large petals of gilt-brass foil scatter across this opulent waistcoat made of an unusual weave of alternating bands of chenille and silk. Patterning wefts of pink and green silk add floral motifs to the fabric, over which are appliquéd chenille and silk flowers worked in chain stitch, with silver-gilt spangles, purl and gilt-foil flowers. The matching coat is similarly worked. Its shaping and construction date it to the 1760s, while its lavish decoration indicates its status as formal wear.

These flashy foils are typically found in the third quarter of the 18th century. They were made from thin sheets of metal, commonly silver or brass, which were usually gilt or otherwise coloured. Simple floral or leaf shapes were stamped out and punctured at the edges to allow them to be sewn to the fabric. A border of metal purl was worked around the perimeter of the foil to hide its raw edges.

A man's waistcoat of woven chenille and silk,
embroidered with silk, chenille, spangles and foil.
French, 1760s
1571:A-1904

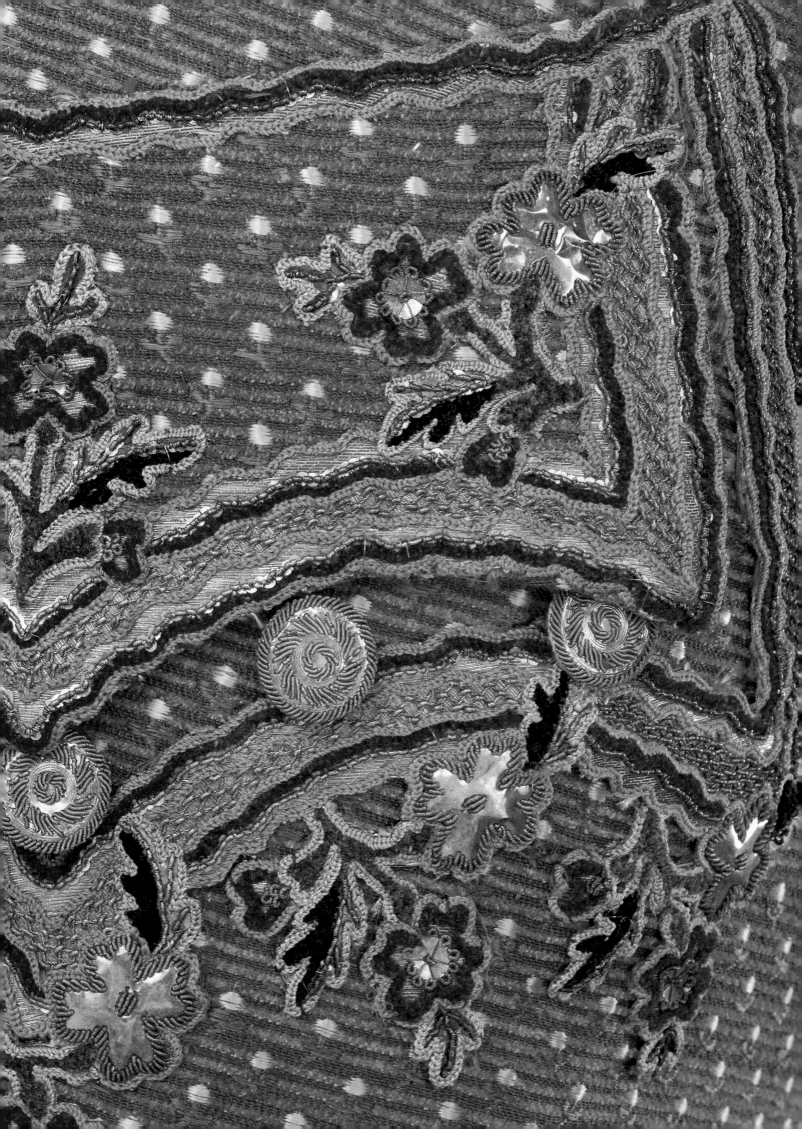

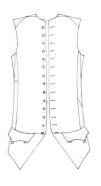 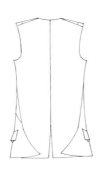

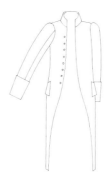 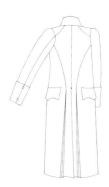

GOLD TISSUE PROVIDES a sumptuous foundation for this extravagant 1780s waistcoat. Over the shimmering ground is worked a delicate pattern of swags, bows and floral sprays in silver-gilt spangles, purl and beads, enlivened with red and green spangles, as well as red foil. The lightness of the pattern conforms to the new neo-classical aesthetic, while the overall richness harkens back to the early 18th century, and demonstrates the conservatism of formal clothing. This garment would have formed the contrasting element to a Court suit, perhaps of a lush red velvet, such as can be seen in Thomas Gainsborough's portrait of Captain William Wade of 1771, which features a similar gold waistcoat.

A man's waistcoat of gold tissue embroidered with spangles, beads and foil, backed and lined with ivory silk.
French, 1780s
Gift of Mrs Phoebe Timpson
T.364-1995

SILVER-FOILED PASTES, silver spangles and purl compose a pattern of floral sprays on this silk velvet coat of the 1780s. Its original turquoise dye has faded over time to a greenish hue. Glass paste was first developed as a substitute for gemstones, particularly diamonds, in the 1670s, and by the 18th century became a very popular type of jewellery; it occurs in embroidery in the last three decades of the 18th century. It usually had a backing of thin metal, either silver to heighten its brilliance, or coloured foil to approximate other precious stones. The paste here has crazed or clouded, but when new it would have sparkled as brightly as a mirror. When Beatrix Potter visited the V&A in 1903 to look for inspiration for her children's story *The Tailor of Gloucester*, she was shown this coat. It appears on page 12 as a backdrop to an illustration of a little mouse dressed in an 18th-century *pet-en-l'air* and mob cap.

A man's Court coat of silk velvet embroidered with pastes, spangles and purl, lined with ivory silk satin and fustian.
French, 1780s
1611-1900

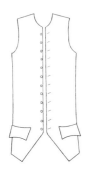 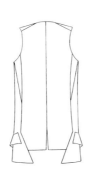

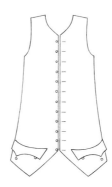 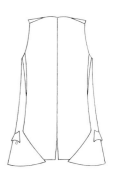

AN EYE-CATCHING contrast of light and dark creates the decorative pattern of this 1780s Court waistcoat. Against a pale ground of silver tissue flow parallel vertical lines of silver-gilt spangles stitched with black silk in a pattern of alternating angles and curves. Small sprigs of silver purl and black silk are interspersed between. The pockets and front edges are bordered with spangles, and floral sprigs worked in black and white glass beads. Along the lower edges, an applied net of silver thread has been embroidered with waving lines of spangles and the glass bead motifs. The richness of the materials contrapose the restraint of the pattern, exemplifying an intriguing blend of up-to-date design on an old-fashioned style.

A man's waistcoat of silver tissue, with silver net, embroidered with glass beads, spangles and purl, lined with silk twill and fustian.
French, 1780s
Gift of the Earl of Gosford
T.133-1921

VARIATIONS OF SILVER tissue, woven-to-shape, form the fabric of this glittering 1770s waistcoat. Against a ground of green silk, with a stripe of silver strip and thread, twists a solid silver band along the front and lower edges, beneath the pockets and on the pocket flaps. Additional pattern wefts in two shades of brown, two shades of green, and pink, create a floral design over the silver meanders. These motifs have been further heightened with red-foil flowers, silver spangles and purl. Silver tissue covers the buttons, which have been decorated with silver purl and spangles, with blue- and red-foil spangles.

A man's waistcoat of silver tissue embroidered with foil, spangles and purl, lined with ivory silk twill and fustian.
French, 1770s
Given by the Earl of Gosford
T.137-1921

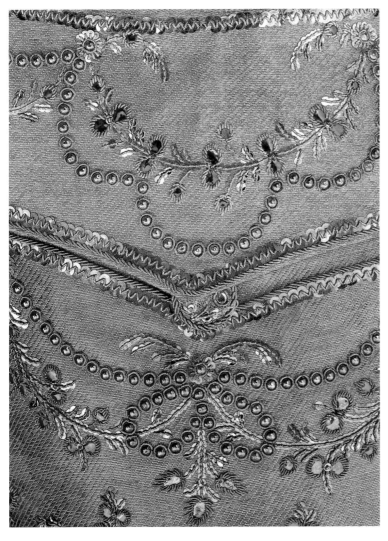
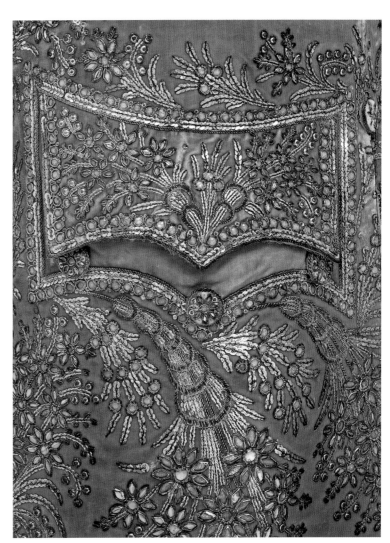
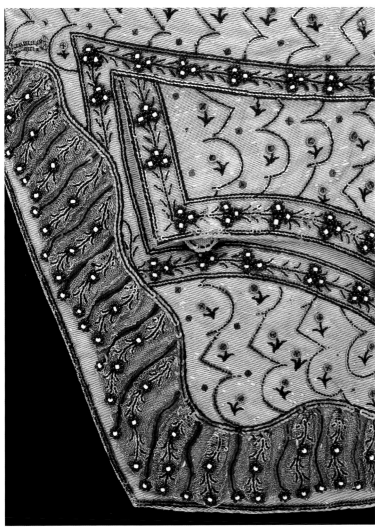
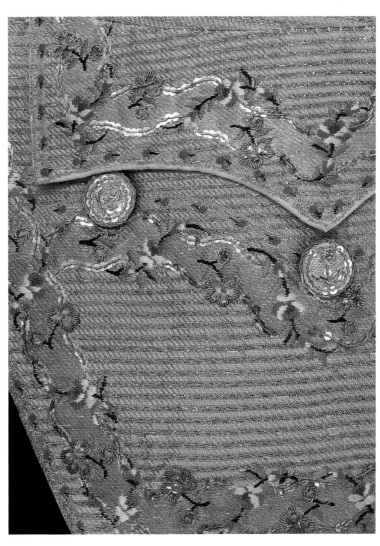

DETACHED BUTTONHOLE STITCH on the peapods and beeswings of this early 17th-century jacket lend a three-dimensional quality to its lush texture. From under each pod peep tiny silver-gilt peas. Silver-gilt thread in plaited braid stitch defines the scrolls which spiral across the spangled linen ground. Amongst a profusion of carnations, roses, foxgloves, borage, honeysuckle, cornflowers, pansies, rosehips, strawberries, quince and vine leaves creep little worms. All are worked in trellis, chain and back stitch in a variety of hues and with silver and silver-gilt threads. The use of the coloured silks is both subtle and eccentric. The vine leaves shade delicately from dark green to yellow, yet the bees have wings of bright blue and deep red. All the black threads have disintegrated, leaving only the stitch holes, but fortunately, it was used only sparely for the antennae of the bees and worms, the birds' and bees' legs, and the calyx of the rosehips.

The design of the embroidery has been carefully planned. The two front sections are mirror images of each other, as are both the outer and inner sleeve pieces. Most unusually an almost identical piece of embroidery survives in the collection of the Embroiderer's Guild, EG 79 1982, a panel probably intended to be a cushion cover. Not only is the pattern and its component elements of flowers, insects and a bird very alike, but the use of colours and stitches corresponds. The striking similarities suggest that both objects were inspired by the same design sources, and the comparable needlework implies that they may have come from the same workshop.

A woman's jacket of linen embroidered with
coloured silks and metal thread, lined with pale blue silk.
English, 1600-1615
1359-1900

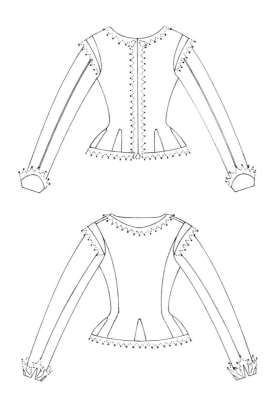

A VARIETY OF WELL-KNOWN flowers have been selected as the embroidered decoration on this linen jacket of 1610 to 1620. Honeysuckle, borage, pansy, rose, foxglove, cornflower and carnation accompany grapes, strawberries, birds and butterflies; all are contained between coiled tendrils of silver-gilt plaited braid stitch. Embroidered linen jackets are particularly associated with English women's fashions of the late 16th and early 17th century. The charming and naive designs of plants and animals are derived from domestic embroideries of the 16th century, which were taken from various sources such as patternbooks, herbals and emblem books. It was also possible to buy embroidery patterns ready-drawn on paper or linen. The detail illustrates some of the floral designs. Trellis stitch has been applied to the flower petals and leaves (some of which have been padded), and stem, chain and long and short stitch, Roumanian stitches, spider knots and speckling also appear, the ground sprinkled with silver-gilt spangles. The embroidery is most probably the work of a professional. Some embroidered jackets were carried out by competent amateurs, as many ladies of this period were accomplished needlewomen: '…it is impossible to say with any certainty whether [embroidery] is domestic household work, or whether it is professional…. It is the integrated expression of a society still creative and joyful in the things it could make and use'.[1] For more details about this jacket, see pp.16 and 74.

1. *Elizabethan Embroidery* by George Wingfield Digby (Faber & Faber 1963), p.35.

A woman's jacket of linen embroidered in coloured silks and
silver-gilt thread, and trimmed with silver-gilt bobbin lace.
English, 1610-1620
T.228-1994

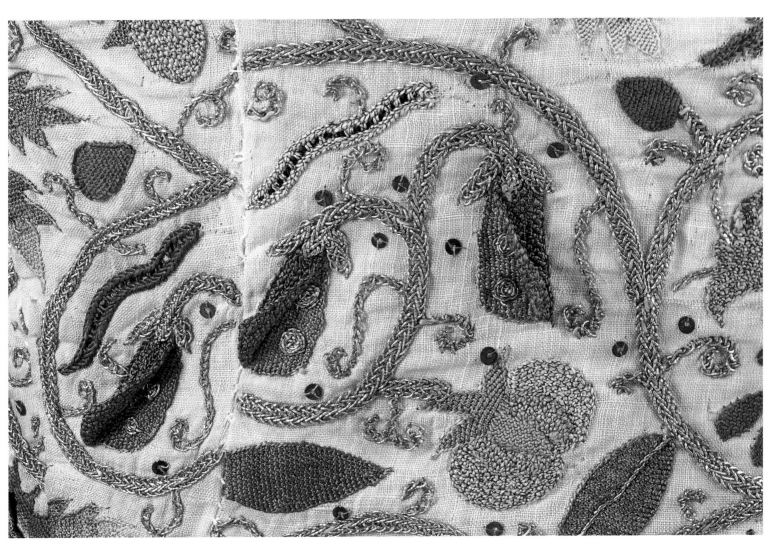

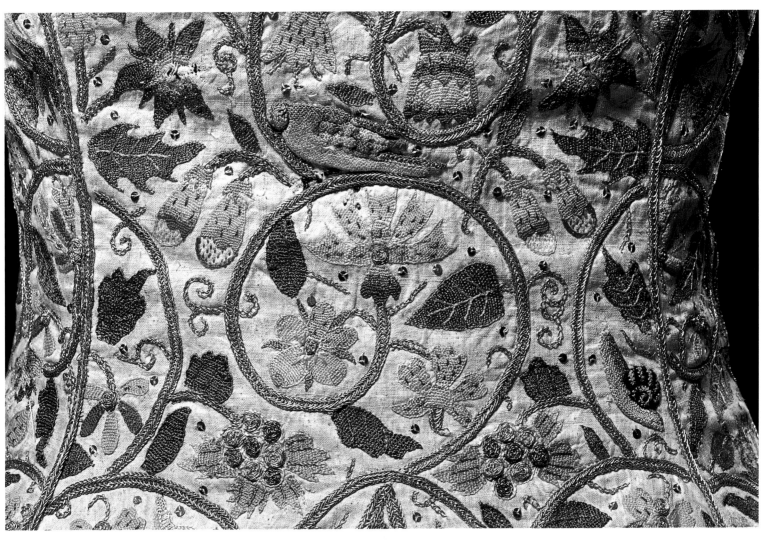

A DEEP CARNATION-PINK silk is the only colour used in the embroidery on this early 17th-century woman's smock. The needlework is equally simple, using just outline stitch. Nevertheless, the interlaced lattice enclosing floral motifs creates a visually satisfying design. The knotted composition was inspired by the strapwork of Italian mannerist ornamentation, which become a popular design element in Elizabethan and Jacobean decorative arts. Late 16th- and early 17th-century portraits reveal the frequent use of strapwork in embroidery, in the form of a grid of rectilinear and circular forms worked in contrasting colours and frequently outlined in metal thread. These are often interspersed with images of flora and fauna, natural and fantastic, inspired by herbals, bestiaries and emblem books. Here the embroidery design consists of two repeating patterns which run diagonally from lower left to upper right: one with a carnation alternating, the other with roses.

<center>
A woman's smock of linen embroidered with silk.
English, 1600-1620
T.326-1982
</center>

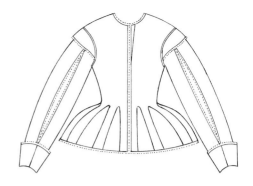

AN EXTRAORDINARY TONAL effect is created with black silk embroidered on linen on this jacket of the 1620s. In the 16th century, blackwork embroidery typically used a variety of geometric patterns within the space defined by the outline of a flower, leaf, insect or bird. A new style of design developed at the turn of the century with the use of speckling stitch. This was a series of tiny seed stitches, longer and worked more densely at the edge of an outline, decreasing in frequency and length towards the centre of the motif, giving a subtle shaded effect. It is thought that the embroiderers were copying the linear visual qualities of the woodblock-printed emblem books, from which they drew so much inspiration for their motifs and figures.

For more details about this jacket, see p.18.

<center>
A woman's jacket of linen embroidered in
silk thread and trimmed with bobbin lace.
English, 1620s
T.4-1935
</center>

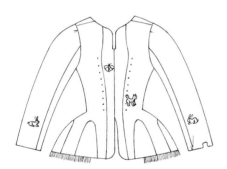

THIS MYTHICAL BIRD is just one of the delightful creatures that populate an embroidered jacket of the 1630s. Worked in red wool on a thick twill of linen warp and cotton weft, the coarseness of the thread and heaviness of the ground lack the delicacy of similar garments embroidered in silk on finer linen, but overall the work has a certain enchanting vitality. The design shows a development in later Jacobean needlework – the scrolling vines seen on jackets of the first two decades of the 17th century have disappeared. Each motif is worked separately, while retaining the curvilinear dynamism typical of Jacobean embroidery. During the later 17th century, this type of needlework, known as crewel work, grew in popularity. It became a principle method of decorating household furnishings, particularly bed curtains and valances.

A number of contemporary alterations to the front and sleeves of the jacket have been made.

<center>
A woman's jacket of cotton-linen
twill, embroidered with red wool.
English, 1630s
T.124-1938
</center>

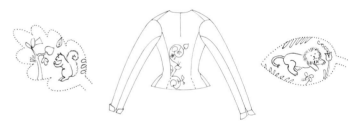

THE IMAGERY ON this remarkable early 17th-century jacket is one of the most visually sophisticated examples of its kind. An extraordinary range of mythical creatures and scenes were embroidered. Three scenes resemble closely images from Geffrey Whitney's *A Choice of Emblemes and Other Devises* (1586): Actaeon devoured by his hounds, Bacchus beating a drum, and the pelican in her piety. A variety of beasts, real and fantastic, have also been included, as well as exotic and domestic birds. All of these devices are incorporated into the design within flower, fruit or leaf-shaped compartments.

The tragedy of this masterpiece of erudition and design is that the black silk embroidery threads contain iron as a mordant, to achieve the desired intensity of the dye. Over the years, the iron causes the silk to disintegrate. The detail indicates the extent of the loss; only a few motifs are now intact. There are no modern conservation techniques to prevent this self-destruction, and a fine dusting of black under the jacket indicates its progress. Photographs taken for this publication record the remaining endangered splendours of this garment.

<center>
A woman's jacket of linen embroidered in black silk thread.
English, 1620s
T.80-1924
</center>

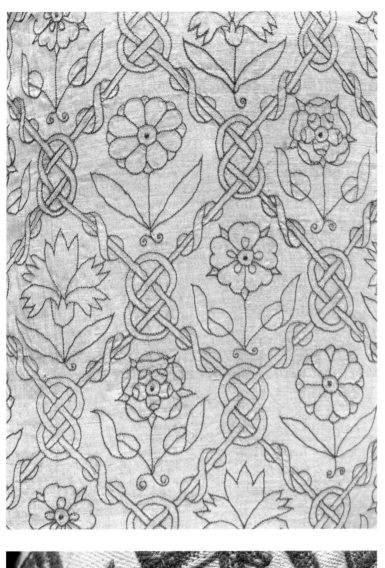

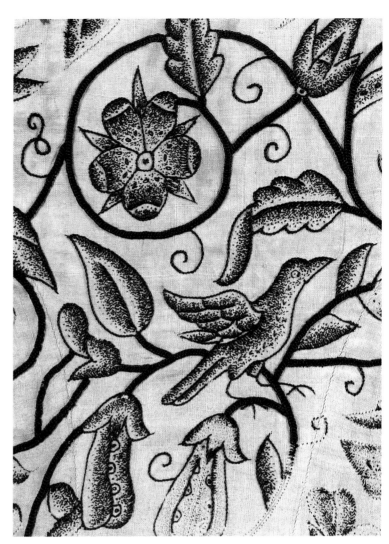

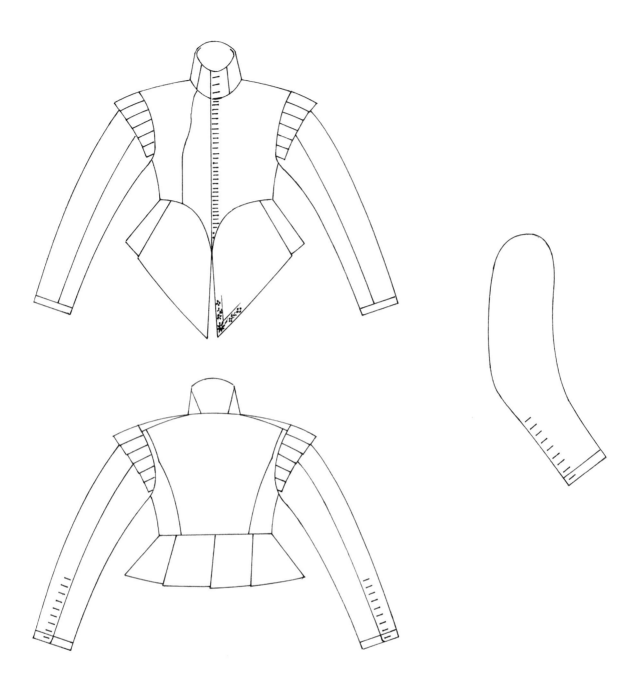

BLACK SILK EMBROIDERY creates a rich effect on this soft kid leather doublet of 1625 to 1630. Very few early 17th-century leather garments of such high quality survive.[1] This doublet has a fine suede finish which was popular for fashionable leather items in the late 16th and early 17th centuries.

The skirt tab in the detail illustrates the various embroidery stitches which have been used; these include raised satin stitch, French knots, couching and stem stitch. The compact design of stylised floral and leaf shapes is divided into panels which are bordered with couched black silk. Giving an added dimension, the larger motifs are worked in raised satin stitch and the ground scattered with French knots reinforces the dense nature of the impressive design. The entire design had first been worked in brown linen thread.

This doublet originally belonged to the Cotton family of Etwall Hall, Derbyshire.

1. Other examples of 16th- and 17th-century embroidered suede leather clothing are held in the Metropolitan Museum, New York, USA, and The Stibbert Museum, Florence, Italy.

Detailed information relating to these items can be found in Janet Arnold's book, *Patterns of Fashion c.1560-1620* (Macmillan 1985).

One of the earliest surviving examples of a suede garment is a gazelle-skin loin cloth of 1500 BC, held in the Museum of Fine Arts Boston, USA.

A man's doublet of
embroidered leather.
English, 1625-1630
Given by Lady Spickernell
T.146-1937

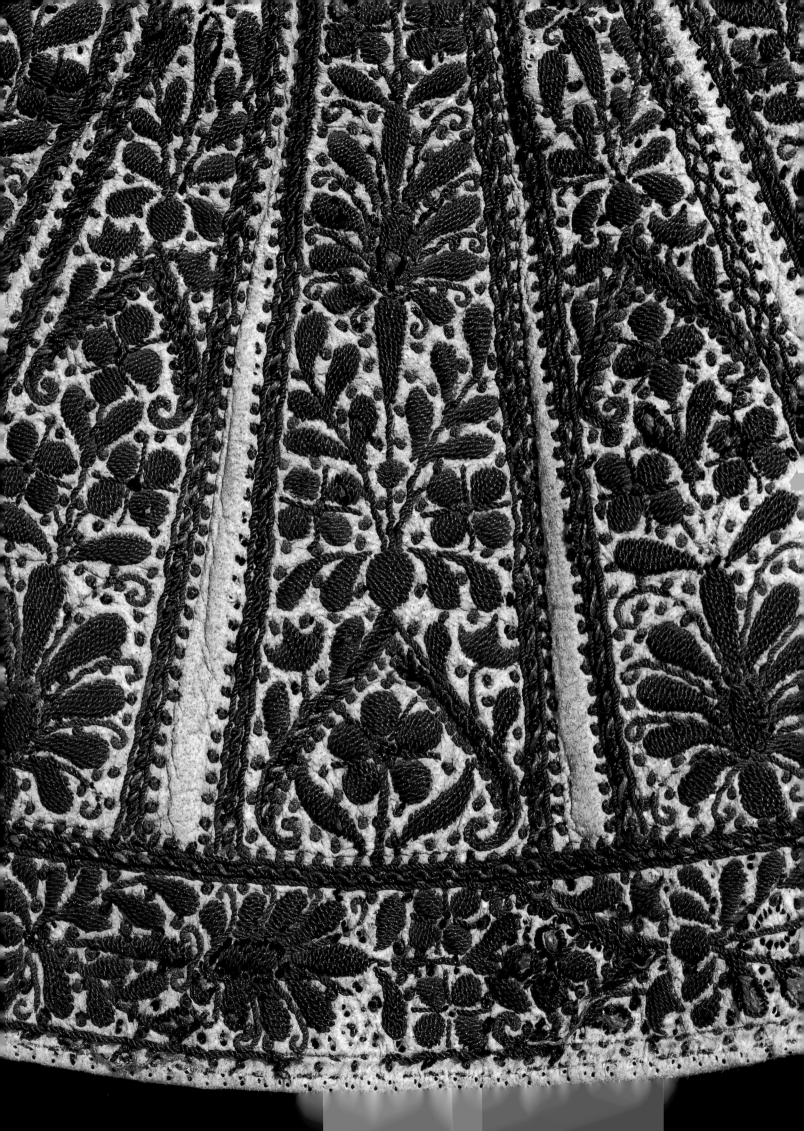

THE SHELL, THE quintessential rococo motif, constitutes the basis of the embroidery pattern on this superb Court mantua of the 1740s. Leafy scrolls, latticed arcades and tassels are also featured, as well a profusion of realistically rendered flowers, including jasmine, peonies, roses, poppies, auricula, morning glory, anemones, hyacinths, carnations, honeysuckle, cornflowers, tulips and daffodils. These have been worked in a variety of coloured silks in satin stitch and French knots. A wealth of couched silver embroidery in filé, frisé, strip and purl delineates the leaves and the non-floral components of the pattern. Some of the scrolls and border elements have a backing of parchment, for solidity and regularity of line. The tassels and bases of the shells have been thickly padded underneath. To replicate the veined texture of each leaf, a technique called gaufrure has been used, which gives the surface of stitching a rippled effect by varying the height of the padding under the silver embroidery. The pattern of the silver shells and scrolls has been arranged symmetrically at the hem, but the layout of the flowers, while balanced, does not match on either side.

Such a naturalistic design so sumptuously executed characterised Court dress of the 1740s. Elizabeth Robinson (later Mrs Montagu) wrote of a similarly worked garment worn by the Duchess of Queensbury in 1740: 'her cloathes were embroidered upon white satin; Vine leaves, Convulvus and Rosebuds shaded after Nature....' [1]

1. Emily Climenson, *Elizabeth Montagu, The Queen of the Blue-stockings, Her Correspondence from 1721-1760*, (London: John Murray 1906), vol.1, pp.63,64.

A mantua petticoat of ivory ribbed silk
embroidered with coloured silks and silver thread.
English, 1740-45
T.260:A-1969

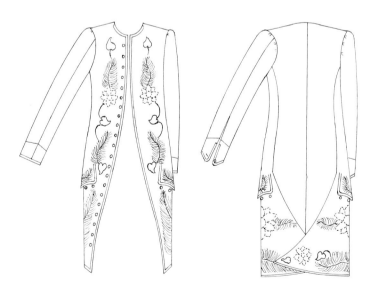

MEN'S COURT DRESS was as lavish as that worn by women. This luxurious sleeved waistcoat of the 1730s is made of yellow satin and embroidered with coloured silks and silver threads including filé, frisé, strip and purl. A pattern of large flowers and leaves with feathered scrolls covers the front edges, the pocket flaps and the whole of the skirt fronts. The silver threads have been couched, while the silk is worked mainly in satin stitch. The heavy borders of plain silver thread have been worked over pieces of shaped vellum or parchment, in a technique known in the 18th century as guipure. In several areas, the metal and fibre embroidery threads have been intermingled, either side by side in narrow strips, or by couching silk threads with silver purl. A honeycomb pattern of silver strip and purl constitutes the centre of the large scrolls and allows the rich saffron satin to show through the needlework. Passementerie buttons, each worked with silver foil, purl, filé and a single silver spangle, edge the pocket opening and fasten the front.

The waistcoat is unusually lavish, the expensive satin has been used for the back of the garment as well as the sleeves. Characteristic of the 1730s are the extent of the embroidery and the length of the waistcoat. To make them stand out, the deeply flaring skirts have been wired at some later date, perhaps for fancy dress.

A man's waistcoat of yellow satin embroidered with
silk and silver thread, lined with fustian and ivory silk.
English, 1730s
252-1906

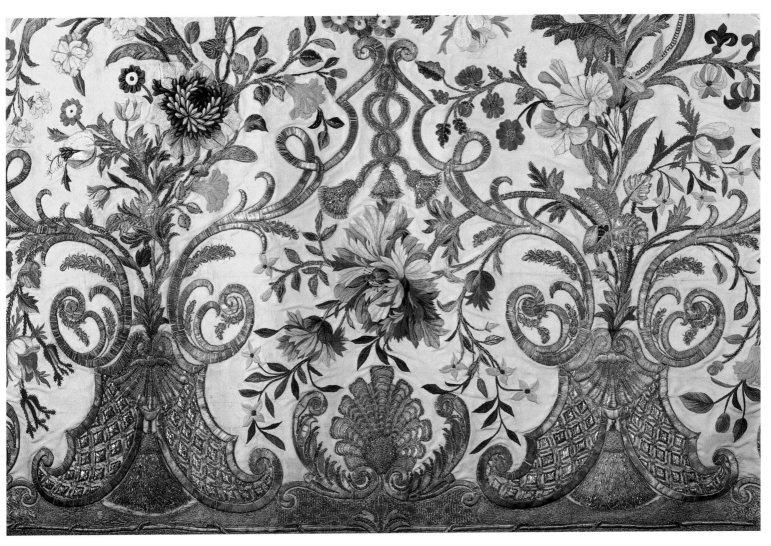

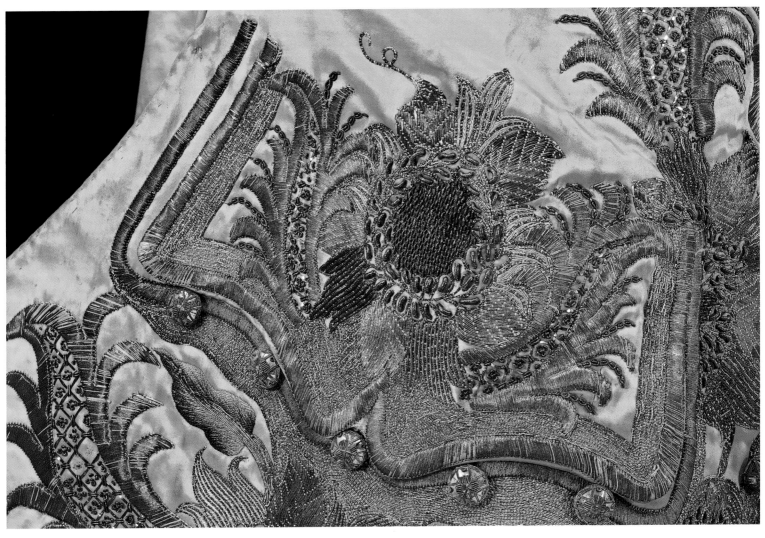

A COMBINATION OF silk and chenille in diverse colours provides a sumptuous embroidered surface to this waistcoat of the 1740s.

Such well-known flowers as peonies, tulips and roses are included in this design of outsize floral motifs. Large flowers and plant forms were a feature of 1740s textile design and appeared to dramatic effect on men's waistcoats. A lavishly embroidered waistcoat like this would have been expensive, probably costing between £6 and £10 or 11 guineas. The higher price level accommodated precious metal threads.[1] This was the last decade when men dressed as flamboyantly as women. Many revelled in extravagant attire selecting bold designs in vibrant eye-catching colours. This conspicuous mode of dressing declined as the second half of the century ushered in more conservative styles.

The donor believed that this waistcoat had belonged to her ancestor Edward Kensington who married in the 1720s and was a hotelier in Salisbury.

1. *The Clothing Accounts of George Thomson 1738-1748* by Avril Hart, *Barbara Johnson's Album of Fashions and Fabrics*, edited by Natalie Rothstein (Thames & Hudson 1987); there is a reference to the purchase of a costly embroidered waistcoat in 1748 'Pd Sanxay for an embroidered waistcoat £10 10s', p.150.

A man's waistcoat of silk
and chenille embroidered with thread.
English, 1740s
Given by Mrs Ensor
T.271-1923

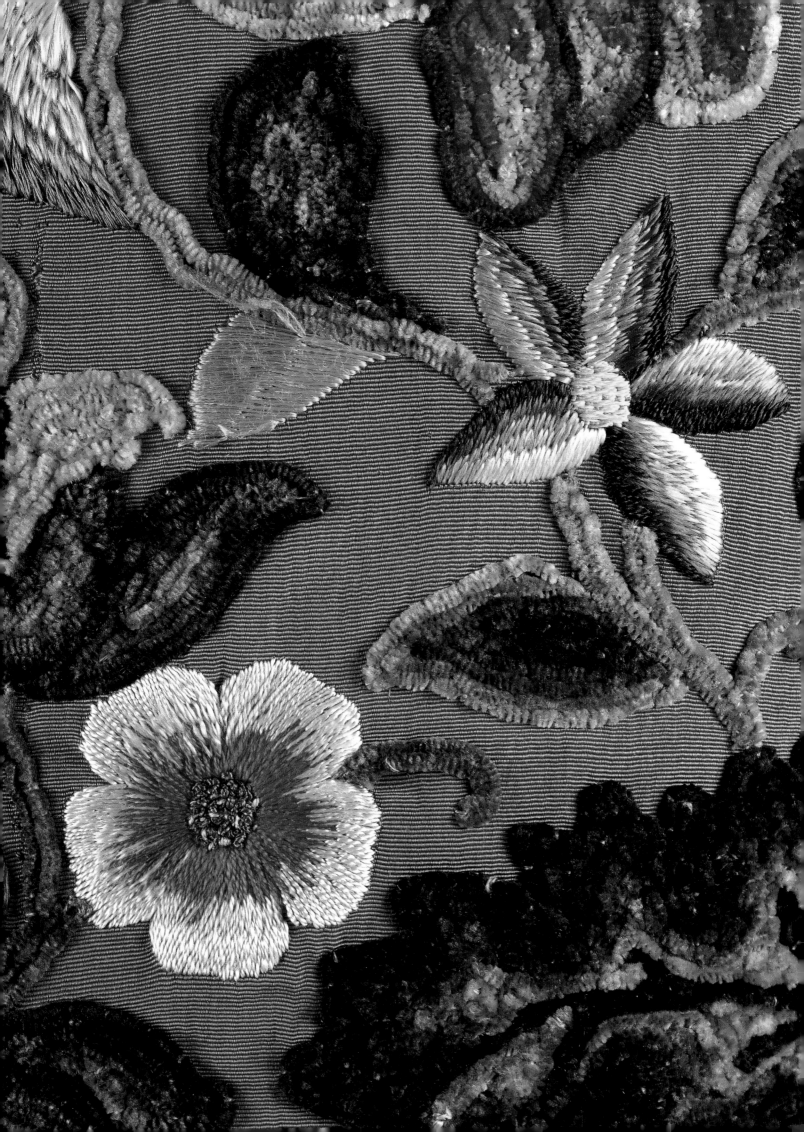

NOT A SPECK of the white satin ground of this dazzling waist-coat is visible, so densely have the metal threads been laid down. A flowing pattern of leaves and flowers has been embroidered in silver-gilt filé, frisé, strip, purl and spangles. The ground between has been filled with silver filé, over which is worked more silver-gilt thread, purl and spangles in small floral motifs. Application of the gaufrure technique adds fur-ther texture to the couched metal threads. By using very fine coloured silks for the couching threads, white for the silver and yellow for the silver-gilt, the tiny stitches holding the metal in place are cleverly concealed. The waistcoat has been altered at the armholes, probably for fancy dress.

Lord Chesterfield wrote about the effect such a sumptuous garment could have in public when Beau Nash, Master of Ceremonies at Bath, appeared similarly attired: '...he wore his gold laced clothes on the occasion, and looked so fine, that, standing by chance in the middle of the dancers, he was taken by many at a distance for a gilt garland'.[1]

1. Lord Chesterfield to Henrietta, Countess of Suffolk, 2 November 1734. *Letters of Henrietta, Countess of Suffolk and her second husband, The Hon. George Berkeley; from 1712 to 1767* (London: John Murray 1824), Vol. II, pp.116-17.

A man's waistcoat of white satin embroidered with
metal thread, lined with white satin and fustian.
French, 1730s
408-1882

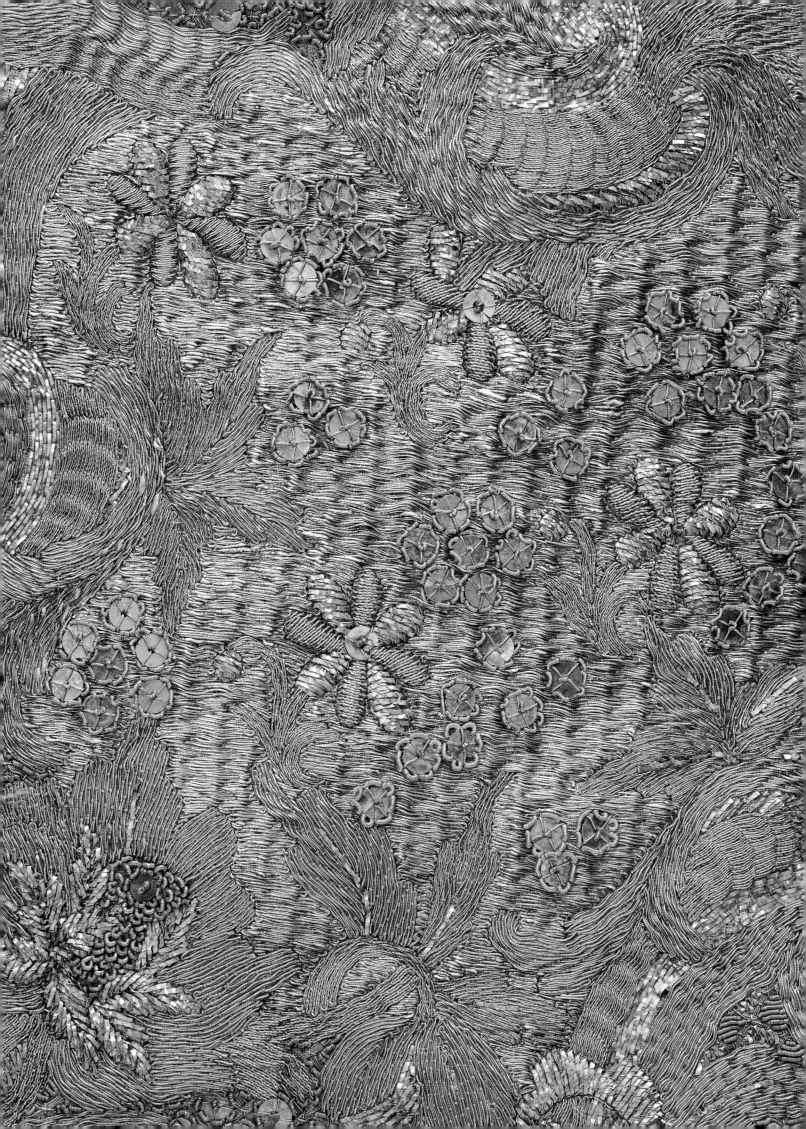

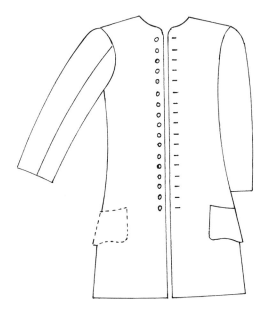

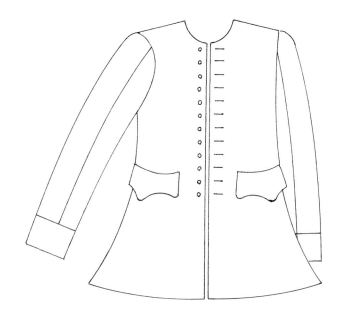

A SLEEVED LINEN waistcoat of the 1720s is embroidered in glossy yellow silk with an intricate vermiculate pattern mixed with floral arabesques. A variety of stitches are used including back, chain, satin, long and short, buttonhole, bullion and Roumanian.

Yellow became a popular colour for fashionable fabrics and embroidery in the early 18th century.

A man's linen waistcoat of linen
embroidered in yellow silk.
English, 1720s
T. 125-1938

A SLEEVED COTTON waistcoat of about the 1740s is embroidered in brightly coloured wools in buttonhole and chain stitch. This attractive garment was probably made in India for the European market and might have been specially commissioned by an individual. The chain stitch was worked on a tambour frame with a hook. The bold floral design is an effective amalgam of Indian and European elements. Making maximum use of space, the flowering stems spring from the waistcoat's front corner and reveal an exotic assortment of stylised florets and leaf clusters.

A man's cotton waistcoat embroidered in coloured wools.
Anglo-Indian, 1740s
Given by Miss K. A. Sauvary
T.217-1953

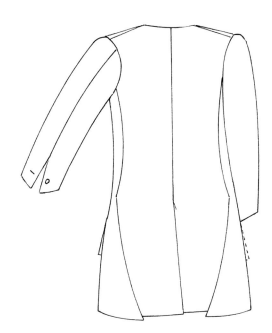

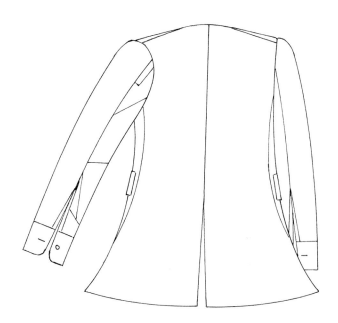

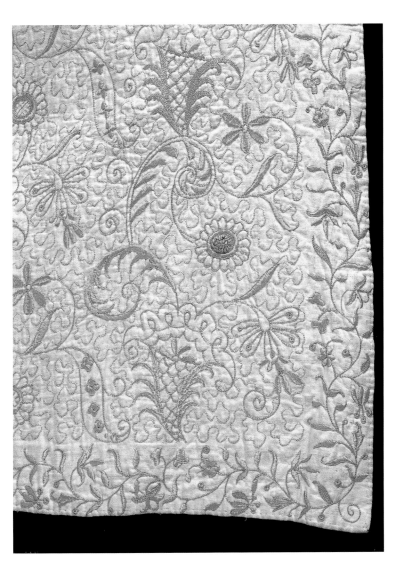 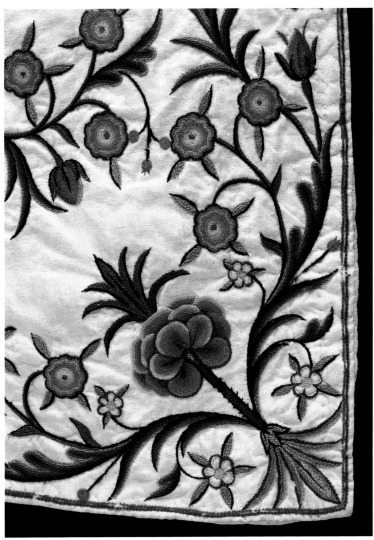

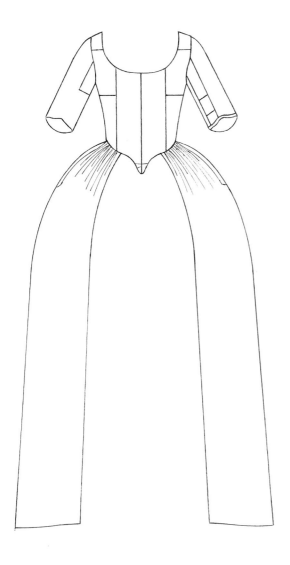
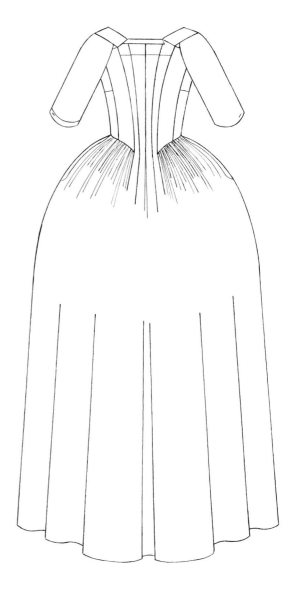

MINUTELY TAMBOURED STITCHES in a myriad of bright colours cover the fine cotton fabric of this dress dating about 1780. The pattern was inspired by the painted Indian and printed English cottons of the 1760s and 1770s. However, the motifs are now smaller, more stylised and less densely arranged. Some of the flowers are too abstract to identify, a very generalised carnation and tulip can just be detected. Although the tambouring was almost certainly done in India, the pattern reflects the changes occuring in European tastes for lighter, more abstract design. The small and large sprays of flowers alternate with a stylised bird in two formations running diagonally.

The art of tambouring was introduced to Europe from India in the 1760s. Instead of using a needle, chain stitch was worked with a tiny hook attached to a wooden handle. The fabric to be embroidered was stretched over a circular frame.

Pressing the hook through the fabric, a loop was drawn through, creating a line of interlocking loops exactly like chain stitch, except that the stitches were finer and could be made much more quickly. This type of embroidery was undertaken by professional needleworkers and also became a genteel pastime for ladies.

The style of the dress reflects the fashionable developments of the late 1770s and early 1780s. The sleeves are elbow length, the front of the bodice fastens down the centre with the skirt opening over a petticoat. Piecing of the fabric in the bodice demonstrates that the fabric was embroidered before it was made up and not worked to shape in any way. Contemporary patches on the lining at the back and under the arms indicate that this dress was much worn and obviously once a favourite garment.

A woman's gown of cotton
tamboured with coloured silks.
English, of Indian fabric and embroidery, c.1780
Given by Mr and Mrs G.H.G. Norman
T.391-1970

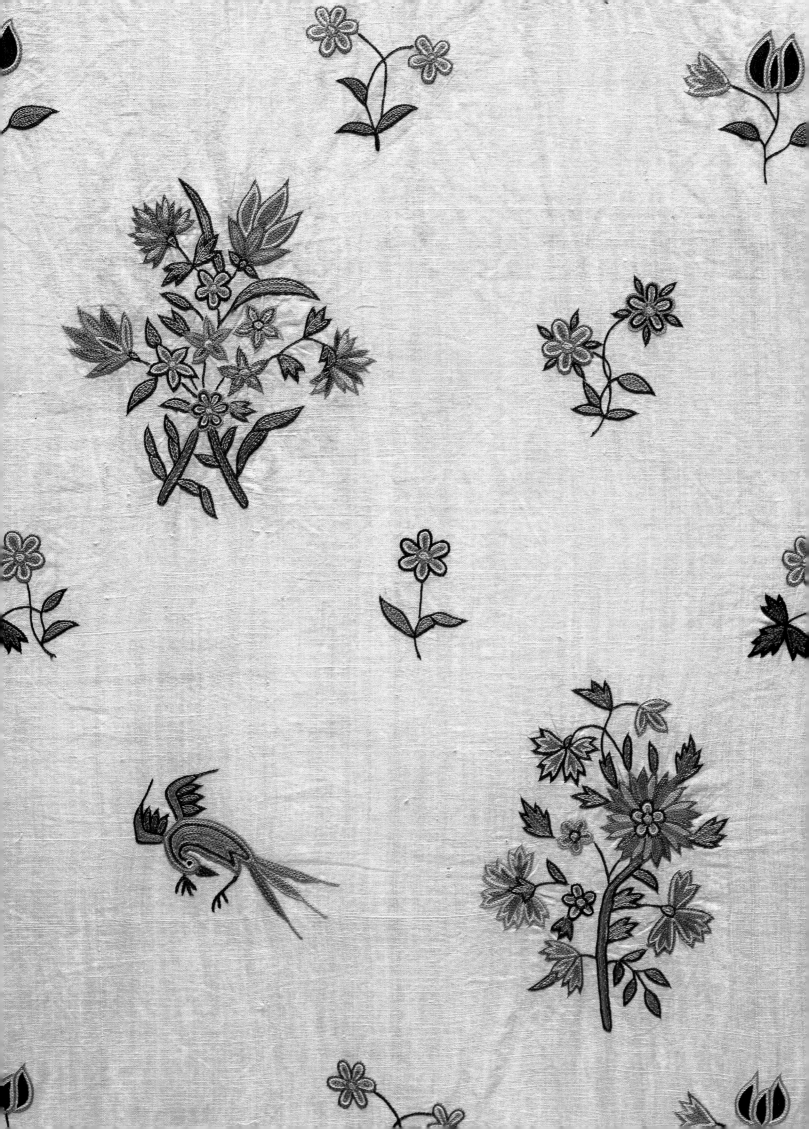

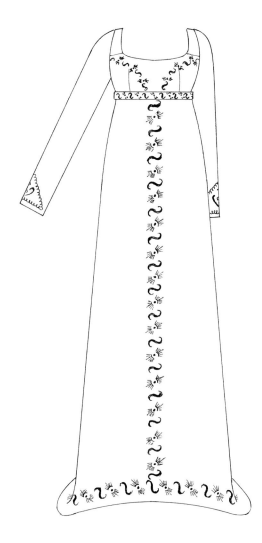

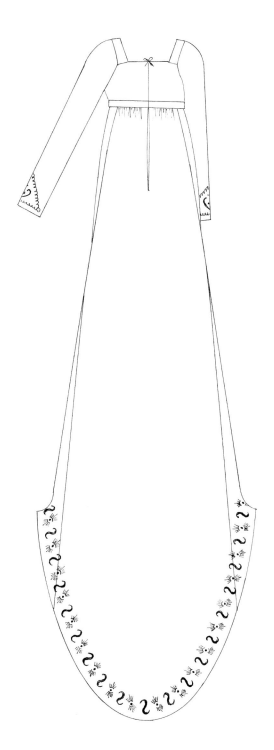

A STYLISED PATTERN of scrolls and loops edges the hem and continues up the centre front of this gossamer-light gown of the turn of the 18th century. It is made of a very fine cotton muslin, tamboured with pale yellow silk. The lines of chain stitch lie flush with one another, giving the embroidery a solidity which contrasts with the delicacy of the fabric. A modified version of the embroidery pattern has been worked on the bodice and at the wrists.

This diaphanous garment is the epitome of neo-classical dress. It has a very high waistline, with a bodice only 4½ inches (11.5cm) deep. A long train extends at the back, and narrow sleeves extend over the wrists. The bodice is secured with a drawstring at the neck. A narrow (1 inch; 2.6cm) embroidered belt covers the seam joining the bodice to the skirt.

A woman's gown of muslin tamboured with silk.
English, of Indian fabric and embroidery, c.1795-1799
Given by Mrs M.E. Wingfield
T.220-1962

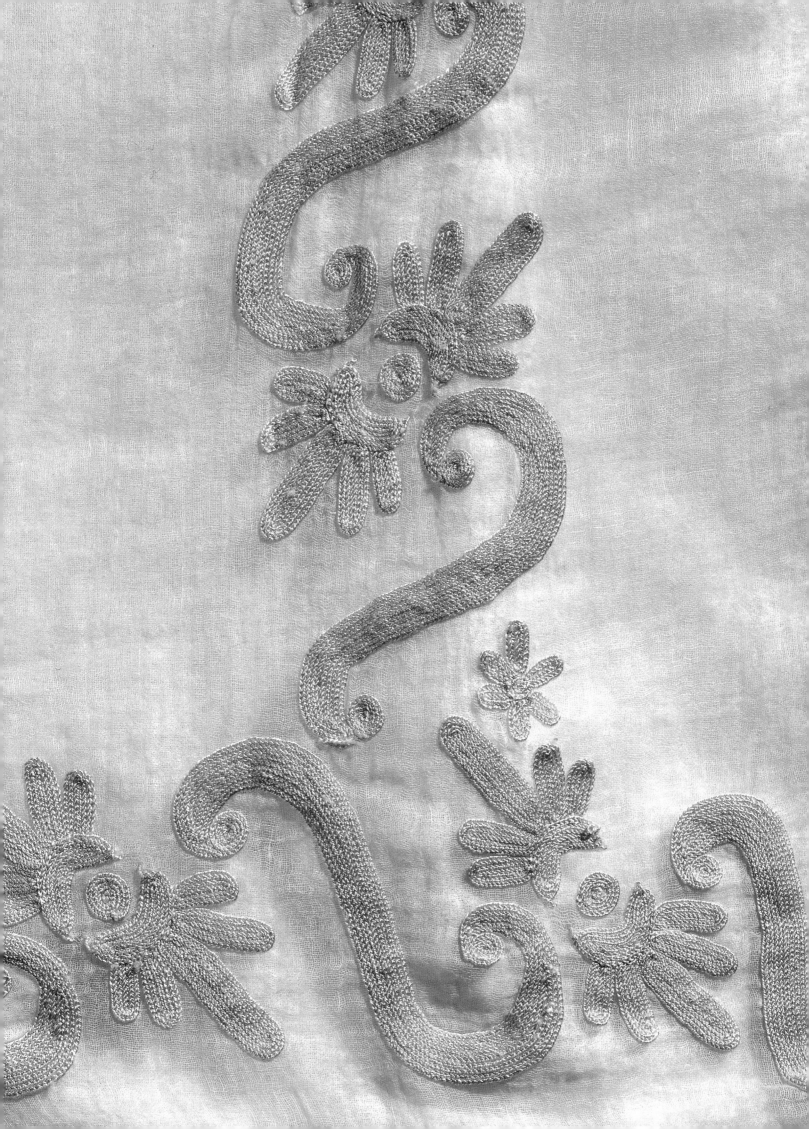

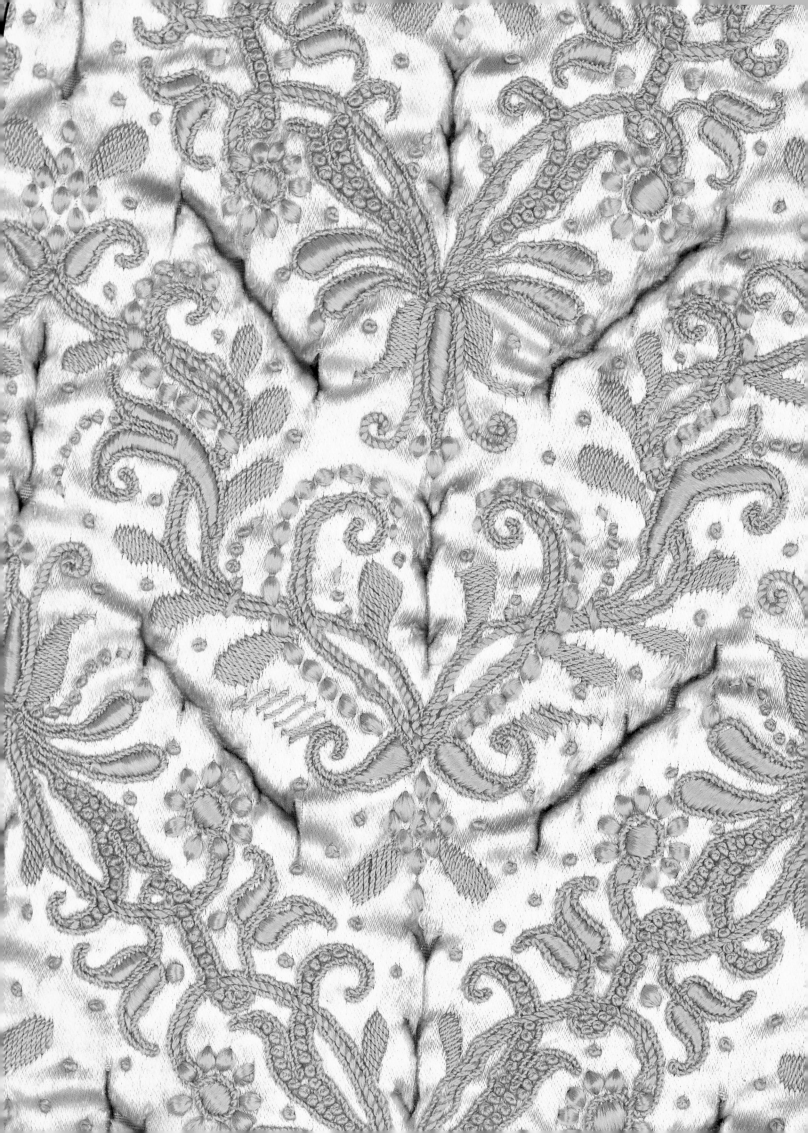

Slashing, Pinking & Stamping

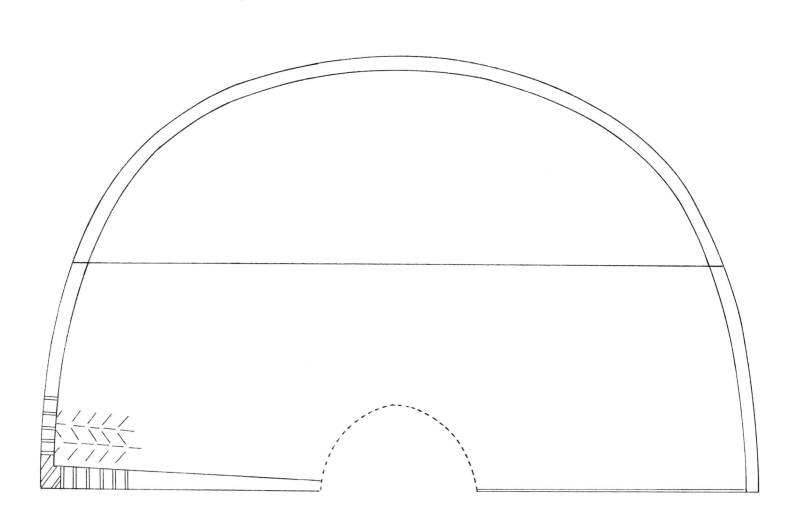

A SEMI-CIRCULAR Italian cloak of 1610 to 1620 made of aquamarine satin (faded to oyster) is elaborately slashed and pinked and richly embroidered in yellow silk and lined with yellow silk taffeta.

The detail shows a part of the cloak including the hem with slashes arranged in vertical rows forming a chevron pattern. Each slash is cross-cut or pinked by a smaller cut. The slashes are graduated from the neck, getting progressively larger towards the hem. A variety of small metal punches were used to make the slashes and the pinking, which was carried out after the cloak had been lined, as some of the cuts have penetrated the lining. The embroidery on the cloak is carried out in floss and twisted silks in satin and padded satin stitch, French knots and knotted chain stitch.

Cloaks were fashionable in the 16th and 17th centuries and considered to be an essential part of a man's costume. They could be circular or semi-circular in shape and of varying lengths, short, medium or long. The collar of this cloak is missing as can be seen in the drawing. It was probably like the stiffened, upright, doublet collar of the period.

A man's cloak of satin,
slashed, pinked and embroidered.
Italian, 1610-1620
378-1898

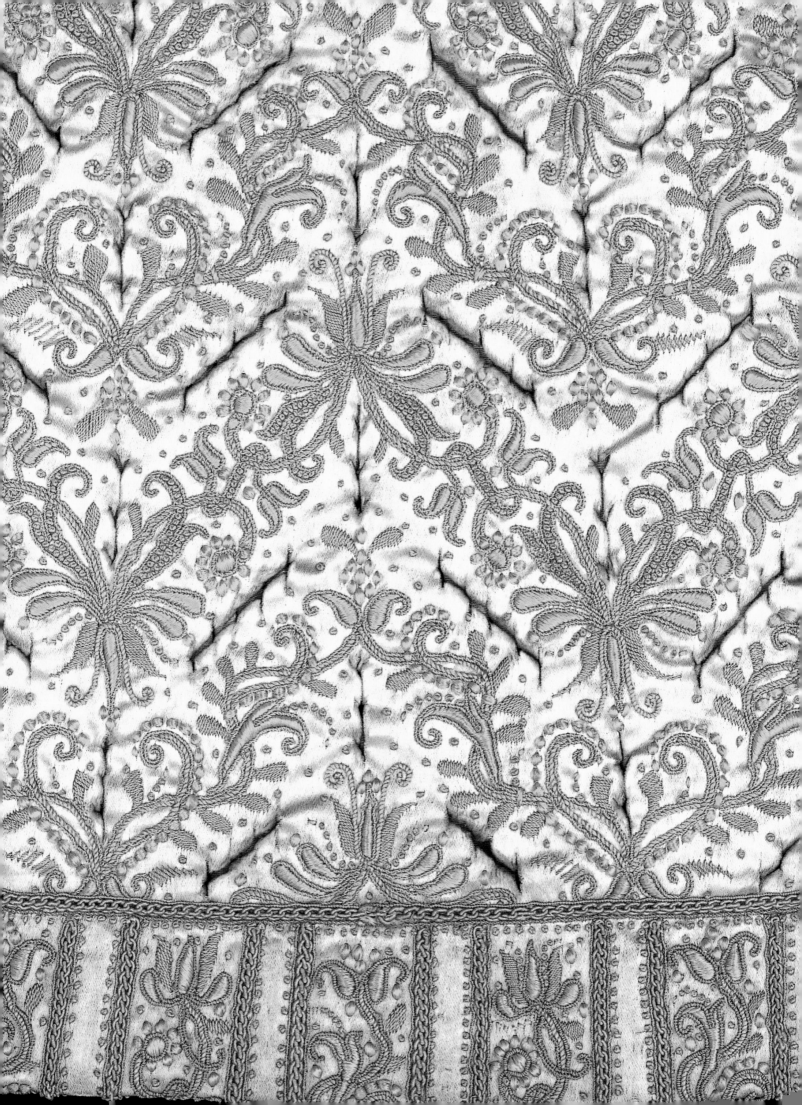

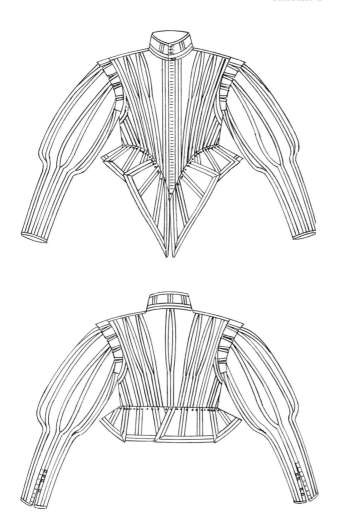

THE EDGES AND seams are trimmed with white silk braid and the doublet is boldly slashed or 'paned' on the chest, back and sleeves. Eight tabs or skirts are stitched around the deeply pointed waist with eyelet holes just below the waist seam for points to support a pair of breeches.

Panes first appeared in the 16th century and were intended to allow a fine shirt or coloured lining to show through, sometimes deliberately pulled through in 'puffs'. They were a particular form of slashing where instead of the small slashes (such as those illustrated on pp.168 and 172) the cuts are much longer and fewer and made parallel to each other. They appear as ribbon-like strips or slits in the fabric. On doublets like this the panes were created by making two cuts on each front panel and two on each back panel, leaving part of the centre back seam open to create a fifth. The detail illustrates part of the left front, the edges of the panes are bound with silk ribbon. The braids are laid on strips of satin and then applied to the doublet. The stamped pattern appears to have been made after the cuts were made. The drawing shows a detail of the stamped design. The black dots which appear around the waistline of the doublet as seen in the drawing are the point holes for lacing the breeches to the doublet.

The front of this and all doublets until the 1660s are stiffened inside with two triangular-shaped 'belly pieces', one placed on either side of the inside centre front, roughly covering the area of the stomach. This stiffening kept the doublet in shape preventing unsightly creasing and ensuring an upright carriage. Made from a variety of materials pad-stitched together in layers and usually including gummed buckram and linen, sometimes interleaved with paste-board. There may also be additional stiffening in the form of strips of whalebone or reeds or even strips of wood. The pointy shape of a belly piece is softened by a final additional covering of coarsely woven wool or linen cloth. Belly pieces were either stitched inside the lining of the doublet or covered with matching lining fabric and stitched on top of the lining.

This lavishly decorated doublet was suitable to be worn at Court and on other important occasions. The portrait of the 1st Duke of Hamilton by Daniel Mytens c.1629, illustrates a similar style of doublet, complete with matching breeches, and conveys an imposing image of a complete outfit finished with luxurious lace accessories.[1]

1. Private Collection of The Duke of Hamilton illustrated in *The Male Image* by Penelope Byrd (Batsford 1979; cover); also *A History of Costume in the West* by François Boucher (Thames & Hudson 1966; rep. 1987), p.268.

A man's doublet of satin, stamped and slashed.
English, 1625-1630
T.59-1910

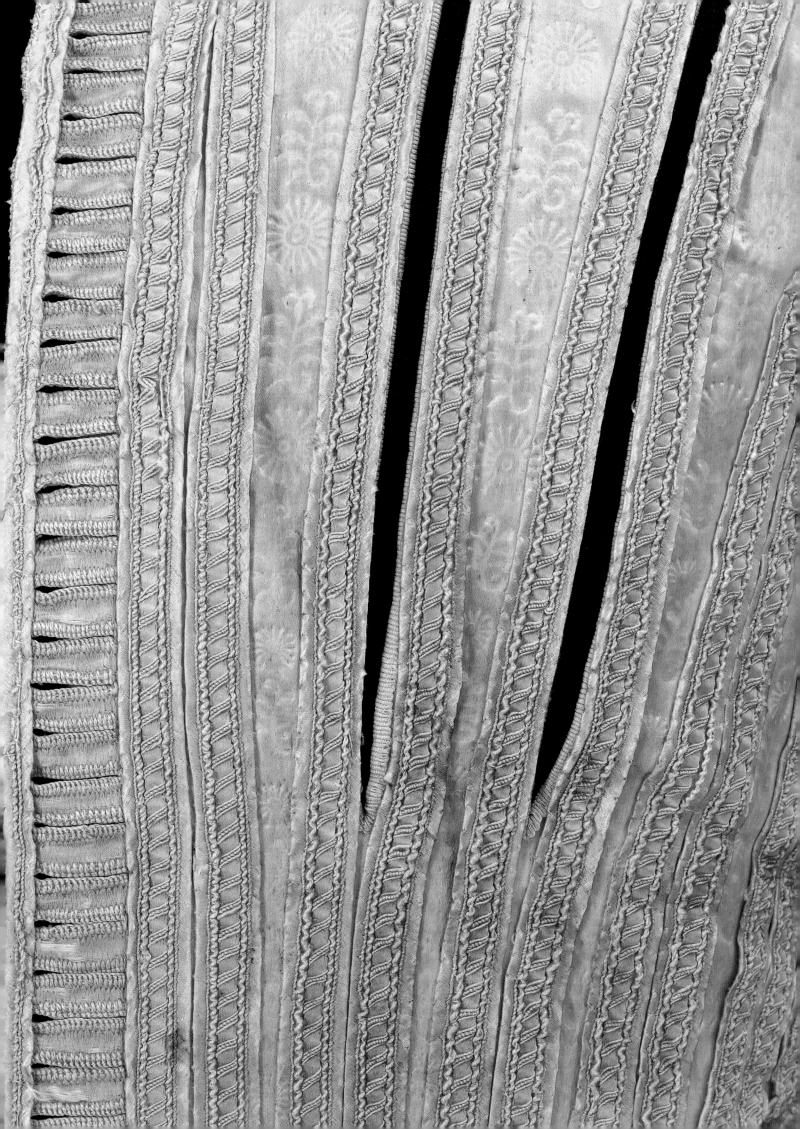

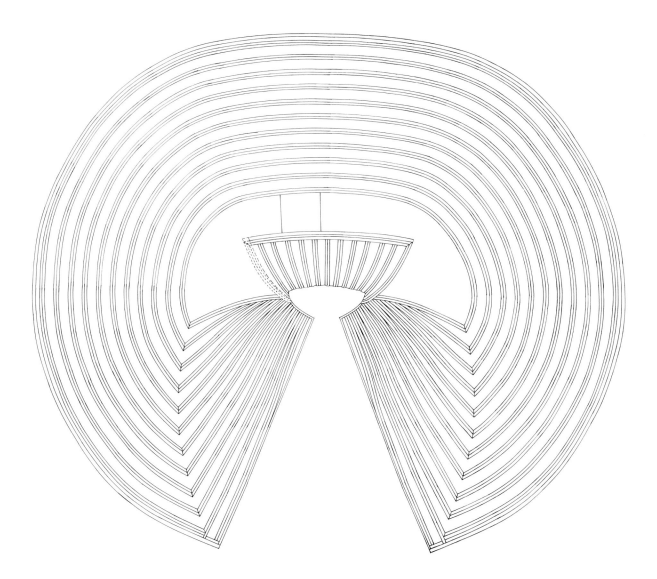

The slashed decoration of this man's three-piece suit consists of carefully arranged cuts emphasised by pinked edges. Narrow bands decorated with silk braid separate the slashes. The slashing is bolder on the cloak, which is shown in the detail. The cuts are graduated in size becoming larger towards the hem and allowing the yellow silk lining to be seen. The cloak is made in a style that proved to be popular in the 17th century of medium length with a hanging, square-shaped collar.

The suit is the height of fashion for the period, made for a man of slight build. The style is a development from the earlier doublet and full padded hose (breeches) illustrating the shift to a simple and elegant mode that followed the natural proportions of the figure.

A man's cloak of satin,
slashed, braided and pinked.
English, mid-1635 to 1640
T.58B-1910

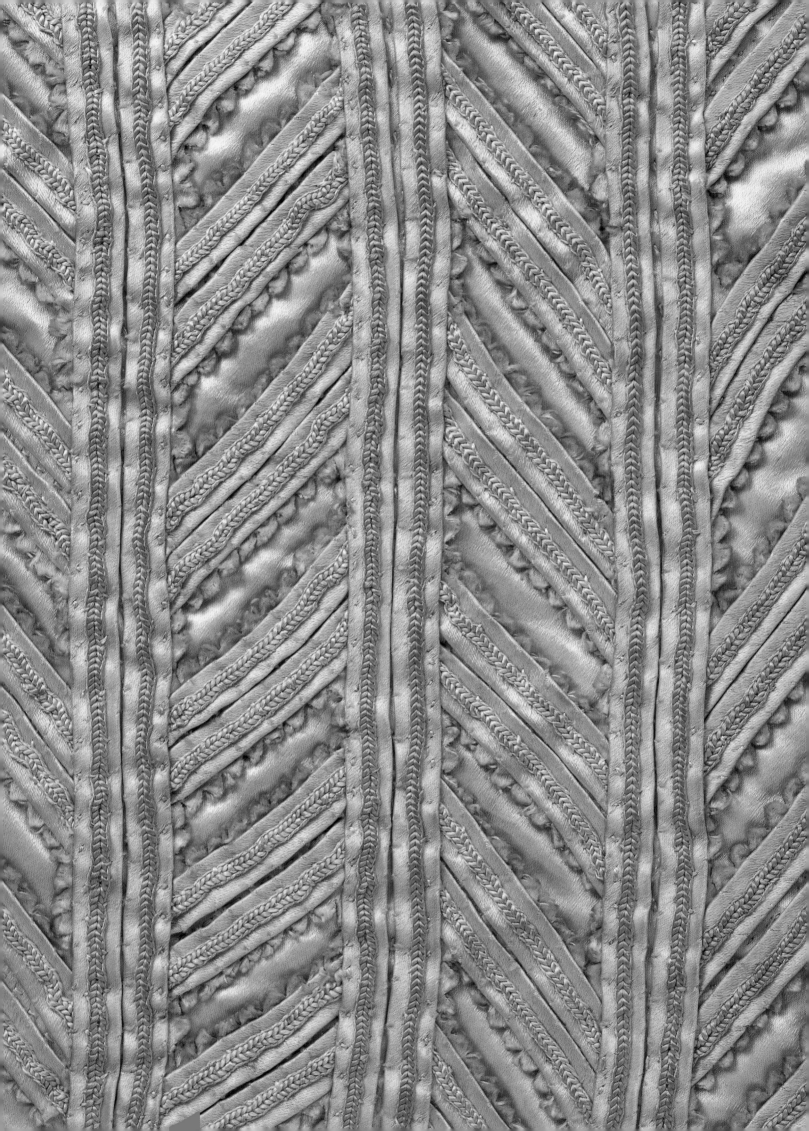

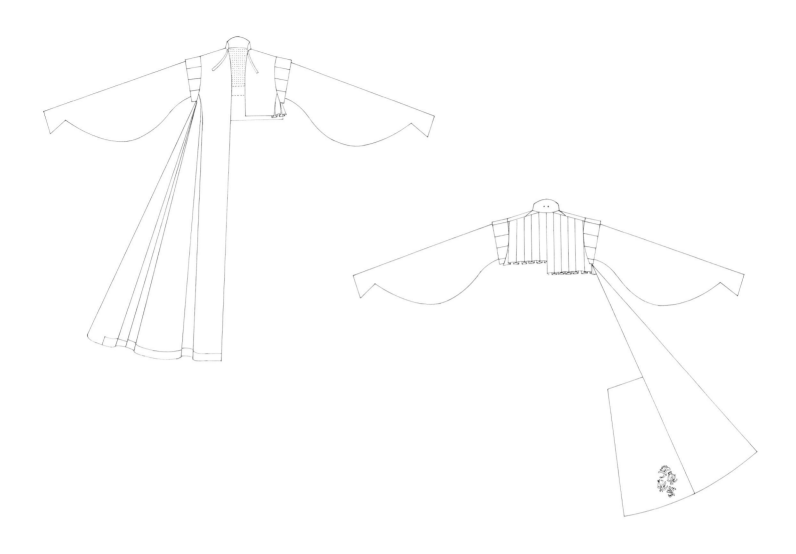

A GRID OF tiny slits patterns the pink silk lining in the sleeves of this early 17th-century gown for a young woman. The practice of making decorative perforations in fabric is known as 'pinking' and it was a popular method of adorning dress from the mid-16th century until the 1630s. While its use waned somewhat in the later 17th century, pinking is found on 18th-century dress and was revived briefly in the 1840s. The holes were made with metal punches, sometimes with a shaped head to create an opening in the outline of a heart or a star. The fabric would be folded several times and cushioned with paper, then placed on a block of lead and the punch struck with a hammer. By refolding the material and punch-ing it again, a pattern of holes was created.

The sleeves of this garment are in a particular style, known as 'hanging sleeves'. They are cut very long with a deep curve narrowing to the wrist. The front seam is left open so that the arm can move free of the sleeve, which is left 'hanging' from the shoulder. The gown is made of a dark mulberry-coloured cut and uncut velvet in two heights of pile, woven in a pattern of flowers and pomegranates. An inner bodice of pink silk lined with buckram and padded with wool provides a base for the back pleats. There is a shaped shoulder wing at the top of each sleeve.

The gown has suffered somewhat over the years: a silver lace trim along the front, hem, sleeve edges and shoulder wings has been removed and a large section of the left front and much of the back cut away. It demonstrates the recycling process to which most historical clothing has been subject: valuable metal trimmings were unpicked and melted down to create something new, and expensive fabric is remade into furnishings. Fortunately, this garment retains enough of its original features to make it an instructive example of early 17th-century construction and detail.[1]

1. See Janet Arnold, *Patterns of Fashion: The cut and construction of clothes for men and women c.1560-1620* (London: Macmillan 1985), plate 122, for a pattern and analysis of this gown.

A woman's gown of cut and uncut velvet,
lined with pinked silk.
English, 1610-1620
178-1900

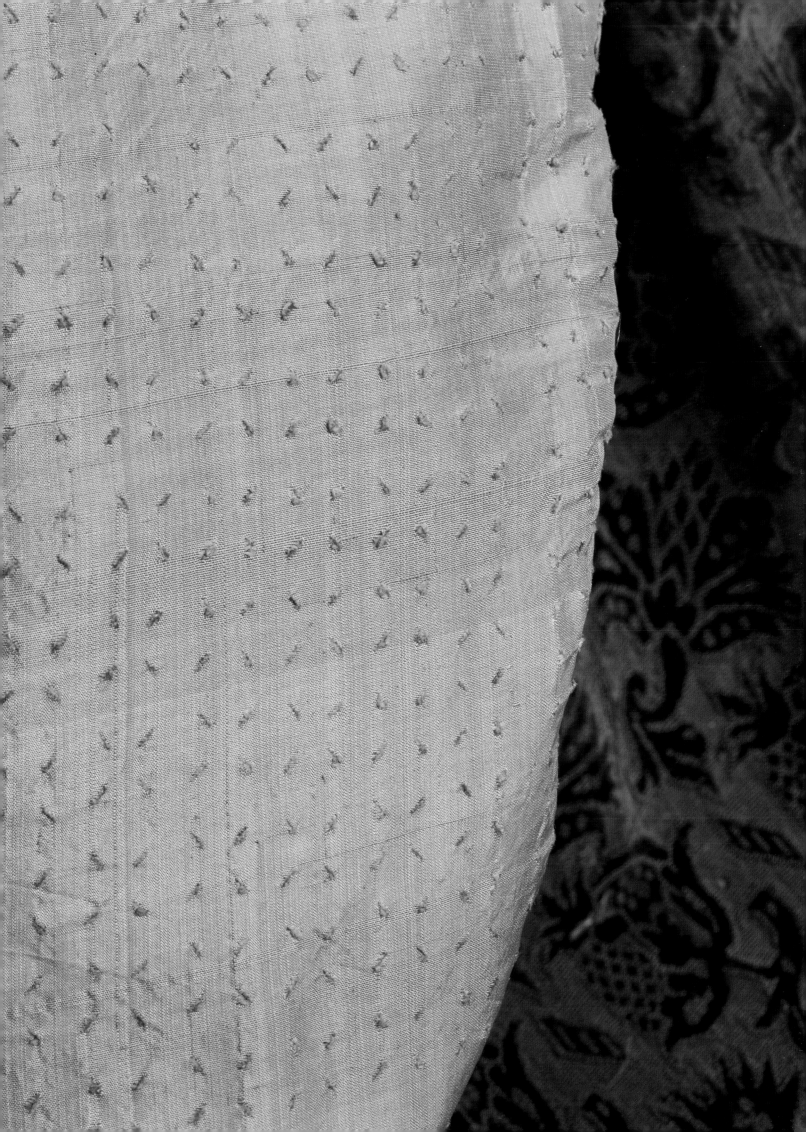

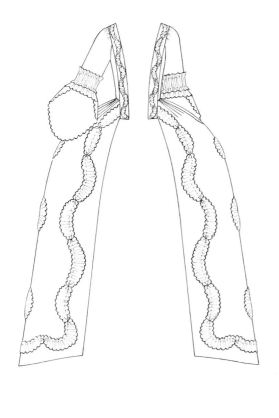
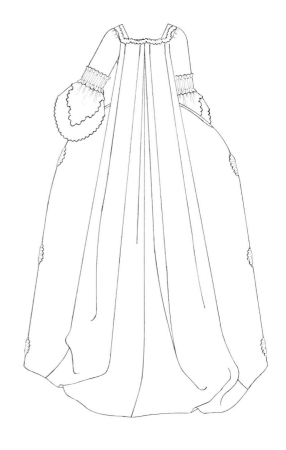
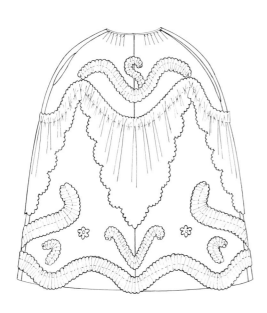
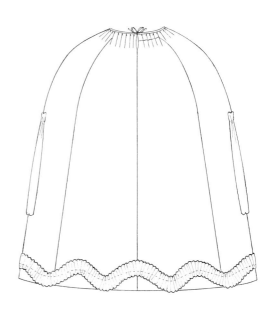

A YELLOW SACK-BACK gown of the 1760s has double sleeve ruffles with scalloped and pinked decoration. Pinking was still popular as a means of creating a pattern on trimmings for women's gowns in the 18th century. Christian Russel, in a letter to her brother Edmund in 1764, gives her suggestions for a sack-back gown for his young wife. She describes with a sketch, the trimmings and ruffles for the gown, and is very precise about the sleeve ruffles, which in her rough drawing look very like this detail. She says that double pleating above the ruffles should be 'like the trimming on bonnets' and the ruffles themselves should be scalloped and pinked on the edges.[1]

1. *Dress in Eighteenth Century England* by Anne Buck (Batsford 1979), p. 74, fig. 40.

A sack-back gown of yellow silk with double sleeve ruffles.
English, 1760s
Given by Lt Col. Robert E. Keg
T.60-1934

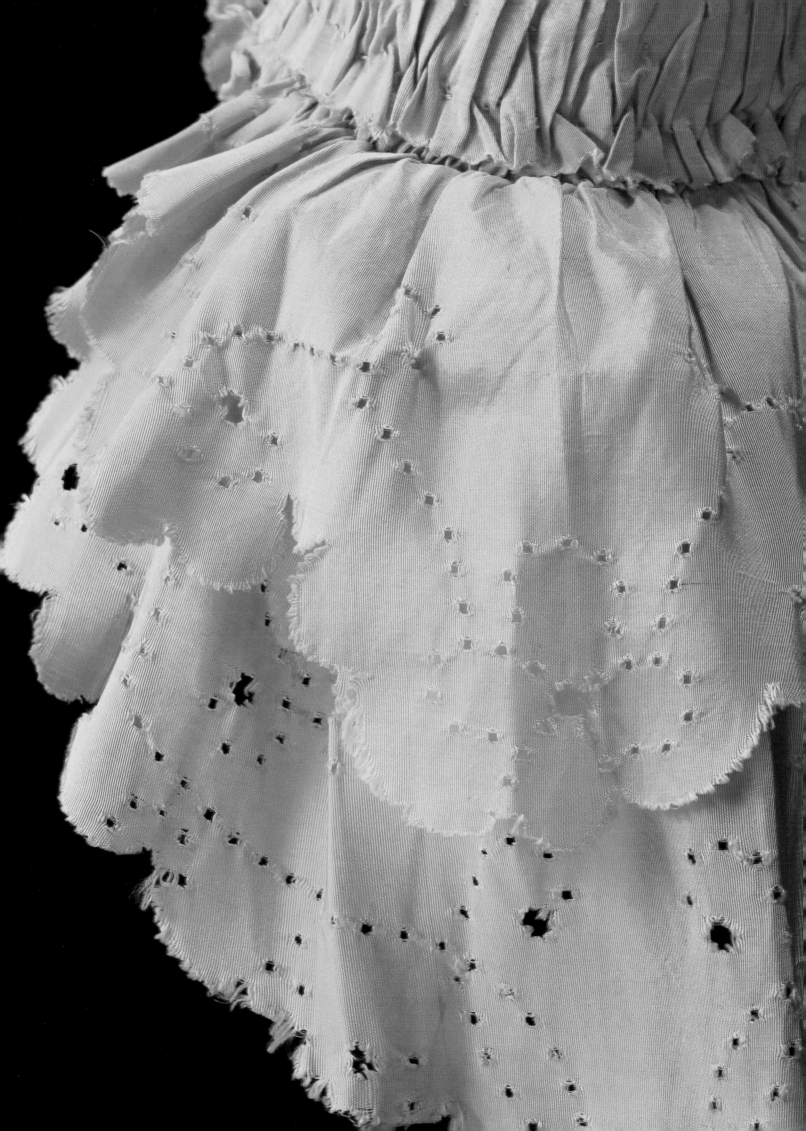

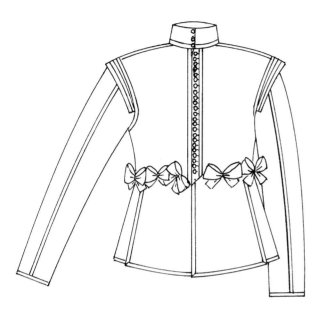
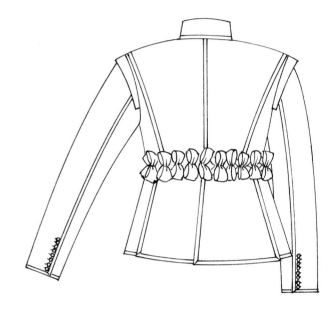

LUSTROUS WHITE SATIN forms a perfect ground for the stamped pattern of a 1630s doublet which is part of a 'grand occasion' suit, completed by a pair of breeches.

The detail illustrates the repeating pattern of decorative daisy-like flower heads and lozenges interspersed with pinking. Decorative silk braid trims the main seams and edges of the doublet. Purely ornamental, silk ribbons with a diaper pattern adorn the waistline.

To achieve the pattern, four small metal stamps, fitted with handles, were employed. Each stamp had a different engraved design (three florets and one lozenge). The work was painstaking and called for considerable skill. Stamping was carried out after the satin panels had been cut out and before they were sewn together to form the doublet. The stamps were heated and carefully tapped (using a special hammer) onto the satin to make a clear impression. The hot metal stamps would have to be exactly the right temperature – possibly tested with spit – as launderesses used to gauge the heat of their irons. A stamp which was too hot could scorch the fabric and ruin an entire panel.

The panels were probably laid over a firm padded surface to prevent the risk of stamps cutting the fabric. It is likely that the satin was dampened slightly before stamping and possibly protected by a layer of paper or fabric which might also have been dampened. A similar technique is employed in bookbinding and the leathers are wetted slightly before stamping as fine leather scorches easily.

For more details about this doublet, see p.114.

A man's doublet of stamped satin.
English, 1630s
348-1905

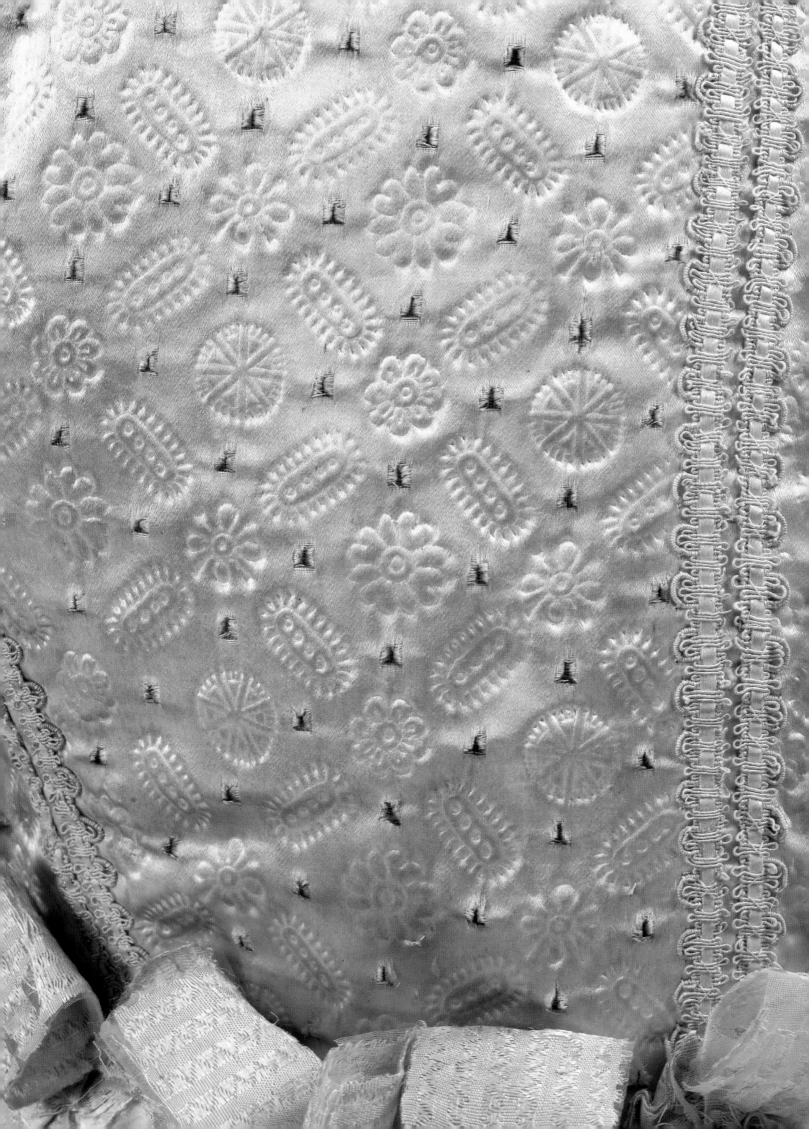

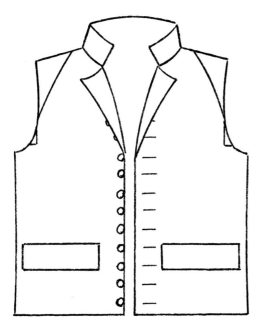 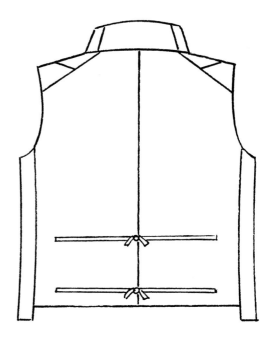

The effect of lace has been created by stamping a configuration of holes on this waistcoat of the late 1780s. Examination under a magnifying glass indicates that the perforations were made by fine, but rounded teeth, which push aside the threads, rather than severing them. The fabric was treated with starch before the pattern was punctured to encourage the threads to stick together, so that the holes would retain their shape. The continuous repeat suggests that the punch was in the form of a wheel which created a seamless design along the length of fabric. The silk of this waistcoat may have been woven especially to be stamped. Stripes of satin weave in large squares and small chevrons alternate with stripes of ribbed silk dense enough to bear perforation without unravelling. The waistcoat front is backed with pale blue silk, which shows through the holes. A fragment of a linen waistcoat in the collection exhibits similar treatment: an abstract pattern of scrolls and floral sprigs comprised of holes of varying size, punched into the fabric. A backing of pink silk, now very faded, once enhanced the perforated pattern.

The inspiration for such a method of decoration comes from a similar procedure employed on the paper and card used for fans, screens and powder boxes. Stamping perforated designs on paper was an inexpensive way of approximating the effect of carved ivory fans. In his *Dictionnaire des Sciences*, Diderot describes how these effects were achieved on a variety of materials, including fabrics, using both decorative punches and rollers with relief designs.[1]

1. Denis Diderot, *Dictionnaire des Sciences* (1757), Vol. IV, pp.525-7.

A man's waistcoat of silk stamped
and embroidered, lined with linen.
English, 1785-1790
835-1907

Knitting, Lace & Openwork

A DEEP CORAL-pink silk and yellow, partially wrapped with sil-ver-gilt strip, make the pattern of curvilinear floral sprigs on this 17th-century knitted jacket. It is comprised of rectangu-lar panels of varying dimensions which constitute the sleeves, fronts and back. The design has been worked in stocking stitch, with a basket-pattern border at the hem. This eye-catching garment, and others like it, pose many questions concerning their method and date of production. Opinions are divided as to whether they are Italian or English, frame or hand-knit.

The design consists of separate floral sprays rendered in a curvilinear style, suggesting a date comparable with jackets embroidered with similar motifs, that is the 1630s. With only eight stitches to the inch, the knitting frame was a fairly crude instrument at this period, and there was no means until the 1750s of accomodating the purl required for ribbing or the basket pattern shown here. So the gauge of seventeen stitches per inch and the ribbed squares at the hem rule out a stock-

ing frame for this jacket. What is perplexing is the strictly rec-tilinear shaping and use of sewn bindings, rather than knitting methods, to finish the neck and front edges. It would appear that knitters in the 17th century had not yet discovered how best to exploit the elastic properties of knitting for garments covering the upper torso. The use of rectangles with, in some cases, sewn-in gores, reflects the traditional cut and construc-tion methods using woven fabrics. The linen linings and bind-ings are also conventional ways of finishing edges and ensur-ing the garment keeps its shape. It is possible that these jack-ets were purchased as a set of panels and made up at home thus allowing adjustments to be made to fit the wearer.

While these jackets were originally thought to have been made in Italy, recent research into the knitting industries in Britain indicates that by the third quarter of the 16th century, the silk for such knitwear was being imported from Naples and made up in London.

A woman's jacket of hand-knitted silk and
silver-gilt wrapped silk, lined with blue linen.
English?, 1630s?
807-1904

A SIMPLE PATTERN of chevrons worked in stocking, reverse stocking and moss stitch, adorns the borders of this modest jacket. It reflects the conventional construction of the previous jacket and contemporary shirts and smocks. In this case, however, the traditional side gore is knitted into the pattern. The fronts and back have been knitted as one piece in stocking stitch, starting at the bottom hem. Gradual decreases at the sides shape the gores, and a decorative line of purl edges each one, recalling a stitched seam. At the armhole, forty stitches from each side have been held on a needle, while the back and fronts continue as separate pieces. They have been shaped at the neck and cast-off together at the shoulder seam. For each sleeve, stitches have been picked up along the front and back armhole edge and along with the forty from the main body, knitted with the same pattern in the centre, from shoulder to wrist and cast off. The front edges, from about 6 ¾ inches (17.2cm) below the neck, are bound with linen, possibly to add reinforcement for buttons. The knitting of the gores in the body of garment and the shaping of the neckline without linen binding demonstrate an advance in knitting technique from the previous jacket.

A two-ply cotton yarn is used; a later addition to the traditional wool and silk, it was not generally employed in knitting until the late 17th century. The small size of the jacket (30¼ inch; 76.8cm chest) suggests a woman's garment, while the elongated waist, 17 ½ inch (44.5cm), fits with the fashionable shape of the torso. Such jackets were worn well into the 18th century with almost no variation in the patterning. While its minimal decoration and warm, washable yarn indicate that it could have been worn as an undergarment, it resembles the little knitted jackets for babies, suggesting that it may have been part of a layette, worn informally by women recovering from childbirth.

A woman's jacket of hand-knitted cotton.
English, 18th century
Gift of Eric Bullivant, Esq.
T.61-1939

THIS MARVELLOUS CREATURE is just one of a series featured on what must be the most extraordinary example of the knitter's art. The place and exact method of this early 18th-century petticoat's manufacture are unknown. It is 10 feet (305cm) in circumference, knitted in two-ply cream wool with a non-repeating pattern of insects, birds, beasts and plants. Starting at the hem, some 2,650 stitches were cast on. After a narrow border, a ground of stocking stitch begins in a gauge of twenty-two stitches per inch, from which springs the rich panoply of figures including a monkey, elephant, hedgehog, lion, pig, rhinoceros, sheep, leopard, goat, stag, horse and ox, as well as birds such as a turkey, hawk, pelican, eagle, parrot, owl, crane, peacock, swan and the ostrich illustrated here.

The pattern has been made entirely of combinations of knit and purl stitches, with tiny eyelets for eyes. Within this limited range of stitches, a wide variety of textures and shapes have been delineated. For example, the ostrich has feet of purl divided by diagonals of single knitting stitches, and the legs are filled in with moss stitch. Lozenges of stocking stitch defined horizontally by short single, double or triple rows of purl and vertically by single lines of purl constitute the feathered body of the bird. The underbody and tail feathers are described with purl delineated by diagonal lines of single knitting stitches. The neck is made of purl stitches, while the head is stocking stitch with an eyelet surrounded by purl and a purl beak.

The leaves have been created mainly by stocking stitch veined with single lines of purl, or the two stitches in reverse, as demonstrated in the upper-right corner. At the far-left and lower edge can be seen complex checkered effects using blocks of purl, alternating with stocking stitch or moss stitch. Each device on this petticoat reveals a mastery, not only of knitting and a knowledge of the textural effects of knit and purl and their many combinations, but also a familiarity with the appearance of a wide range of creatures.

How was such a masterpiece created? It has been knitted continuously; if done by hand it must have required a huge number of needles (the circular needle is a 20th-century invention). If frame-knitted, it would require a very large one specially constructed and able to accommodate purl stitches. And how was the pattern converted from drawing to knitting stitches? It might have been created as tapestry is, with the pattern behind the work. This would require exceptional skill, for every line of every image on this petticoat is crisp and each pattern clear. There is not a stitch out of place.

The petticoat is thought to be Dutch, on the basis that they were the most accomplished knitters in Europe. Dating the work is equally problematic. The dimensions suggest the wide paniers of the 1740s (and for someone very short: under 5 feet; 152cm), while the imagery recalls 17th-century design. A somewhat similar knitted petticoat, dated 1722, and thought to be Dutch, sold at Christie's in 1981. Despite its mysteries, the petticoat remains a remarkable work. Anyone who has ever held a pair of knitting needles in their hands can only marvel at the artistry of such a design and the skill with which it was accomplished.

A woman's petticoat of knitted wool.
Dutch? 1700-1750
Bequeathed by Lt Col. G.B. Croft Lyons, FSA
T.177-1926

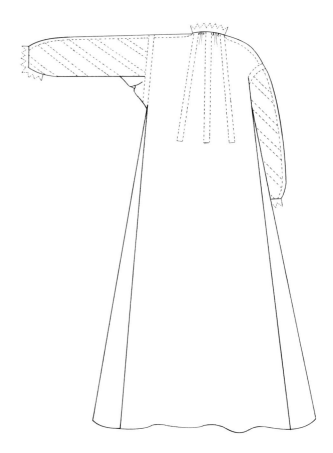

A WOMAN'S FINE linen smock of the 1620s to 1630s is lavishly trimmed and inset with bobbin lace arranged in a distinctive diagonal pattern shown in the drawings.[1] The detail illustrates the upright collar and part of the right front.

There has been some confusion in differentiating between early examples of men's shirts and women's smocks. In cut and decoration they are very similar being made from a length of linen folded over at the shoulders with a T-shaped slit for the neck opening and straight seams on either side. However the difference in cut occurs in the side seams – a woman's smock has gores set in the side seams and a man's shirt has open seams from the hem, sometimes almost reaching the waist.

These lace insertions (probably Flemish) are of two different qualities but of the same design – they are cleverly placed in alternate rows. There was obviously not enough fine lace to complete the inset diagonal design – a miscalculation might have been made or, as lace has always been one of the costliest forms of trimming, it may have been just too expensive to use the best lace throughout. An elaborate and fragile garment, it had to be worn and cleaned with great care. Normally lace trimmings at the neck and cuffs were taken off before laundering, but in this case the lace insets could not be removed and the entire smock had to be washed very gently in order to preserve the lace.

Evidence suggests that this is a night smock; this garment is calf-length and day smocks were usually shorter. Such elegant (and intimate) apparel was often given as a present. The excellent condition of this work indicates that it was hardly worn. According to contemporary literature, smocks and other fine linens were perfumed: 'Be taken with the scent of cambric smocks, wrought and perfum'd.'[2]

This garment has an aristocratic background. It was originally from the Royal Collection at Windsor and given by Queen Victoria to one of her Ladies-in-Waiting who in turn bequeathed it to the donor's aunt.

1. Janet Arnold describes and illustrates a portrait of Sir John Eliot wearing a shirt of very similar design in her article, 'Elizabethan and Jacobean Smocks and Shirts', *Waffen-unde Kostümekunde* (1977), Vol. 19, no. 2, pp.89-110.

2. *The City Madam* by Philip Massinger, Act II, Sc. I, Vol. 4, p.33; *The Plays of Philip Massinger*, edited by W. Gifford (London 1813), 4 Vols.

A woman's smock of linen
with bobbin-lace trimming.
English, 1620s-1630s
Given by L.K. Elmhirst
T.243-1959

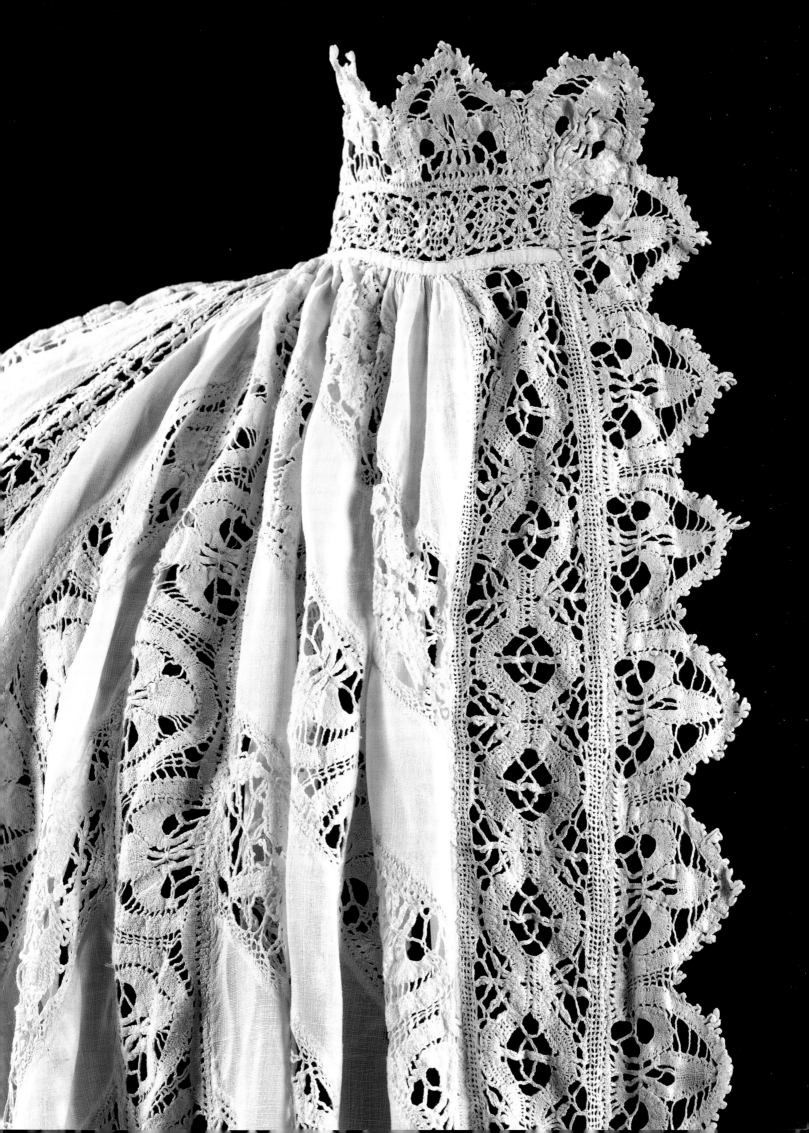

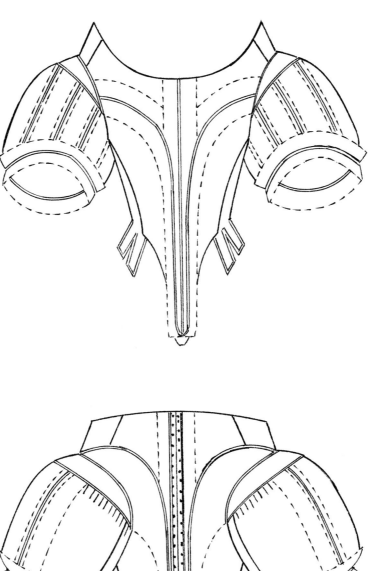

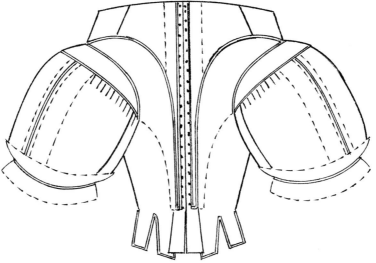

A GLISTENING OYSTER satin bodice of the 1660s is lavishly decorated with trimmings of bobbin lace and parchment strip, ornamented with colourful silk tufts and dainty three-dimensional wire florets. Each trimming is outlined with variegated silk cords.

This choice of decoration with its variety of textures and techniques offers a subtle contrast to the smooth lustre of satin. Such complex decoration was a popular form of ornament on dress for both men and women in the late 17th century.

The detail illustrates a back view showing the top of the left sleeve and bulky gauging helps to shape and fit the sleeve.

The pleats are partly concealed under the decorative wing of the armhole. Most of the trimming is of bobbin lace. Over some three-hundred years the colours have become muted.

This is an extremely fashionable bodice of the period, with a typical wide neckline that is almost off the shoulders, and a tightly fitted, elegant body tapering to a small waist with a deeply pointed front decending below the waistline. The sleeves are short and full reaching to just above the elbow. The bodice would have been worn with a matching petticoat.

A woman's bodice of oyster satin trimmed
with bobbin lace and parchment strip.
English, 1660s
429-1889

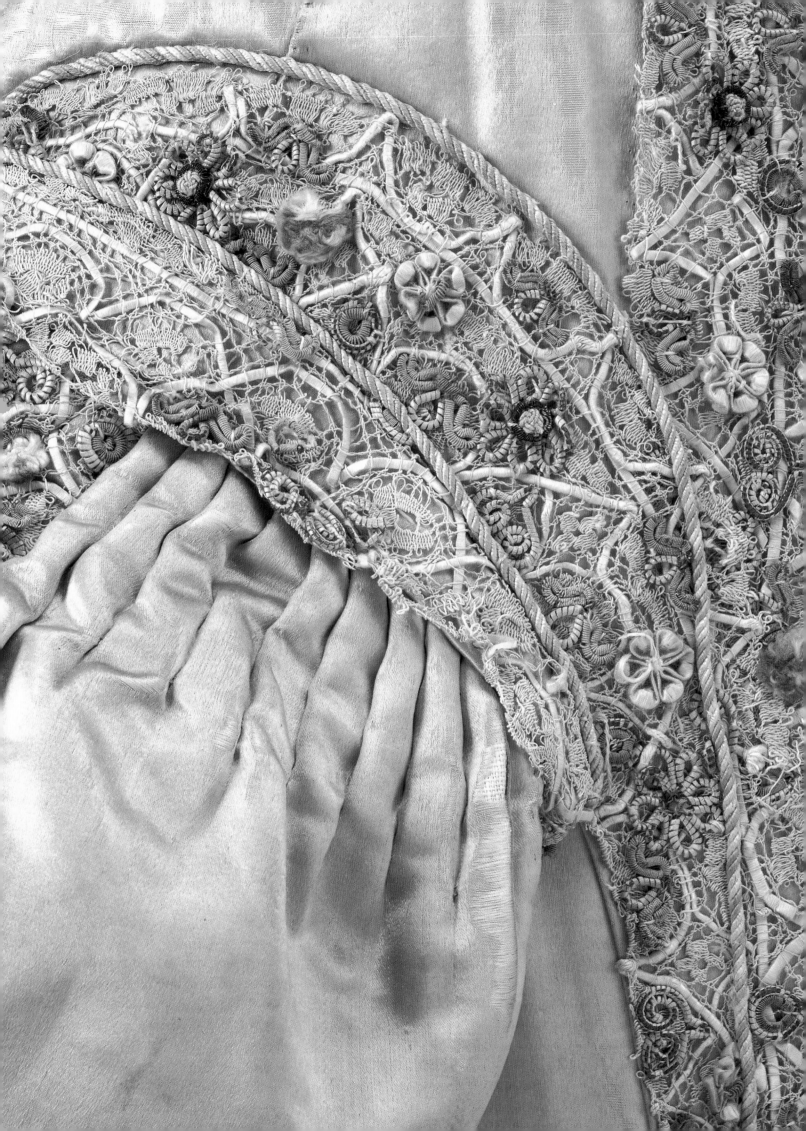

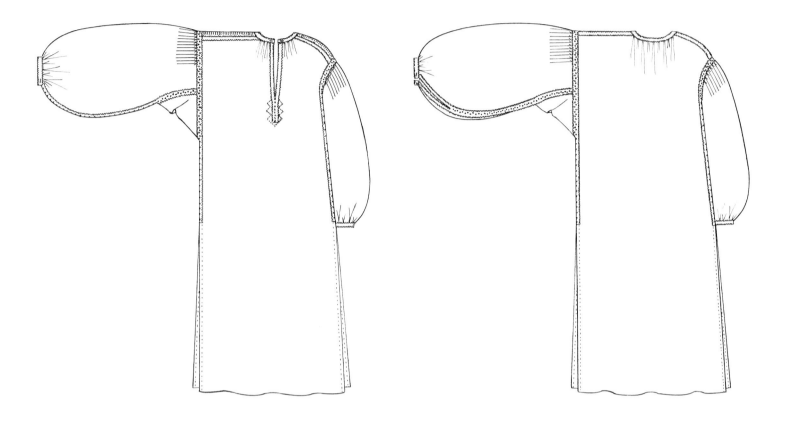

Four bands of intricate insertion work camouflage the shoulder seam of this early 17th-century shirt. An E-shaped piece of linen carries two bands of buttonhole insertion stitch within it and is bound on either side with Italian buttonhole stitch. In between, the linen has embroidered pulled fabric work, with buttonhole eyelets, French knots and bullions in white silk thread. The pulled fabric work extends to every edge of the garment and all the seams are joined with insertion stitches. A narrow strip of linen (³⁄₈ inch; 1cm), embroidered in French knots, bullions and a picot-stitch edging, binds the neck and wrists. The top of the sleeve has been minutely pleated and the tucks held in place by the insertion stitches. Pulled fabric work and picots edge the front opening which is secured with insertion stitch at the bottom and surrounded with more whitework.

The construction of a man's shirt was similar to that of a woman's smock, except that there were no gores in the side and the sleeves were slightly shorter and fuller. It is still not certain where this finely worked shirt was made. Although the overall needlework style is similar to Italian embroidery, it is different in detail, which suggests an English imitation of an admired foreign model.

A man's shirt of linen embroidered with white silk.
English or Italian, 1625-1650
Given by Miss F.M.P. Hipwood
T.49-1934

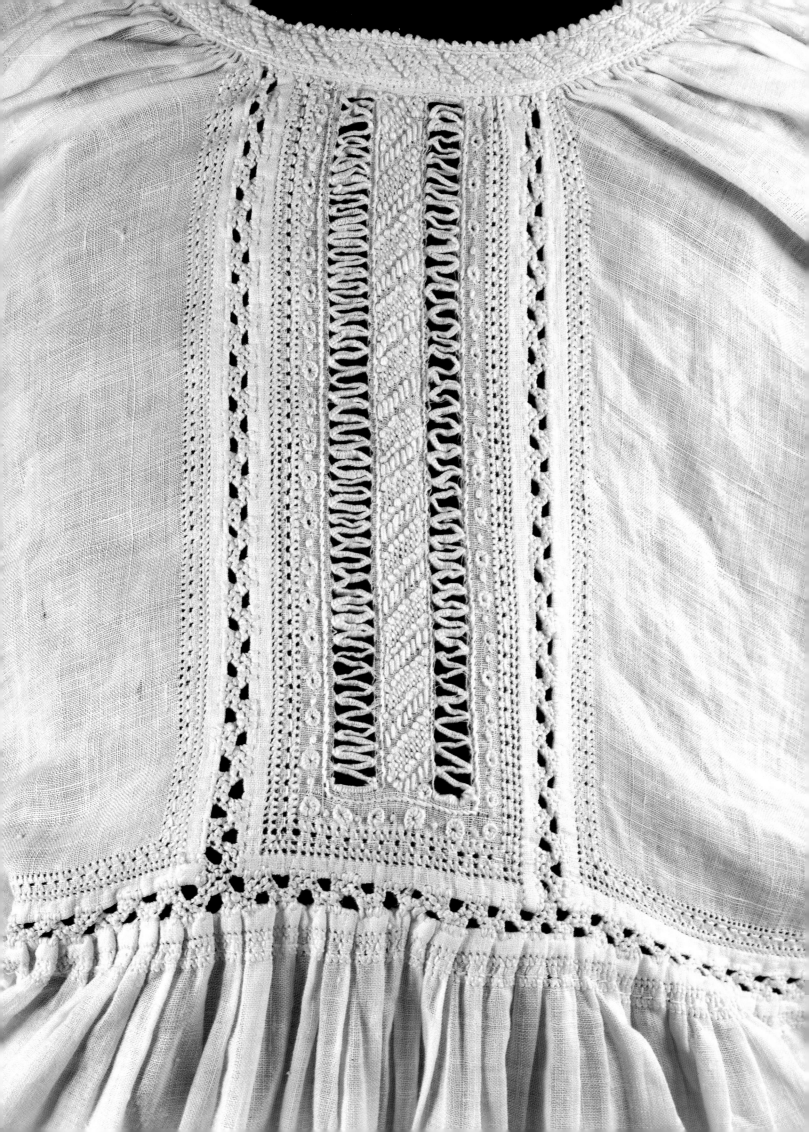

Snowy white linen neckwear of the finest quality was the final flourish of a fashionable ensemble of the 17th century. Contemporary literature and inventories include many references to neckwear which had become almost an obsession for the dress conscious in the 1630s and 1640s. The illustration shows part of a linen cutwork falling band (collar) of modest design, of the 1630s. Here the cutwork was achieved by embroidering the pattern in out-line and cutting out the fabric between the stitching before buttonholing the infills. James Master, on his coming of age in 1646, set about improving his wardrobe; amongst the many items of clothing and neckwear he ordered were '6 pair of band strings @4d each, and 2 bands and 2 pair of cuffs – 5shillings'.[1]

The style first appeared in the late 16th and early 17th centuries, when ruffs were still the fashion, but as bands were so much easier to wear and care for, they eventually replaced complex ruffs which demanded constant attention to look clean and smart. Maquerelle in *The Malcontent* exhorts his companions: ' and – do you hear?– you must wear falling bands; you must come into the falling fashion. There is such a deal o'pinning these ruffs...if you should chance to take a nap in the afternoon, your falling band requires no poting-stick to recover his form. Believe me, no fashion to the falling, I say.'[2]

1. 'The Expense Book of James Master Esq 1646-1676', *Archeologia Cantiana*, Vol. XV, pp.152-216.

2. *The Malcontent* by John Marston (1604), Act IV, Sc. 4; *Early 17th-Century Drama*, (Everyman Edition 390 1963), p.215.

A man's falling band of linen cutwork.
English, 1630s
190-1900

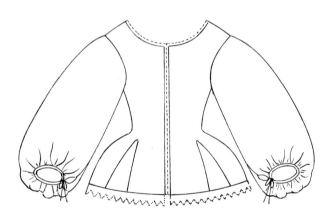

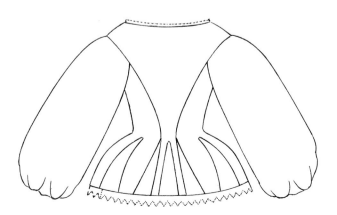

A delicate linen jacket of the 1630s, of drawn thread and pulled fabric work, gleams with a multitude of silver-gilt spangles. It is cut in the fashionable shape of the period with billowing sleeves that tie at the cuffs with tapes, a fitted torso accentuating a small high waist, and a short skirt gored to fit over padded hips. The hem is trimmed with Genoese bobbin lace decorated with spangles.

This almost transparent garment is a remarkable survival. It would have been worn over a cambric or a silk smock. It does not appear to have been lined at any time.

The detail shows the fine work of a skilled embroiderer. Spangles of different sizes are meticulously arranged to form the symmetrical geometric design.

This jacket would have glimmered and twinkled as the wearer moved about. It would have been especially attractive at night in the soft light of candles.

A woman's jacket of drawn thread and pulled fabric work with sequins.
English, 1630s
324-1903

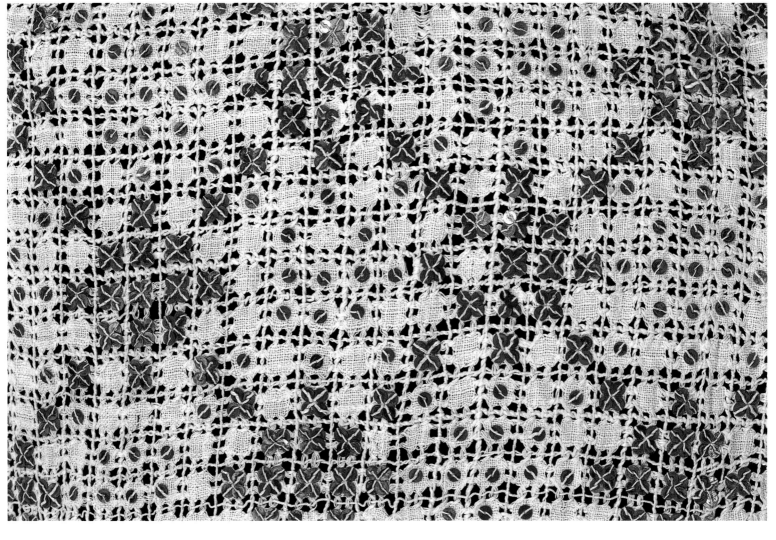

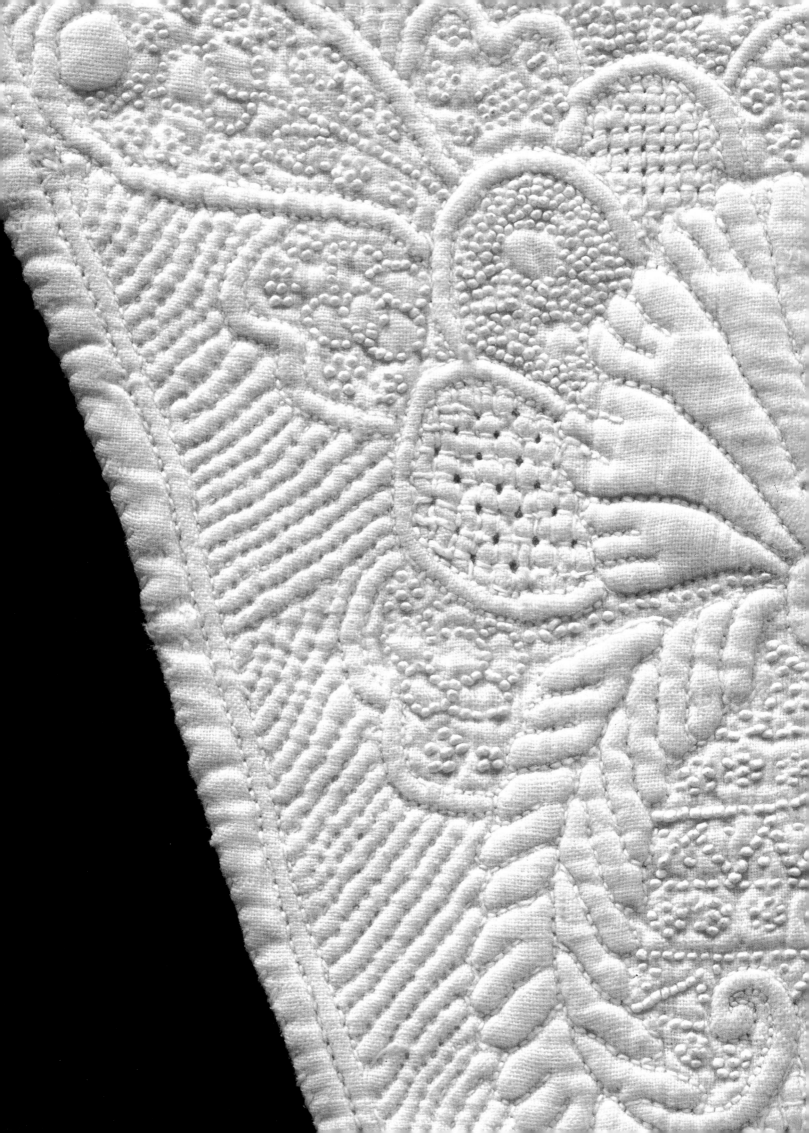

Stomachers

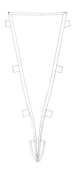

STOMACHERS ARE DECORATIVE V-shaped panels which cover the front of a bodice and were a part of women's dress from the 16th to the 18th centuries. The detail shows a lavishly embroidered stomacher of 1700 to the 1720s. It has a ground of laid and couched silver thread with branched flowers embroidered in long, short, satin and chain stitch and French knots. On very grand occasions a stomacher offered a perfect background for the display of superb jewels. At the Prince of Wales's birthday in January 1738/39, Mrs Delany observed: '...the Princess was in white satin, the petticoat covered with a gold trimming like embroidery, faced and robed with the same. Her head and stomacher a rock of diamonds and pearls'.[1]

1.*The Autobiography and Correspondence of Mary Granville, Mrs Delany*, ed. Lady Llanover (1861), Vol. II, pp.27-8.

A stomacher of embroidered silk.
English, 1700-1720s
T.404-1977

ON THIS WHITEWORK STOMACHER of the 1730s to 1740s the entire surface is quilted and embroidered in linen thread, in running and back stitches and French knots. The bold design includes floral and leaf motifs, pomegranates and shells. This stomacher would have been worn with a day ensemble.

A stomacher of cotton whitework.
English, 1730s-1740s
Given by Mrs Lewis Day
T.209-1929

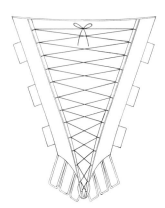

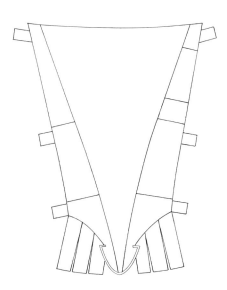

THIS SILK STOMACHER of the 1730s to the 1740s is embroidered in coloured silks, laced with silver cord and trimmed with silver braid. The set of tabs at the bottom and the criss-cross lacing are survivals from late 17th-century stomachers.

Ribbons were sometimes used instead of cord. The laces served a dual purpose being decorative and providing an anchorage for the ends of a kerchief. The meandering floral embroidery was designed specifically for the stomacher and includes carnations worked in satin, stem and back stitches with laid work in silver thread. Most stomachers are lined in plain linen but this one is lined with a block print in madder dye of the 1740s or 1750s and is one of the Museum's earliest examples of a European block print.

A stomacher of embroidered silk with lacing.
English, 1730s-1740s
Given by Messrs Harrods Ltd
T.708:B-1913

A COLOURFUL STOMACHER of the 1730s to the 1740s is embroidered in coloured silks and silver thread in satin stitch and couching. It resembles the one on the left though it lacks lacing and has a broader, less elegant shape.

A stomacher of embroidered silk.
English, 1730s-1740s
702-1902

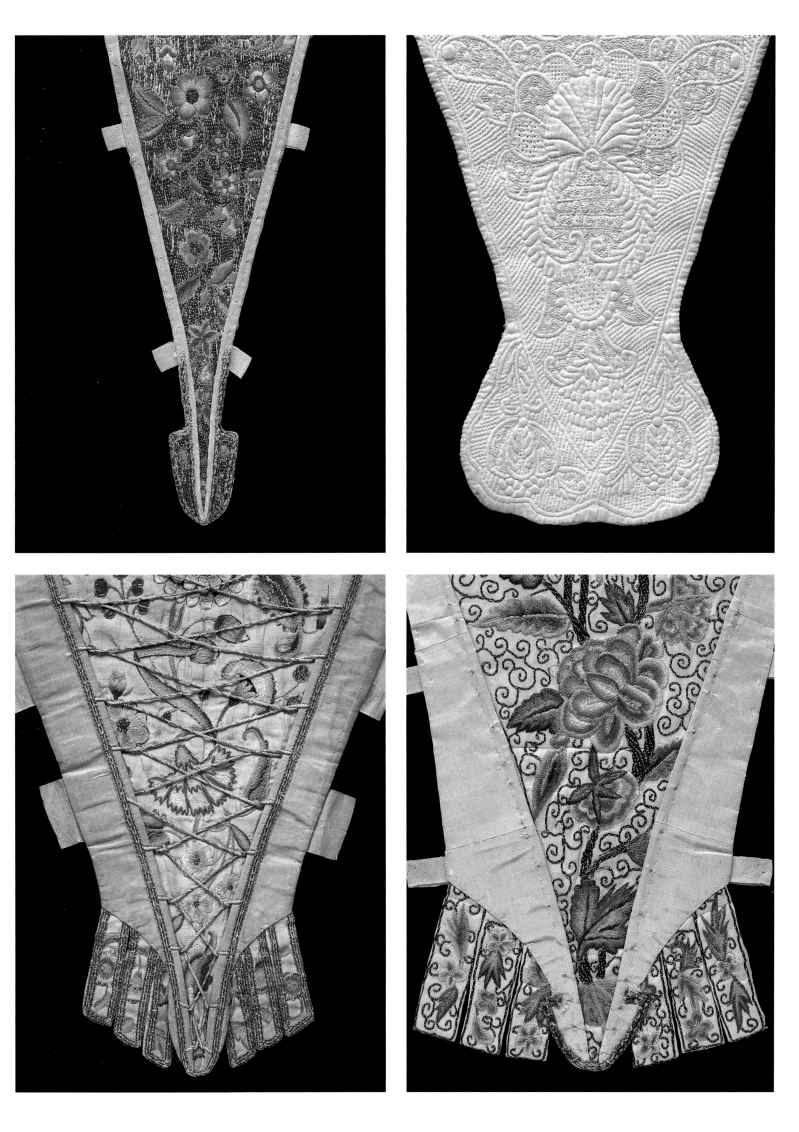

Silver-thread bobbin lace constitutes this stomacher from the 1740s. A rose surrounded by leaves forms the central motif worked in filé, frisé, strip and sequins. Its solid edging and those of the leaves and leaf veins have been formed with silver thread wrapped around parchment strips and then incorporated into the lace pattern. A stomacher as lavish as this was probably worn as part of Court dress with a mantua, also embellished with silver-thread embroidery.

A stomacher of bobbin lace of silver thread.
English, 1740s
Given by Mrs R. Stock
T.80:B-1948

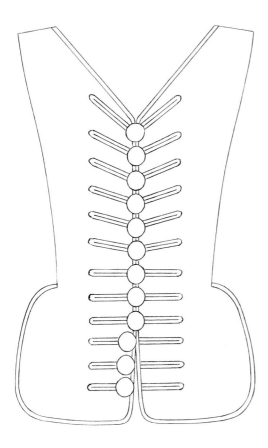

Echoing the lines and features of a man's waistcoat, this mid-18th-century stomacher has a V-shaped neckline, a line of decorative buttons and buttonholes, as well as a contour of the 'skirts' all imitating masculine styling. The stomacher was probably designed to be worn with a caraco, brunswick or other jacket modelled after men's fashions. It is richly embroidered in a pattern of simple flowers, worked with coloured silks with a loose satin stitch, and scrolls and curving brackets in silver-gilt thread. Applied to the front are blind buttonholes made of parchment strips wound with silver-gilt thread. The buttons have a wooden core covered with silver-gilt thread and strip. A braid of the same thread binds the neckline and lower edge. Four thin strips of whalebone reinforce the stomacher's centre front.

The design and execution of the embroidery, along with the style of the stomacher, suggest an Italian origin.

A stomacher of silk embroidered
with silk and silver-gilt thread.
Italian, 1760-1780
Given by Mrs P. Sanguinetti
T.182-1958

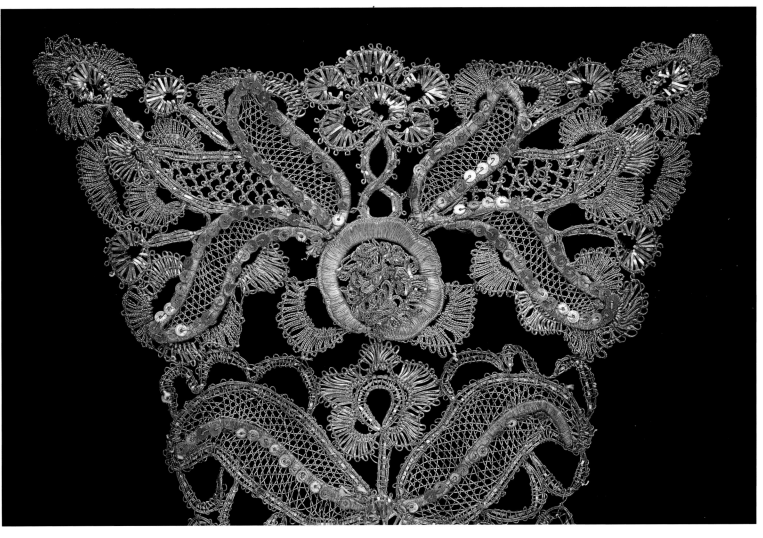
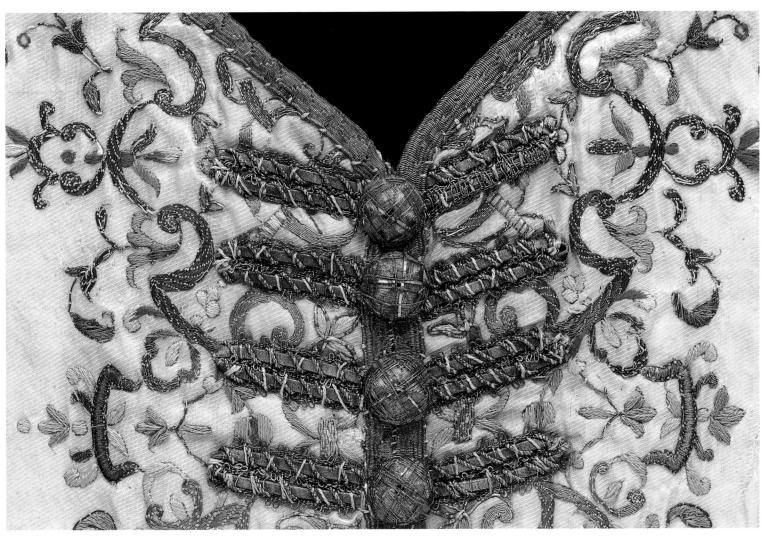

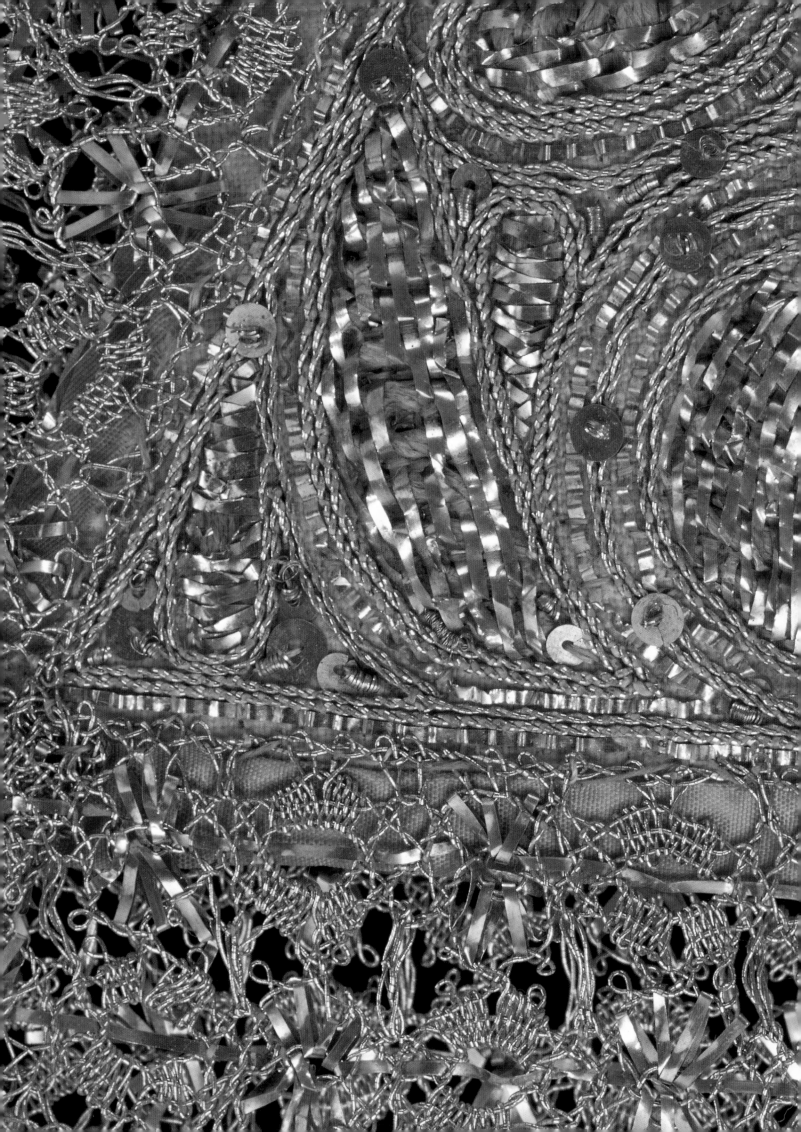

Gloves &
Shoes

SILVER AND SILVER-gilt embroidery and fringing decorate the gauntlet of this leather glove of about 1610 to 1625. Silver-gilt spangles are scattered between the embroidered motifs. A variety of metal threads (filé, frisé and purl) have been used, creating subtle changes in texture. To enliven the design, part of the embroidery has been worked over pieces of red satin. The pattern is based on leaf shapes formed by a raised pad of linen stitches over which the silver-gilt thread is couched.

Samuel Pepys recorded in his diary for February 1661: 'my wife and I and Mrs Martha Batten, My Valentine, to the Exchange; and there, upon a payre of embroidered and six payre of plain white gloves, I laid out 40s on her.'[1] Gloves for men and women were frequently perfumed. Queen Mary I's New Year gifts in 1556 included sixteen pairs of gloves of which four were listed as perfumed.[2]

1. *The Diaries of Samuel Pepys 1660-1669*, edited Robert Latham and William Matthews Bell (London: Bell 1970; reprinted 1973). pp.38,40.

2. *Manners and Expense*, John Nicol (1797). New Year Gifts presented to Queen Mary I.

A glove of embroidered leather (one of a pair).
English or French, 1610-1625
T.154-1930

THIS RICHLY DECORATED leather glove of the 1660s has silver and silver-gilt embroidery on the gauntlet. The detail illustrates part of the gauntlet which is trimmed with silver and silver-gilt bobbin lace and embroidered with silver-gilt strip, thread, purl and spangles.

As the century progressed, the shape of gloves changed – the gauntlets became smaller and the fingers less elongated.

Embroidered decoration often revealed a preference for purely metal thread embroidery, the designs arranged in simple shapes and using a wide variety of threads. Metal bobbin lace and silver and silver-gilt fringing retained their popularity.

A glove of embroidered leather (one of a pair).
French, 1660s
Bequeathed by Mrs E. A. Blandy
T.225-1968

THIS CRIMSON SILK VELVET mitten has a richly embroidered silk gauntlet. The embroidery is worked in silver and silver-gilt thread and purl with couched work, and the coloured silks are worked in long and short and satin stitches. Familiar flowers, favourites of the embroiderers, such as borage, pinks and lilies, as well as insects and fruits, scattered amongst elaborate foliage, decorate the gauntlet cuffs. In the centre of each cuff and repeated front and back, is a pillar entwined with a sprouting vine. This device bears a close resemblance to an emblem variously described as a spire, obelisk or pyramid, which appears in Geffrey Whitney's *A Choice of Emblemes* (1586). These mittens are said to have been presented by Queen Elizabeth I to one of her Maids-of-Honour, Margaret Edgecumbe (1560-1648), wife of Sir Edward Denny (1547-1599).

A mitten of embroidered velvet and silk (one of a pair).
English, about 1600
Given by Sir Edward Denny
1507-1882

AN ELABORATELY DECORATED leather glove of the 1660s has a gauntlet encrusted with silver and silver-gilt embroidery. The detail illustrates a heart-shaped motif, worked with enormous skill in purl and filé with silver and silver-gilt bobbin-lace trimming and spangles. The heart is surrounded by borders of silver strip worked over blue silk taffeta. This glove is similar in style to the example shown above.

A glove of embroidered leather (one of a pair).
French, 1660s
Given by Mr E. Saville Burrough
T.202-1928

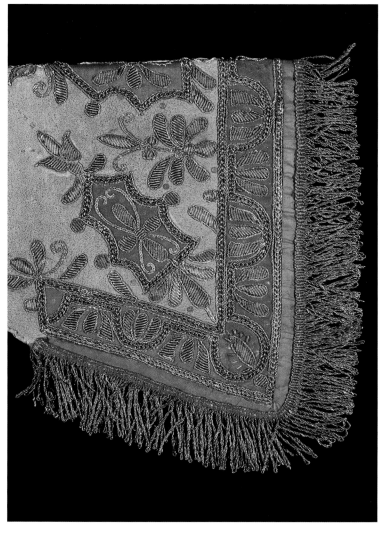
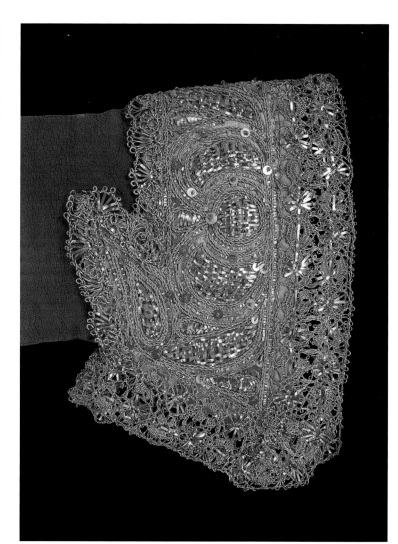
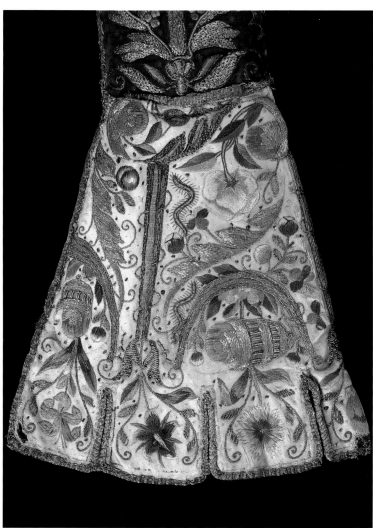
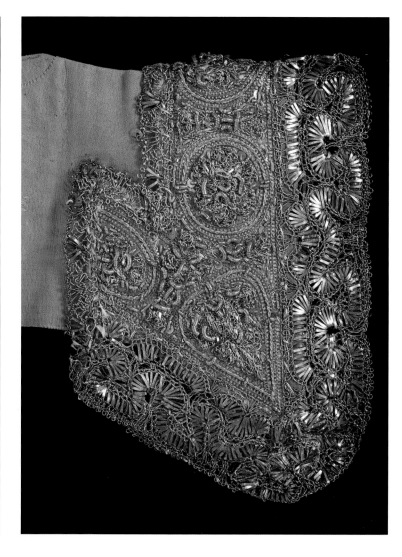

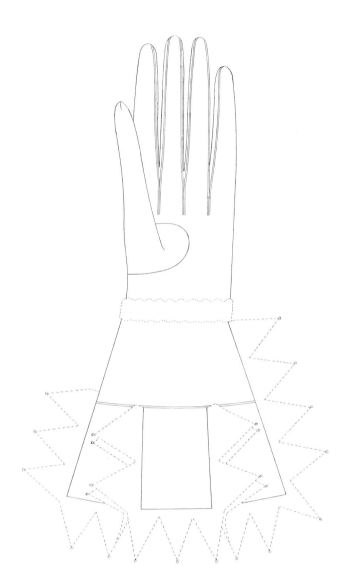
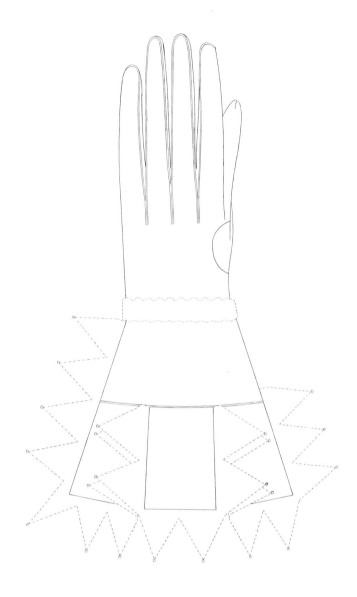

SEED PEARLS PROVIDE an interesting addition to the decorative materials on this early 17th-century glove. They are densely applied in combination with silver-gilt and silver thread, purl, spangles, and coloured silks on the gauntlet of white satin.

Each motif is heavily padded to give a pronounced three-dimensional effect. Silver-gilt and silver bobbin lace, dotted with spangles, trims the edge of the gauntlet. Typically, the imagery of the embroidery is both vivid and somewhat mysterious. In keeping with much Jacobean needlework, the devices are naturalistic as well as symbolic. Appearing at the base of the gauntlet is the snail illustrated here, with a lion and a sheep; on the tabs are two crowned roses and a crowned thistle. The donor's family once thought this pair of gloves was a gift of Henry VIII to one of their ancestors. However, the presence of the thistle with the rose indicates an association with James I, which corresponds with the gauntlet's decorative style.

Gloves, elaborately decorated and trimmed with ribbon and lace, were particularly popular gifts made to the sovereign by his or her subjects and foreign diplomats. Elizabeth I received dozens during her lifetime and so did James I. They were also a desirable favour given by the monarch and this pair may well represent a gesture of commendation from James I to one of his courtiers.

A glove of buff leather with satin gauntlet embroidered with silk
and metal threads, spangles and seed pearls, trimmed with metal bobbin lace.
English, 1603-1625
Given by Sir Edward Denny, Bart.
1506-1882

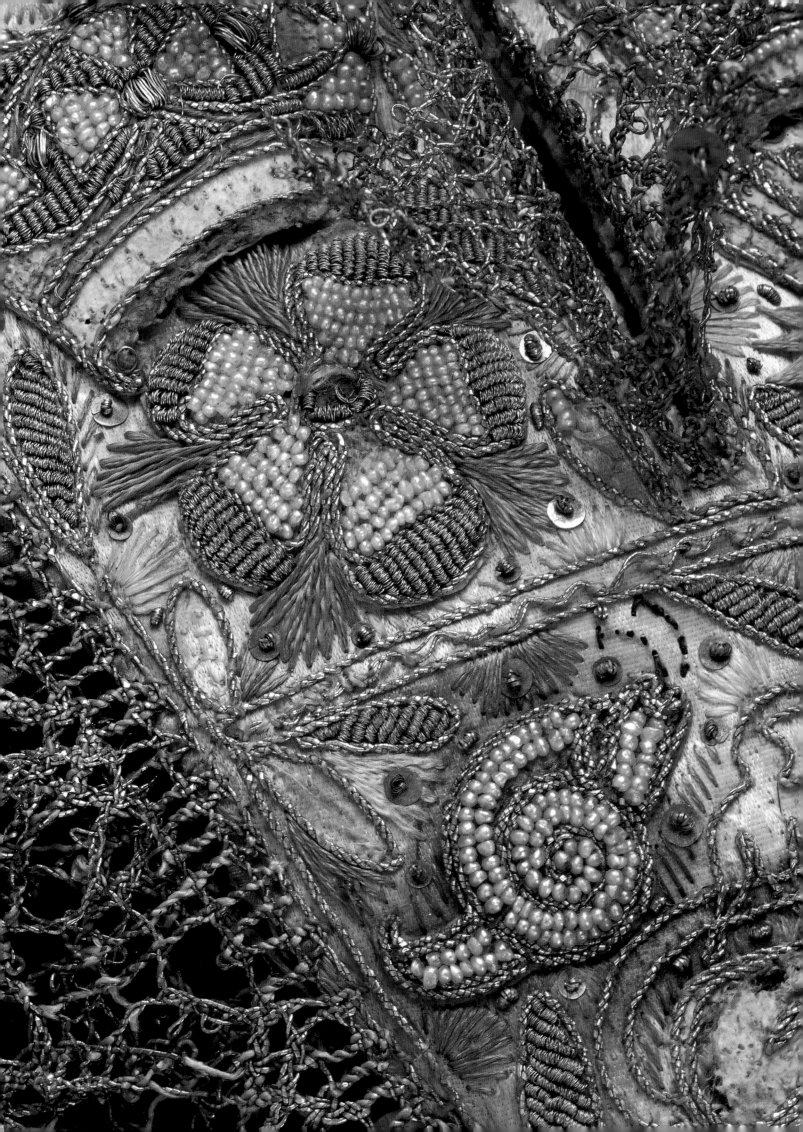

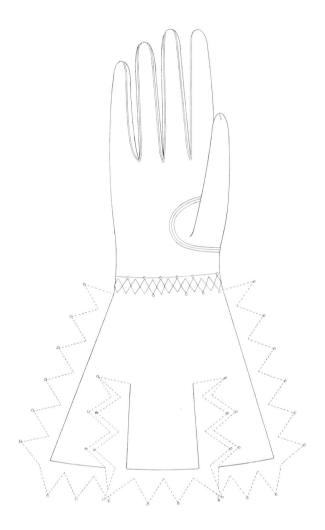
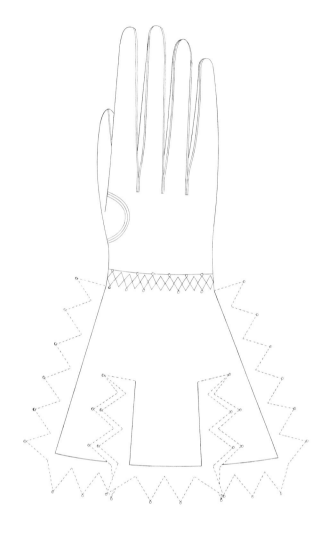

A sophisticated use of metal thread distinguishes this luxurious early 17th-century glove. An assortment of silver and silver-gilt purls in various thicknesses and finishes have been skilfully assembled giving a range of textures. The smoothness of the bird's breast is conveyed by the couching of silver and silver-gilt filé over thick padding, while a rippling of couched silver strip defines the tail feathers. The central rose motif has been worked with coloured silks in satin stitch. Above it are three sprays of wheat; the texture of the wheat ears is im-parted by scatterings of silver-gilt purl. Although not strictly heraldic, the motifs on the glove may have been chosen as personal devices, or more generally, for the virtues or qualities each represented.

Covering the seam joining the gauntlet to the cream leather glove is a coral-pink silk ribbon, overlaid with spangled silver-gilt bobbin lace. A deeper border of such lace edges the gauntlet and its tabs.

A glove of cream leather with satin gauntlet embroidered with silk and metal thread, purl and spangles, trimmed with silk ribbon and silver-gilt bobbin lace.
English, 1600-1625
Bequeathed by Sir Frederick Richmond, Bart.
T.42-1954

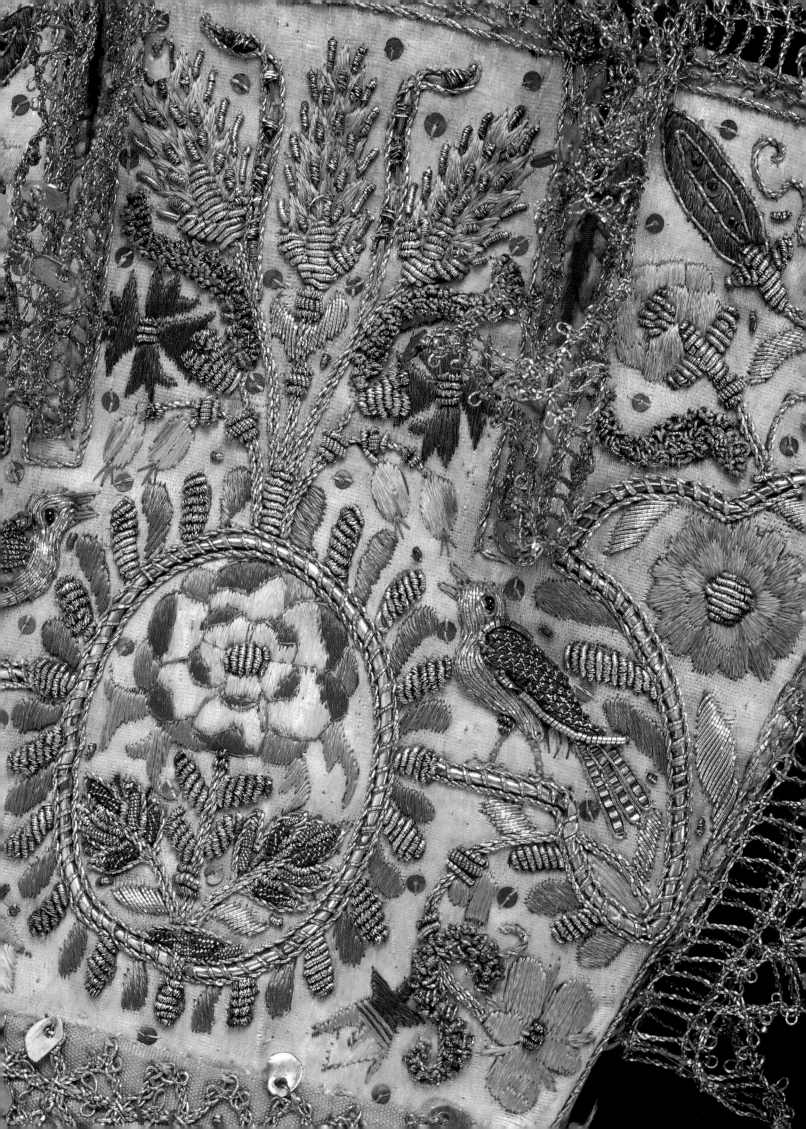

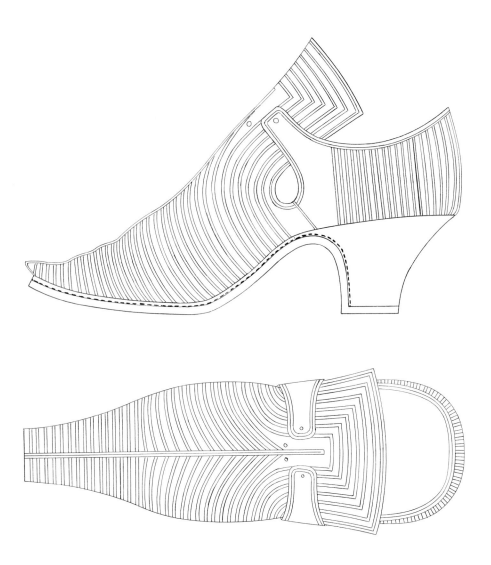

NARROW RED SILK braid has been meticulously applied in close parallel lines, to create an attractive linear pattern on this woman's buff leather shoe (one of a pair) of the 1670s. The use of decorative braid was a popular feature of fashionable shoes in the late 17th and early 18th century. The shoe has an elegant shape with tapered uppers finishing with a narrow square toe. The heel is moderately high and thrust well beneath the foot. Until the 1660s and 1670s shoes for both men and women were usually fastened across the instep by ribbons. In 1658 James Master paid 4s 'For a pair of shoe strings and other black ribbon'.[1] This braided shoe has tiny holes in the tongue and latchets that probably accommodated a narrow silk ribbon finished with points (tags) or a small buckle. It is probable that, when buying shoes, customers had to stipulate whether they wanted to use buckles or shoe strings. Shoe buckles were introduced from the 1660s, Samuel Pepys recorded wearing them in 1660:[2] 'This day I began to put on buckles to my shoes, which I had bought yesterday of Mr Wotton.'

A portrait of *The Ladies Catherine and Charlotte Talbot* shows Lady Catherine wearing a pair of shoes (closely resembling this style) with gold braid trimming, and fastened by dainty buckles set with jewels.[3] John Evelyn recorded the introduction of shoe buckles in his diary of 1666 'set with precious stones'.[4]

This shoe and its pair were probably perfumed. Scented clothing in the 17th century was popular, and, as personal hygiene was not a high priority, helped to mask body odours. Philip Massinger, in his play, *The City Madam*, has the character Lady Frugal ask her servant Milliscent: 'Where are my shoes?' She replies, ' Those that your Ladyship gave order should be made of the Spanish perfum'd skins?'[5]

1. 'The Expense Book of James Master Esq 1646-1676', *Archeologia Cantiana*, Vol. XV, pp.152-216.
2. *The Diary of Samuel Pepys 1660-1669*, edited by Robert Latham and William Matthews Bell (1973), Vol. I, 22 January 1660.
3. *The Ladies Catherine and Charlotte Talbot* by John Michael Wright (1679). The National Gallery of Ireland.
4. *The Diary and Letters of John Evelyn 1641-1705/6*, edited William Bray (Murray and Son 1870), p.324.
5. Philip Massinger, *The City Madam*, (1632), Act I, Sc. I (London 1813), Vol. 4 , p.10.

A woman's shoe of leather decorated with braids.
English or French, 1670s
Given by Talbot Hughes
T.107-1917

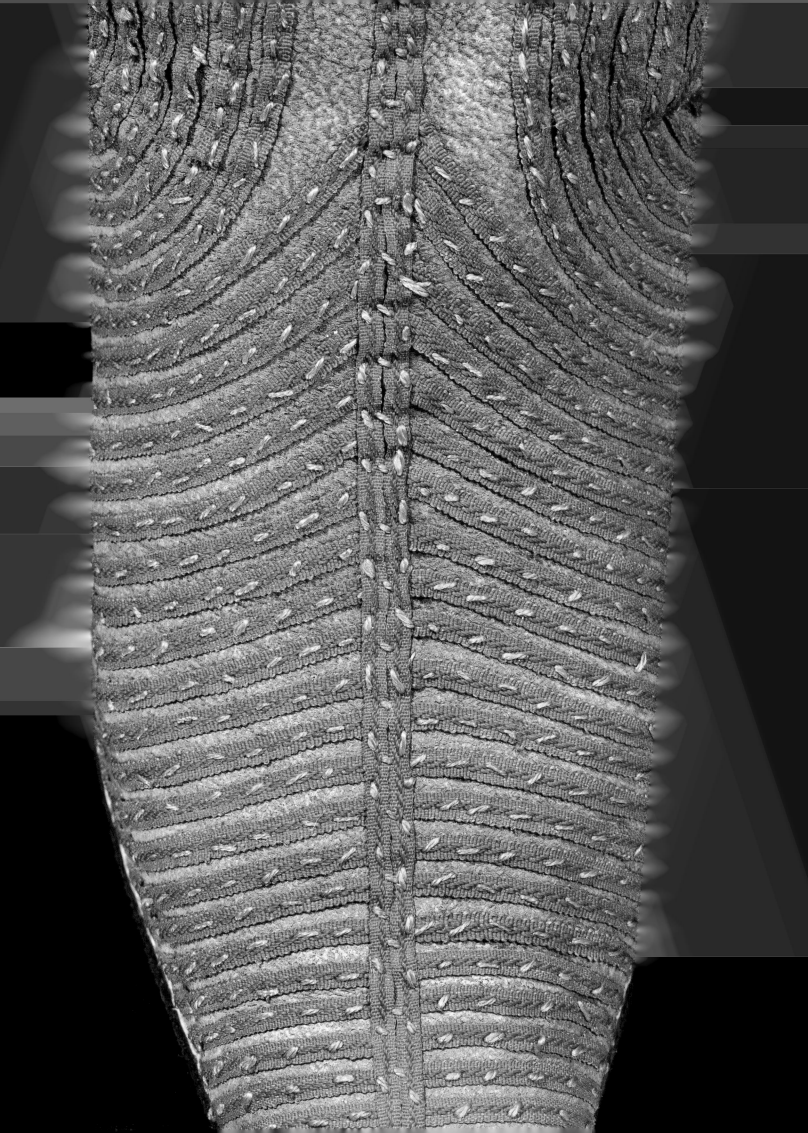

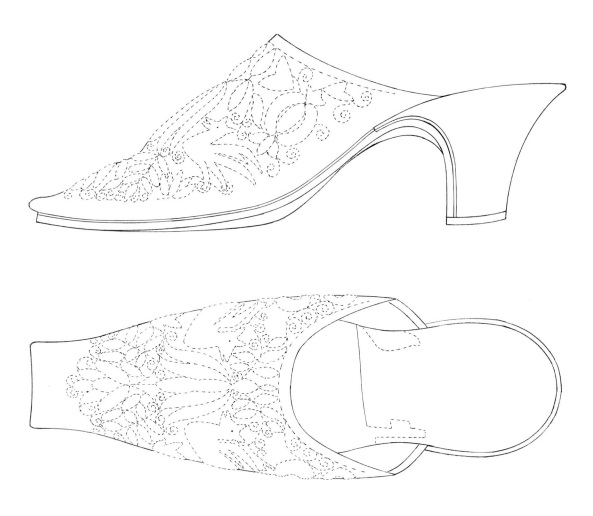

A woman's slipper of red velvet of the 1650s to 1660s is richly embroidered in raised and couched silver-gilt thread. A number of evocative names have been used for such shoes including pantoffle, pantacle or pantable. Historically these terms have been used somewhat indiscriminately, Randle Holme in his book *The Academy of Armory and Blazon* (1688) depicted slippers as 'Slippers, are shoes without Heel quarters', and added amusingly 'Slippers (or a Pantable)...I need not much to describe , because a thing of so common a use amongst us...'.[1] June Swann in her book *Shoes* describes slippers as being made in mule form for the period 1660 to 1720, although the word had gone out of use by 1678.[2] In the 17th and 18th century, both men and women wore the style known as slipper, but men had low heels while women's slippers had elegant high heels. In modern parlance, according to the Oxford English Dictionary, a slipper is a 'light and sometimes heeless covering for the foot, capable of being easily slipped on, and worn indoors'.

1. Randle Holme, *The Academy of Armory and Blazon* (1688), Book III, Chapter II, p.14.
2. *The Costume Accessories Series*, General Editor Aileen Ribiero; *Shoes* by June Swann (Batsford 1982), p.22.

A woman's slipper of embroidered velvet.
English or French, 1650s-1660s
T.631-1972

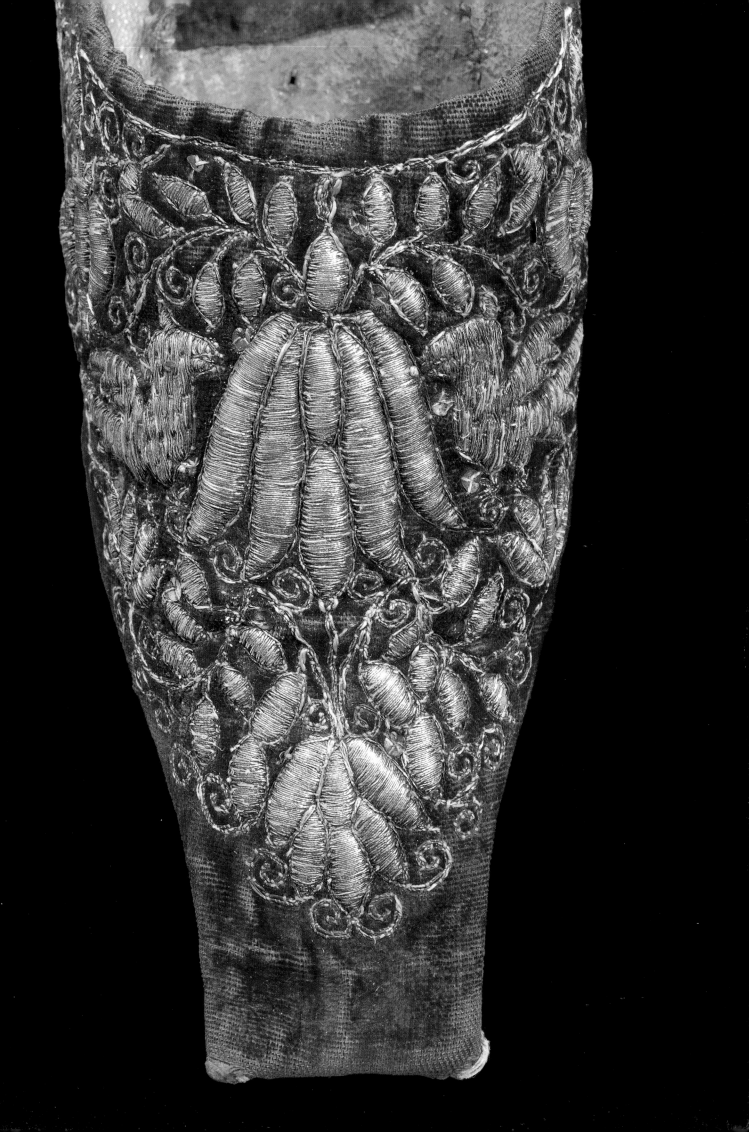

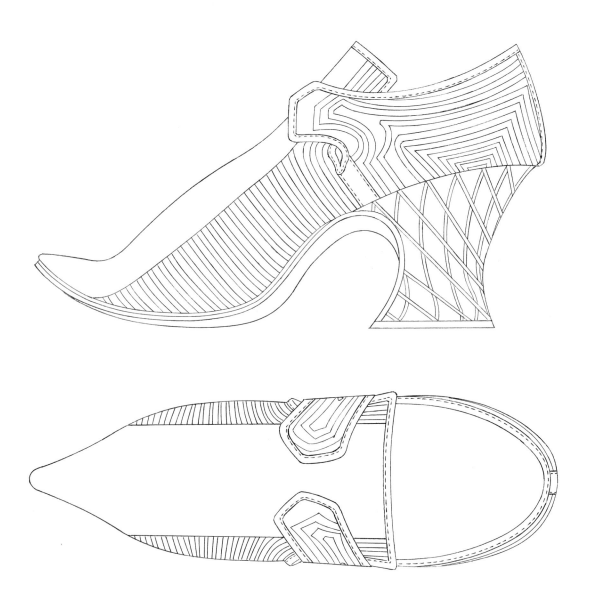

A WOMAN'S FASHIONABLE silk shoe of the 1720s to 1730s is decorated with silver-gilt braid and embroidery. The embroidery is worked in buttonhole stitch on ivory satin and applied in close parallel stripes, imitating applied silk braid of 17th-century shoes. The heel has been meticulously embroidered in a lattice pattern, shown in the detail. The embroidered satin ground has been laid over white kid leather.

Silver-gilt braid on shoes was always referred to as lace in contemporary literature. Samuel Richardson (1689-1761), in his romantic novel *Pamela* published in 1740-41, makes frequent and detailed references to dress. Laced shoes such as the illustrated example would have been worn by a lady and not by a servant or country girl like Pamela, the heroine of the novel. However, her master Mr B., in one of his many and unsuccessful attempts to seduce her, tempted her with the gift of some of his mother's clothes, including 'Three pair of fine Silk Shoes, Two hardly the worse, and just fit me (for my Lady had a very little Foot), and the other with wrought Silver Buckles in them'. Later in the novel she describes them as 'laced shoes, that were my Lady's'.[1]

Henry Purefoy in 1744 wrote to his laceman in London requesting silver twist buttons for his waistcoat and 'enough fashionable Silver Lace to Lace four pair of shoes for my Mother and a yard of narrow silver lace to go up the seam behind the shoes'.[2]

1. *Pamela* by Samuel Richardson (1762; 8th edition), Vol. I, Letter VII, pp.12,13; and Letter XX, pp.49,50.

2. *Purefoy Letters 1735-1753*, edited by G. Eland (Sidgwick and Jackson 1931), 2 Vols, Vol. 2, p.311.

A woman's shoe of embroidered
silk with silver-gilt braid.
English, 1720s-1730s
Given by Miss C. E. Keddle
230-1908

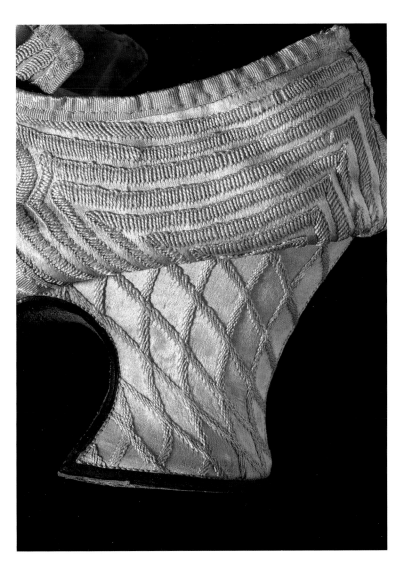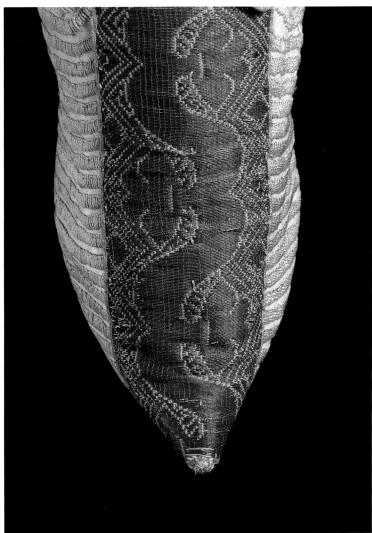

SIMPLE FLORAL SHAPES tamboured with coloured silks adorn this late 1790s woman's shoe. The decorative stitching outlines the pattern cut out of the green leather on the sharply pointed toe, and decorates the white silk satin it reveals. White silk grosgrain ribbon binds the shoe and white leather covers the low-shaped heel. The sole is leather and the lining linen. This was a popular style of shoe; an almost identical version survives in the collection, in black leather with cut-out decoration and tambouring on the toe, and a similar-shaped heel in yellow leather.

While neo-classical style dress introduced a flat shoe with less decoration than had been previously worn, heels remained fashionable. In 1797, a contemporary fashion magazine noted: 'Small Italian heels are coming in with the rising generation, and simplicity of dress is now the criterion of good taste.'[1] Not until the 1820s would the heel be completely ousted from women's footwear.

At this time there was no distinction in shape between right and left footwear. Due to the technical problems in making mirror-image lasts for heeled shoes, it was not until the 1840s that the production of right and left shoes became widespread. As the drawing illustrates, the shoe is completely symmetrical and the wearer made it conform to the shape of the foot it covered.

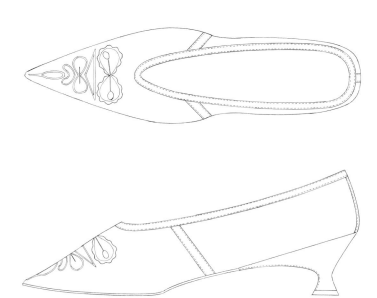

1. *The Ladies' Monthly Museum*, June 1797.

A woman's shoe of green leather
tamboured with silk, bound with silk ribbon.
English, *c*.1797
Given by the late Frederick Gill, Esq.
T.196-1914

STENCILLING CONSTITUTES THE bold decoration on this woman's shoe dating from the very end of the 18th century. An abstract floral pattern made of large and small black dots covers the yellow leather. The stencilling process has not been carried out very precisely, an excess or paucity of paint at various points is clearly evident. Plain yellow leather binds the shoe and covers the low, shaped heel. This relatively simple technique created another pair of shoes in the collection with stencilled black rings on pink leather.

For most of the 18th century, leather was reserved for boots, while silk, wool and linen formed the principle fabrics for women's footwear. From the 1780s there was a significant increase in the use of leather for women's shoes. This development in female footwear corresponded with the use of dyes in a wider range of colours; pink, green, maroon and navy are all found in shoes of the late 1790s in the collection.

A woman's shoe of yellow leather stencilled in black.
English, *c*.1799
Given by Sydney Vacher, Esq.
T.10-1918

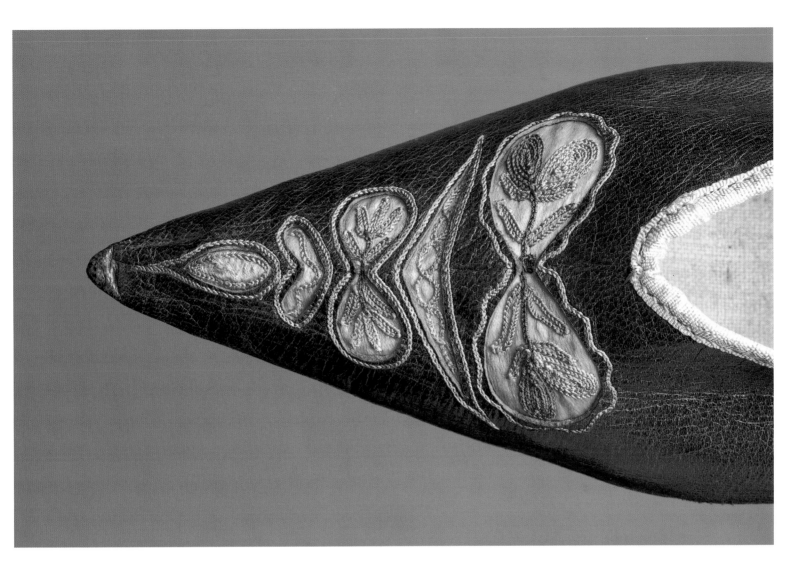

Glossary

BAND: A white collar originally a shirt neck-band. Subsequently the term was applied to different styles of detachable neck wear.

BELLY PIECE: A triangular stiffening of buckram or pasteboard. One was sewn to the lining on either side of a man's doublet at waistlevel. The base of each triangle was placed vertically along the front edge. Forming a corset-like restriction or support to the 'belly'.

BIB-FRONT: A gown with a dropped front or 'bib' which is attached at the waist and held in place by pins or buttons at the shoulders.

BOBBIN LACE: Lace made by plaiting or twisting together a number of threads around pins that control the design. The threads are wound on small bobbins and the work is supported on a pillow.

BLOCK PRINTING: One of the oldest methods of printing. Wooden blocks have the pattern cut in relief and each colour in the pattern has a separate block. The colour is transmitted to the cloth from the face of the block by hitting the back of the block with the handle-end of a mallet.

BROCADED: This term had a precise technical meaning in the 17th and 18th century indicating that design effects in a woven textile had been produced with an extra weft whose incorporation was limited to the width of the design produced.

CAMBRIC: A fine, lightweight, plain woven linen.

CHENILLE YARN: A tufted weft yarn (in use from the 17th century onwards) of cotton, silk or wool, caterpillar-like in appearance. Fabric woven with such yarns is a chenille fabric.

CHINÉ: A patterned fabric with a characteristic blurred appearance achieved by winding the warp threads on a frame and then printing with a design. The printed warp threads are transferred to the loom and the weft threads woven in, resulting in a blurring of the warp pattern.

CORDUROY: A cotton fabric with vertical cut-pile ribs made with an additional weft pile thread.

DAMASK: Patterned textile with one warp and one weft in which the design is formed by the contrast of the binding systems, and appears on the face and back in reversed positions.

EMBLEM BOOKS: Printed collections of allegorical visual scenes, devices or symbols, derived from classical mythology and heraldry, usually accompanied by verses and associated with moral themes and virtues.

ENGLISH BACK: A close-fitted bodice following the shape of the stays. It has a pleated and sewn-down back which extends into the skirt without a waist seam. The style is linked with the mantua. A later development misleadingly known as a nightgown was seamed at the waist and the skirt was pleated onto the bodice. This was also called the *le robe à l'anglais*.

EYELET: A lacing hole to take a cord or tape, to join parts of a garment or garments. Until the 19th century these were bound in silk thread. Metal eyelets appeared after 1828.

FALLING BAND: A collar which is turned down. A 16th- and 17th-century term which originally referred to the attached shirt collar which turned down over the doublet collar. The term was subsequently applied to the detachable collar or band which draped over the doublet collar onto the shoulders.

FICHU: An early 19th-century term for female neck wear which replaced the earlier terms of *handkerchief* or *neckerchief*.

FUSTIAN: A mixed fabric, where the warp is of linen and the weft of cotton.

GIMP: A type of trimming made of silk wrapped around a core of linen or cotton, often combined with other threads in flat braids and fly fringe.

GLAZED COTTON: Cotton which has a shiny surface achieved as a result of various chemical or physical finishing processes.

GORE: Usually a triangular-shaped piece of fabric inserted into a main seam to create additional fullness to a garment. An alternative term is *gusset*.

GUSSET: see GORE.

GROSGRAIN: A type of weave used frequently for silk ribbons with silk warp threads closely and firmly woven over thick weft threads of silk or cotton to achieve a ribbed effect.

HOOP PETTICOAT: An under-petticoat of linen distended and kept in shape with cane or whalebone hoops.

LUSTRING: Lightweight, crisp and very glossy plain woven silk. The lustre was achieved by glazing, stretching and heating the warp before weaving.

METAL THREADS:
FILÉ (plain): Silver or gold strip wound on a silk or linen core.
FRISÉ (frost): Silver or gold strip on a core one end of which is twisted more tightly than the other giving a crinkled effect.
PLATE: Silver or gold strip used flat.

NEEDLE LACE: Lace constructed stitch by stitch with a needle and thread.

PANES: Fashionable in the 1620s to 1640s, long, graduated parallel slits or cuts made in a garment. The slits allowed the shirt or smock and coloured linings to be seen or even be pulled through the openings.

PASSEMENTERIE: A French term covering a wide range of trimmings used on dress, uniform and upholstery, including braids, gimps, tassels, buttons, cords, ribbons, fringes, using silks and metal threads. Known in England in the 18th century as parchmentery, haberdashery or narrow wares.

PETTICOAT: A skirt which formed part of an outer garment such as a robe or gown. Always referred to as a petticoat until the 19th century when this term was reserved solely for an undergarment.

PINKING: A method of decorating the ground of a fabric in a pattern of tiny holes or its edges in a saw-tooth pattern, by perforating with small shaped punches.

POCKET HOLES: One or two slits in a petticoat and robe which allowed access to the pocket bags worn about the waist beneath the outer petticoat.

POCKET BAGS: Flat often pear-shaped bags with a vertical slit opening. They were attached either singly or in pairs to a tape that tied about the waist beneath the outer petticoat so that the bags were placed on each hip and within easy reach of the pocket holes.

POINTS: A term used from the 15th to the 17th centuries for ties or laces which held garments together. The term originates from the pointed metal ends or tags of laces. An alternative term was *aglet* or *aiglet*. Points were often visible and became decorative trimmings and were made of gold or silver.

POLONAISE: A term which was applied to a draped skirt of a robe or gown which revealed the petticoat. The style was fashionable from the 1770s to the 1870s.

SATIN: A close warp-faced weave which is constructed to give an unbroken or smooth lustrous surface. Originally satin was all silk; it is now made from silk, cotton, rayon and other fibres.

STAND COLLAR: An upright neck-band or collar to a doublet, coat or waistcoat.

REBATO: *1.* A white collar wired to stand up round the neck of a low-necked bodice. Fashionable from 1580 to 1635. *2.* The increased size of ruffs in the late 16th and early 17th centuries made them ungainly to wear and unsightly to look at if they were not properly supported around the neck, and starching gave extra weight. To preserve their shape and appearance it became necessary to provide a support which was light yet strong and the *rebato* was adapted for this use. See also SUPPORTASSE.

RESIST DYEING: The colouring and patterning of a fabric or yarns for a fabric by blocking off patterned areas with resist agent (usually wax) that prevents these areas from taking the dye. The resist agent is then removed. By repeating this process a multi-coloured design can be achieved.

REVERS: The turned-back edgings of a coat, waistcoat or bodice.

ROBINGS: The revers or the decorations on either side of the bodice of an open-fronted 18th-century gown, extending either to the waist or to the hem.

RUFF: A pleated and starched frilled collar made of fine line. Fashionable for both men and women from the 1570s until the 1620s. At first the frill was attached to the shirt or smock neck-band but as *ruffs* grew in size they became separate articles of dress. The tubular folds which are the distinguishing features of ruffs were called *sets* and were formed by *poking sticks*. These were pointed tubular tools of iron, bone or wood which were heated and poked into the folds each time the ruff was starched or when it had become limp and needed to be rejuvenated.

RUFFLES/ENGAGEANTES: The English and French terms for the scalloped flounces of lace or cambric worn singly, doubly or in threes with the elbow-length sleeves of an 18th- century gown or mantua.

SACK BACK: A style of 18th-century women's gown with the fabric at the back arranged in box pleats at the shoulders and falling loose to the floor with a slight train.

SHIRRING: A decorative effect achieved by gathering a piece of fabric in rows.

SKIRTS: A term applied to the panels below the waistline of a coat or a doublet.

SLASHING: This term is applied to the technique of cutting fabric in a series of decorative slits or slashes. It is carried out with either a sharp knife or a cutting tool not unlike a buttonhole cutter which has a chisel-shaped blade. These cutters were made in various widths and some had crinkled or serpentine edges. The intention was to show a coloured lining or linings beneath the outer fabric. Sometimes the first lining was slashed to show a second lining.

STAYS: *1.* A close-fitting bodice or undergarment worn by women, usually reinforced with whalebone, to mould the figure to the fashionable shape. *2.* BUTTON STAY: This term is applied to a strong linking thread holding, for instance, two pleats in position on a coat by using a button or buttons as an anchor on one pleat.

STOMACHER: A decorative V-shaped panel worn by women in the late-17th and first three- quarters of the 18th century to fill in the front of the bodice between the edges of an open-fronted gown.

SUPPORTASSE: A rigid collar-shaped support worn about the neck to hold up a ruff. It can be made of pasteboard covered in silk or of wire whipped over with gold and silver or silk thread and decorated with spangles. This type of support was also called a *pickadil, underpropper* or REBATO.

TABS: Abbreviated divided skirts of a doublet or pair of stays which occur below the waistline of the garment. Sometimes tabs were stiffened with whalebone. *1.* Their function on a pair of stays is to prevent the waist seam from cutting into the body. *2.* Tabs on a doublet disguised the points which held up the breeches.

TAFFETA: A plain weave silk cloth characterised by its stiff crisp feel and lustrous surface.

TISSUE: A woven fabric with an additional binding warp and at least one additional weft (often of metal thread) used for decorative effect.

VELVET: A pile weave in which the pile warp is raised in loops above the ground weave. These loops may be cut at a later stage. Uncut loops are literally called uncut velvet and both cut and uncut finishes can be created in the same textile.

WARP: Strong structural threads running vertically from top to bottom of a fabric.

WEFT: The threads which form the pattern or surface of a fabric and are woven horizontally across the warp threads from selvedge to selvedge.

Selected Further Reading

Arnold, Janet, *Patterns of Fashion Englishwomen's Dresses and Their Construction 1660-1860* (London, Macmillan and New York, Drama Book 1977)

Arnold, Janet, *Patters of Fashion c.1560-1620* (London, Macmillan and New York, Drama Book 1985)

Bridgeman and Drury, eds, *Needlework: an illustrated history* (New York and London, Paddington Press 1978)

Buck, Anne, *Dress in Eighteenth Century England* (London, Batsford 1979)

Clabburn, Pamela, *The Needleworker's Dictionary* (London, Macmillan 1976)

Colby, Averil, *Quilting* (London, Batsford 1972)

Cumming, Valerie, *Gloves, The Costume Accessories Series* (London, Batsford 1982)

Cunnington, C.W. and P., *Handbook of English Costume in the 17th Century* (London, Faber & Faber 1955; third edition 1972)

Cunnington, C.W. and P., *Handbook of English Costume in the 18th Century* (London, Faber & Faber 1957; revised 1972)

Cunnington, C.W. and P., *A Dictionary of English Costume* (London, A&C Black 1960; revised 1976)

Freeman, Rosemary, *English Emblem Books* (London, Chatto & Windus 1948)

Germaine de St Aubin, Charles, *Art of the Embroiderer*, trans. and annotated by Nikki Scheuer (Los Angeles County Museum of Art 1983)

Hefford, Wendy, *Design for Printed Textiles in England from 1750 to 1850* (London, V&A Museum 1992)

Johnstone, Pauline, *Three Hundred Years of Embroidery 1600-1900: Treasures from the Collection of the Embroiderers' Guild of Great Britain* (South Australia, Wakefield Press 1986)

Kerridge, Eric, *Textile Manufactures in Early Modern England* (Manchester University Press 1985)

King and Levey, *Embroidery in Britain from 1200 to 1750* (London, V&A Museum 1993)

Levey, Santina, *Lace: a History* (Leeds, W.S. Maney & Son 1983)

Ribeiro, Aileen, *Dress in Eighteenth-Century Europe 1715-1789* (London, Batsford 1984)

Rothstein, Natalie, ed., with Madeleine Ginsburg, Avril Hart, Valerie Mendes, *Four Hundred Years of Fashion* (London, V&A Museum and William Collins 1984; reprinted 1996)

Rothstein, Natalie, *Silk Designs of the Eighteenth Century* (London, Thames &Hudson 1990)

Rutt, Richard, Bishop of Leicester, *A History of Hand Knitting* (London, Batsford 1987)

Swann, June, Shoes, *The Costume Accessories Series* (London, Batsford 1982)

Thomas, Mary, *Mary Thomas's Dictionary of Embroidery Stitches* (London, Hodder and Stoughton 1934,1979)

Waugh, Norah, *The Cut of Men's Clothes 1600-1900* (London, Faber & Faber 1964; reprinted 1988)

Waugh, Norah, *The Cut of Women's Clothes 1600-1900* (London, Faber & Faber 1968; reprinted 1987)